LEONARDO DA VINCI
Experience, Experiment and Design

D1493778

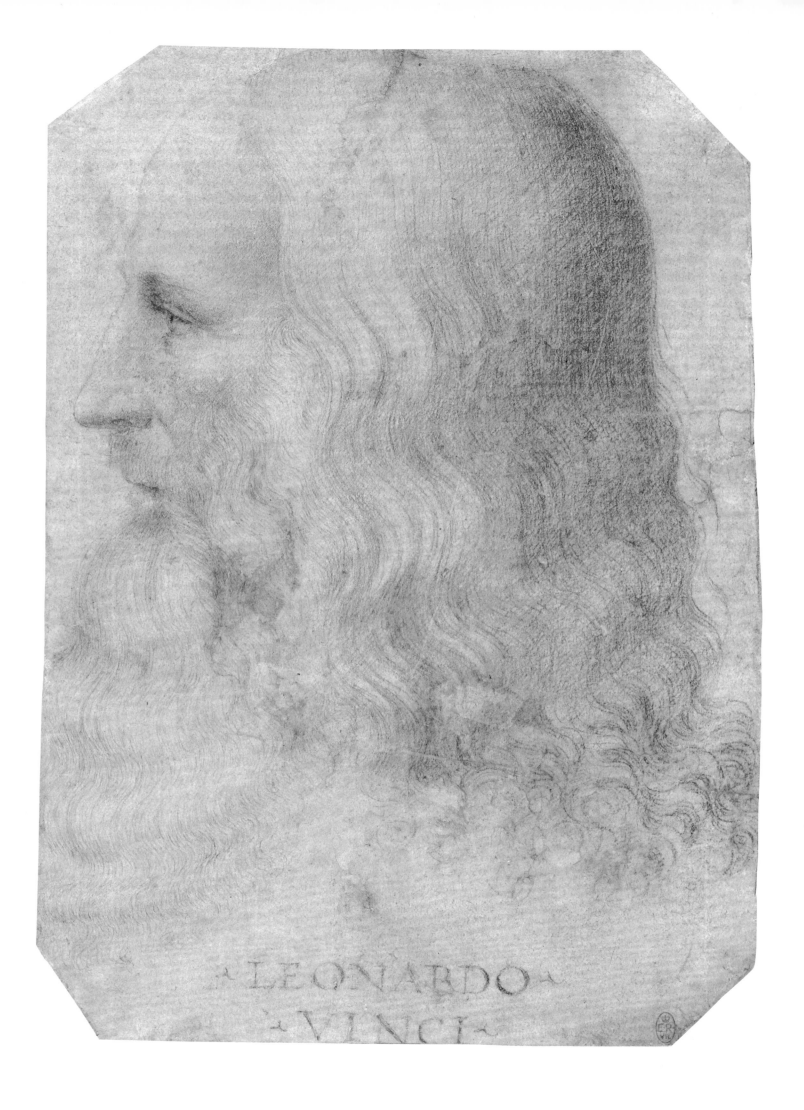

LEONARDO
VINCI

MARTIN KEMP

LEONARDO DA VINCI

Experience, Experiment and Design

V&A PUBLICATIONS

Universal Leonardo

This exhibition has been organized in association with Universal Leonardo (University of the Arts London) and is part of the 28th Council of Europe Art Exhibition.

First published by V&A Publications, 2006
V&A Publications
Victoria and Albert Museum
South Kensington
London SW7 2RL

© The Board of Trustees of the Victoria and Albert Museum

The moral right of the author has been asserted.

HARDBACK EDITION
ISBN-10 1 85177 486 6
ISBN-13 978 1 85177 486 9

10 9 8 7 6 5 4 3 2 1
2011 2010 2009 2008 2007

PAPERBACK EDITION
ISBN-10 1 85177 487 4
ISBN-13 978 1 85177 487 6

10 9 8 7 6 5 4 3 2 1
2011 2010 2009 2008 2007

A catalogue record for this book is available from the British Library.

All rights reserved. No part of this publication may be reproduced, stored in a retrieval system, or transmitted in any form or by any means electronic, mechanical, photocopying, recording or otherwise, without written permission of the publishers.

Every effort has been made to seek permission to reproduce those images whose copyright does not reside with the V&A, and we are grateful to the individuals and institutions who have assisted in this task. Any omissions are entirely unintentional, and the details should be addressed to V&A Publications.

FRONT JACKET/COVER ILLUSTRATION: *Vessels of the arm with comparison of vessels in the old and the young*, PLATE III.36 (detail)
BACK JACKET/COVER ILLUSTRATION: *Vertical and horizontal sections of the human head and eye*, PLATE I.28 (detail)
FRONTISPIECE: Francesco Melzi (?), *Portrait of Leonardo da Vinci*, c.1508, Red chalk, 27.5 × 19 cm, Windsor Castle, The Royal Collection 12726
PAGES X−1: *Studies of men climbing stairs and a running man stopping*, PLATE III.11 (detail)
PAGES 20−21: *The human brain, cerebral nerves and eyes*, PLATE I.29 (detail)
PAGES 94−5: *Men at work, digging, carrying, pulling, etc.*, PLATE IV.2 (detail)
ENDPAPERS (hardback only): *Battle scene with men and elephants*, PLATE IV.17 (detail)

Designed by Philip Lewis
Project management by Geoff Barlow
New V&A photography by Peter Kelleher,
V&A Photographic Studio

Printed and bound in Italy by
Conti Tipocolor Srl, Florence

V&A Publications
Victoria and Albert Museum
South Kensington
London SW7 2RL

www.vam.ac.uk

CONTENTS

SPONSOR'S FOREWORD

Deloitte is proud to sponsor *Leonardo da Vinci: Experience, Experiment and Design.*

From the very beginning of his career, Leonardo was recognized for his unparalleled ability to think laterally across a range of disciplines. He was the original Renaissance man: a scientist, an artist, a theorist, an originator, an astute observer and, quite simply, an innovator before his time.

Five hundred years after he completed his most famous creation, the *Mona Lisa*, Leonardo's inventiveness still provokes and inspires, and his name has become a byword for genius. His attributes of ingenuity, insight, creativity and leadership are qualities that endure.

We are delighted to be associated with the V&A for the first time, especially given the outstanding nature of this exhibition, which will reveal the workings of Leonardo da Vinci's mind and bring his unique vision to life.

At Deloitte, we foster a collaborative culture where talented individuals can produce their best work. We value innovative thinking, diverse insights, and we strive to offer an exceptional breadth and depth of service expertise.

May this publication inspire your own lateral thinking and imagination.

John Connolly
CHIEF EXECUTIVE AND SENIOR PARTNER
DELOITTE & TOUCHE LLP

Deloitte.

PREFACE

The V&A is pleased to be participating in the series of exhibitions taking place across Europe under the aegis of the 'Universal Leonardo' project. Leonardo is one of those iconic figures who, like Charlemagne or Beethoven, is felt by all European countries to be a part of their heritage. His continual examination of the physical and organic universe, and his unending flow of questions about the laws and forces that govern it, make him endlessly fascinating and ever contemporary.

This exhibition shows manuscripts and drawings that allow us, with the aid of modern technology, to follow his thought processes and working methods more immediately and vividly than ever before. The V&A's own Leonardo notebooks came to the Museum with the library of John Forster in 1876, bequeathed in support of the Museum's educational mission. They help us to explore a theme of central importance to the V&A: the way in which a great genius explored and developed ideas on paper.

We are extremely grateful to Martin Kemp and the Universal Leonardo project; to Deloitte for their energetic support and imaginative development of the ideas in this exhibition; and to the lenders whose generosity has made it possible.

Mark Jones
DIRECTOR
VICTORIA AND ALBERT MUSEUM

ACKNOWLEDGEMENTS

Since I decided to discuss in the text and illustrate every drawing in the exhibition, providing not only a book but also a kind of 'narrative catalogue', this publication has made complex demands on everyone involved. A series of elaborate checks and tabulations have been made to ensure that every drawing is discussed, that sheets used in more than one place in the text are referred to by plate number at each mention and that each plate (or detail) appears in the best place in the text (not necessarily where it is first mentioned). Without the patient assistance of Dafna Talmor I might well have given up on more than one of these tasks. Uta Kornmeier has provided superb support during the whole of the later stages of the publication.

Technically this is the most difficult publication I have ever written, and the struggles have required great patience from the publications team at the Victoria and Albert Museum. Mary Butler and Geoff Barlow have never been less than understanding and helpful. Mandy Greenfield provided valuable and accurate advice in copy-editing. Working with Philip Lewis has been a pleasure, and his book design is all I could wish for.

During the genesis of the exhibition, Linda Lloyd Jones has been enthusiastically supportive and imaginative, and Tina Manoli has provided excellent curatorial services. Rowan Watson has also generously shared his expertise relating to the Codex Forster. The concept for the show was developed integrally with the superb designer Paul Williams, of Stanton Williams Architects, for whom Juliet Phillips undertook the detailed oversight of the design. Steve Maher of Cosgrove Hall ingeniously created the computer-graphic realization of Leonardo's aspirations to create drawings that 'moved'. All sectors of the Museum involved in the exhibition have been unfailingly collaborative and good-humoured and it has given me much personal pleasure to see the many exciting developments that have occurred since I resigned as a Trustee in 1989.

The exhibition has arisen within the context of the 'Universal Leonardo', a project conceived and developed by Marina Wallace and myself, in collaboration with Fred Schroeder. It involves simultaneous exhibitions in a number of European venues, a programme of technical examination of Leonardo's paintings, and the genesis of a major website. The website (www.universalleonardo.org) gives details of the project as a whole, and will provide an enduring resource after the closure of the exhibitions. The Universal Leonardo Team in the Artakt office at Central St Martin's College of Art, London, has been vital to the whole project. Marina Wallace resolutely kept going in the face of the plural adversities of international non-cooperation. Thereza Wells, before the birth of her daughter, was deeply involved in the curation of the show and has provided valued subsequent help. Philippa Jarvis provided vital and enthusiastic liaison between the office and the Museum. Sandy Mallet valiantly headed the Universal Leonardo project in its early stages, to be succeeded by Sabita Kumari-Dass, who has brought special skills of organization and know-how to the final realization of the project. Caterina Albano and Rowan Drury have been constant sources of support. During 2006 Uta Kornmeier has been acting as my personal assistant for projects and research. Her enthusiastic orderliness and good-humoured determination have been wholly invaluable. Gheri Sackler has been steadfast in her commitment to the vision of the Universal Leonardo, and to my work in particular. Her assistance has made the impossible possible.

NOTES TO THE READER

The basic research for the exhibition was conducted while I was Mellon Senior Fellow at the Canadian Centre for Architecture in Montreal. Phyllis Lambert was a constant source of support and provided telling commentaries on what I was doing. The staff of the centre – most notably the librarians – were unstinting in their assistance.

Financial support in the research and development of the project was provided by Bill Gates, for whom Fred Schroeder acted with energy and aplomb. It is sad that it was not ultimately possible to include in the exhibition the Codex Leicester owned by Bill Gates, which it was our intention to show fully integrated with related sheets from other collections. The sheets are, however, included in the book. Funding money for the realization of the Universal Leonardo project was generously provided by the Council of Europe, from which organization Domenico Ronconi, David Mardell and Irene Weidmann have been very supportive. The University of Oxford, most notably in the person of John Robertson, facilitated the research through the provision of two sabbatical terms.

Abbreviated source references in the text to Leonardo's manuscripts and drawings (e.g. Urb 109r–v) are as follows:

Manuscripts A–M: Bibliothèque de l'Institut de France, Paris
Arundel: Codex Arundel, British Library, London
BL: British Library, London
BM: British Museum, London
BN: Mss 2037–8, Bibliothèque Nationale, Paris
CA: Codice atlantico, Biblioteca Ambrosiana, Milan
Forster I, II and III: Victoria and Albert Museum, London
Leic: Codex Leicester, Bill and Melinda Gates Collection, Seattle
Madrid: Biblioteca Nacional, Madrid
Turin: Biblioteca Reale, Turin
Urb: the 'Trattato dell Pittura', Codex Urbinas Latinus 1270, Vatican Library, Rome
W: The Royal Collection, Windsor Castle, Windsor

References in sans serif (e.g. 1.16) are to illustrations reproduced in this book, citing the relevant chapter number followed by the illustration number.

All exhibition objects are reproduced at actual size, and are also listed in the correct exhibition order on pp. 193–8.

INTRODUCTION: UNITY IN DIVERSITY

 HIS BOOK, and the exhibition that has occasioned it, is about how Leonardo used paper. That he used a lot of paper is not in doubt. There are some 6,000 surviving pages. It can be estimated that around four-fifths of his written and drawn output is lost. Altogether he must have used the equivalent of about 130 times the number of pages in this book.

This estimate comes from a comparison of the *Treatise on Painting*, compiled by Francesco Melzi (aristocratic pupil and faithful custodian of Leonardo's legacy) with the manuscripts now known to us. Only one-fifth or so of the sections in the *Treatise* can now be recognized in the surviving sheets and codices. There may be a chance of more appearing, as happened in the winter of 1964–5, when two bound manuscripts were discovered in the Biblioteca Nacional in Madrid, but it is certain that by far the greater quantity of the sheets of paper containing his writing and drawing is irredeemably lost. This is not altogether surprising. Although drawings began to be collected in the sixteenth century, general interest in the privately written notebooks of even the most famous people is relatively recent, and it was only in the late nineteenth century that they began to become a major focus of attention as the key to the inner life of creative individuals. Leonardo's own manuscripts – written in mirror script in a very difficult hand, and containing an apparent chaos of sketches, technical scribbles and notes, rather than anything organized for publication – cannot have seemed an attractive proposition for any but the most percipient collector. His writing begins in what is more or less a late-medieval notary's style, but becomes increasingly summary and abrupt, with an idiosyncratic letter formation that can trouble even the most expert readers. That so much has actually survived is a tribute to Melzi's pious stewardship and to successive collectors and librarians who were captivated by the continuing magic of Leonardo's name.

Amongst the heroes of this enterprise are Pompeo Leoni, a Milanese sculptor who carried many of them to Spain, where he was working for the King; Count Galeazzo Arconati, who was responsible for the holdings in the Biblioteca Ambrosiana in Milan; and Cassiano dal Pozzo, librarian to the Barberini in Rome, who set in motion the first publication of Leonardo's *Treatise* in Italian and French in 1651. The star British collector was Thomas Howard, the 2nd Earl of Arundel in the seventeenth century, who was clearly keen to acquire any authentic Leonardo material. He not only possessed the large compilation now bearing his name in the British Library, the Codex Arundel, but also purchased the suites of drawings now in the Royal Collection at Windsor, which comprise the major collections of his drawings for works of art and of his anatomical studies. Another prominent player in our present context is John Forster, critic, biographer of Dickens and passionate collector of books and manuscripts, whose legacy passed to the Victoria and Albert Museum, including his three precious Leonardo codices.

Leonardo's separate pages and bound notebooks must have looked very odd in his own day. No one used paper so prodigally – perhaps unsurprisingly, since it was not the ubiquitous and cheap product that we take for granted today. To be sure, artists had been sketching on paper quite extensively before Leonardo's day. His master, Andrea del Verrocchio, tried out designs on paper, often making rapid sketches in pen and ink, but no one used paper as a laboratory

PLATE INTRO.I (overleaf)
Profile of a man, plants, geometrical figures, machinery, etc. (also known as the 'Theme Sheet')
c.1488
Pen and ink
32 × 44.6 cm
Windsor Castle,
The Royal Collection, 12283r

for thinking on Leonardo's kind of scale. No one covered the surface of pages with such an impetuous cascade of observations, visualized thoughts, brainstormed alternatives, theories, polemics and debates, covering virtually every branch of knowledge about the visible world known in his time. They would still be exceptional in later eras of paper plenitude. We tend to miss how exceptional they are, since they are familiar to us through large numbers of publications. We take them as simply what Leonardo did. But not even the most extensive sketchers and note-makers, such as Thomas Edison, the great American inventor, created profusions of pages looking like Leonardo's. Even those who sometimes used the same page to explore different topics were not as profligate as him. Some of the sheets contain more than a dozen apparently unrelated topics from the many different disciplines he explored.

Leonardo is now the very image of the *uomo universale* – the 'universal man' of the Renaissance, somehow mastering a range of pursuits that would be unthinkable for a single individual today. His Florentine contemporaries, however, would not have been so surprised to find an 'artist' possessing such a range of skills in technology and even in science. Verrocchio and his rivals, the brothers Antonio and Piero del Pollaiuolo, operated in all kinds of artistic media – marble, bronze, precious metals and terracotta – as well as providing designs for textiles, stained glass and armour. They were noted for their command of perspective and the anatomy of the human body. For good measure, Verrocchio was involved in the manufacture and erection of the great bronze ball that stands atop Brunelleschi's dome for Florence cathedral – a considerable feat of engineering. Filippo Brunelleschi himself was a sculptor, architect, engineer and renowned inventor. Early in his career he demonstrated how buildings could be portrayed on flat panels according to precise optical rules, as part of the science of *perspectiva*, which dealt with the geometry of light. Brunelleschi's contemporary, the sculptor Lorenzo Ghiberti, listed the spheres of knowledge that the 'learned' artist should master: grammar, geometry, philosophy, medicine, astrology, perspective, history, anatomy, theory of design and arithmetic. This reads like a recipe for a Leonardo (though engineering is surprisingly absent from Ghiberti's list).

As the (illegitimate) son of a major notary, Ser Piero da Vinci, who rose to a high position in Florentine government service, Leonardo had a background that was not that of an artisan. Brought up in the household of his grandfather's family in Vinci, where they were landowners of some status, he would have received a good basic education in literacy and numeracy. His father may well have facilitated his placement in Verrocchio's studio, which brought Leonardo into contact with the Medici and the cathedral workshop. He was, given his potential, in the right place at the right time.

Where Leonardo differed from his master, and from the elite cadre of 'super-artists' who preceded him in Florence, was that he actually implemented the full brief for *uomo universale* with a depth, intensity, fertility and range that no one had ever matched, or was to match again. This programme, albeit in a fraction of what once existed, is what we witness as we turn the pages of his manuscripts – bewildered by the teeming diversity of creative thinking that is expressed not only by the codices as a group, but also on a single page.

The 'Theme Sheet'

The large folded page that Carlo Pedretti has justly dubbed the 'Theme Sheet' in his catalogue of the Windsor collection (INTRO.1) gives an idea of Leonardo's extraordinary way of using paper. It is exceptionally large at 32 × 44.6 cm/ 12½ × 17½ inches. The extraordinary diversity of figurative and abstract motifs on this sheet perfectly sets the tone for our present quest, and it will be worth looking at it in some detail to see if we can make sense of what is happening.

Dating from about 1490, when Leonardo was 38 years old and working in Milan for Duke Ludovico Sforza, it contains drawings belonging to at least eight of what we would classify as distinct categories. In the centre of the left half of the sheet is one of his typical portrayals of the head of a man with a 'Roman' profile, albeit with more body than usual, puzzlingly interlocked with a tiny sketch of a tree and a geometrical diagram. The geometrical

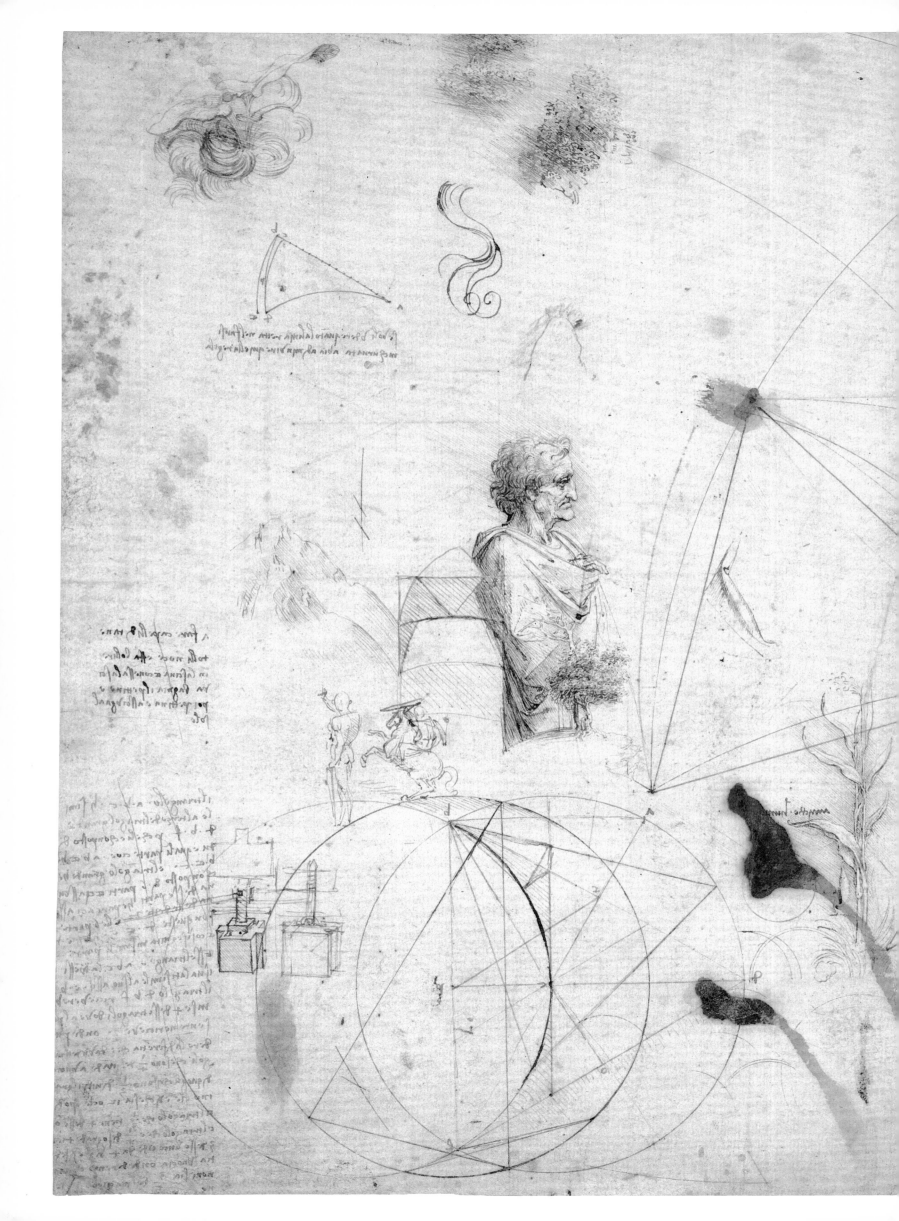

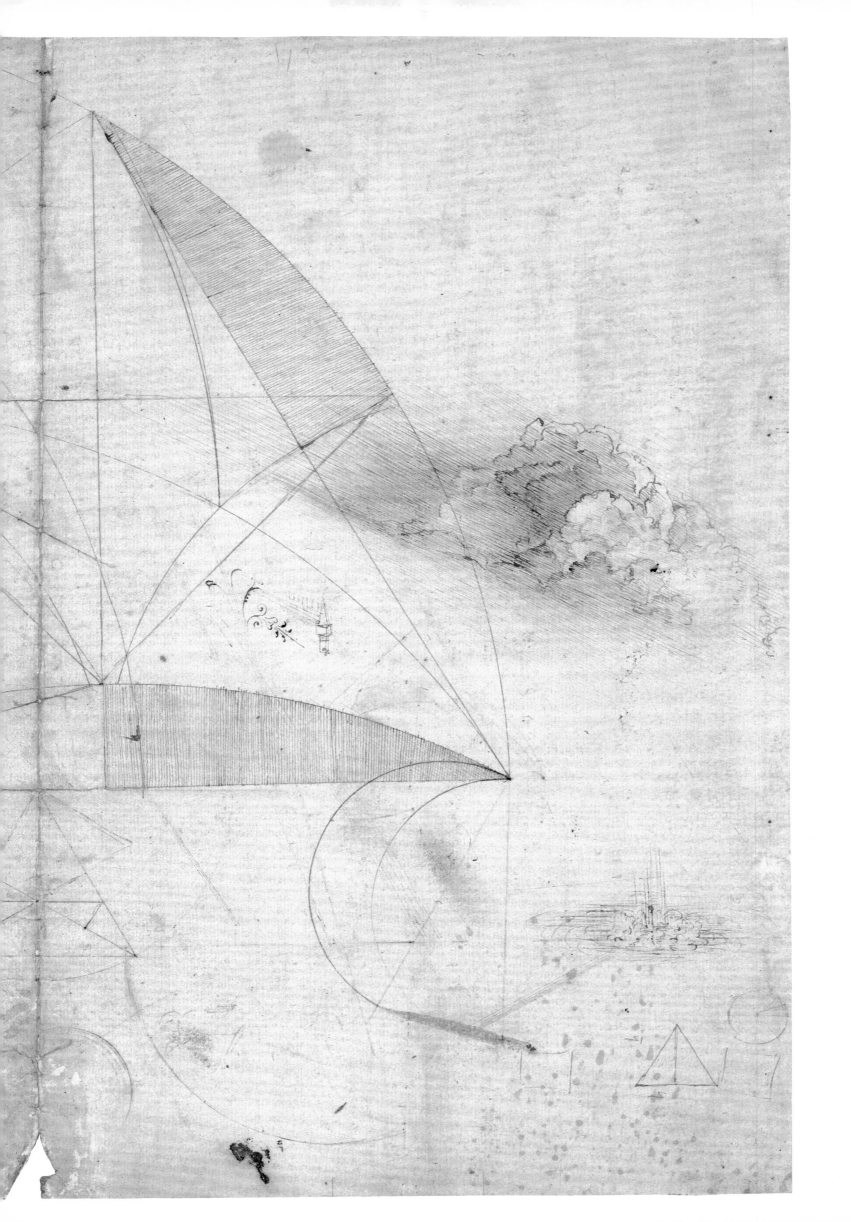

diagram seems to bound off to the left to become a conical hill. Behind and below the man is one of Leonardo's slight, but amazingly eloquent, sketches of a rearing horse bearing a rider with upraised shield, and a gesturing man who is apparently nearer to us and may be holding a shield in an upright position and edge-on. Below and to the left of the standing man are two engineering designs unaccompanied by any note of explanation. Towards the centrefold are two leafy stems, apparently of a type of rush, rising from curving grasses. The stems appear to have been drawn from life, which is probably not the case with the man and the tree. But Leonardo drew natural forms so well from his head that it is often difficult to tell. Above the stems is an isolated fold of drapery. Near the top left is a dangling curl, perhaps of hair, but possibly of water. The little scribbles immediately above the curl explore the effects of light and shade on bunches of foliage. In the top left corner the leaves of an arum lily can be seen above swirling leaves of grass.

Halfway up the right side of the sheet Leonardo has added a little decorative motif formed from curves, commas and a straight line. Beside it is a minute sketch of a bell-tower with a steeple. At the right is a nice drawing of the effects of light and shade in a cloud. Below is a hasty sketch that appears to depict a column of water falling vertically into a pool, with turbulent consequences. Further to the left and lower down is a barely visible outline of a pacing horse. Finally, distributed across the sheet are a series of geometrical diagrams, the largest of which spans the centrefold. There are also sundry blots and smudges.

There are three blocks of notes, written in Leonardo's characteristic hand, two of which are partly struck through, and a fragment of formal writing beside the stems. The crossing-out either indicates that they have been transcribed elsewhere or that they were considered erroneous. All the texts are in his mirror script, which, as a left-hander, he was clearly adept at writing. He could, when the need arose, write normally from left to right; but, working at his speed in slow-drying inks and smudgeable chalks, writing in reverse from top right to bottom left possessed obvious advantages. The main problem for us in reading it is not the reversal as such, but its style. He writes in the kind of difficult late-medieval hand that his father used as a notary,

which is replete with stock abbreviations. Michelangelo, by contrast, wrote in the more fashionable and up-to-date italic hand favoured by the humanists, who thought it more 'Roman'.

Scattered and seemingly random though the component parts may appear, this page signals a remarkably high proportion of Leonardo's diverse but interlocked obsessions. Indeed, it can provide a springing-off point into a thematic understanding of his unity in diversity. In what follows, I will be pursuing a kind of meander across the motifs on the sheet – not directly aspiring to reconstruct Leonardo's sequence in covering it in sketches, but making the transition from topic to topic in a way that is in keeping with his thought processes.

Looking at Nature

Pride of place must, in keeping with his own insistence, probably be given to 'Nature', and above all the meticulous observation of the seen world. The two stems (INTRO.2) signal that aspiration, standing in a long line of freshly compelling drawings from nature. They are drawn with a wiry vitality and extraordinary delicacy that reflects both the tradition of naturalism in Florentine art and the impact of Netherlandish painting in Italy in the second half of the fifteenth century. What Leonardo did was to ally this tradition with an all-embracing theory of knowledge. For Leonardo, no knowledge has value unless it can be observed and confirmed through the tangible experience of natural forms and phenomena. The proofs he sought in nature were to be as certain as the truths of mathematics. He dismissed abstract speculation, whether philosophical or theological, since it did not have the required contact with the direct experience of nature: 'if you say that sciences that begin and end in the mind exhibit truth, this cannot be allowed and must be denied for many reasons, above all because such mental discourses do not involve experience, without which nothing can be achieved with certainty' (Urb 1r–v). The 'certainty' he sought was as certain as the truths of mathematics. He stressed 'that the painter will

INTRO.2

INTRO.2
The 'Theme Sheet'
PLATE INTRO.I (detail)

INTRO.3
The 'Theme Sheet'
PLATE INTRO.I (detail)

Looking at Faces

The supreme creation of nature, and the prime subject for observation, was of course man himself. The toga-clad man (INTRO.3) belongs to a very extended series of explorations of this kind of *all'antica* profile – 'in the ancient manner' – based generically on Roman coinage and closely related to Verrocchio's images of warriors. Leonardo's characterizations range from sober nobility to ribald caricature. The noses, chins and mouths are frequently manipulated to grotesque effect (e.g. W 12448). When we look closely at the man's features, we can see that the noble profile has begun to collapse with age and there is a hint of the onset of baldness. The manipulation of physiognomies allows Leonardo to stretch characterization to its limits, like a kind of muscular exercise undertaken to give him more than the capacity he needed when he came, say, to give character to the disciples in the *Last Supper* (INTRO.4). Judas's beaked profile is intended to mark him as the villain, whereas the youthful St John (definitely not the

produce pictures of little excellence if he takes other painters as his authority, but if he learns from natural things he will bear good fruit' (CA 387r). If you have to paint a plant, therefore, you study it directly from nature, rather than using formulas devised by other artists. Basically the same stricture applied to the practice of science, since those who unquestioningly accept established theory – represented in Leonardo's time by the late-medieval development of Aristotle's ideas – would never progress towards a secure mastery of nature as it is. His repeated disclaimer that he was a 'man without book learning' can be seen as much as a boast as a confession of weakness. Lacking a traditional education in the classics or in the natural philosophy of the universities, he was effectively claiming that all he could do was read the book of nature itself through direct and unprejudiced access. In practice, of course, things were somewhat different. No one can explain how nature works without a starting point in some kind of theory. And Leonardo himself went to considerable trouble to master the basic natural laws as outlined in the Aristotelian tradition, as conveyed in the Latin texts that he read with difficulty.

The fragment of formal script beside the stems, '*amicho humil[issimo]*' ('most humble friend'), which disappears into a blot, is seemingly unconnected, and may merely have been one of his pen-testing phrases. However, we might look at the close stems and their intertwined leaves and see in them an emblem of friendship; they support each other when each may have been too slender and frail to stand alone. Leonardo was a fertile inventor of emblems drawn from nature. The book of nature was as full of meaning as it was of diverse beauties and wonders. Humble plant stems could thus teach us a lesson in mutual support.

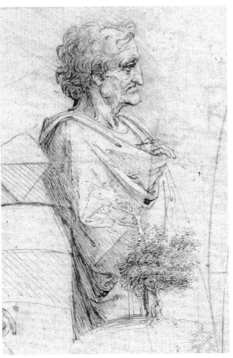

INTRO.3

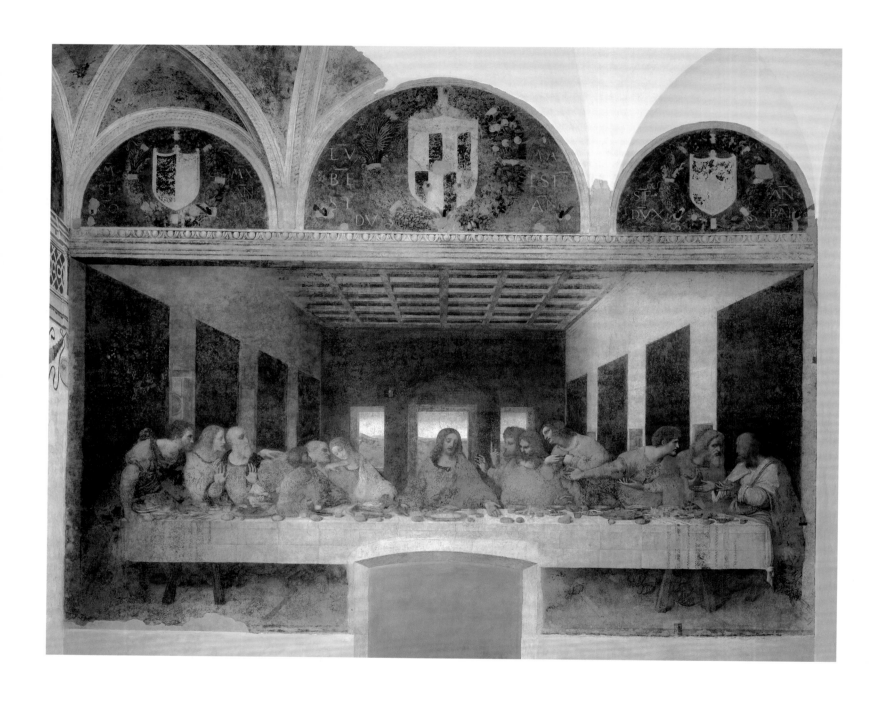

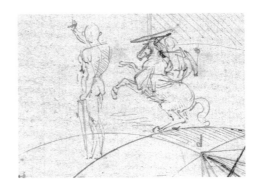

Magdalene of Dan Brown's best-seller *The Da Vinci Code*) is the very picture of young innocence. Even though he devised methods for succinctly recording notable features of faces that he encountered, such as noses, Leonardo does not appear to have ascribed to the more formulaic prescriptions of traditional physiognomics, which read particular facial features as set signals of character. He did believe that the nature of the soul of the person was manifested in the outer form of the body, but his instinct seems to have told him that it was the effect of the total ensemble of the face, rather than an aggregate of separately definable indicators.

Instead of developing a physiognomics of fixed signs, he paid greater attention to what was later called pathognomics – that is to say, the expression of emotions through the alteration of facial features. He emphasizes that 'the good painter has to paint two principal things, man and the intention of his mind. The first is easy and the second difficult' (Urb 109r–v). In a narrative painting he endeavoured to convey *il concetto dell'anima* (the intention of the mind or 'soul') of each of the actors in accordance with their characters, roles, ages and gender. At the very centre of the brain, in the system he had adopted from medieval psychology, voluntary action was driven by the intellect and the soul, the latter of which dictated the inherent character of the actor. Leonardo was clearly fascinated by the way in which a few lines could serve to conjure up a particular character with a specific expression. The kind of muscles he was exercising when he sketched the profile on this sheet came into play when he wanted to characterize the grave St Bartholomew at the extreme left of the *Last Supper*.

Men in Action

Il concetto dell'anima relies upon emotion and motion. It is through motion – whether of facial parts or the whole body – that the painted or sculpted figure reveals its inner feelings, even if they are as complex and contradictory as those of Judas. Leonardo's pages teem with little figures in diverse poses, drawn with astonishing rapidity and economy. We may sense his wonder at the way that a few deft marks of the pen bring a whole figure to life in expressive or effective motion. He studied men pulling, pushing, carrying (IV.2 and IV.3), picking up, putting down, running, stopping, walking uphill and downhill, getting up and sitting down and, in one remarkably cinematic sequence of thumbnail sketches, a man wielding a hammer to mighty effect (IV.43). In the little pen-men here (INTRO.5), one rhetorically registers surprise, pivoting around the axis of his body to look at the combative rider on his embattled horse. These motifs first entered Leonardo's mind when, as a young man, he was planning his *Adoration of the Magi* in the late 1470s. A dozen years later a rearing horse was one of the options he considered for the bronze equestrian monument to Francesco Sforza, father of the Milanese ruler. His reversion to the more conventional and technically feasible pacing pose may be recorded in the very slight outline that is barely visible in the lower right of the sheet. The rearing motif was to be revisited some 15 years later when he was planning his *Battle of Anghiari* for the Florentine council hall (IV.16), and finally re-entered the fray when he was planning an equestrian memorial to Gian Giacomo Trivulzio, a Milanese general in French service (INTRO.6).

The torsions of the standing man, the cascading curls at the back of the 'Roman's' head, the twisting of the leaves around the stems and the rhythmic curling of the grasses signal what became one of the leitmotifs of Leonardo's visual thinking, namely the motions in nature that assume serpentine, spiral or helical form. The curved lines above the man's head, slight though they are, overtly explore the vortex form, which is characterized by the tightening of the spiral as it moves inwards. It is unclear whether this little linear notation involves statics, such as the curling of hair, or dynamics, as in the motion of turbulent water. As Leonardo wrote later:

> Note the motion of the surface of water, which conforms to that of the hair, which has two motions, one of which responds to the weight of the strands of the hair and the other to the direction of the curls; this water makes

INTRO.6
**Studies of the monument to
Gian Giacomo Trivulzio**
c.1510
Windsor Castle, The Royal
Collection, 12355

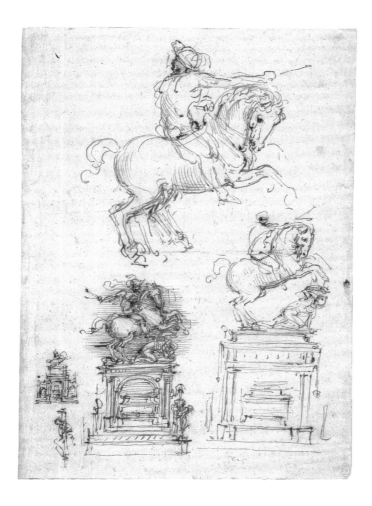

illuminated by different kinds of sunlight and as viewed from different angles. Clouds were not a major feature in Italian paintings, but when he did introduce them, as in the *Last Supper* and the *Madonna Litta* in the Hermitage, Leonardo was concerned to get them right rather than adopt the conventional white, lumpy things that generally served his predecessors. It is incredible how his parallel hatching in pen somehow captures the play of light and shade across such an evanescent form.

It was the same with trees. The little study that seems to merge with the man, and the two at the top of the sheet, are typical of many in which he is not so much recording the form of the tree as trying to capture the visual 'impression' of it for a relatively distant viewer. He is concerned simultaneously to understand how light plays on leaves and bunches of leaves, and how the 'perspective of distance' (as he called it) decrees that we progressively lose any perception of the individual leaves, and eventually even of the clusters, as we move further from the tree. Finally, of course, we will lose the trees for the wood. Even in these tiny, impulsive sketches the wonder of the subtle relationship between object and the act of seeing is manifest.

Microcosms

But why is the tree entangled with the man? There is more than enough room on the sheet to avoid their close encounter. It seems likely that the tree was there first and that the man was originally to be limited to a head or head and shoulders, as was characteristic of Leonardo's many small drawings of profiles. The progressive addition of the man's garments, with his right hand protruding awkwardly from the top fold of his toga, extended him precisely to the level of the rocky knoll on which the tree is rooted. But Leonardo could have stopped earlier. He cannot but have been fully conscious of the incongruous effect that was emerging – the man becoming surreally colossal by juxtaposition. He once produced a vivid pen picture of an awesome giant, and may have delighted in the accidental transformation in the man's scale. But there may have been

turning eddies, which in part respond to the impetus of the principal current, while the other responds to the incidental motion of deflection. (I.19)

Light and Shade

All such things, as Leonardo stressed, are seen only through the action of light and its perpetual companion, shadow. He went to immense pains to study the complex play of light in nature, both in itself and in relation to how effects vary when the relative positions of the light and the spectator are changed. In his *Treatise*, as assembled by Melzi, he meticulously described clouds of different types

another resonance when he saw what was happening to the man and the tree. He believed in the inner unity of the human body with nature as a whole, in the context of the universal laws that governed the largest components of the cosmos and the smallest particles in nature. This was the traditional doctrine of the microcosm and macrocosm:

> By the ancients man was termed a lesser world and certainly the use of this name is well bestowed, because, in that man is composed of water, earth and fire, his body is an analogue for the world; just as man has in himself bones, the supports and armature of the flesh, the world has the rocks; just as man has within himself the lake of the blood, in which the lungs increase and decrease in breathing, so the body of the earth has its oceanic seas which likewise increase and decrease every six hours with the breathing of the world; just as in that lake of blood the vessels originate, which make ramifications throughout the human body, so the oceanic sea fills the body of the earth with infinite vessels of water [*vene d'acqua*]. [A 55v]

Later, when he made a rough sketch of the vascular system in isolation from the body (1.31), he referred to it as the 'tree of the vessels'. This is a natural description for someone who believed that all branching systems obeyed the same rules, whether the blood vessels and bronchial tubes of the body, the branching of trees or a system of rivers and tributaries.

When we look more closely at the tree, we see that Leonardo has added a taller, leafless tree behind it. Its shaded trunk can be seen to the left of the gnarled trunk of the leafy tree. Its bare branches rise into the man's toga, stopping artificially at the V-shaped fold below his wrist. Yet the diagonal line that continues the main line of this section of drapery passes behind the lower limbs of the bare tree. This means that the tree and the extended drapery were drawn together in concert, deliberately, as part of the same evolving design. Something similar has happened with the geometry to the rear of the man. The right edge of the diagram in part intrudes into, and is in part overlaid by, the man. Again Leonardo exhibits a full

consciousness of the graphic and visual incongruities that were arising.

In his book *On Painting* (1435–6), Leon Battista Alberti, the humanist and architect, had noted:

> The movements of hair and manes and branches and leaves and clothing are pleasing when represented in painting ... Let [hair] twist around as if to tie itself into a knot, and wave upwards in the air like flames; let it weave beneath other hair and sometimes lift on one side and another. The bends and curves of branches should be partly arched upwards, partly directed downwards; some should stick out towards you, others recede, and some should be twisted like ropes. Similarly in the folds of garments care should be taken that, just as the branches of the tree emanate in all directions from the trunk, so folds should issue from a fold like branches. [II, 45]

It is difficult to think that this passage, with its suggestive analogies, did not echo repeatedly in Leonardo's mind when he was thinking about hair, water, branches and drapery. Indeed, he has singled out one branch-like fold for special attention in front of the man. Maybe Alberti's parallel is enough to explain Leonardo's visual play between the branches and the folds in the man's draperies. But his play rarely stopped with just one analogy, if another was readily to hand. The text I quoted above from Manuscript A is from the same period as the drawing. He can hardly have missed the microcosmic dimensions of the juxtaposition. That is just how his mind worked.

'A Second Nature in the World'

Even if the theme of the microcosm emerged opportunistically here, there is no doubting its centrality to Leonardo's thinking. It provided the basis for his unshakeable belief that all created things relied upon the same basic set of natural 'causes' (rules or laws) for their operation. The human creator must rely upon the same set of rules if his

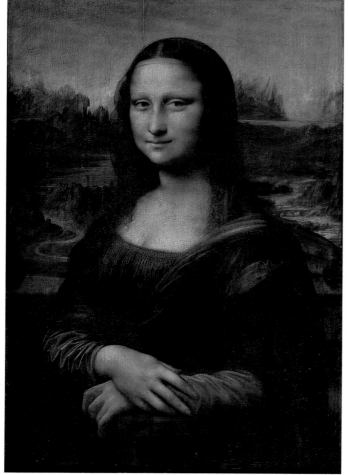

INTRO.7

INTRO.7
Mona Lisa
c.1503–13
Paris, Louvre

INTRO.8
The 'Theme Sheet'
PLATE INTRO.I (detail)

bodies that perform desired functions. The flying machine may take its cue from birds and, increasingly, bats, but Leonardo knew that human flight had to be achieved on its own terms on the basis of a deep understanding of natural design. Most of his engineering designs were more remote from the actual forms of nature than his '*uccello*' or 'great bird'. The design here, drawn twice, consists of a strong cruciform block, drawn with chunky conviction, into which a broad, screw-threaded shaft has been inserted (INTRO.8). There appears to be one or more capstans inserted into the shaft, below a simpler block through which it passes. Lacking any guiding words from Leonardo, it is difficult to know what the device is, but it appears to be concerned with the generation of considerable power to raise heavy weights, inch by gradual inch. Such lifting devices were constant concerns for builders of stone structures. Again, a spiral is involved.

or her creations are to be valid. This applies to the painting of the *Mona Lisa* (INTRO.7) no less than to the design of a flying machine. Leonardo's extraordinarily famous portrait is not so much an ocular record of what the painter saw, when Lisa Gherardini sat before him, as it is a re-creation or remaking of a human being in a remade landscape. The rules of optics govern the play of light across her features, the misty blue distance and her scale in relation to the landscape (in reverse of the tree–man juxtaposition). The rules of serpentine motion are observed in her curling hair, her spiralling draperies and the meandering valleys behind her. The rules of anatomy – above all with respect to how a woman's flesh covers her bones and muscles – inform the way she is made to look feminine. The rules of mountain formation, erosion and collapse, which account for the presence of lakes at different heights, are obeyed in the portrayal of the landscape. And of course there is *il concetto dell'anima*, in all its beguiling ambiguity. The living body of the human being and the living body of the earth are re-created by Leonardo in perfect concord, in the context of the natural laws that govern the micro- and macrocosms.

In a manner wholly comparable to the painter, the engineer acts as a 'second nature' in the world. The engineer does not so much imitate the wondrous and perfect creations of nature, but invents new kinds of artificial

Geometry

Overlying or underlying these more figurative representations are a series of geometrical diagrams. They serve to underscore how mathematics provides the substratum on which the whole of nature is built. On one of his anatomical drawings Leonardo wrote, 'let no one who is not a mathematician read my principles' (W 19118r).

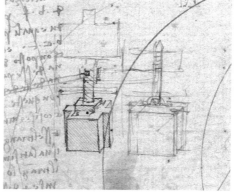

INTRO.8

The largest drawing, at the centre, produced with straightedge and compass, manifests his enduring fascination with the way that geometrical shapes with straight and curved sides of equal area can emerge from a series of procedures undertaken with the same opening of the compass. Two of the equal areas are typically shaded in. It is difficult to follow all Leonardo's moves here, as he improvises with his compass and ruler, but they centre around three equally spaced points, which would form an equilateral triangle if the third side had been drawn in. On the verso of the sheet is a related drawing, in which the equilateral triangle has convex sides.

The complex diagram in the lower right corner is accompanied by a note that is slightly trimmed at the left margin. It is another of those elaborate excurses on areas and proportions that Leonardo took so seriously, and which we tend to find heavy-going. It is almost painful to quote it in full:

> The triangle *abc* is similar to a third of the large triangle *dbf* because it is made up of two equal parts, that is *abe* and *bec*, and the large triangle is made up of 6 parts, and each of these parts is equal to each of the said 2, and the 6 parts are these: *dec* and *ced* and so on, in similar parts. And if the triangle *abc* had its sides similar to its axis, *cb* [actually *cp*], the triangle *dbf* would receive in itself 4 of these triangles, whereas at present it receives 3; thus to see the difference from one of the triangles which are ¼ of the large one and one of those which are ⅓, have the large triangle divided into twelfths, and say that it is 12 twelfths; then say that the triangle which is ⅓ of it is 4 of these twelfths and the triangle that is ¼ of this large one contains three of these twelfths, so that the difference between 4 and 3 is one twelfth, whence we can say that the smaller is ¾ of the larger.

Without any succinct form of notation, the effect is rather like listening to someone trying to give a description of a spiral staircase without pictures or gestures. But for Leonardo, there was a special kind of magic in the way such conjunctions and proportions arose inexorably as he manipulated his compass and ruler in an apparently endless series of variations. The effect must have seemed akin to music.

He was creating a kind of polyphonic version of Euclid.

It is with some relief that we can turn to the simpler diagram towards the top left corner (INTRO.9). He explains, 'If you want to see how much the straight line will diminish in making itself curve, here is the rule.' The result is clear enough. The 'shortening' is denoted by the distance between the lower points in the two arcs drawn from the line marked with the scale. But since Leonardo does not describe the procedure – as is promised by the added letters – it is difficult to follow how the 'rule' works. The 'rule' is potentially of considerable utility, since it would, for instance, tell a constructor precisely how much less a distance will be spanned by a curved beam than by a straight one.

Finally, in the lower right corner are the simple figures of a circle, a triangle (with the numbers 12 and 2) and two rough squares, which appear to have been jotted down as aids to his thinking, but perform no clear function on their own.

Hair Colour

There remains one note we have not discussed so far. It is halfway up the left margin and reads: 'To make hair tawny, take nuts and boil them in lye and immerse the comb in it and then comb the hair and dry it in the sun.'

However hard one might try, it is difficult to bring this note into any kind of unity with the other topics in the sheet. I suppose we could speculate that the ageing 'Roman' might need something to mask any greyness appearing in his locks. But this is pushing the case too hard. This simply seems to be one of those things jotted down on the handiest piece of paper, without it having any relationship with the other things already on the paper. My own desk is full of such bits of paper with unrelated notes, a proportion of which mean nothing to me after just a short interval. Even with Leonardo, not everything is related, and not everything is significant. Why he wanted to record the recipe is unclear. Perhaps it would be useful in one of the theatrical performances with which he was involved at this time. Or perhaps, in his late thirties, he was beginning to go grey himself.

This propensity to add notes to a piece of paper readily to hand, without any internal relationship to other topics on the sheet, is apparent throughout Leonardo's notebooks. An example is the page in the Codex Arundel containing a perpetual-motion machine to be studied later (1.7), to which he has added one of his typical word lists, making a somewhat obscene play around the word *cazzo* (44v). In polite terms, *cazzo* is a vernacular word for the male member; its vulgar translation is 'prick'.

nuovo cazzo (new prick)
cazuole (shovel)
cazzellone (?)
cazatello (?)
cazata (stupid thing)
cazelleria (?)
cazate (stupid things)
cazo inferingo (shovel?)
cazo erbato (grassed shovel?)
caza vela (sail shovel?)
pichellone (?)

The basic play is around 'prick' and types of shovel, but some of the words are obscure, probably regional colloquialisms. Whatever occasioned it, the list is an example of a strain of vulgarity that surfaces occasionally in Leonardo manuscripts – casting another light on someone who is too easily dehumanized in the face of cultural deification.

The Parts and the Whole

At first sight, the plastic studies of organic form on this sheet and the abstract precision of the geometrical diagrams seem to belong to different realms of endeavour. However, for Leonardo, every form – however complex – was constructed on the basis of underlying rules of a geometrical nature. The relationship of natural design to geometry might seem relatively apparent in such forms as shells and (as we will see) a heart valve, but it is visible everywhere if we know how to look. The vision is less one of statics than of dynamics. The muscles of the human body worked immaculately according to the laws that governed levers. The flow of the blood in the vessels and of the air in the bronchial tubes in the lungs was governed by the geometrical rules that applied to all branching systems. A flying bird was designed in perfect conformity with the geometry of air flow. And so on.

As he emphasized: 'That mental discourse that originates in its first principles is termed science. Nothing can be found in nature that is not part of that science, like continuous quantity, that is to say geometry' (Urb 1r–v).

The geometry of areas explored on this sheet is related to his interest in 'transformation' – that is to say, the plastic moulding of one shape into another without change of area or volume. It was later to manifest itself in his quest to 'square the circle' – that is, to define a square that is precisely equal in area to a given circle. The opening and closing of a heart valve is an exercise in 'transformation', as is the contraction of a muscle or the sinuous swimming of fish. In practice, for Leonardo, there was no such thing as absolutely 'pure' geometry, totally abstracted from reality. He knew philosophically that a geometrical point had no tangible existence; that a line exhibited no material width; and that a surface possessed no real depth. But whenever he manipulated geometrical shapes or forms, they always assumed a concrete and real existence in his mind and in his hands, as a form of mental sculpture.

Taken as a whole, therefore, the 'Theme Sheet' contains within its compass rich potential for the understanding of Leonardo's unity in diversity. But can we reconstruct how it came to acquire its present appearance? One drawing must have been the first to mark the blank page, and one must have been the final addition, before it dropped out of use.

Given its size, it is likely that the sheet was first used for the central geometrical study. The bigger the scale, the easier it is to achieve precision. It may be that the separate arcs towards the lower part of the sheet were tests for the compasses. The secondary geometry probably followed. Then the sheet was turned over, and further explorations took place. It is likely that the sheet was set aside, folded to make storage easier. However, when Leonardo needed a surface for sketching on, he picked it up again, finding enough space for a series of small studies in the interstices

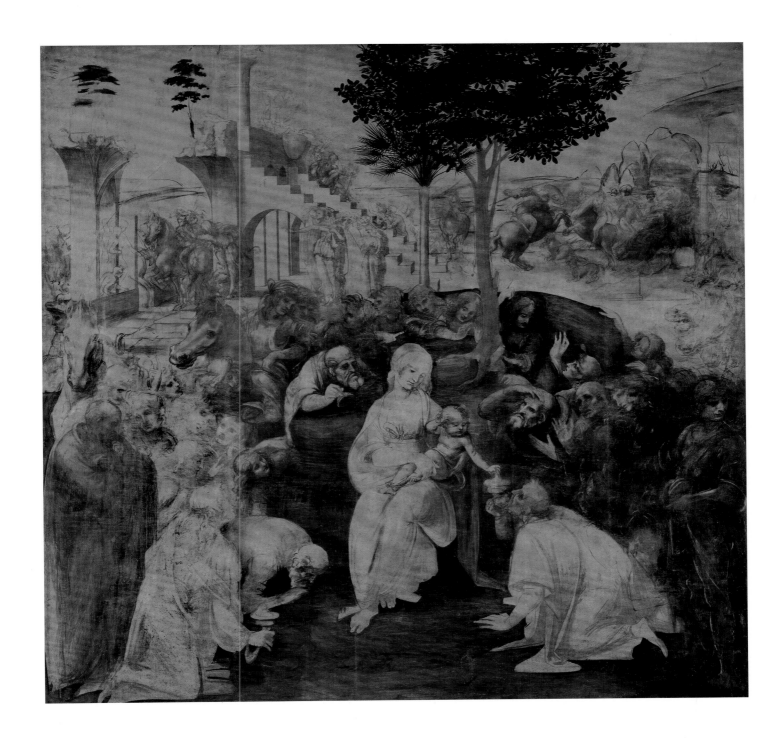

of the geometrical figures. I suspect, as this stage, the sheet remained folded. Perhaps the man's head came first, followed by the stems and trees, with the interweaving of man and tree and the separate drapery study improvised once the tree was formed. Further studies of light on trees and the arum leaves followed. The mechanical studies probably arrived late in the process, perhaps after an interval.

It is likely that the other half of the folded sheet was utilized separately, though the theme of light on clouds may well have been triggered by thoughts about the play of light on clusters of leaves. A few additional sketches were scribbled in before it was set aside for good. Piously treasured by Melzi as part of Leonardo's paper memorial, the sheet was subsequently subject to the miracle of survival, and we can now study it as precious testimony to one of the most remarkable minds the human race has produced.

Brainstorming

Whatever the actual sequence of the drawings, it is clear that we are dealing with someone who is, to use a later term, a 'lateral thinker' of the most extreme kind. Leonardo was habitually seeing relationships between things that most of us would consider distinct subjects. Even when dealing with the same subject, his mind teemed dynamically with alternatives. The rearing horse and rider on this sheet are a case in point. They are part of a recurrent series, running from the *Adoration* to the last of his schemes for an equestrian monument, and spanning the greater part of his career. Looking at the *Adoration of the Magi* (INTRO.10) and at the related drawing in the Uffizi, we can sense the unleashing of an unbridled inventiveness. The problem becomes not that of finding it difficult to see a solution, but that of selecting one from an endless stream of exciting ideas. And it is not a question of finding a form to match the preset content, but of content and form evolving in a reciprocal and dynamic unity. The turbulence of the graphic style and the turbulence of the subject play off each other as he transforms the normal processional background of an Adoration into a vision of a pagan world of violent disorder, or perhaps even into a premonition of the rupture that Christ's advent was to trigger. Once the creative process becomes so free, the determination of a fixed meaning according to traditional iconography becomes subverted. Yet, for all its raging chaos, the Uffizi drawing is also an essay in meticulous geometry. The tiled floor, which is to become the stage for such frenzy, is laid down with minute perspective precision. I know of no drawing or painting, with the possible exception of Piero della Francesca's *Flagellation*, that continues to push the construction of the horizontal intervals into such depth that the construction becomes almost impossible to execute in practical terms.

This paradoxical combination of contained measure and unconstrained improvisation characterizes many of Leonardo's drawings. We find it in some of his maps (I.11), in which precise geometrical scales provide the groundbase for freehand drawing of the most dynamic kind. The combination is seen at its most extreme in the British Museum drawing (INTRO.11) for the cartoon of the *Virgin, Child, St Anne, Christ and St John* in the National Gallery, London. In the central drawing, coherence becomes submerged under a maelstrom of densely overlaid alternatives. However, the rectangular crucible that contains this explosive energy is designed precisely to scale with straightedge and compass. Or, rather, Leonardo has surrounded it with a number of alternative frames with slightly differing scales. I know of no other artist or designer who worked quite like this. Perhaps the closest equivalents are musical: a Mozart cadenza or a Charlie Parker solo.

The parallel he adduces on his own account is the writing of poetry:

Have you never reflected on the poets who in composing their verses are unrelenting in their pursuit of fine literature and think nothing of erasing some of these verses in order to improve upon them? Therefore, painter, decide broadly on the position of the limbs of your figures and attend first to the movements appropriate to the mental attitudes of the creatures in the narrative rather than to the beauty and quality of the limbs. [Urb 61v–2r]

INTRO.11
**Studies for the Virgin,
Child, St Anne, Christ
and St John**
1508–9
London, British Museum

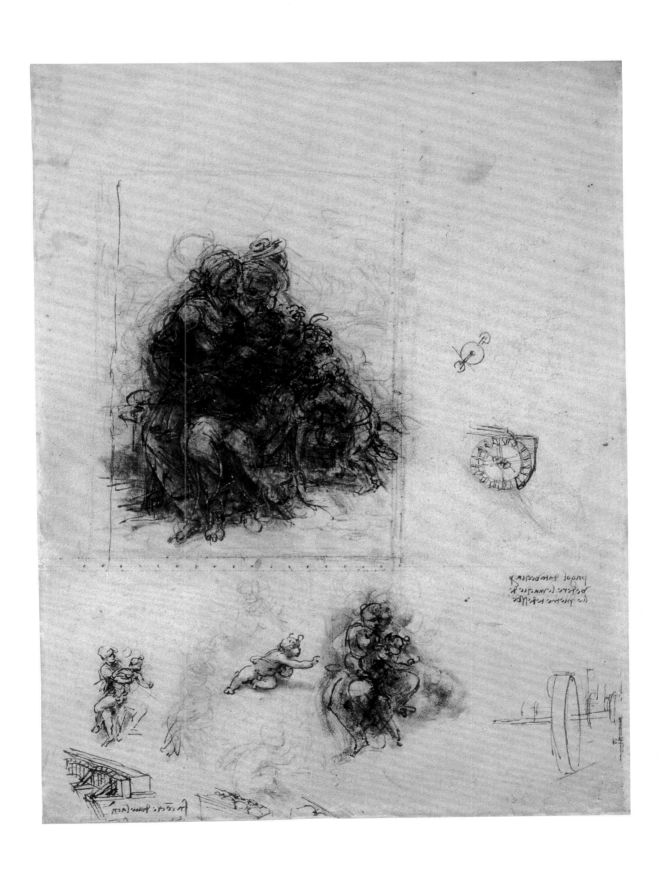

INTRO.12
**Right-angled triangles
within a semicircle**,
based on Leonardo
Technical Art Services

That Leonardo himself was aware of the wonders of this process is not in doubt. He attributed it to the mental faculty called *fantasia*, the kind of imagination that Dante had seen as being responsible for his great literary inventions – *alta fantasia* as Dante called it. For Leonardo, the *fantasia* of the artist was in no way inferior to that of the poet. The great *invenzione* is the goal to which their imaginations should direct themselves:

> The poet may say, 'I will make a story which signifies great things.' The painter can do the same, as when Apelles painted his *Calumny*. The poet says that his science consists of invention and measure … The painter responds that he has the same obligations in the science of painting, that is to say invention and measure – invention of the subject he must depict and measurement of the things painted, so that they shall not be ill-proportioned. [Urb 13r]

Citing the famous example of the *Calumny* by Apelles, known only through descriptions of the Greek's artist's masterpiece, is hardly the act of a man 'without letters'.

Like Dante, Leonardo believed that the faculty of *fantasia* was not a law unto itself, but that its proper exercise involved the integral action of intellect. Intellect expressed itself in the form of *scientia*; that is to say, a rational body of demonstrable knowledge rather than our more constrained definition of 'science'. *Misura* – involving the measurement of proportions, perspectival diminution, the operations of light and shade, and so on – was a fundamental expression of the 'science' of painting.

On folio 33v of the Codex Arundel, he jots down one of those fragments of Dante so beloved of Florentines, and which remain so enigmatic for us:

> *O se d'un mezzo circol far si pote*
> *Triangol su ch'un recto non avessi.*

> (Or if in a half-circle there can be made
> A triangle such that it has no right-angle.)

These two lines from *Paradiso* (XIII, 101–2) are preceded by one in Latin:

> *Non si est dare primum motum esse.*

> (If it can be that there is not a prime mover.)

In this section of the *Paradiso*, St Thomas Aquinas is instructing Dante about the kinds of philosophical questions excluded from King Solomon's practical wisdom. For the King to govern wisely, it did not matter whether Euclidian mathematics and Aristotelian dynamics were true. However, for the seeker after ultimate truths, the issues pushed to one side by Solomon were foundational. The theorem stating that any triangle inscribed in a semicircle whose base is the diameter of that half-circle will be a right-angled triangle (INTRO.12) is one of those irrefutable truths that Leonardo (and Dante) treasured. And the existence of the 'Prime Mover' is absolutely necessary to his theory of dynamics, as it was to Dante's notion of the cosmos. Since nothing moves unless it is subject to force, we must suppose the existence of some great, general 'mover' outside the physical system to set the cosmological machinery in motion in the first place. Dante's laconic but deep wisdom about geometry, optics and natural philosophy generally provided vital sustenance to Leonardo in his continuing mission to express *scientia* through *fantasia*.

Just as the radiant visions of Dante's *Paradiso* are conveyed to us in vehicles designed according to the laws of Euclidian geometry and medieval optics, so Leonardo's extraordinary inventions disport themselves in spaces mapped out by the rules of perspective. The Latin word

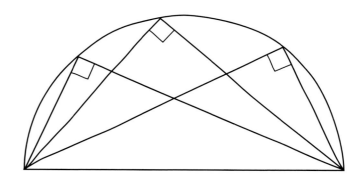

perspectiva and the Italian word *prospettiva* both meant 'optics' in the broadest sense, rather than being confined to the technicalities of the painter's construction. Leonardo's perspective constructions are not just ways of creating space for his actors; they are statements about divine order in nature. Like the medieval philosophers who wrote on *perspectiva*, he considered himself to be a privileged witness to such divinely decreed geometry in nature.

The Art of Visual Modelling

What we witness on our own behalf as we look across a range of Leonardo's drawings is a unique kind of plastic moulding of ideas ultimately drawn from nature – both nature as observed and the invisible causes he detected as lying behind all natural forms and phenomena. His aim was to penetrate so deeply into nature's 'causes' that he could remake natural 'effects' on his own account in any given situation and to meet any given need, whether this need was the drawing of water in motion, the painting of a picture or the construction of a machine.

His process of visual thinking depended predominantly on a form of three-dimensional modelling. Even his flat geometry tends to have a spatial dynamic. The little mechanical drawings are very plastic in character. Even the *Mona Lisa* can be seen as reconstituted in space by human artifice, not in actual three dimensions, but rendered illusionistically on the surface or 'window' of the picture. The flying machine was a remodelled flying creature, synthesizing birds and bats, albeit on a scale larger than any of the originals. It was intended to allow man at last to master motion in three dimensions at once.

This process of modelling provides the theme of the first of the chapters that follow. Given his propensity to model effects from causes, it is a natural step to try to remodel some of Leonardo's experiments and designs, to translate his ideas into living reality. This form of 'experimental history' provides the subject of the next chapter. The two chapters that comprise the second part of the book look in detail at his ways of thinking on paper.

They deal in succession with how he used extraordinarily inventive graphic methods for the characterization of form in space, and with the phenomena of motion. I will be proposing that we can best think of his drawings as 'theory machines', in which forms are represented according to their functions in the context of natural law.

I am conscious that the sources and contexts for Leonardo's ideas and art are handled only through a series of shorthand allusions. I have written extensively elsewhere about the ancient, medieval and Renaissance frameworks for his thought. Here I am concerned to characterize how his thought was realized through graphic expression, rather than to provide an adequate contextual account.

The four chapters differ in precise disposition from the thematic sections of the exhibition, as listed at the end of this book (see pp.191–8), but they carry through its main thrusts in a way that suits the vehicle of a publication that is intended to have a life both during and after the exhibition itself. Not least, the book takes advantage of the way in which a single sheet may contain motifs that deal with different subjects, to return to it on more than one occasion. The overall purpose of both exhibition and book is to incite a fresh look at the way Leonardo filled his pages with words and images, with results that do not look quite like anything else in the history of writing and drawing.

I MODELS AND MODELLING

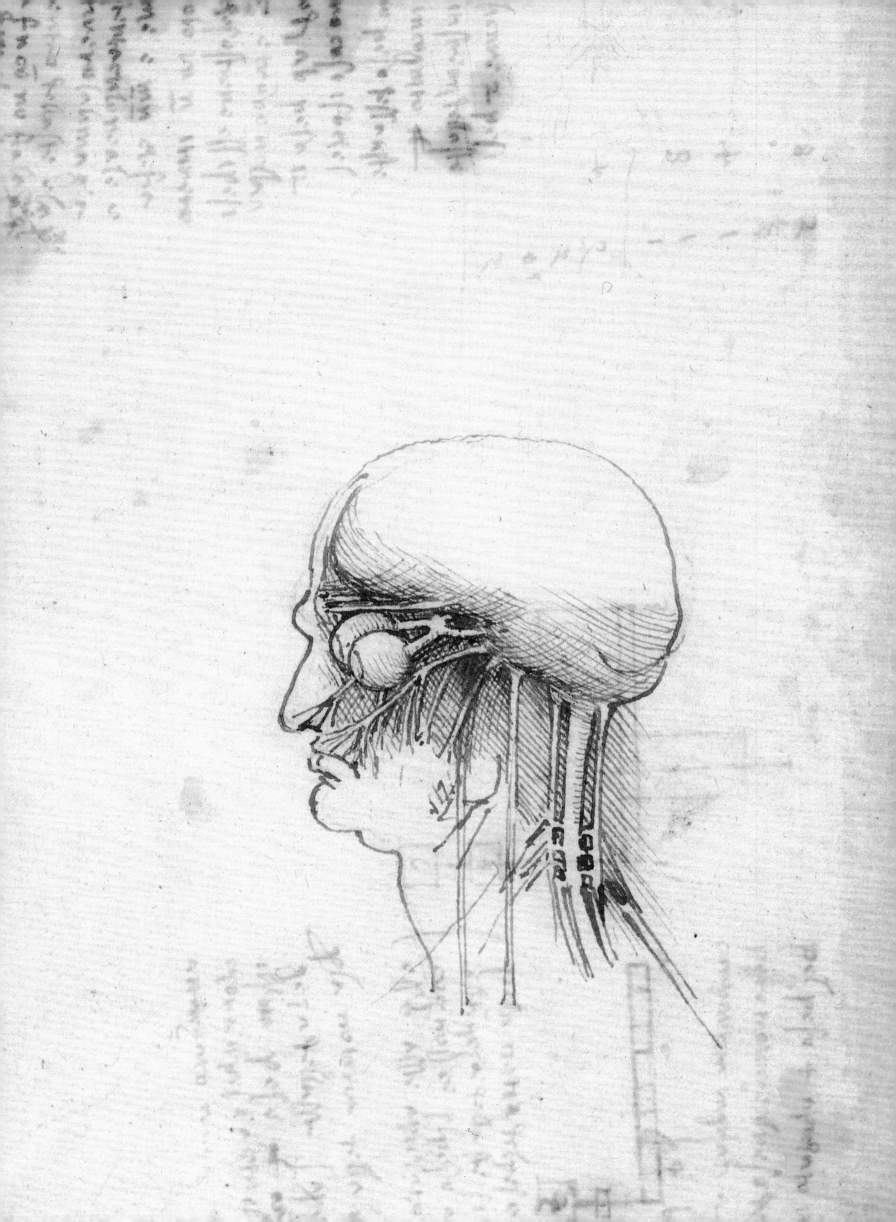

An Excursus on Traditional Wisdom

Leonardo insistently characterized himself as a man 'without book learning' and a 'disciple of experience'. He intended that this insistence would separate him decisively from the long tradition of learning in natural philosophy that consisted of serial commentaries on the Greek philosopher Aristotle, and from the great and often innovatory corpus of Aristotelian science that had been generated by Christian thinkers in the monasteries and universities. However, Leonardo's innocent protestations cannot be taken at face value. Reliance upon 'experience', in the form of sensory data, was integral to the Aristotelian tradition, not least in optical science as developed and transmitted by Islamic thinkers. Even more profoundly, the interpretation of any phenomenon relies, at least tacitly, on a theory of how and why things happen. Leonardo's necessary framework of natural law, in mathematics, statics and dynamics, was essentially that which drove medieval natural philosophy.

Where his claim to lack 'book learning' was justified was in his possession of a very limited knowledge of the full spectrum of ancient and medieval wisdom compared to his university-educated colleagues. He probably never read Latin texts with ready fluency. However, his book lists testify to his efforts to inform himself about existing explanatory frameworks for the way nature operates. He could also turn to an increasing body of vernacular literature that gave some insight into these frameworks, not least the writings of Dante. Like other thinkers with extraordinary powers of visualization, he was able to build much on relatively slight foundations.

Where Leonardo's claim to be a 'disciple of experience' was justified was in the way his drawings conjured up an experience of the 'real thing' in a way that far surpassed anything then in existence. A stock idea like the microcosm was presented with a tangible conviction that places us in the position of a direct eye-witness to the truths he saw. He often called his drawings '*dimostrazioni*' (demonstrations), simultaneously demonstrating what could be seen and why it looked as it did. They were essentially models of nature, employing theory integrally with observation. I am calling the drawings that served as demonstrations 'theory machines'.

His powerful sense of the necessity of combining tangible reality with the mathematical laws, introducing grit into the well-oiled machinery of theory, resulted in him questioning many aspects of received wisdom, above all in dynamics and anatomy. In this respect Leonardo has much in common with the later proponents of the 'Scientific Revolution'. Where he did not attain the goals of his successors, like Galileo, was that his mathematics did not allow him systematically to undertake measurement and quantification, and his scientific method was more intuitive in practice than his pronouncements would lead us to expect. But the drawings in their own right stand as one of the supreme achievements in the history of human witnessing of the natural world.

I LEONARDO'S MODELLING

HE BELIEF THAT sanctioned Leonardo's process of modelling the forms and phenomena of the natural world was that of the perfection of natural design. In the created world, laid out before our eyes, every form was perfectly designed to fulfil its function under inexorable pressure from the 'Necessity' of natural laws. There was no redundancy in the creations of nature. Nor was there any superfluity. 'Necessity' – a divine decree that everything must necessarily adopt its due form and performance – determined that every component in nature acted with the greatest efficiency and economy. This applied at the level of the whole organism and at the level of the minutest detail of its parts. At least, this is what Leonardo came to believe in his later science. Earlier he was prepared to simplify the detail in the service of a ready understanding of the function of larger components and entities. But the perfection of natural design rules in either case.

This belief underpinned his methods of thinking, and his conviction that certainty was possible. If the causes were rightly understood, the function was properly defined and the form was determined as matching the function in the context of the causes, then a complete proof would be achieved. The tightness of the proof would share the certainty of mathematics: 'No one argues that twice three makes more or less than six, or whether the angles of a triangle are less than two right-angles, but every argument is eternally silenced in these sciences' (Urb 19v). Indeed, even the most complex organic form or the most complex natural phenomenon should ultimately yield to mathematical analysis of its design and operation. Leonardo's mathematical methods relied less upon quantification of the kind favoured in modern science than upon proportional relations and the magic of geometry. He instinctively preferred to see nature as geometry in action, rather than thinking of it as involved with counting. The kind of geometrical manipulations that we saw him undertaking on the 'Theme Sheet' (INTRO.1) seemed to relate more extensively to natural design than to numbers.

The preference is in part related to his own strengths and weaknesses. He was a superbly natural geometer. He always experienced difficulty with numbers, rarely being able to add up a column of figures without making a mistake. And he had no algebra, the symbolic method that was to reform the mathematical sciences for later generations. It is difficult to believe that he did not encounter algebra at some point in his reading and personal contacts. Piero della Francesca, the most mathematical painter of the previous generation, could operate some basic algebraic formulas. But its symbolic abstractions would not have appealed to Leonardo. He sought a close, tangible match between solid, real things and his plastic thoughts. Unless he could envisage something, however abstract, as a concrete thing or process – getting his visual hands on it, so to speak – he seems to have been unwilling or unable to interest himself in it.

The preference is also intellectual. He described geometry as the science of 'continuous quantity'. That is to say, a line or surface contained an infinity of points within itself, yet none of the points possessed a separate reality, since each part of a surface flowed indivisibly into the next. Bodies were composed of surfaces that were conjoined and continuous. Space was similarly continuous. Although we can choose to define a position in space, representing a moving

object frozen at a point in time as it traverses the space, the reality was one of continuity. As a draughtsman – we may suspect to his frustration – Leonardo was effectively limited to the depiction of a body in motion at a set moment, but he knew that this was a convention born of necessity. The closest he came to overcoming this limitation was when the suggestiveness of his sketching evoked, either by its incompleteness or by its overlaying of alternative positions, something of the blur of motion. We will be looking more closely at this issue in Chapter IV.

By contrast, he defined number as dealing with 'discontinuous quantity'. Such discontinuous things seemed to him not to correspond with the nature of physical forms. The one area in which number acted with real potency was in capturing the proportional systems at work in statics and dynamics. Numerical proportions represented the physical music of nature. Leonardo undoubtedly knew the way that Pythagoras had defined the octave in terms of physical ratios. Nichomachus tells us that Pythagoras:

> discovered that the string stretched by the greatest weight, when compared with that stretched by the smallest weight, gave the interval of an octave. The weight of the first was twelve pounds, and that of the latter six. Being therefore in a double ratio, it formed the octave … Then he found that the string from which the greater weight was suspended compared with that from which was suspended the weight next to the smallest, and which weight was eight pounds, produced the interval known as the fifth. Hence he discovered that this interval is in a ratio of one and a half to one, or three to two, in which ratio the weights also were to each other. Then he found that the string stretched by the greatest weight produced, when compared with that which was next to it, in weight, namely, nine pounds, the interval called the fourth, analogous to the weights. This ratio, therefore, he discovered to be in the ratio of one and a third to one, or four to three; while that of the string from which a weight of nine pounds was suspended to the string which had the smallest weight, was again in a ratio of three to two, which is 9 to 6. In like manner, the string next to that from which the

small weight was suspended, was to that which had the smallest weight, in the ratio of 4 to 3 (being 8 to 6) but to the string which had the greatest weight, in a ratio of 3 to 2, being 12 to 8. Hence that which is between the fifth and fourth, and by which the fifth exceeds the fourth, is proved to be as nine is to eight. But either way it may be proved that the octave is a system consisting of the fifth in conjunction with the fourth, just as the double ratio consists of three to two, and four to three; as for instance 12, 8 and 6; or, conversely of the fourth and the fifth, as in the double ratio of four to three and three to two, as for instance, 12, 9 and 6.

This rather laborious passage has been worth quoting at some length because it is so precisely in tune with Leonardo's thinking, and even with his elaborate style of verbal explanation. Pythagoras's demonstration of the link between proportional beauty in music and the physical behaviour of real things, such as a bowed string stretched by varied weights, effectively confirmed the 'roots in nature' that gave rise to artistic beauty. Leonardo was said to be an accomplished performer on the *lira da braccia*, a stringed instrument played with a bow, and he was closely involved with musicians at the Sforza court in Milan, not least Franchino Gaffurio, who was the leading musical theorist of his generation. If he did not know the Pythagorean theory of music – and the story of Pythagoras's discovery of it when observing a blacksmith at work – before he met Gaffurio, Leonardo certainly would have done so afterwards. We will shortly see that his elaborate embroideries on the science of weights assumed the guise of a form of concrete music.

Alberti had stressed that the painter's science had its 'roots' in nature. Leonardo agreed unreservedly. He placed a huge emphasis upon 'experience' as the route to certain knowledge. Unless knowledge was potentially verifiable in nature through the senses, it had no status. Revelation of ineffable things beyond the sensed world was the province of the holy books. The 'definition of the soul' he left 'to the minds of friars, fathers of the people, who by inspiration know the secrets. I let be the sacred writing for they are the supreme truth' (IV.15). It is appropriate that this

acknowledgement of the status of the 'word of God' should occur on a sheet devoted to the wonders of the tongue and lips in giving voice to our thoughts. Leonardo was prepared to grant the realm of revelation its due place, but it was not the realm that he considered productive to investigate with rational tools of observation and mathematics. However, this does not mean that he espoused a systematic empiricism, drawing knowledge only in one direction, extracting it only from observation and experiment. The perfect circle of form and function meant that the investigator could proceed in either direction, beginning with observed form or pre-defined function.

The perfect matching of form and function in the context of laws of a mathematical nature enabled the investigator of the 'marvellous works of nature' to adopt a double method. The fundamental process of understanding was to 'begin with the experience and through this investigate the cause' (E 55r). However, since 'there is no effect without cause, once the cause is understood, there is no need to test it by experience' (CA 398v). Although Leonardo has been hailed as an early advocate of the scientific experiment as the prime vehicle for research, his method was not that of the systematic empiricism that has, broadly speaking, dominated the aspirations of scientific practice from the time of Francis Bacon in the seventeenth century. In reality he proceeded by an untidy mixture of deductive and inductive reasoning, habitual observation, hands-on intervention, 'thought experiments', 'drawn experiments', actual experimental testing and analogy. Not least by analogy.

Since all created things operated under the same dictat of natural law, if Leonardo had determined to his satisfaction how one form operated, then a comparable form elsewhere in nature could be assumed to operate in basically the same way. We will see him applying this method repeatedly. We still use analogy as a powerful form of thinking, and it still serves scientists well when they encounter a phenomenon for the first time. Seeing something in terms of something else may not produce the right answer, but it can provide the necessary starting point for the construction of a theoretical model and may open up fresh possibilities via lateral thinking. Leonardo used

analogy in this way, as I suspect that humans always have. But analogy struck at a deeper reality in Leonardo's system of thought. It was not just a tool for thinking, but carried a fundamental truth within it. The microcosm-macrocosm theory did not just say that there were handy analogies to be observed, but that the reality was of entirely homologous forms and functions at the deepest levels of causation. The theory does not really involve an analogy at all. It is a matter of profound identity.

It is on this basis of the commonality of causes in nature that Leonardo created his mental and drawn models of the way things worked. In the case studies that follow, I will begin with some phenomena that lend themselves to relatively abstract mental analysis and move on to those that entangle with complex aspects of reality in a more intricate manner.

The Music of Balances and Pulleys

The basic rule of weights suspended from balance arms, as codified by Jordanus de Nemore in the thirteenth century, is simple enough. It states, in essence, that arms with suspended weights will be in balance when the product of multiplying one weight by its distance from the point around which the arms pivot is equal to the same product for the weight on the other arm. Thus, if a weight of four units is suspended two measures from the fulcrum, it can be balanced by a weight of two units suspended four measures along the other arm. Leonardo is able to translate this rule into his beloved pyramidal law of the performance of nature's powers. In the Codex Arundel (1.7) he draws the pyramid once again and writes:

> Conception.
> None of the intersections of the pyramids made at equal intervals from the base of the triangle will be of equal length. This is given for the weights hanging from balances, which are lesser at the ends than near the beginning of their intervals [on the arms].

This laconic note only makes sense in terms of how the weight needed to balance a given weight diminishes

I.1
Franchino Gaffurio, **Diagram
of Musical Harmonics** from
**De Harmonia Musicorum
Instrumentorum Opus**
1518

pyramidally as it moves away from the fulcrum of the balance.

If there are two different weights suspended at different distances along the arm, the basic equation is the same, but the products need to be added together to convey the proportional value of the force that is acting downwards on each arm. Once the principle has been understood, and worked through in a few cases, that seems to be enough. It is a simple and elegant axiom of statics.

For Leonardo, combinations of weights in ever more complex compounds became a matter of almost inexhaustible fascination. Not only did he explore compounds of weights hanging directly from the balance arms, but he also considered what happened if the weights pulled at angles on their points of attachment. Sometimes the notional ropes run across pulleys to produce the desired angle. Alternatively, a single weight is suspended asymmetrically from strings attached to more than one point along the arm, on a sheet misleadingly headed 'On percussion in its self and in its mover' (1.2). In the upper diagram he explores the centre of gravity of a rhomboidal body, before turning to the strange balances. Along the right arm in the upper of the balances, the four strings are attached at successive intervals of four units. They pull with forces equivalent to 1:2:3:4, making a total of 10. The other arm must be endowed with a force equivalent to 10 at its end. He adds the interval of four successively to 1, 2, 3 and 4, as designated by the curved linking lines, to calculate the required central weight as 5 + 6 + 7 + 8 = 26. An odd solution to an odd task! In the diagram below he repeats the exercise, but with the axis of the weight hanging asymmetrically rather than vertically under the fulcrum of the balance. Elsewhere in the codex, Leonardo mentally tested various diagrammatic ways of solving what happens when the hanging weights act obliquely on the arms, without having the full means to undertake what is a non-trivial mathematical task.

It is difficult for us to see immediately why he needed to rework the problem of the balance arms so many times with so many variations. The general case remained unaffected. The angular pulls might be of relevance to constructional problems, but his interest goes beyond any obvious utility. However, there may be a clue to what

drives his interest in the way that he often linked complex arrays of weights with arcs (e.g. Madrid I 167v). This is precisely what Gaffurio did when explaining musical harmonics (1.1). Leonardo was fascinated with proportional systems, both numerical and geometrical, as we will see in Chapter III. Proportional numbers appear regularly on the pages of his notes, together with more developed sets of numbers in various layouts (e.g. Arundel 153r). Proportions governed the beauty of the bodies in both man and animals, the distribution of forms in architecture, the statics of an arch, the diminution of an object according to perspective, the speed of a body falling through the air, the distance travelled by a cannonball, the growth of a plant, and so on, indefinitely. Every power, every weight, every moving body acted proportionately, diminishing – or, more rarely, increasing – according to a proportional law.

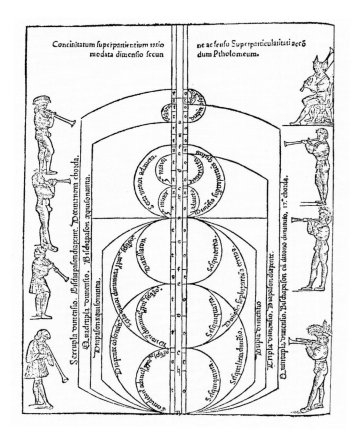

PLATE I.2
**Studies of centres of gravity
and compound balances**
c. 1508
Pen and ink
21 × 14.75 cm
London, British Library,
Codex Arundel, 3r

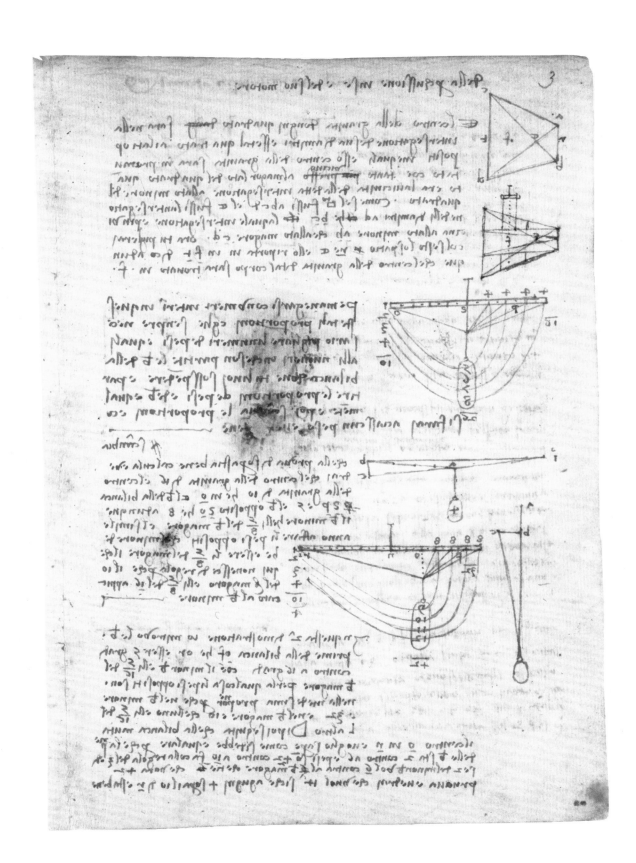

1.3
System of 33 pulleys,
based on Leonardo
Technical Art Services

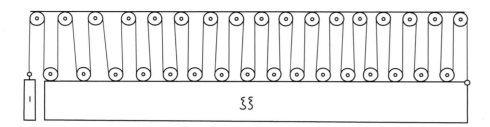

The musician, in purveying proportional harmonies to the ears of listeners, was literally in tune with the powers of nature. Of all the arts, music presented the most serious challenge to Leonardo's beloved painting. Indeed, it could claim to present the harmonic beauties of nature in their purest form. Musicians had traditionally enjoyed a higher status, as practitioners of a 'Liberal Art', than the painters with their craft-based practice. But Leonardo diagnosed two faults in music, shared with poetry. The first was that it entered human consciousness through the ear, which was a less noble organ than the eye. The second was that the beauties of music were spread out over time, living and dying in a transitory manner. By contrast, the painter's harmonies were visible in 'a single glance' at any one moment and over as long a time as the painting is in existence: 'Painting excels and is superior in rank to music, because it does not perish immediately after its creation, as happens with unfortunate music. Rather painting endures and displays as lifelike something that is in fact on a single surface' (Urb 16v).

His science of weights, on which he planned to write in one of his unrealized 'books' (as we know from a note on the verso of the first page of the Codex Arundel), seems to have served as a form of engineered music, all the more potent because its harmonies could be seen in 'a single glance'.

Clearly this branch of the science of weights did not need to rely on physical experiment. Leonardo knew the 'cause' or rule. The drawings are executed in thin lines. Sometimes the balance arms are drawn with a top and a bottom, but this is so that the lines marking the scales can be rendered more apparent, as if on a ruler. They are essentially 'thought experiments', in which the act of drawing serves as an act of analysis and sometimes as the tool for the construction of a new theory. We can often gain the sense that an added straight line or arc is an active part of the process by which he is grappling his way towards an understanding of the set-up. In the act of visual thinking, the feedback from the marks on the paper is absolutely vital.

His multiple drawn 'experiments' in the science of pulleys rely upon similar considerations of the proportional actions of force and weight. The theory is stated by Leonardo himself: 'Whatever the proportion of the number of cords placed in the pulley blocks that draw the weight to those which sustain the weight, such is the weight that moves to that which is moved' (Forster II 72v). Thus a system illustrated on folio 36v of Codex Madrid I, which involves 33 pulley wheels, enables a weight of one to suspend a block weighing 33 (1.3). The majority of the set-ups of pulleys sometimes compounded with balances, are drawn in line diagrams, like the balances, and are clearly theoretical variations on the underlying theme.

However, there are exceptions to what are predominantly theoretical demonstrations. On folio 67r of the Codex Arundel, Leonardo has written '*sperimentata*' beside one of his drawings of balances and centre of gravity. This term, 'experimented', he seems to have reserved for occasions when he has actually performed the test physically. We can only assume that he felt the urge to set up actual balance arms with weights to bring the theoretical abstractions into the real world.

His drawings of pulleys also sometimes move into a realm of reality. On one of the large number of sheets that he devoted to the casting of his bronze equestrian colossus, he sketches two pulley systems, the more developed of which appears to operate in a pit (1.4). Below it hangs

I.4
**Studies for the casting of
the Sforza monument**
C.1493
Windsor Castle, The Royal
Collection, 12349r

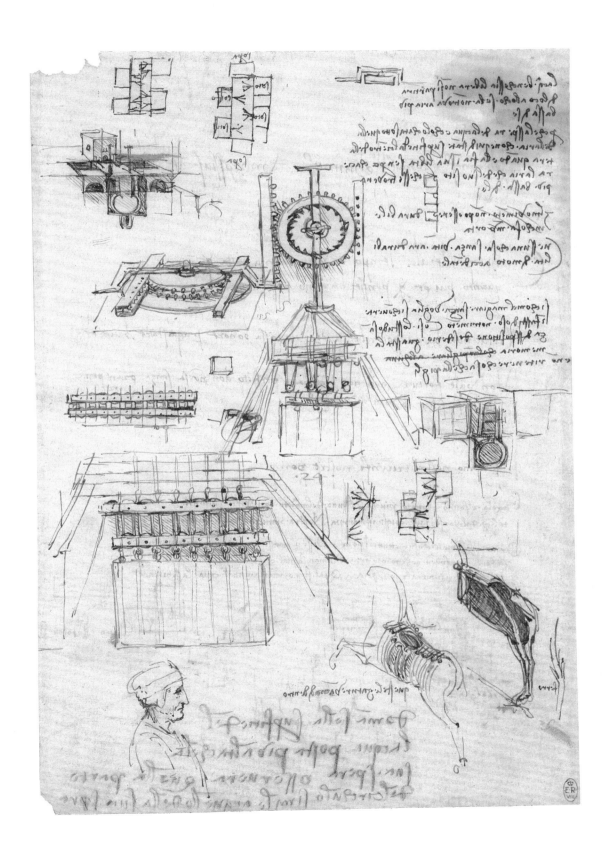

1.5
Perpetual-motion machines
c.1493
London, Victoria and Albert
Museum, Codex Forster I, 43v

1.6
Perpetual-motion wheels
c.1500
London, Victoria and Albert
Museum, Codex Forster II, 90v–91r

a mighty block. Is this the block (or one of the blocks) of bronze that was to be melted in Leonardo's infernal furnace? In the upper diagram he seems to be suspending the pulley system from a massive gear wheel with a ratchet (shown horizontally orientated in the perspective drawing to the left). Although the details are sketchy (literally), it looks as if the pulleys and the wheel are designed to lift the massive weight and then move it horizontally along the lateral bars with their toothed tracks. The theory of pulleys is moving into the messier world of real materials.

Once the theories of balances and pulleys moved into reality, Leonardo discovered that the neat precision of their mathematics was compromised. The physical world invariably introduces grit rather than oil into the theoretical machine. He realized that the finite dimensions and weight of the balance arms would have at least some effect on the system:

> The science of weights is led into error by its practice, and in many instances practice is not in harmony with this science nor is it possible to bring it into harmony; and this is caused by the axis of balances … which according to ancient philosophers were placed by nature as poles of a mathematical line, and in some cases as mathematical points, and these points and lines are devoid of substance, whereas practice makes them possessed of substance. [CA 257]

And we cannot but think that he knew how actual pulleys, especially ones involving multiple wheels, did not deliver their theoretical performance. The levels of friction involved with, say, a 1:33 system would have been formidable, particularly on the scales that Leonardo needed to work with bronze casting and as an architect.

The way that he is potentially prepared to complicate the theoretical with the real is characteristic of what was beginning to happen in the as-yet-nascent 'Scientific Revolution'. As the natural philosophy of the universities emerged into the cold light of real mechanical practice, so the old Aristotelian rules needed replacing with the kinds of laws that Galileo and Newton were to provide.

Perpetual Motion

Leonardo's studies of balance arms and oblique forces were closely related to his interest in devices with rotating arms. In the Codex Arundel this interest is expressed primarily in his quest for a perpetual-motion machine. The prize for the successful invention of such a machine, needless to say, was (and is) immense. Indeed, when he was in Venice in 1500 he recorded a competition to create mills that turn in still water:

> I remember having seen many men from various countries brought by their infantile credulity to Venice with great hope of gain by making mills in dead water. Being unable, after much expense, to move such a machine, they were compelled by great fury to escape from this debacle. [Madrid I flysheet]

However, in the earlier 1490s he had himself toyed seriously with the idea of water-driven perpetual-motion machines. The last 14 folios of Codex Forster I contain a series of speculative devices, which rely upon spiral tubes. The most promising seemed to be those that combined two helices of differing widths: 'the double screw … will have continuous motion' (1.5). Water falling down a larger outer spiral would turn the machine with sufficient power to wind more water up the narrower helix from the pool at the base of the device, feeding the wider spiral, and so on. At least, that was the idea.

In the second of the Forster Codices, which dates from a few years later, Leonardo discusses and illustrates, in a series of elegantly compact little diagrams, purely mechanical devices in the form of perpetually revolving wheels. One shows a toothed drum that contains an inner wheel with hinged 'hammers' that fall into fully extended positions on the left and gradually fall back towards the centre on the right (1.6). The theory is that each fully extended limb would take its turn in exercising sufficient torque to move the wheel and lift the drooping 'hammers' before they played their part in keeping the device turning. The facing page shows an ingenious wheel design consisting of vanes of straight and curved channels along which little balls are intended to run, producing a constant turning motion.

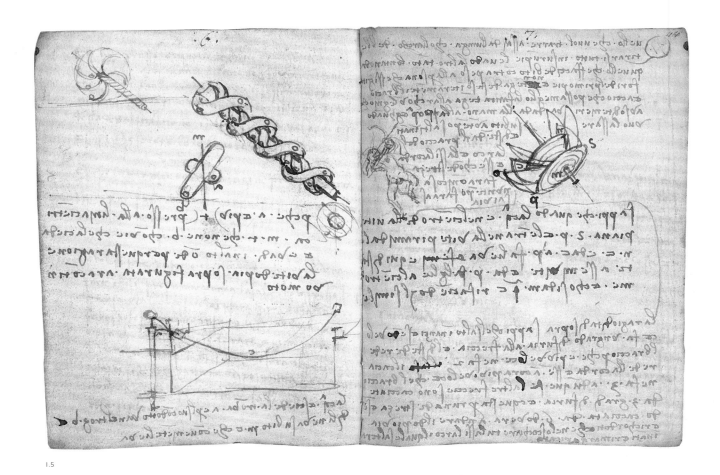

1.5

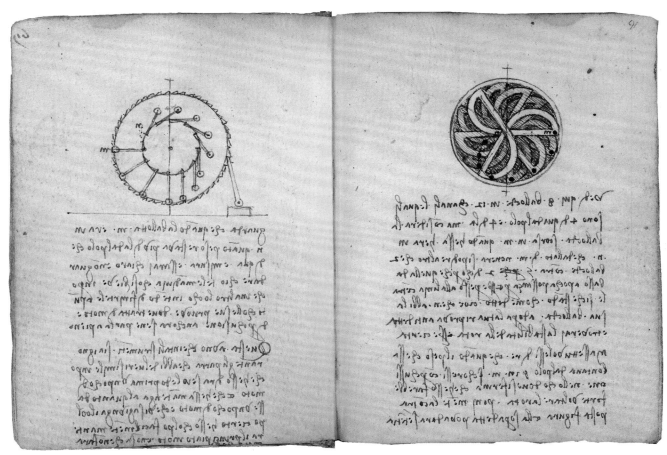

1.6

PLATE I.7
**Analysis of a perpetual-motion
machine, the pyramidal rule for
weights on balances, a joint
and optical study**
C. 1500
Pen and ink
21.5 × 15.75 cm
London, British Library,
Codex Arundel, 44v

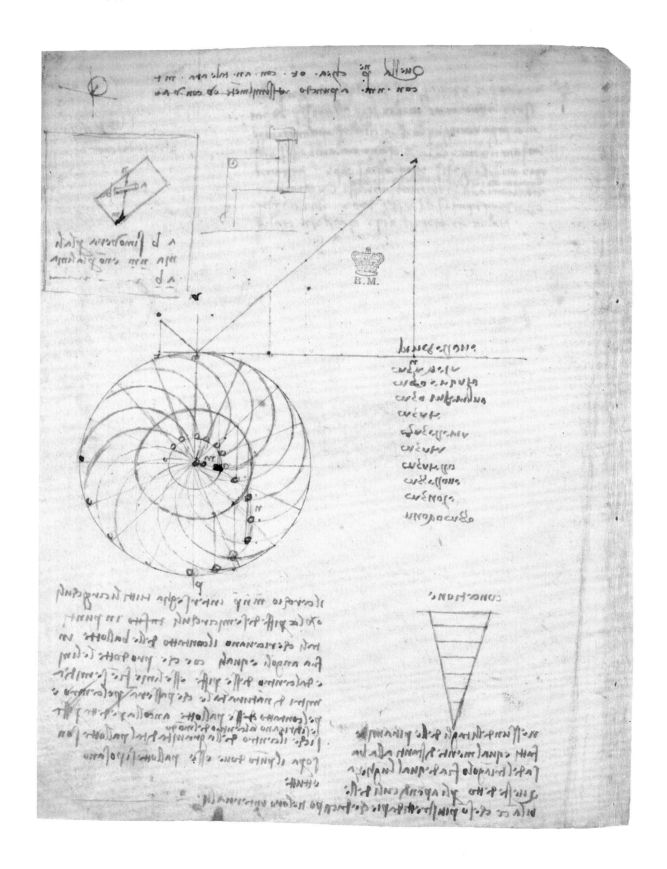

However, despite his earlier optimism about the water-driven machines, he is now rigorously sceptical about the efficiency of any machine that claims to achieve perpetual motion. He announces that he intends to show, 'in another place, where motion and percussion is treated', why this machine on folio 90v cannot deliver its promise.

That place may be in the Codex Madrid I (147–148r), where he undertakes another extensive analysis of the wheels with weights, concluding that 'such a wheel is sophistical'. In yet another place, the Codex Arundel (1.7), he undertakes a mechanical analysis of the device with channels and balls, looking at the way gravity works as the balls run along their tracks. Compared to the drawing in the Codex Forster, the Arundel study is more abstract, so that he can concentrate on the geometrical analysis of the device's operation. Neither of the inventions stood up to such scrutiny.

By the time he studied the machines in Forster II, Arundel and Madrid I, around or shortly after 1500, Leonardo had moved from his earlier optimism about such devices to dismissive hostility: 'O speculators on perpetual motion, how many vain designs you have created in the like quest. Go and join up with the seekers after gold' (Forster II 89v). Thus the seekers after perpetual motion are cast out into the same dark never-land of futility as the alchemists.

Clearly an analytical drawing like that in the Codex Arundel is based upon diagrammatic reasoning rather than experimentation on an actual device. But what of the related drawings of machines in the Codex Forster? As his note of the Venice debacle indicates, he had witnessed actual attempts to create perpetual motion. He himself may well, during his more optimistic phase in the early 1490s, have tried out some of the possibilities. It is difficult to believe that he could have resisted the temptation. However, the tone of the discussions in the notes shows that he reverted predominantly to theoretical analysis rather than physical testing. Such analysis could go beyond the efficiency of a particular device, since it could potentially lay bare the general problems with such systems. For instance, he argued in the Codex Forster that each of the 12 weights would only contribute one-twentieth of the required motion (89v). He also concluded that the weights would inexorably tend to settle, so that they would predominantly

come to rest below the axis, rendering the device static. He could have reached this conclusion by physical experiment, but it seems to flow more naturally from his 'drawn experiments' or 'theory machines' in the Codices Forster and Arundel.

Fluid Motion

There can be no doubt that Leonardo dedicated large amounts of time to looking at water in motion and observing the more elusive effects of moving air. Equally, there is no doubt that he undertook some very elaborate theoretical modelling of fluid flow, particularly of the kind of turbulence that generated vortices. It is not always easy to tell which is which. Such is the brilliance of his draughtsmanship, allied to his powers of plastic visualization, that he can endow his theoretical models with the air of observed reality. Let us begin with some undoubted incidents of observation.

Late in life, when he was in the service of King Francis I, Leonardo was working on a great project for a palace at Romorantin on the Saudre, which involved an extensive network of canals, designed for both utility and pleasure. He also looked at the flow of the Loire near the royal palace at Amboise and close to the manor house in which he lived, Clos Lucé. In the Codex Arundel (1.9) he records a complex situation that results in reverse flow in part of the stream. He notes the 'island where there is part of Amboise'; as the water flows into the section where it diverges around the island, the larger of the channels is divided by an embankment or dam. He observes that 'the water is higher at *ab* in the dam'. The consequence is that at the end of the dam, about two-thirds of the way along the island and just below the 'bridge *cde*', the current reverses itself, flowing back past the top of the island and down the lesser channel on the other side. He explains:

> The Loire River which passes through Amboise passes through *abcd*, and after having passed the bridge *cde* it turns around going upstream through the canal *debf*

PLATE I.8
**The River Arno immediately
west of Florence**

1505
Red chalk
14.5 × 21.5 cm
London, British Library,
Codex Arundel, 149r

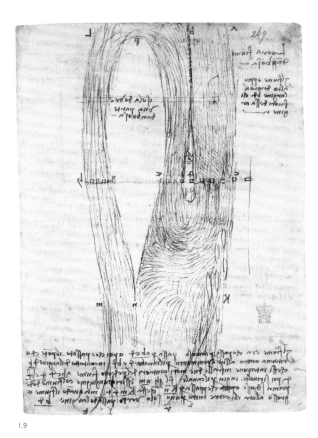

I.9

I.10

I.9

Analysis of the flow of the River Loire at Amboise

c.1517

London, British Library, Codex Arundel, 269r

I.10

Steps to control the descent of water at Vigevano

c.1508–9

Seattle, Bill and Melinda Gates Collection, Codex Leicester 5B (32r)

along the bank *db*, which is interposed between the two contrary motions of the said river, that is *abcd* and *debf*; afterwards it turns around again, going down through the canal *fighnm* to rejoin the main current of the river.

It was this kind of observation that he had earlier undertaken for the Florentines, when they were considering diverting the River Arno past Pisa during their efforts to reassert their dominance over the port city. He was one of the *maestri d'acque* ('masters of water') whom the Florentine authorities consulted. His studies of the Arno resulted in some brilliant observations about the vast transformation that the valley had undergone over the years, leading him to speculate that it was once covered by two extensive lakes at different heights. An echo of this speculation is seen in the two bodies of water at different levels in the background of the *Mona Lisa* (INTRO.7). He also began to consider the reality of a plan that had been proposed earlier, to build a great canal to bypass the unnavigable section of the Arno upstream from Pisa (I.8). The route he proposed pursued a great northerly curve past Prato and Pistoia, avoiding the hilly terrain immediately to the north of the river (I.11). This is more or less the route now taken by the A11 *autostrada*.

It seems that he continued to think about the Florentine scheme when some years later he drew a schematic, polygonal view of the city, labelled with its 11 gates (I.12). In the lower left corner of the sheet, someone (probably Francesco Melzi) has for some reason listed the names of the city gates of Milan. Everything about the plan is idealized, including the straight course of the Arno through

the precise centre of Florence. It is as if not only the Arno is to be straightened, but the city as well – transformed into a town even more ideal than the new towns that the Florentine government had earlier constructed in the Tuscan countryside. The function of this drawing remains mysterious. Even Leonardo cannot really have believed that Florence could be totally reshaped in this way. The hills south of the Arno forbade it – regardless of other practicalities. It is a 'demonstration', but for whom and why? Sometimes the precise motives of Leonardo's thinking on paper escape us.

We do have one precious record of the result of Leonardo acting in practice as what we would call a consultant water engineer. On folio 270r of the Codex Arundel (III.25), when he was considering improvements to the flow of the Loire and its tributaries, including the 'river of Romorantin', he reminds himself of work he had earlier undertaken: 'Let the sluice be mobile like the one I arranged in Friuli, where the water, on the channel being opened, excavated the bed'. This work was undertaken in 1500 when he was briefly in Venice following the overthrow of his patron, Duke Ludovico Sforza, in Milan. It was on that occasion that he recorded the debacle of the perpetual-motion mills.

We also see clear evidence of his journeys in the Lombard countryside, near Vigevano, where Ludovico was setting up model farms and state-of-the-art schemes of irrigation. Leonardo observed the mechanisms of gates and sluices, inevitably thinking of improvements. One nice observation, accompanied by a small sketch, records a series of water steps (I.10):

> Stairs at Vigevano, below the Sforzesca, with 130 steps a ¼ of a *braccio* high and ½ *braccio* wide, down which the water falls without wearing away anything in its final percussion; and by these stairs so much soil has come down as to have dried up a swamp, that is by having it filled up, and it has formed meadows from swamps of great depth.

This note was written more than a dozen years after Leonardo had explored the waterways around Ludovico's country residence. The effect of the stairs clearly impressed

PLATE I.11
Plan for an Arno canal
c. 1504
Black chalk, pen and ink, wash,
with signs of pouncing
24 × 36.7 cm
Windsor Castle, The Royal
Collection, 12685r

PLATE I.12 (overleaf)
**Schematic plan of Florence
with the Arno**
c. 1515
Pen and ink over black chalk
29.8 × 19.9 cm
Windsor Castle, The Royal
Collection, 12681

36

37

PLATE I.12

I.13

**Studies of water in motion
past uprights**

c.1508–9
Seattle, Bill and Melinda
Gates Collection,
Codex Leicester 15B (22r)

I.14

**Studies of the meeting of
two rivers**

c.1508–9
Seattle, Bill and Melinda
Gates Collection,
Codex Leicester 18B (18v)

I.15

**Studies of water flowing through
a bridge and past stanchions**

c.1508–9
Seattle, Bill and Melinda
Gates Collection,
Codex Leicester 9A (9r)

I.13

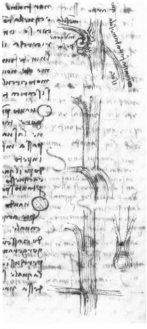

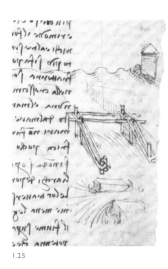

I.15

I.14

him as a way to harness nature's powers in a collaborative manner.

On the same page in the Codex Leicester, he studies the consequence of erosion in a meandering river. The problem is that a house on the convex side of the sweeping bend in the river is being undermined by the scouring currents. His answer is to insert a weir upstream from the house, so that the flow is diverted in such a way as to deposit silt along the bank beside the house, thus protecting it and securing its foundations.

> I have a house on the bank of a river, and the water is carrying off the soil beneath it and is about to make it collapse. Consequently I wish to act in such a way that the river may fill up again the cavity that has been made, and strengthen the house for me. In a case such as this we are ruled by the 4th of the 2nd [the fourth case of the second book in his projected treatise], which proves that the impetus of every movable thing pursues the course along which it was created. For this reason we shall make a barrier at the slant *nm*, but it would be better to make it higher up at *op*, so that all the material from your side of the hump might be deposited in the hollow where your house is … But if the river were great and powerful, the barrier would have to made in 3 or 4 stages.

He then illustrates and discusses a set of dams placed parallel to each other, as a way of maximizing their benefits while minimizing the tendency of water to excavate the bed at the foot of dams. The impression is that the drawings and analyses were set up in his mind and drawn on paper, rather than acting as records of an actual experience.

The principle, as he always tried to observe as an engineer, is that anyone intervening in nature should work with natural forces and 'desires', rather than trying to fight them. Getting nature to work for you is better than trying to combat it.

The sense that natural bodies and elements have 'desires' is deeply entrenched in his thought. Every body and element 'desires' to find its natural place in the scheme of things. Anything in motion 'desires' to expend its impetus according to its due performance in terms of time and distance. If some portion of one of the four encircling elements, earth, water, air and fire, found itself out of its natural place – as when a ball is thrown into the air – it would 'desire' to return to its assigned level in the shortest possible way. The action of the force that has been applied to the thrown ball embeds a certain quotient of impetus in it, and this must be expended inexorably, according to the pyramidal law that decrees its progressive slowing and eventual falling to the ground. It is this inexorability that results in the 'percussion' caused by an interrupted blow or by a water current that encounters an obstacle. A ball encountering a surface before it has expended all its impetus will bounce forcefully on and away from that surface.

Water and air behave in a particular way when they encounter resistance. They bend back on themselves in a vortex motion, which is particularly evident when moving water encounters a static body of water. Vortices are strange and uniquely powerful. As the motion spirals into an ever more constricted space towards the centre of the vortex, it does not slow as it would if it were moving freely in space. Rather, as the motion becomes compressed, it becomes faster and more violent. It was this paradoxical quality of vortex motion, witnessed in our own time so destructively in tornadoes, that gave this kind of motion such a grip on Leonardo's imagination.

PLATE I.16
Water pouring from a culvert
c. 1510
Pen and ink
8.4 × 19.3 cm
Windsor Castle, The Royal
Collection, 12659r

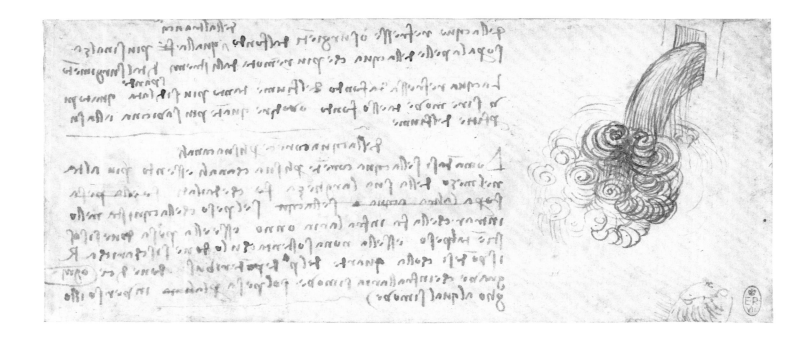

PLATE I.17

**Studies of water swirling away
from a concave surface**
c. 1508
Pen and ink
8.8 × 10.1 cm
Windsor Castle, The Royal
Collection, 12666r

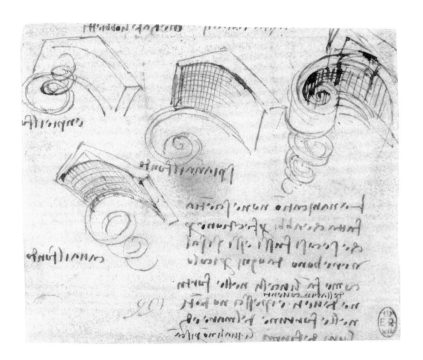

I.18
**Study of the spiral course of
an ascending bubble**
c.1508–9
Seattle, Bill and Melinda
Gates Collection, Codex Leicester
12B (25r)

His theory of motion, relying upon weight, force, 'impetus' and 'percussion', was derived generally from late-medieval natural philosophy and built more distantly upon the principles adumbrated by Aristotle. What Leonardo did was to endow the ideas with astonishing reality in visual form through his dynamic sketching. His impulsive pen records water currents noisily swirling past obstacles, excavating banks and undermining jetties (I.13). A few strokes of pen and ink etch out the turbulent collision of intersecting streams of water (I.14). Currents surge between the stanchions of a bridge (I.15). Columns of water from culverts tumble disruptively into still pools. Vortices perform their geometrical dance with fierce precision (I.16 and I.17). Obstacles cut into onrushing streams, resulting in great curling manes of turbulence. Leonardo being Leonardo, he could hardly have failed to notice the analogies with the curling of hair, as we noted earlier.

The image of the old man seated in front of the ever-curling water (I.19), apparently lost in melancholy contemplation of its infinite complexity, may be fortuitous, since the sheet was originally folded, but it does – however inadvertently – symbolize Leonardo's inexhaustible fascination with water in motion. We now know that the complexity of turbulence is one of those phenomena that resists prediction. Its chaotic nature is such that it can be described in terms of probabilities rather than certainties.

Leonardo, given his belief that every form and phenomenon has mathematical foundations, was determined to blend observation and modelling into a definitive whole. With many of the sketches of impetuous water it is difficult to know whether they are observations, synthesized memories or theoretical models. In as much as every act of drawing

is an act of analysis for him, every observation embeds modelling to at least some extent. There is complete continuity between a 'portrait' of a form or phenomenon and its diagrammatic exposition.

Since his ultimate aim, in representing anything, is to synthesize the visual effects on the basis of the rules drawn from 'experience', the most complex of his 'demonstrations' must be regarded as the result of preparations at least as intricate as those behind a picture. The most complex of his drawings at Windsor (I.20), depicting a stream of water pouring from a rectangular culvert into a still pool, is the result of an elaborate compounding of theory, graphic experiment and observed phenomena. The behaviour of such culverts was of more than academic interest to Leonardo, since Louis XII had granted him the right to a water concession that he could sell on to farmers.

To understand the flow from such culverts, Leonardo studied the behaviour of water moving 'in itself' on a number of sheets, including one that he devoted to the layers of vortices at different levels in the pool (I.16). He notes that he needs to consider 'the water that reflects from the bottom of a river to the surface of the current'. He gradually builds up a composite picture of the 'anatomy' of the phenomenon, studying not only effects within the body of water, but also the configurations on the surface.

He also separately concentrated on the behaviour of the air bubbles forced below the surface by the falling column of water (I.21). The note begins, 'The water that hits the bubble of air that is submerged expels such air with doubled impetus, which impetus sends them out from the surface of the water to a level even higher than the start of [its] motion.' He notes that 'the sides of bubbles are much

PLATE I.19
**An old man seated in a landscape
and studies of water flowing
past an obstacle**
c. 1513
Pen and ink
15.2 × 21.3 cm
Windsor Castle, The Royal
Collection, 12579r

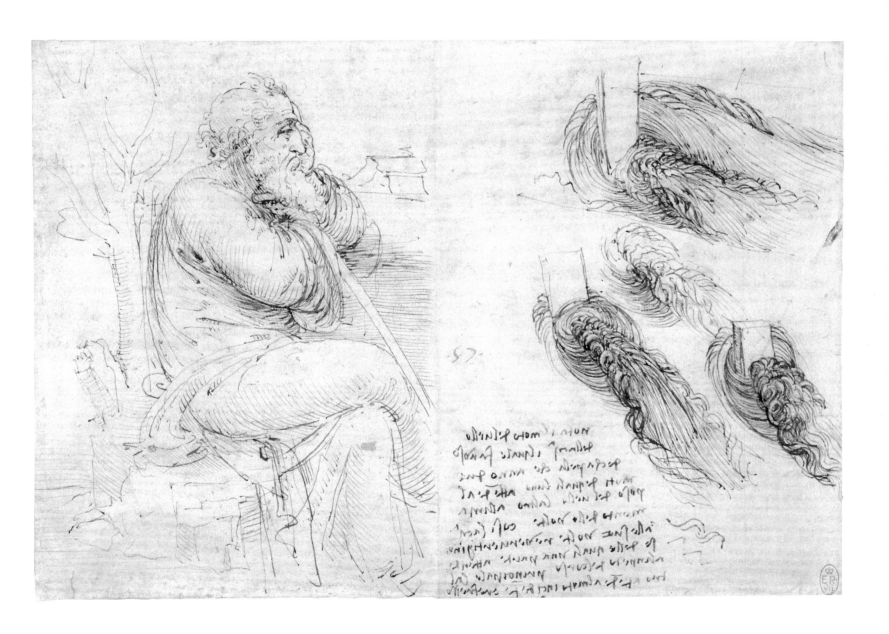

43

I.20
**Studies of turbulent flow and
water pouring from a culvert**
c.1510
Windsor Castle, The Royal
Collection, 12660v

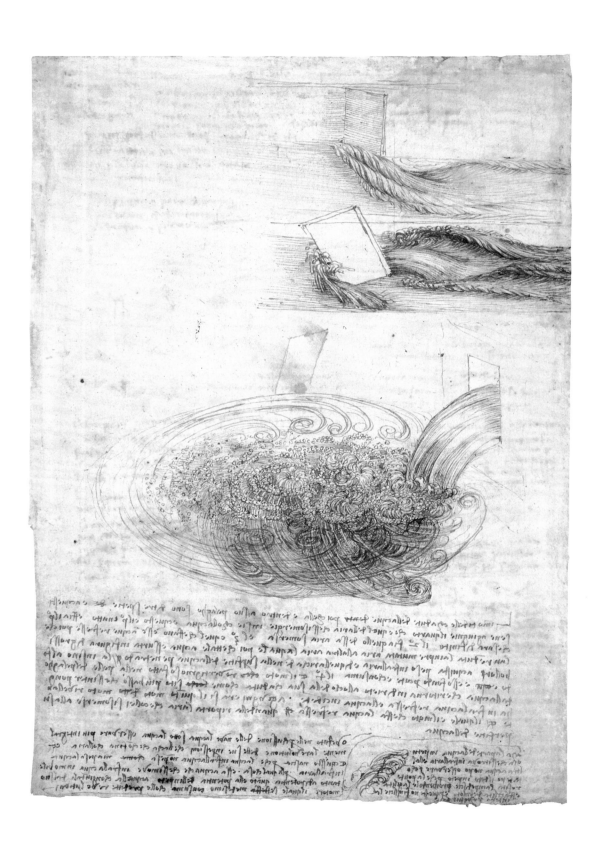

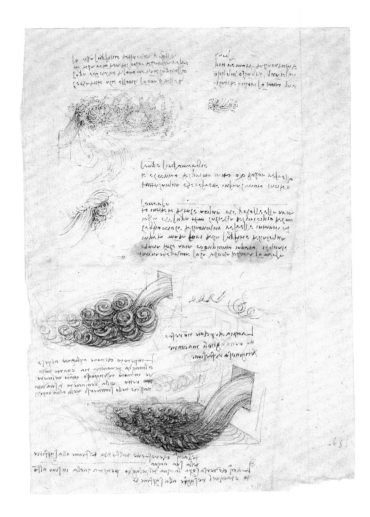

more oblique and elongated the farther they are from the fall of the water'. In the Codex Leicester he looks at the tendency of the ascending bubbles to pursue a spiral path on their own account (I.18). He also analyses the architectural geometry of a bubble to determine whether it is stable or not in different configurations, and when it will break, having burst to the surface (Leic 12 B (25r)).

The vortices of water within water perform their remorseless revolutions according to the laws that Leonardo had formulated, and the bubbles obey the rules of air within water. The final compound is a great cerebral and graphic visualization of almost unbelievable spatial complexity and refinement. We can sense how this single demonstration contains in microcosm universal truths about the nature of fluids and the motions that are decreed by divine 'Necessity'. It is a cosmos in miniature.

Indeed, Leonardo himself extrapolates the lessons of this study on to the smallest visible scale, in the heart valves, as we will see, and on to the largest scale of cataclysmic destruction. He recorded a number of large-scale natural disasters, fascinated by the awesome power of nature and by man's helplessness when the elements moved and surged in their most extreme way. However, his series of *Deluge Drawings* at Windsor – more than a dozen, if we include

related studies – are clearly not documentary records (I.22 and IV.26). They show what form the great *fortuna* would take, were such unbridled power to be unleashed. They are essentially predictive of the behaviour of water, air, dust, trees, buildings and even rocks under the impact of great scouring vortices. They are 'visionary', but not in the sense of dream-like, irrational fantasies. They are terrifying visualizations of the unleashing of forces that no structures or forms in nature can resist, characterized on the basis of his *scientia*, his accumulated understanding of the way vortices move inexorably to their assigned destiny. His own accounts of how to portray a 'deluge' are laced with his technical terms, especially 'impetus' and 'percussion:

Let the pent-up water go coursing round the vast lake that encloses it with eddying whirlpools that strike against various objects and rebound into the air as muddied foam, which as it falls splashes the water that strikes it back up into the air. The waves that in concentric circles flee the point of impact are carried by their impetus across the path of other circular waves moving out of step with them, and after the moment of percussion leap up into the air without breaking formation. [W 12665r]

PLATE I.22
**Deluge with rocks, floods
and a tree**
c. 1516
Black chalk
15.8 × 20.3 cm
Windsor Castle, The Royal
Collection, 12377

I.23
**Cross-section of the earth
showing *vene d'acqua***
*c.*1508–9
Seattle, Bill and Melinda
Gates Collection,
Codex Leicester 6A (31r)

And so it continues, in a torrent of spirited description infused with technical terms.

Eventually every element involved in the cataclysm will achieve its ultimate 'desire', settling in tranquillity at its proper level in the scheme of things. The rocks, rent from their beds, will tumble once again to earth, reconfigured. The dust and leaves will finally settle inert on the ground. The gyrating waters will lie stilled in new lakes and flowing in new river beds. The air will clear and become temperate. But not until the pent-up impetus of the terrible storm has expended its full fury, wreaking whatever havoc it will. No act of visual remodelling ever envisaged a more terrifying collision of the three elements on and in which we live and through which we have our being.

Body of the Earth

There is no doubt that Leonardo drew directly from nature, out of doors, in the smaller notebooks he took with him to record anything of note that caught his eye. A great number of things seem to have done so. We can sometimes match the drawing with a surviving view in a way that testifies to his first-hand observation. The kind of mountainscapes that were to be reshaped in the *Mona Lisa* seem to have been a particular favourite, sometimes drawn atmospherically in red chalk on red prepared paper (e.g. W 12410). But mere recording was never the end point of his studies of the earth. He was always reading the physical 'signs' of the body of the earth as keenly as he read the physiognomic and other signs of the human body. The overall theoretical framework that conditioned his reading was of course the micro-macrocosm analogy, but his development of it was

exceptional – at least in terms of the thinking current in his own day.

Two contentious problems greatly exercised him in the Codex Leicester. The first concerned the reason why springs high on mountains spouted forth with such pressure, when they were far above the natural 'head' of water, which was at sea level. Was there some kind of pump at work? The second involved apparent contradictions between the biblical account of the Deluge, famously ridden out by Noah's Ark, and what Leonardo could observe in the earth's topography.

At first, the pressure evinced by high springs seemed to fit beautifully with the micro-macrocosm concept. Did it not compare to the severing of a blood vessel in the temple of a man, as he once suggested (H 101v)? Just as our blood rises under pressure to our heads, so the *vene d'acqua* convey water under pressure to the summits of mountains. This was an explanation that ancient Roman authors had aired. The Codex Leicester contains a number of little sketches of the earth in cross-section, permeated by subterranean channels in the form of *vene d'acqua* deep in its body (I.23, III.21). However, the absence of any apparent mechanism in the body of the earth, comparable to the pumping heart, left this explanation wanting, and he turned to other solutions. Earlier he tacitly assumed that the heat of the sun might draw the water upwards: 'the warmth of the elements of fire and by day the heat of the sun have power to attract the humidity of the low places and to draw it to a height' (A 56r). He also asked if the mountain sucked up water like a sponge. He considered in the Codex Leicester that the water might accumulate in high caverns by a process of condensation resembling that in a still (I.24):

The heat of the fire generated within the body of the earth warms the waters that are pent up in the great caverns and other hollow places; and this heat causes these waters to boil and pass into vapour and raise themselves to the roofs of the said caverns … Where coming upon the cold is suddenly changed into water as one sees happen in a retort. [Leic 9B]

Eventually none of the more ingenious explanations that depended on an animate earth seemed to work adequately. Those solutions that were either not plausible physically or that smacked of metaphysics were discarded. Leonardo concluded, more prosaically, that the high springs were fed by precipitation on the mountain tops, accumulating enough weight to spurt out a little lower down, as the water strives to reach its true position by the most direct route: 'the water of the rivers does not originate from the sea but from the clouds' (CA 433).

One consequence of such internal debates in the Codex Leicester is that one of the central notions of the microcosm is abandoned: 'The origin of the sea is contrary to the origin of the blood, since the sea receives into itself all the veins that are caused solely by the water vapours raised into the air; but the sea of the blood is the cause of all the veins' (W 19003r). This did not mean that the greater and lesser worlds were released, even in part, from their shared obedience to the common stock of natural law, but it did mean that each case or apparently analogous phenomenon needed to be scrutinized rigorously on its own account. Analogies were to be treated critically rather than accepted with blind faith.

The second of the major debating points in the Codex Leicester was a hugely contentious matter. Ancient authors such as Seneca had developed a clear sense that the earth had undergone great changes during the course of its long life, just like a human body. However, the prevalent Christian framework of the creation story and the account of the biblical Deluge had constrained both the theoretical and observational scope of medieval natural philosophy with respect to the earth's origins and antiquity. The presence of layers of sea shells, stranded high above the levels of the present seas, fascinated Leonardo. He recorded that some peasants brought shells to him, because they knew that the master from Vinci was interested in such things and would presumably reward them accordingly. On the face of it, the stranded shells seemed to testify to the biblical inundation, which had raised the seas to the summits of the very highest mountains. However, looked at more closely, the Deluge that Noah and the paired animals survived could not adequately account for what Leonardo saw.

During the course of a protracted and complex argument with implicit adversaries in the Codex Leicester, he rehearses all the traditional arguments and strives to consider every possible explanation for the present appearance of the earth and the stranded shells. Some claimed that the 'fossils' had rained down or formed as the result of celestial influences, but this was even less acceptable than the idea that the biblical Deluge was responsible. The presence of shells at various levels and in different rock strata indicated conclusively that there must have been more than one great immersion of the lands. However, since there were no shells above a certain level, none of the immersions was as deep as that described in the Bible. The few days of the Deluge would not have allowed slow creatures like the cockle to have climbed so high, and they were not washed there when dead, since remaining traces of their tracks are clear indications that they were alive at the levels where they are now found. Also, why are there no marine creatures stranded in high lakes? These and other possibilities jostle competitively with each other, in as impressive a debate as Leonardo ever conducted on any subject.

When he could not rely upon his own first-hand observations, he eagerly sought information from those of his friends who had travelled, to build up a bigger picture. His consideration of the evidence led to just one conclusion: huge transformations had occurred, and there must have been multiple inundations, which had endured longer than the forty days and forty nights of the biblical Deluge. This did not in itself disprove the biblical account; it simply meant that there must have been other great and more enduring cataclysms, resulting in massive changes in the relative distribution of land masses and waters over the history of the world's existence. The observational evidence came from Leonardo's imaginative visual reconstruction

I.24
**Studies of water rising in
a mountain and in heated vessels**
c.1508–9
Seattle, Bill and Melinda
Gates Collection,
Codex Leicester 3B (34r)

I.25
**Study of a pyramid partially
surrounded by a sphere of water,**
based on Codex Leicester 2A (35v)
Technical Art Services

I.26
**Diagrams of the collapse of
the outer crust of the earth,**
based on Codex Leicester IB (36r)
Technical Art Services

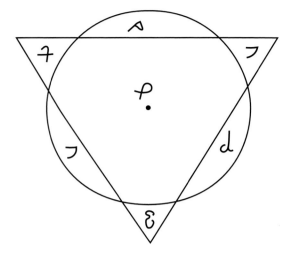

of how the topographies he studied had been sculpted into their present shape. Everywhere he looked, the landscape spoke of change – of great upheavals and collapses, of remorseless erosion and steady accretion. This flux went beyond the local.

He developed an ingenious theoretical model that embraced a total view of the earth and its encircling waters. He asks us to imagine a pyramid or cube surrounded by water, or rather not completely surrounded, but covered only to the extent that the corners are left jutting out (I.25). The situation will stabilize, since the centres of gravity of the geometrical earth and sphere of water will move to coincide. He then tells us to envisage an essentially hollow earth, riddled with caverns, into which portions of the outer crust periodically collapse (I.26). Within the caverns themselves, great fragments will shatter and move. The centres of gravity of the earth and the waters will no longer coincide, and vast adjustments will occur. Previously submerged segments of the earth will heave up above the waters, and areas of land will sink below the foaming waters. The newly raised lands will, over the ages, be sculpted by the snows, ice, rains and rivers. He explores and tests these ideas in a set of small diagrams, one of which, showing a U-shaped crust filled with water, is crossed through as inaccurate.

The vast upheavals account for the stranded shells and for bodies of water at different heights. The higher waters will pour into the lower, and the beds of elevated lakes will eventually be transformed into valleys traversed by rivers. This model of slow reshaping tallies with all the evidence of exceedingly long-term changes in the body of the earth. These processes of vast change have been, and are, clearly at work in the landscape behind Lisa Gherardini (INTRO.7).

Leonardo's exploitation of sharp observations in the field and a vividly compact theoretical model in his vision of earthly flux, expressed most potently in a few eloquent sketches, is undeniably impressive both in its mode of argument and in its results. Although we should not press his way of proceeding into a modern mould, the basic interplay of cogent observation and daring theory has much in common with Charles Lyell's achievements in *The Principles of Geology* (1830–33), in which he argued that there was nothing in the earth's present appearance that could not be explained by the observation of processes now apparent to the keen observer. That basic insight would have appealed greatly to Leonardo.

The Human Body

There was no area of study that engaged Leonardo so passionately as the unravelling of the inner secrets of the body's operation. And there was no subject in which he more fervently argued the benefits of first-hand observation. He was well aware of the many obstacles that stood in the way of direct dissection of human corpses. The practice of human dissection was closely controlled by ecclesiastical and civil rules, though not actually prohibited as such. Dissection of executed criminals was sometimes possible, particularly if they had no relatives in the locality, and provided rules of Christian execution and burial were strictly observed. Autopsies were also conducted under special circumstances. One such set of circumstances led to Leonardo dissecting a 'Centenarian' in the Florentine hospital of Sta Maria Nuova in the winter of 1507–8:

This old man, a few hours before his death, told me that he had lived 100 years, and that he was aware of nothing wrong with his body other than weakness. And thus sitting on a bed in the hospital of Sta Maria Nuova, he passed from this life. And I made a dissection to see the cause of so sweet a death. This I found to be from the lack of the blood for the artery that nourishes the heart and the other parts below it, which I found very dry, thin and withered. [W19027v]

He also mentions that he conducted an anatomy on a two-year-old, in which he found everything to the 'contrary to that in the old man'; however, no record remains in his surviving drawings or notes of the dissection of the child.

Presumably Leonardo's existing links with this monastery – he banked his money and left his books in storage there – placed him in a favourable position when seeking a corpse to dissect. Sta Maria Nuova was renowned for its advanced medical treatments, and it is entirely likely that Leonardo was acquainted with one of the surgeons or physicians employed in the hospital. The attached chapel of S. Egidio contained the great altarpiece painted in Bruges for Tommaso Portinari by Hugo van der Goes. Leonardo knew members of the Portinari family, and specifically reminded himself to 'ask Benedetto Portinari how people go on the ice in Flanders' (CA 611ar). Perhaps the Portinari, as major patrons of the hospital, were able to pull strings for him. The altarpiece itself set new standards of detailed naturalism for Florentine painters, Leonardo included.

This is not to say that dissection was uncontroversial. When Leonardo was housed in the Vatican after 1513, he fell out with some German technicians who were supposedly working for him on a salaried basis. Leonardo complained that they would not learn Italian and spent too much time shooting in the forum with the German-speaking Swiss Guards. The Germans responded by denouncing Leonardo's anatomical investigations to the Pope. There is no indication that his activities were subsequently curtailed, but his accusers obviously considered that his dissections were likely to subject him to ecclesiastical censure.

The other major obstacle was the repellent nature of dissection itself: 'If you have a love of such things, you might be deterred by your stomach, and if this did not deter you, you might be deterred by the fear of living the night hours in the company of these corpses, quartered and flayed and disgusting to see' (W 19097v). This more visceral obstacle applied little less to animal dissection, which, for the most part, provided Leonardo's main access to bodies for examination. The autopsy of the 'Centenarian' is in fact the only full-scale dissection of a complete human corpse that we can securely document.

Yet, paradoxically, the anatomy of the inner human body is the zone of science in which Leonardo's starting point is mostly schematic and traditional. Partly this is a consequence of limited opportunities to dissect, but it is more profoundly related to the nature of anatomical investigation and our propensity to see what we want to see. Dissection – particularly in the era before preservatives and methods of injection – was an exceedingly messy and confusing business. Working rapidly in sequence through the abdomen, thorax and cranium before putrefaction rendered the organs illegible was a hit-and-miss business. Observation was necessarily directed by a set of organized expectations. It was for such expectations that Leonardo turned to traditional guidebooks, most notably that by Mondino de' Luzzi, written in 1316, first published in 1478 and reissued with illustrations by Johannes de Ketham in 1491 in Latin as *Fasciculus Medicinae*, and in 1493 in Italian. Leonardo also looked at existing diagrammatic demonstrations of the distribution of human organs and their functions within the body, in single-sheet prints. The framework of form and function that he accepted relied upon doctrines that had been transmitted from ancient medicine to medieval theory. At the centre of this framework were the concepts of the four humours – the sanguine, choleric, phlegmatic and melancholic – and of the 'spirits' or powers of the body that were transmitted by the nerves and blood vessels.

There are three other factors to bear in mind before we can look at his anatomical drawings in an appropriate way. The first is that he was not undertaking 'Descriptive Anatomy' in the sense of Henry Gray's famous and enduring textbook of 1858. Leonardo was pursuing what we might call, anachronistically, physiological anatomy; that is to say,

he was consciously portraying organs and bodily systems in such a way that their forms spoke of their functions. The second factor, closely related to the first, is that since every form was perfectly designed by nature to fit its function, he could build what *ought* to be there, provided he understood the function well enough. The third, closely related to the second, is the proportional beauty of the body, no less apparent within than without – a proportional beauty that is intimately tied into the body's functioning according to the mathematical laws of nature.

Leonardo's earliest set of dated anatomical illustrations meets all these points precisely. They centre around the studies of a real skull to which he had access in 1489. He produced a series of wonderfully precise drawings of the cranium, both whole and sectioned (1.27). At first sight these look like 'Descriptive Anatomy', but their purpose is directed as much towards the brain within as it is to the bony cranium itself. The proportional centre of the skull, where the axes cross, is the focal point of a series of converging nerves, which come together in the traditional manner to feed the *sensus communis*, the 'common sense', where sensory data of different kinds is gathered and coordinated. It is this system, relying upon medieval 'faculty psychology', that is illustrated in the vertical section of the whole head at Windsor (1.28). The sites of mental activity were believed to be the fluid-filled ventricles – not a daft idea, since the grey matter of the brain looks notably unpromising as a site for high-level mental activity. Leonardo entirely accepts the premises of faculty psychology, and designs his system to work according to what he understands of mental processes, revising the traditional locations to accommodate his notions of perception and imagination. The first of the three ventricles is dedicated to reception, as the *imprensiva*. This 'receptor of impressions' is not apparently found in any of the classical or medieval sources, but was presumably deemed to be necessary in view of Leonardo's sense of the teeming variety of information entering our senses, above all through the eye.

The central ventricle performed all the 'higher' functions. First of all the *sensus communis* did its work, blending the sense impressions into coherent and coordinated 'pictures' of the living, moving, speaking, sounding, smelling and

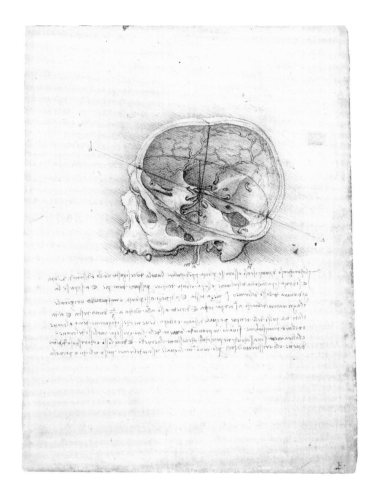

tasting world around us. The imagination, intellect and motion could then make their play. This prime ventricle was also clearly the only just site for the soul, which was able to endure its bodily imprisonment because of the nourishing of the intellect by the senses. The shift of imagination from the first ventricle, where it was customarily located, to the second was vital, since Leonardo could not conceive that the *fantasia* of the inventor-artist was physically divorced from *intelletto*. The last ventricle, effectively a vessel, was appropriately devoted to memory.

Detecting the true form of the all-important ventricles was no easy matter, given the soft, collapsing and rapidly rotting nature of the brain's substance. For earlier anatomists, their function was probably more important than their precise configuration. Leonardo's complete identity of

form with function meant that he could not push the issue of their true shape into the background indefinitely. Accordingly, around 1510 we find him injecting the ventricles of an ox with wax – a spectacularly innovatory method of investigation. The resulting configuration was far more complex, with two large, backward-curving horns and two other chambers of varied shape and size (1.29). He also became aware of the joining and subsequent divergence of the nerves from the eye in the optic synapse. The horns were identified with the *imprensiva*, while the centre contained the *senso commune*, presumably with all their associated faculties, and *memoria* resided in the last (W 19127r). The configuration had radically changed, but the required functions had not.

The other key organ of the body, the heart, was unsurprisingly another major focus of Leonardo's attention. The autopsy of the 'Centenarian' provided a field day for the exercise of shrewd observation and microcosmic analogy. Again his investigations of form were locked into concepts of function and the most profound issues of human nature. The old man's system of bodily 'irrigation' occupied much of his attention. In one drawing (1.30), synthesizing the results of his dissection '*del vecchio*', Leonardo sketches the basic disposition of the major vessels of the thorax, and places beside the main drawing two sketches that are designed to demonstrate that it is the heart that provides the origin of the vascular system – not the liver, as some had argued. One drawing demonstrates a '*nocciolo*' (nut or stone) germinating into a plant, with branches above and roots below. The other shows a schematic heart, '*core*', thrusting the 'roots' of its branching vascular system into what he terms the 'dung of the liver'. End of argument, for Leonardo.

It was probably this sense of the affinity between branching structures in nature that enabled him to conceive his remarkable plan to display the vascular and nervous systems in isolation from the body, or set within a transparent outline, as three-dimensional trees (1.31). '*Albero*' (tree) is the actual term he used. He explained that 'here shall be represented the tree of the vessels generally, as Ptolemy did with the universe in his Cosmography'. Whether he actually produced finished demonstrations of the vascular trees 'from behind, from the front and from the side' is not known – though we can see what he had in mind when Andreas Vesalius reinvented the technique in his *De humani corporis fabrica* in 1543. Leonardo did, however, essay an even more complex demonstration involving all the main bodily trees in his astonishing drawing of the respiratory, vascular and urino-genital systems of a woman (III.37), which we will look at in more detail in Chapter III.

He also became aware that the 'Centenarian's' vascular system was conspicuously different from that of a young person. Beside a drawing of the superficial vessels of a left arm, he again adds two comparative sketches. The one on the right, labelled '*giovane*', shows a nice straight system of branches, bifurcating neatly, presumably in accordance with his law that the cross-sectional area of any two subsidiary branches added together should equal the cross-sectional area of the main branch, if the flow is to be non-turbulent. The same rule applies to all branching systems, whether of trees or rivers. The sketch on the left shows the vessels of the '*vecchio*' pursuing a wrinkled and tortuous course. As Leonardo well knew, a meandering river did not flow fast and true, depositing silt around the bends. As it was in the '*vene d'acque*' of the body of the earth, so it was in the *vene* of the old man. His irrigation system was no longer facilitating the vigorous ebb and flow of his blood from and to his heart, his lungs, his organs and his distal regions. As we noted, he drew particular attention to the 'artery that nourishes the heart', which was no longer doing its job efficiently. Hence the gradual nature of the old man's 'sweet death'. Again the microcosm theory has fuelled an insight of great beauty.

Since the central thrust of the thinking that emerged from his anatomy of the '*vecchio*' concerned the general irrigation of the body, the detailed operation of the heart also became a matter of substantial concern. How could the pump achieve its ends, forcing blood through tiny vessels into the very tips of our fingers and toes? Like any pump, the heart needed non-return valves – and we should recall that Leonardo was a keen pump designer as a *maestro d'acqua*. He began to look at the various valves that governed the flow from the heart into the aorta. The three-cusp valve system proved to be of special fascination, and he continued to contemplate its action over a number of years.

PLATE I.28

Vertical and horizontal sections of the human head and eye

c. 1489
Pen and ink and red chalk
20.2 × 14.8 cm
Windsor Castle, The Royal
Collection, 12603r

PLATE I.29

The human brain, cerebral nerves and eyes

c. 1508
Pen and ink
28.7 × 21.1 cm
Windsor Castle, The Royal
Collection, 12602r

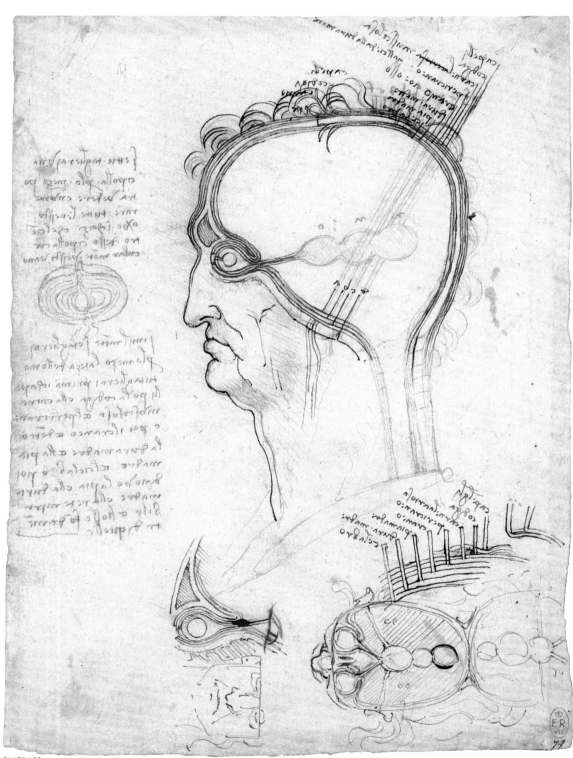

PLATE I.28

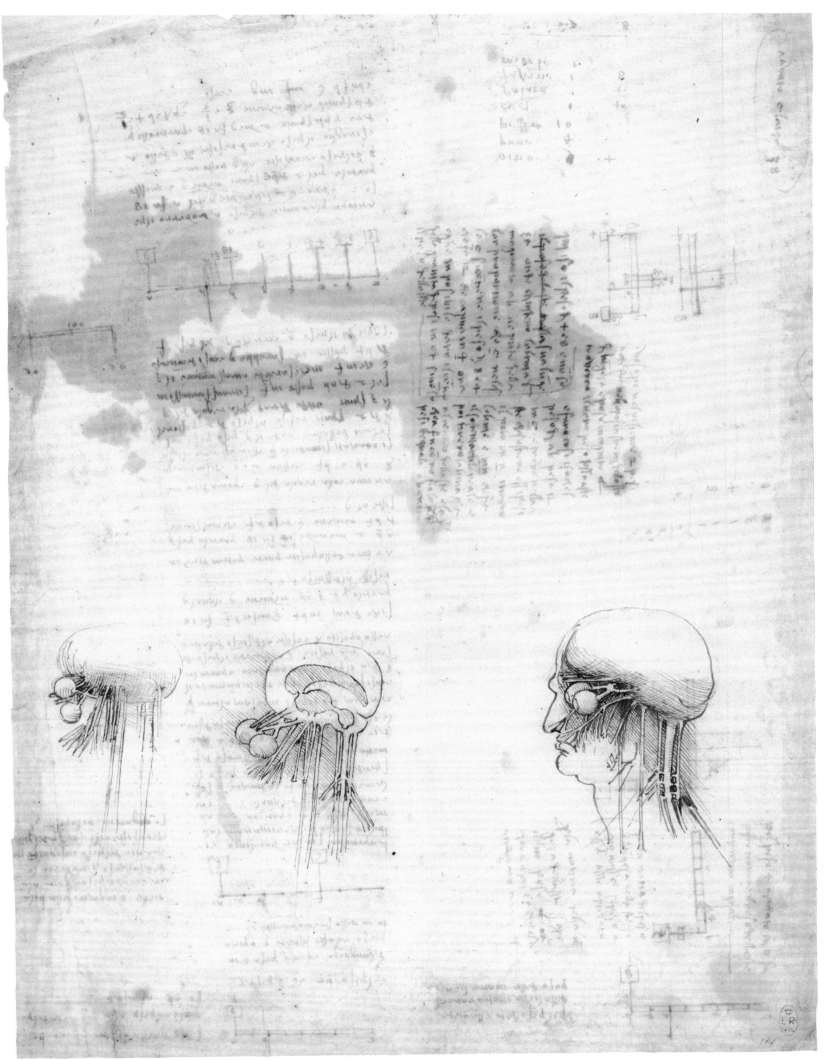

PLATE I.29

PLATE I.30

**Vessels of the thorax with
comparison of the heart and
a germinating seed**
c. 1508
Pen and brown ink (two shades)
over traces of black chalk
19 × 13.3 cm
Windsor Castle, The Royal
Collection, 19028r

PLATE I.31 (opposite)

**The 'tree of vessels', staircase
designs and paired 'tree-trunk'
columns**
c. 1508
Pen and ink, sepia wash and
red chalk
29.2 × 19.7 cm
Windsor Castle, The Royal
Collection, 12592r

PLATE I.32 (overleaf)

Studies of the heart of an ox (?)
c. 1515–16
Pen and ink on blue paper
28 × 41 cm
Windsor Castle, The Royal
Collection, 19073–4v

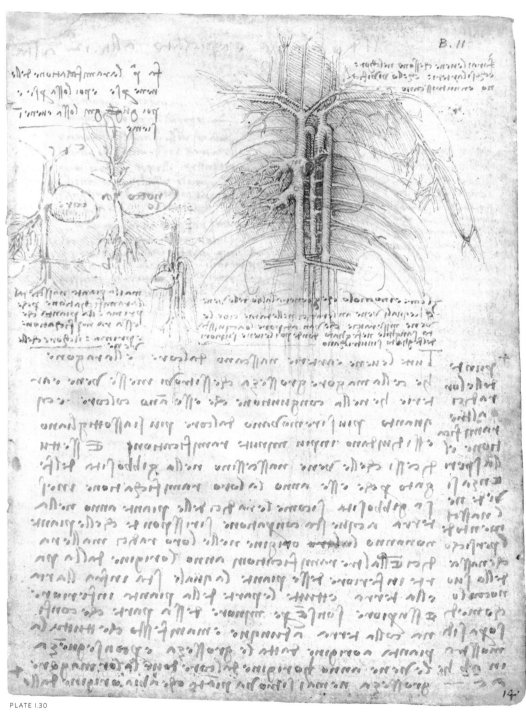

PLATE I.30

PLATE I.31

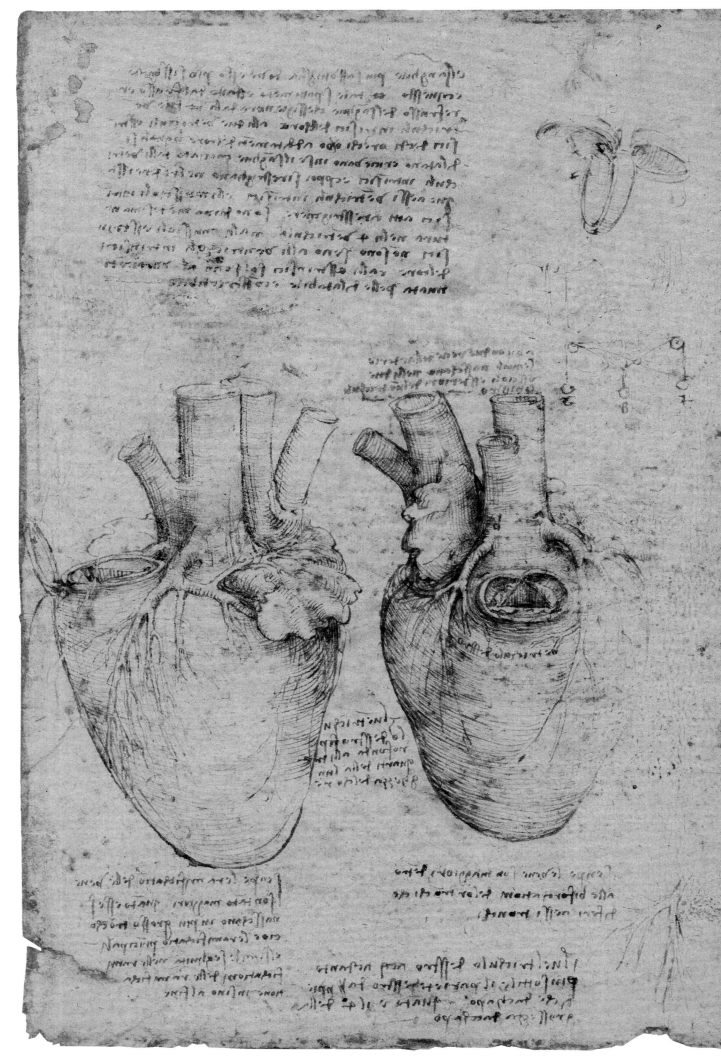

PLATE I.32

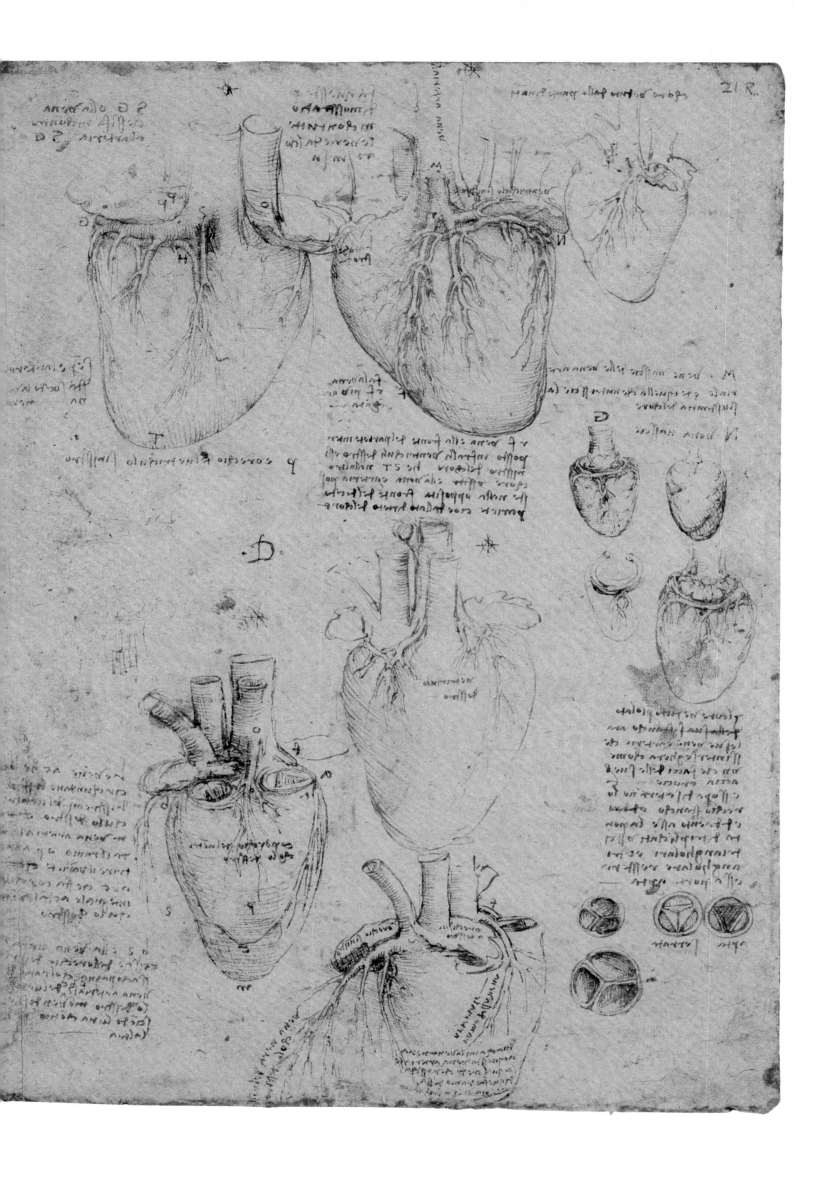

PLATE I.33
**Diagram of the atria and
ventricles of the heart**
C.1513
Pen and ink
29.1 × 21.5 cm
Windsor Castle, The Royal
Collection, 19062r

I.34
**Three-cusp valve in isolation
from above and below**
C.1513
Windsor Castle, The Royal
Collection, 19079v

His most authoritative drawings of the valves, as of the mechanisms of the heart as a whole, were made from an ox heart around 1513 (I.32). He envisaged the three cusps in isolation, in a nice act of three-dimensional visualization (I.34), and thought hard about their action. He determined that they worked passively – that is to say, they did not rely upon their own muscular motion. Rather, he diagnosed that the crush of onrushing blood in the progressively constricted neck of the aorta resulted in a reverse flux that spiralled turbulently into the cusps, filling them and snapping the entrance shut – before the next contraction of the muscular pump forced more blood through from below, thrusting the cusp walls apart from each other.

He could not, of course, see the blood moving within the living valves – that had to await modern imaging techniques, as we will see – so he transferred his science of water in motion into the tiny crucible of the valves. He devised graphic models for the flow in the valves, sketching the paths of the blood flow like the curling osiers used in basket weaving, or like the spirals of an Ionic capital (II.22). This haemodynamic geometry was perfectly in tune with the design of the cusps themselves. The way that the three cusps of equal size perfectly fill the round neck of the blood vessel, and then collapse away to create an opening of a triangular disposition, seemed to Leonardo to be a perfect example of living geometry – a manifestation of 'transformation' in which the substance of the valve walls is reconfigured under the action of the forces of nature. Towards the end of his work as an anatomist, he had achieved what must have seemed to be the ultimate demonstration of the kind of deep truth about the nature of the body that he was always seeking when he dissected, or, indeed, when he delved into any of the inner workings of nature.

At the same time as his graphic techniques were rising to this extraordinary peak of efficacy, we find, paradoxically, that words come to play an ever greater role. Many of the pages from 1508 onwards in which he analyses the operation of the heart contain dense columns of written analysis (I.33). A typical page contains just one relatively schematic illustration, clearly showing the auricles and ventricles of a four-chambered heart. The notes conduct an elaborate discussion of the action of the ventricles, inspired by the

I.34

writings of Galen, the ancient Alexandrian anatomist, whose work Leonardo increasingly came to know and respect. What is happening is that Leonardo has come to realize the morphological and physiological complexity of the human body, and that images and words must act in elaborate concert if this complexity is to be respected. Forms and functions are of matching intricacy. Therefore it is, as he said, 'necessary both to illustrate and to describe' (W 19013v).

II MODELLING LEONARDO

E-CREATING LEONARDO'S models and experiments is a way of working with him to realize his vision and to test his ideas in ways that he himself would have recognized. The most obvious models for us to re-create are his designs for machinery and devices, and these will indeed concern us here. However, there are two other kinds of modelling that are deeply in keeping with his own aspirations. One kind involves the reconstruction of experiments that he either planned or actually undertook, sometimes with surprising results. The other uses computer graphics, above all animations, to realize aspects of his vision that he could only express incompletely in his static drawings. As in the preceding chapter, a series of case studies with some general remarks will give an idea of the issues involved. First, I will look at engineering, particularly the flying machine. Second, I will deal with the re-creation of his own experimental modelling of phenomena, with special emphasis on the heart valve. Finally, I will look at the role of computer graphics in scratching itches that Leonardo would have loved to scratch in this way.

Jacks, Crossbows and Flying Machines

Leonardo made no engineering drawings in the modern sense. His drawings range from rough, 'thinking-in-progress' drawings for devices or their components to highly finished pictorial renderings of what the completed machine or component would look like. There are none of the measured plans, elevations or isometric perspectives that a nineteenth-century or modern engineer would produce to guide the building of a machine with precisely tooled components. Indeed, we know little about the modes of communication between the inventor-designers and the makers of machines. Most devices would have been constructed along established lines – of 'the common usage' as Leonardo described them – perhaps with on-the-hoof improvements and adjustments, but without the intervention of any master designer and without the use of fancy drawings. We tend to look at his most developed drawings as if they were to be set before the technician as a sheet of visual instructions. This idea needs to be severely qualified, and the best way to do so is to categorize the types of drawing that he produced and define their possible utility.

It is clear that he sketched existing devices for his own later reference, as other engineers had done. Such drawings were part of the stock-in-trade of any workshop that undertook engineering projects. Leonardo was one of a number of engineers who had sketched the renowned lifting machines that Brunelleschi had invented for his work on the towering dome of Florence Cathedral (e.g. CA 1083v and 965r). The young Leonardo was especially privileged in this respect, in that his master, Andrea del Verrocchio, was charged with the fabrication and erection of the large ball on top of the lantern, on which he is documented as working from 1468 onwards. Leonardo is likely to have entered Verrocchio's studio when the project was under way, and it would have granted the master and his assistants direct access to the surviving machines in the cathedral workshop. Leonardo's drawings, probably made around 1475, concentrated on those aspects of Brunelleschi's inventions that were 'outside the common usage', such as

the roller bearings on the teeth of the cog wheels, designed to reduce friction. Looking at other of his engineering designs, it is difficult to tell if he is drawing existing devices or inventing his own, since it is rare to have the kind of records that survive for Brunelleschi's famed creations.

Another traditional kind of drawing that he undertook involved the portrayal of machines that had an antique pedigree – that is to say, based upon what were believed to be Greek or Roman inventions, especially those for war. Romanizing stylishness had deeply permeated the design of Italian war machines, arms and armour for the leading military commanders, a number of whom were keen students of classical antiquity. Bartolommeo Colleoni, whom Verrocchio portrayed in a magnificent bronze equestrian monument in Venice, was a case in point, matching military prowess with humanist learning, and leaving a tangible Renaissance legacy in his magnificent memorial chapel in Bergamo. The essence of the classicizing tendency is captured in Roberto Valturio's picturesque anthology of ancient-style weaponry, *De re militari*, published in Latin in 1472 and in a rarer Italian edition in 1483. Valturio, as engineer to Sigismondo Malatesta in Rimini, was fully in tune with the latest humanist-style military endeavours. Leonardo undoubtedly knew Valturio's book and enjoyed drawing machines devised in this spirit on his own behalf (II.1 and IV.34). Chariots with scythes, spiked clubs and metal balls whirling ferociously on rotating arms were particular favourites. It is likely, as suggested earlier, that such designs were produced as much for the dialogue between Leonardo and his patrons as for direct implementation. The pictorial nature of the drawings was certainly directed at presenting a lively picture of the inventions, sometimes in envisaged action, rather than providing detailed instructions for any potential maker.

He also produced what is best called 'treatise engineering'. There was a long tradition of bound sets of drawn designs for engineering devices of all kinds, with accompanying texts, and some of his most famed predecessors in Italy had produced splendid treatises for presentation to actual or prospective patrons. The writings and drawings of Mariano Taccola, a noted Sienese engineer and colleague

of Brunelleschi, were produced and reproduced in splendid volumes of designs on vellum. One was presented to Emperor Sigismund of Hungary and another found its way to Constantinople. The latter was apparently produced in a Venetian context, since it contains an image of the great military commander, Bartolommeo Colleoni. It came into the possession of Sultan Mahommet II, presumably as a result of the diplomatic exchanges between the Turkish and Venetian empires.

Francesco di Giorgio, also Sienese and for a time a colleague of Leonardo, produced a series of bound volumes of brilliantly inventive designs for military and civil machinery and architecture, ranging from relatively informal workshop compilations to fine presentation copies. Leonardo owned one of Francesco's treatises, which he duly annotated (Biblioteca Laurenziana, Florence). Again the style and presentation of the drawings in the treatises were pictorial rather than technical, indicating that they were descriptive of the form and appearance of the devices, rather than primarily intended to serve as working drawings for the prospective builders of the machines. Many of Leonardo's own earlier drawings for both machinery and buildings stand firmly in this tradition, and were designed to demonstrate the scope of his knowledge and his powers of invention, probably with a prospective treatise or two in mind.

How such designs made it off the page and into manufactured reality is unclear. It may be that the fabricators of the machines could comprehend the nature of the components and their assembly on the basis of the pictorial renderings, since they knew the available technologies of gears, axles, and so on. Alternatively, there was another kind of potential dialogue with the makers that would have involved discussions, perishable sketches on any available surface, and trial-and-error testing in the workshop. This kind of dialogue, which seems to me to be altogether likely, has unsurprisingly left no trace in the historical record. That Leonardo did communicate his designs to the technicians is not in doubt. He records payments to German technicians in his Milanese workshop for the manufacture of candlesticks, tongs, locks and a wooden jack (H^1 41r). One of his types of innovatory jack is recorded in Codex

PLATE II.1
**Chariots armed with flails,
an archer firing an arrow through
a shield, and a horseman with
three lances**
c. 1483–4
Pen and ink wash
20 × 27.8 cm
Windsor Castle, The Royal
Collection, 12653

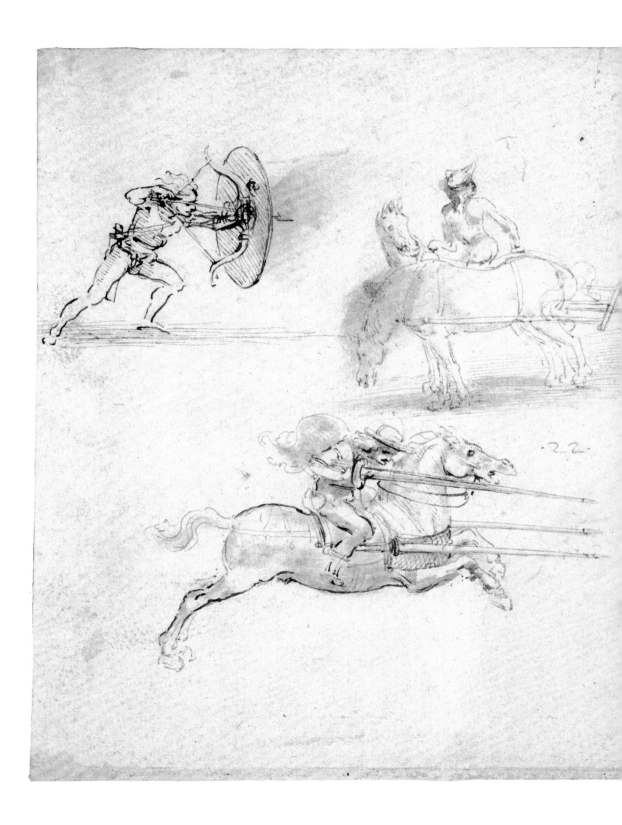

II.2
Jack with roller bearing
c.1500
Madrid, Biblioteca Nacional, I 26r

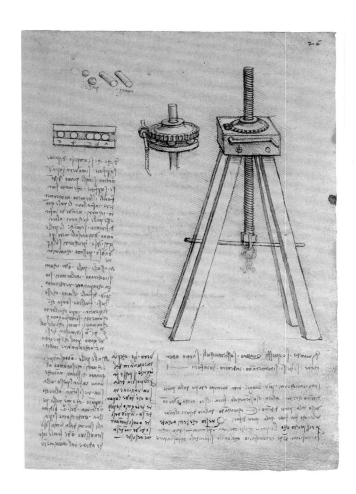

Madrid I, and has been successfully realized in a modern re-creation (II.2).

Codex Madrid I, dating from the late 1490s and early 1500s, contains splendidly incisive drawings for the 'elements of machines' – what are, effectively, anatomical components for mechanical bodies. They can, like the jack, be used as the basis of modern reconstructions. On the whole, the drawings support their translation into reality reasonably well. This is notably the case where Leonardo provides separate demonstrations of key parts of the device, either by isolating that part in an enlarged detail or by his wholly original technique of 'explosion', in which the individual components of the device are separated from each other in space. This technique is exploited with particular brilliance in his design for a two-wheel hoist (II.3). Where the drawn designs generally need to be adjusted is in such detail as the number and pitch of teeth in a gear wheel, or the precise relations of interlocking components. Some of the devices, such as the jack, are self-sufficient, while others provide a repertoire of components that could potentially perform the same role in the context of different devices. The 'elements' are again presented in the manner of treatise engineering rather than workshop instructions, though their clarity is such that they could provide (and have provided) reasonably unambiguous indications for a potential constructor.

Some of the more extravagant designs probably come into the category of 'visual boasting'. They are the *jeux d'esprit* of an inventor whose mind is teeming with wondrous things, and would have induced a gasp of awe from assembled courtiers. But it is probably unwise to be too categorical about the visionary impracticality of all the 'fantastic' designs, seeing them purely as visual rhetoric.

For instance, the giant crossbow in the Codice atlantico (II.4) looks like a dream machine rather than an intended reality. Leonardo tells us that its wingspan is a monstrous 42 *braccia* (25 m/82 ft). However, it was the subject of a series of careful and systematic studies of its main working

parts, including the release mechanism. In the final drawing he provides separate images of alternative ways of releasing the bowstring. The system of laminations in the bow's huge arms was carefully thought through, as was the carriage with its canted wheels. The finished drawing was also produced with great precision, on the basis of an elaborate armature of incised lines drawn with straightedge and compass, so that the internal structure and dimensions of the weapon should be clearly laid out in the most systematic manner. Leonardo has set down the machine and its components at a consistent angle and with the minimum of foreshortening, so that the design is at once pictorially

compelling and capable of imparting a great deal of precise information. It is as close as he came to the kind of isometric perspectives that engineers favoured in the nineteenth century; that is to say, a design that presents objects from a diagonal perspective, but does not portray parallel lines as meeting in vanishing points. An isometric (or orthogonal) design accordingly retains the same dimensional scale throughout. Leonardo's drawing does not quite do this, but he has knowingly minimized the foreshortening of more distant components in order to retain clarity. This diagonal mode of demonstration, with no obvious perspectival diminution, became one of his standard techniques when

he wanted to portray a complex structure with maximum lucidity (II.5).

It is characteristic of his developed presentation of machines that he shows vital components in isolation to clarify their structure and operation. To the right of the bow he isolates the large toothed wheel at the end of the central screw, and shows how it is turned by a worm gear on an axle that is turned by two capstans. Sometimes, as on the Arundel sheet, the isolated parts are sectioned or cut away to disclose their inner arrangement. On other occasions he presents alternative designs. To the left of the crossbow he lucidly demonstrates two alternative release

PLATE II.5
**Scheme for a rubble-filled dam
and mechanical studies**
c. 1503–4
Pen and ink
22.1 × 14.5 cm
London, British Library,
Codex Arundel, 81r

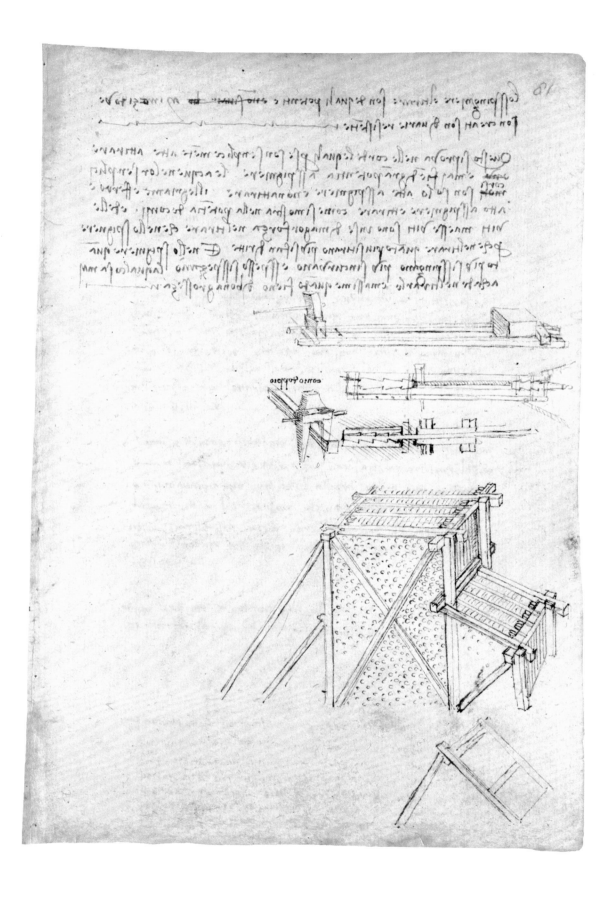

68

mechanisms, one operated by a lever and the other by a blow from a hammer.

The monster crossbow promised to heave mighty missiles to great effect. He speaks of it propelling a missile of stones weighing 100 lb (45.4 kg). In theory, power should increase proportionately with size. In practice, there is a strict upper limit on the size of any device, and these limits are particularly severe for items manufactured from wood and other organic materials. But could it have worked?

An attempt to build the machine was made for a pair of television programmes, *Leonardo's Dream Machines*, produced by ITN Factual in Britain in 2003, directed by Paul Sapin. Relevant types of wood were sought that were both available to Leonardo and that potentially exhibited the necessary properties for each of the components of the weapon. One of the problems was that in this era of high-tech engineering, with advanced metals and composites, a great deal of traditional wood know-how has now been lost. Leonardo's predecessors and contemporaries were well used to building a huge range of items in wood, on varied scales. They knew, by long experience, how different kinds of timber performed in various circumstances. They knew about seasoning, shaping, rigidity, bending, elasticity, compression, graining, durability, cracking, weight, drilling and fixing. Modern experts tried to double-guess Leonardo, reworking his design in terms of what they assumed would work. Eventually, in its modern guise, the mighty crossbow was wheeled ponderously into a broad field and tested. Groaning and creaking as the straining bowstring was drawn back by the great screw, inch by agonizing inch, the great weapon finally delivered its missile with a disappointing plop, achieving only a modest distance and hardly threatening the terrifying destruction that Leonardo intended. Further trials induced what had always been feared – namely, the cacophonous cracking of the thick arms. Too late it was realized that it might have been better not to have departed from Leonardo's design of the bow's laminated arms, held together by a complex system of metal bands, pinning rods and rope bindings. There was not enough time for a full-scale reversion. The result of the experimental re-creation suggests that the bow would probably not have delivered the kind of power Leonardo envisaged, but that it was not as wildly impractical as it might at first sight seem. However, in the final analysis the experiment remained inconclusive. By contrast, the pious re-creation of a Leonardo wing design as part of the same pair of programmes was notably conclusive. But that is to jump ahead in our story.

Leonardo seems first to have thought about airborne devices when he was in Florence as a young man. What appear to be his earliest designs involve bat-like wings and may have been intended as festival entertainments, soaring over the heads of spectators, rather than serious and sustained attempts to achieve man-powered flight. Dating the various designs is not easy, and it seems likely that a number of them are earlier than previously thought. It is possible that some of the schemes for flapping wing machines – what are now called ornithopters – were connected with his efforts to sell himself as a military engineer to Ludovico Sforza in the early 1480s. The promise of soaring over enemy lines offered obvious attractions. A number of these designs appear in Manuscript B (owned by the Institut de France), which is usually dated to the later 1480s, although some of them may be appreciably earlier.

The most developed of his schemes from the 1480s involve the translation of human muscle-power in such a way that it might flap wings of the necessary dimensions – around 11 m/36 ft from wing-tip to wing-tip. Leonardo became aware that arm-power alone, without the great breast muscles of a bird, would not suffice. He therefore tried to create mechanisms that harnessed leg- and even back-power to amplify the arm movements (11.6). The other focus of attention in the *uccello* project was the design of the wings. Not surprisingly, he went to considerable trouble to unravel the anatomy of birds' wings, noting how like they were to the human arm and hand, even to the extent of possessing a visible 'thumb' (11.7). However, he recognized that birds' wings with their complex arrangement of strong, light feathers and variable permeability lay outside his scope to imitate on the necessary scale. He can hardly have been unaware of the cautionary legend of Daedalus, whose wings of wax and feather disintegrated, with fatal results. He strove for the lightest cloths that would have the necessary strength, and considered a system

PLATE II.7
**Bird's wing, architectural
sketches, pulleys, ground plans
for courtyards**
c. 1512
Red chalk, gone over with pen
27.5 × 20.1 cm
Windsor Castle, The Royal
Collection, 19107v

of flaps that would shut on the downbeat and open as the wings were raised. He sought thin, supple wood for the skeleton, and suitable materials for the 'ligaments' and 'tendons' that were to hold the limbs in place and transmit the power of the aviator. He also considered various kinds of tail, knowing well that birds used their tails in many subtle ways to regulate their flight path. He thought deeply about how the aviator might shift his centre of gravity, since that was something that birds fluently accomplished to notable effect. Having begun to arrive at what seemed to him a suitable design for a palmate wing, he planned to test one on an apparatus of levers on a flat roof to see if it generated the necessary lift.

Occasionally less bat- or bird-like schemes cross his imagination. The famous air-screw device, often misleadingly hailed as 'Leonardo's Helicopter', is the most notable case in point (II.8). The accompanying note explains:

Let the outer extremity of the screw be of steel wire as thick as cord, and let the circumference to the centre be 8 *braccia*. I find that if this instrument with a screw is well made, that is to say made of linen in which the pores are blocked with starch, and turned quickly, the said screw will make its spiral in the air and it will rise high. [B 83v]

There is no indication that the device had any way of accommodating human passengers on its dizzily spinning structure. I suspect that it is essentially a large-scale version of a well-known children's toy, designed to astonish viewers at a spectacle. But it is easy to see how such a spiral device would attract Leonardo, since its form echoed the very motion of air itself.

Sometimes something notable is signalled in one of his little isolated thumbnail sketches, ideas thrown out and

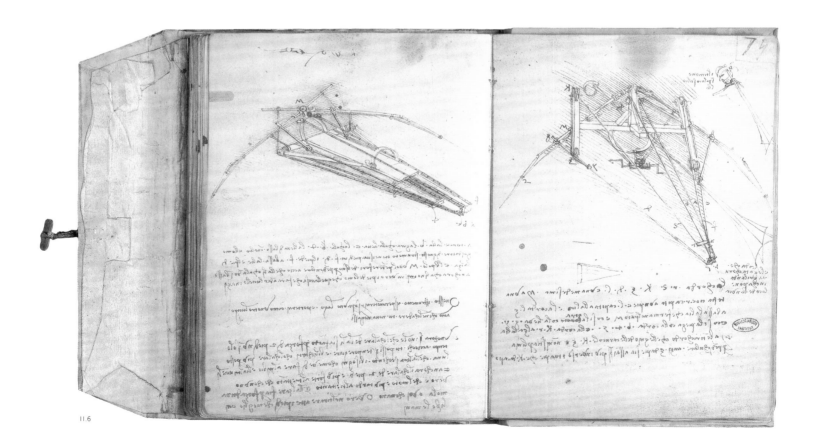

II.6

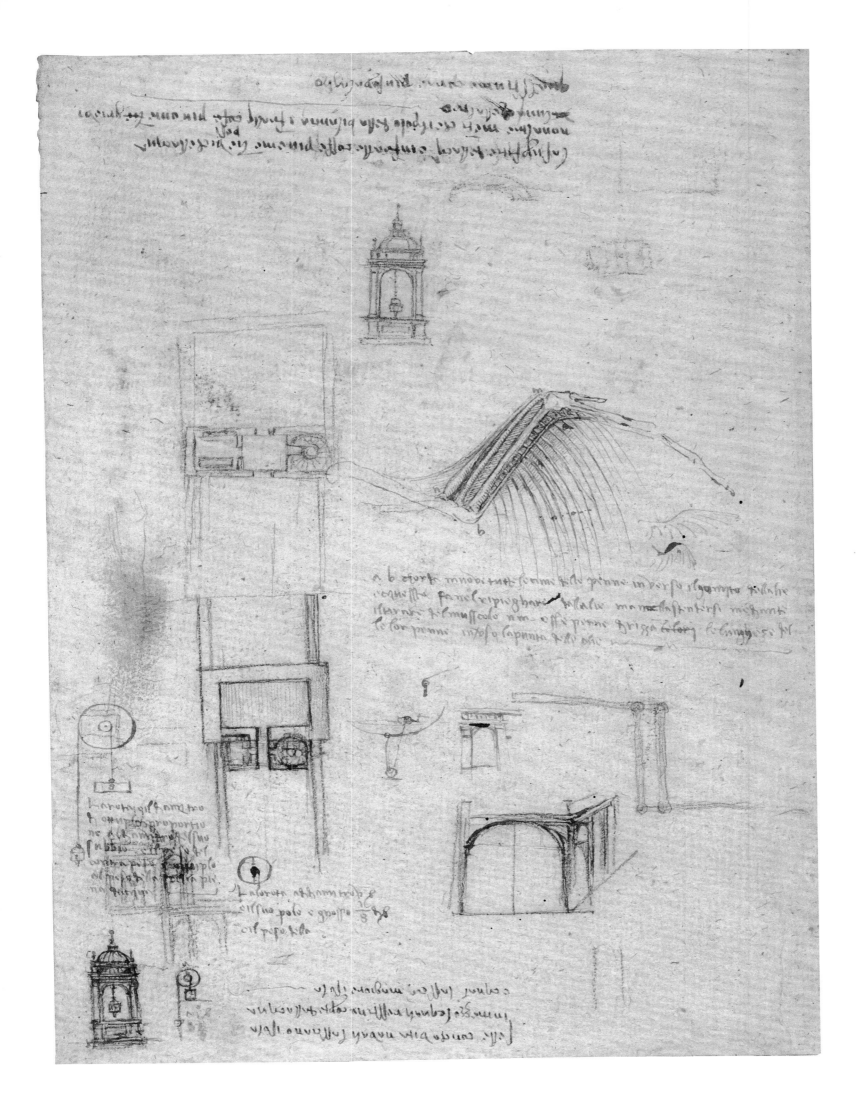

II.8
Designs for a spiral flying device,
'tank' and ornithopter
*c.*1488
Paris, Institut de France, B 83v

away – bits of debris ejected from the whirling cerebral machine of his mind. The pyramidal 'parachute', built and tested to extraordinary effect by Adrian Nicholas, intrepid explorer of flying devices (II.9 and II.10), makes just one brief appearance, at the margin of a sheet on which Leonardo was discussing the resistance of air to the beating of an eagle's wing. He adds one laconic note: 'If a man have a tent of linen of which all the apertures have been blocked, and it is 12 *braccia* across and 12 in depth, he will be able to throw himself down from any great height without sustaining any injury' (CA 1058v).

On 25 June 2000 Nicholas tested the parachute he had constructed from materials available to Leonardo. Launching himself from 3,000 m/10,000 ft in South Africa, he demonstrated that the cloth pyramid with its square frame delivered a performance at least as good as

that of the earliest known parachutes in the late eighteenth century. A man of extraordinary spirit and bravery, Nicholas was killed in a skydive in 2005.

What was the parachute's function? It seems to have only marginal utility for military purposes, but would potentially have delighted audiences within the courtyards of the towering Castello Sforzesco in Milan. But Leonardo tells us nothing of his specific intentions; perhaps he had none.

For the 1989 Leonardo exhibition at the Hayward Gallery in London, James Wink of Tetra Associates constructed under my guidance the basic mechanism and wing-form for an ornithopter, which was the form of flying machine to which Leonardo most regularly returned. There is no definitive design for a complete machine, and it was necessary to combine what appeared to be the most developed parts from a number of drawings. The frame

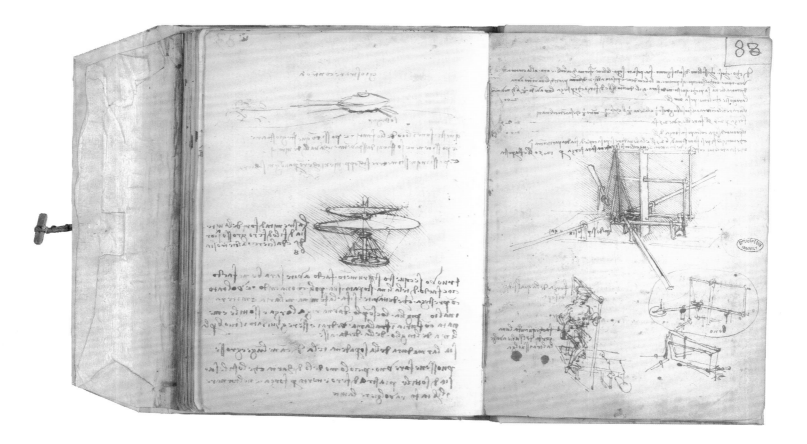

II.9

**Design for a parachute
and ornithopters**

c.1488

Milan, Biblioteca Ambrosiana,
Codice atlantico, 1058v

II.10

**Adrian Nicholas descending in
Leonardo's parachute**

2000

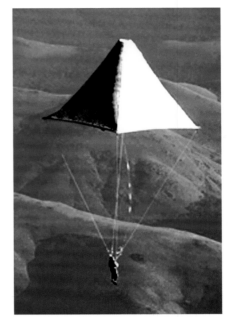

II.10

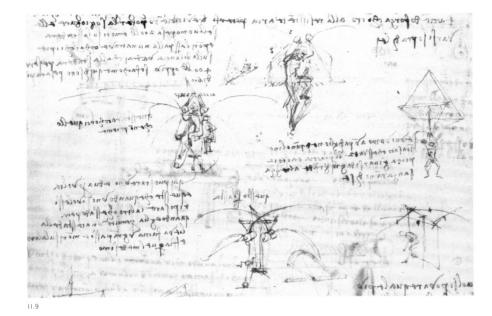

II.9

and its mechanisms were constructed from materials signalled by Leonardo himself in his descriptions of his intended machine (II.11). There was no thought that it would actually fly, not least given the poor power-to-weight ratio with the relatively heavy materials available to Leonardo. Rather, the purpose was a homage to Leonardo, re-creating his 'great bird' as visual (if not functional) manifestation of the ambition to act as a 'second nature' in the world. His bird-like machine, as realized, was an object of great organic beauty, in keeping with his insistence on the mechanical probity of natural forms. It moved with a sinuous grace that belied its few articulated joints. As he said:

> A bird is an instrument working according to a mathe-matical law. It lies within the power of man to make this instrument with all its motions, but without the full scope of all its powers; but this limitation only applies with respect to balancing itself. Accordingly we may say that such an instrument fabricated by man lacks nothing but the soul of man. [CA 434r]

There is no one strategy for building Leonardo's *uccello*. If we want to delight in a re-creation close to his visual intention, we will do something of the kind that we produced for the 1989 exhibition. If we want something that would actually stand a chance of flying, we will have to adopt another strategy altogether. There are two possibilities. The first is to exploit modern knowledge and materials to create something that is likely to be aerodynamic, while remaining as close to Leonardo as possible. The aim is to take Leonardo's vision and design style, and to realize them in the context of modern engineering. This is what the late Sandy McAuslan achieved with *Il Cygno* ('the Swan', II.12), named after Monte Ceceri (Florentine for 'Mount Swan') above Florence, which Leonardo envisaged as the launch pad for his machine (II.13). There is something thrilling about the idea of Leonardo – or, more probably, his designated aviator – swooping from the steep-faced slope towards the rooftops of the city of Florence, nestled far below in the bowl of the surrounding hills, in full view of someone in the lantern of Brunelleschi's dome.

McAuslan's method was to take inspiration from the morphology of the wings that Leonardo designed, working with his insights into the way natural wings operated and might be remade artificially. He had no scruples about the

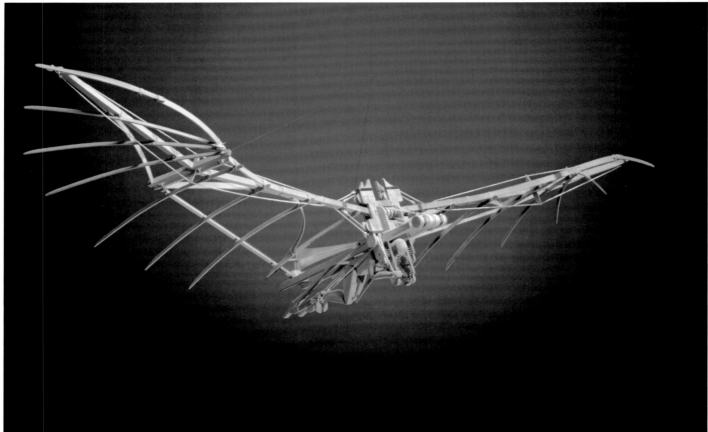

II.11

use of modern materials or about allowing his choices to be informed by what we now know to work. Essentially McAuslan conducted dialogues between Leonardo's designs, the patterns of thinking that he discerned in the drawings and manuscripts and what he knew about the theory and practice of flight today. Much the same approach has been adopted by Mark Rosheim in his reconstruction of Leonardo's automata. Rosheim's goal, as a practising engineer, has been to work creatively with Leonardo's sketches to produce reconstructions that function well. The fragmentary nature of the surviving designs for the 'robots' recorded in Leonardo's manuscripts, such as the water clock with the mechanized man who strikes the hours on a large bell, means that a good deal of educated guesswork is involved, together with the harnessing of modern materials and construction methods.

It may be objected that the results of McAuslan and Rosheim are not 'authentic'. In terms of techniques and materials, *Il Cygno* and the reconstructed water clock are undeniably inauthentic to varying degrees. But if authenticity lies in realizing Leonardo's ambition to fly or to make a working water clock with an automaton, they conform to the spirit of his intentions. Authenticity, in these terms, is defined by ends and not means. Literal, historical authenticity of a flapping ornithopter, based on a strict period reconstruction of a flying machine from his drawings, will result in something that stands no chance of flying. However, is it less 'authentic' to produce a Leonardesque device that will fly, as was his intention? Equally, is it 'inauthentic' to fill in substantial gaps in Leonardo's design for his water clock? Both approaches have roles to play, provided we are clear and open about our own intentions.

The second of the flight-orientated strategies selectively develops a particularly promising aspect of Leonardo's many designs in the light of modern knowledge, without departing from his design, his materials and his principles. Such was the strategy that we adopted for the ITN Factual programmes. Working with Skysport in Bedfordshire, specialists in the restoration of early aeroplanes, we looked through the full range of Leonardo's drawings for winged machines. The obvious practical route to take was to concentrate on designs that gave primacy to gliding rather than flapping. Generally speaking, the idea of a gliding device gradually assumed more prominence in his mind as the difficulties of the flapping machine became evident. But, as always with Leonardo, it would be unwise to assume a linear or consistent development. At one point in Codex Madrid I he considered an altogether unbird-like single aerofoil, orientated with its long axis along the line of flight, with a suspended aviator (Madrid I 64r), but this seems not to have been pursued any further.

II.11
**Re-creation of
Leonardo's ornithopter**
1989
James Wink of
Tetra Associates

II.12
Il Cygno ('the Swan')
2003
Sandy McAuslan

II.13
**The view from Leonardo's launch
site at Monte Ceceri, near Fiesole**

II.12

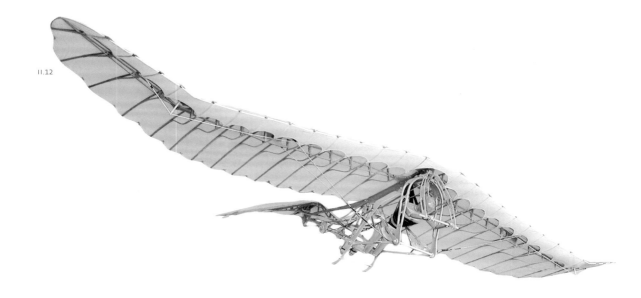

II.13

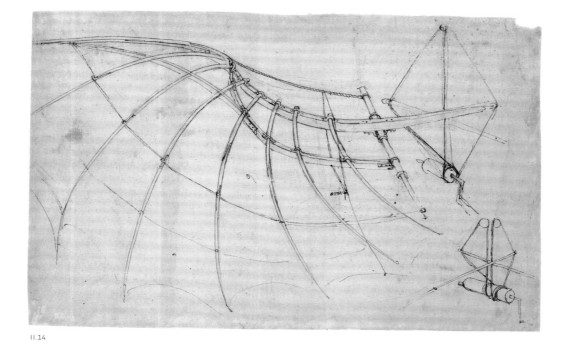

II.14
**Design for a wing of
a flying machine**
c.1482
Milan, Biblioteca Ambrosiana,
Codice atlantico, 858r

II.15
**Hang glider based on
Leonardo's wing in II.14**
2002
Skysport

II.14

The designs that appealed most to the Skysport engineers, Steve Roberts and Martin Kimm, were those based on a bat-like skeleton, with a curved leading edge and a scalloped trailing edge. One design (one of the earlier series) looked particularly promising (II.14). What, they asked, was the line that passed from the rear of the upper surface of the wing, over the front edge and to the midpoint of the lower surface? It was labelled '*panno*' (cloth). It seemed to me to have little significance, and I had not noticed it before. It indicated that Leonardo intended to clothe the wing with a skin of cloth. This small detail, noticed by the aeronautical specialists, proved to be crucial, since it promised a profile for the wing's surfaces and leading edge that was known to produce lift. A small-scale model confirmed that this was the case, though there were severe problems with stalling. The precise position of a weight suspended beneath the model's wings proved to be critical. With that insight, the building of the full-scale machine proceeded apace.

The plan was to use Leonardo's wing design in what was to be a hang-glider. The selected design was not actually for a craft with fixed wings, but for one in which the suspended aviator could achieve some measure of flapping, though certainly not enough to generate powered flight. One of the designs (CA 860r) shows a boat-shaped 'body' in which an aviator could 'row' the machine through the air. We decided to concentrate on a glider that would utilize the potential lift of the shape of Leonardo's wing, ignoring its articulations. The job was complicated enough, and risky for any potential pilot, without letting the wings move. The frame for the pilot under the wing took its cue from a number of drawings in which Leonardo considered how the valiant flyer might adjust his or her centre of

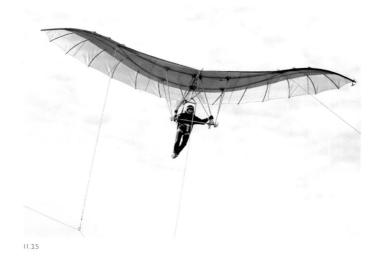

II.15

gravity to navigate the craft, but the precise design needed also to call on what was known about hang-gliders – again with pilot safety in mind.

On a cold clear morning in October 2002, the full-scale *uccello* was transported to a long hillside on the Sussex Downs, facing the brisk breeze off the sea, a locale favoured by hang-gliding enthusiasts. The aviator was to be Judy Ledden, women's world champion in hang-gliding. In spite of encouraging tests, the risks were considerable and legion. The machine might rise high, only to stall, crashing backwards to earth. It might pitch precipitately on its nose. It might roll catastrophically, all lift lost. As it was wheeled to the best position on the gradual slope, it tugged eagerly at the hands and ropes that held it down. There was certainly lift – but how much, and was it controllable? A few short and limited trial runs were made, the wings tightly tethered by ropes held by running attendants. The lift was more than enough to get the craft well and truly

airborne (II.15). The problem was that it required modes of control different from a modern hang-glider. Ledden needed to learn how to tame it through subtle but definite and controlled motions of her body. Gradually the mind and body of the human pilot and the wings of the 'great bird' began to act in concert. The climactic flight, reaching some 9 m/30 ft above the ground, exceeded in length the Wright brothers' epoch-making journey in 1903. As the commentator reported, the mood was jubilant.

The intention was not to prove that Leonardo invented flight, any more than the Hayward Gallery ornithopter was designed to prove that his flapping wing machine was destined to fail. Rather its intention was, in the context of public communication, to study Leonardo's ways of thinking, his imaginative inventiveness, the beauty of his vision and the extent to which his insights led him into fruitful areas in his ambition to remake nature on human terms. The purpose was public insight, but as always in such reconstructive quests, the questions that the researchers and constructors must ask of the historical material are of an intensity and rigour that are rare in orthodox historical research. The interplay of the precise demands of modern engineers, who have the pilot's safety in their hands, and of the historical specialist are of a nature that brooks none of the ifs and buts that are part of the historian's normal evasions and qualifications. It is a good context in which to have to think, and not entirely remote from the demands that Leonardo was making on himself, if the intended flyer of his machine was not to perish in the attempt.

Experiments with Material Things

The flying machine was in one sense a kind of experiment, testing simultaneously a whole series of assumptions and theories about how a creature might remain aloft. But it was not an experiment in the modern scientific sense, focused on the controlled and repeatable testing of a specific phenomenon to formulate a general rule. Although it would be wrong to claim that Leonardo was a precocious practitioner of 'Experimental Science', with all that is implied by this term, he undoubtedly saw focused experiment through the controlled modelling of natural effects as a major key to unravelling how nature worked. As we have seen, he sometimes writes '*sperimentata*' beside something he has tested, either after or before drawing it on a page in his notebooks. In other cases it is often difficult to tell whether he has actually tested the results that he outlines. Sometimes he believed that he understood the 'causes' so well that he could demonstrate the 'effects' without further testing, while at other times the act of drawing a set-up itself served as a kind of surrogate experiment. However, there are few cases where the results are so counter-intuitive that not even Leonardo could have achieved them solely by thinking and drawing. I intend to look at three of these, before looking at two experiments centred on microcosmic problems. The initial three all contain a strong element of surprise.

The first case is secreted near the right margin of a diverse page of drawings and notes in Windsor (II.16). A circle is set well within the margins of a square. Leonardo explains that this is a plan of a cube of wax, on top of which is placed a flat plane of glass or crystal. Then, if the plane is pressed down evenly, steadily compressing the cube at right-angles to its upper and lower faces, the cube will, needless to say, become progressively squashed. The surprise is that its four lateral faces will begin to bow outwards in a cylindrical fashion. Eventually the compression will suppress the last remaining residues of the squared vertices (II.17 a–d). A perfect shallow cylinder is the result! How, and why, he even thought of this experiment is unclear. Perhaps he had a cube of sculptor's wax in his workshop that began to be inadvertently squashed. In any event, he must have delighted that material substances in nature acted out exactly the same types of 'transformation' that he studied more abstractly in his solid geometry. He had in effect 'circled the square' – the reverse of the classic problem of squaring the circle. The sheet containing the small sketch of this experiment belongs to a series that primarily considers the malleability of water. Leonardo also accorded particular priority to the transformation of one regular solid into another. The cube-to-cylinder

II.16

II.16
**Diagram of the compression
of a cube**
c.1508
Windsor Castle, The Royal
Collection, 12664

II.17a–d
**Stages in the compression
of a cube**
V&A Science Section

II.17a–d

phenomenon must have seemed almost like a material version of squaring the circle, the ancient 'Holy Grail' of Euclidian geometry, the quest that he pursued with considerable persistence, as we will see later.

The second case involves a kind of party trick, but Leonardo typically uses it to adduce a principle. In the margin of the right page of Codex Leicester 4B he places an apparently inconsequential little sketch of a pile of flat cylinders, with one standing alone beside it. He explains that 'the game counter [at the base] is removed from the bottom of its pile by the blow from another counter' (II.18). He obviously enjoyed these kinds of tricks, and they no doubt provided amusement at court, enhancing his reputation as a *magus*. But the removal of a supporting layer and the corresponding lowering of whatever is stacked above is, in a notable act of lateral thinking, used

as a 'proof' of what happens with an 'unsupported wave'. Again, the trick must have been performed, because it is not obvious that it will work.

The third case, like the first, involves the behaviour of materials of the kind Leonardo had around him in the studio. The set-up involves a layer of powder, on top of which is poured a conical pile of powder of a different colour. We may imagine them to be pigments ground to the same fine consistency by one of his apprentices. If the pile is then agitated – for instance, by hammering on the table on which the two pigments sit – in due course, if you are fortunate, some grains from the centre of the lower layer amazingly emerge from the summit of the upper pile, having migrated vertically upwards along its central axis (Madrid I 26v; and II.19). Another instance of the geometry of materials in action – in this case readily

78

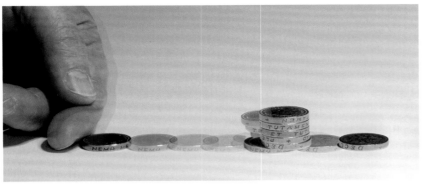

II.18

II.18
A trick with coins
V&A Science Section

II.19
**Rising of grains from a base layer
to the summits of a granular cone**,
based on Codex Madrid I.26v
Enzo O. Macagno

II.19

imagined as a happy accident in his studio. The grinding of pigments involved much initial pounding with a pestle and mortar, which could well have generated the vibrations necessary for the grains to migrate upwards to an adjacent pile. The results can hardly have failed to remind Leonardo of the eruptions of volcanoes.

The next experiment involves real mountains, but this time in the context of Leonardo's microcosmic investigations of high springs, already considered in the previous chapter (see pp.47–50). During the course of his debates on how water arose so high, he considered the possible role of heat in drawing the water upwards. He thought he would try an experiment: he inverted a flask in a bowl of water and heated it with a hot coal (II.20). Air would be expelled from its neck as the hot air expanded. When the coal was removed and as the air cooled, water would be drawn up into the flask above its level in the bowl. (We know that the water is forced up by atmospheric pressure on the water in the bowl, to compensate for the loss of air pressure in the flask.) I was told by a hydraulic scientist that this would not work, but it did (II.21 a and b). Leonardo also pointed out that if a hole was made in the flask above the water level, the water would not rise. In the final analysis, as we have seen, he discarded the idea that heat was responsible for the high water within mountains, but his speculations threw out a nice and valid experiment with a far-from-obvious result.

The final of the 'experiments' is the most remarkable of all, in as much as it dealt with complex, largely invisible phenomena, and involved the interaction of fluids with organic structures. He really had no right to succeed as well as he did. It concerned the three-cusp heart valve, which

II.20

**Rising of water in an inverted
vessel that is heated and
then cooled**
c.1508–9
Seattle, Bill and Melinda
Gates Collection,
Codex Leicester 3B (3vr)

II.21a & b

**Rising of water in an inverted
vessel that is heated and
then cooled**
V&A Science Section

PLATE II.22

**Studies of a three-cusp valve
and scheme for a model of the
neck of the aorta**
c. 1516
Pen and ink on blue paper
28.3 × 20.7 cm
Windsor Castle, The Royal
Collection, 19082r

we have already discussed as a perfect example of natural engineering on a very small scale (see p.61). On one of the pages in Windsor in which he progressively thinks through the living geometry of the valve, Leonardo announced his plan to make a model of the set-up in the neck of the aorta: 'make this test [*prova*] in glass and have water and millet move in it' (II.22). Towards the left of the page he provides see-through views of the valve, simplified for the sake of clarity, and at the top a little sketch of the valve walls folding as the valve opens. Below the model he draws the *cordae tendínae*, and speculates about the form of the vortices in the valve. He sketches large, primary vortices turning back into the cusps, and secondary, in-turning vortices in the narrowing neck of the aorta.

When I was in California in 2001, I learned that Mory Gharib, Professor of Aeronautics and Bioengineering at the California Institute of Technology, was researching the dynamics of blood in the heart and was so fascinated by Leonardo's drawings that he was constructing Leonardo's model. When I visited his lab in Caltech, I found that he had already constructed a glass model of the neck of the aorta and was using modern imaging techniques to study the flow. As yet, the model lacked the valves, but the flow patterns were astonishingly like those predicted by Leonardo. A paper was published, to which I contributed some information on Leonardo. Subsequently the valves have been added, to complete the Leonardesque picture

(II.23, II.24 and II.25). To see the little Leonardo valve living, as it were, pulsing shut and open, fragile and yet perfect in its operation, is very moving – surrounded as it is by the high-tech paraphernalia of a twenty-first-century laboratory. Courtesy of the imaging techniques now available to those studying fluid dynamics, we are able to witness in reality what Leonardo could only see in his mind's eye.

Mory Gharib is of the opinion that Leonardo must have made his model to describe the flow as fully as he did. I am happy to accept that opinion, with the qualification that there was no way in which Leonardo could have seen the vortices in clear water (or even with the added grains of millet that he suggested using) as clearly as he drew them. His characterization of the action of the valve is an astonishing piece of theoretical modelling, based on anatomical observation, transformational geometry and studies of water in motion, which could be tested through the construction of a physical model. The model, either drawn or constructed, is what I am calling a 'theory machine'. If Leonardo did indeed make his model, and witnessed its successful functioning, he must have felt a sense of completing the circle of what he would have regarded as the ultimate form of proof: God's creation – natural form – observation – analysis – synthesis – re-creation. It is a circle that stands at the heart of his art as much as it does at the heart of his science.

II.20

II.21a & b

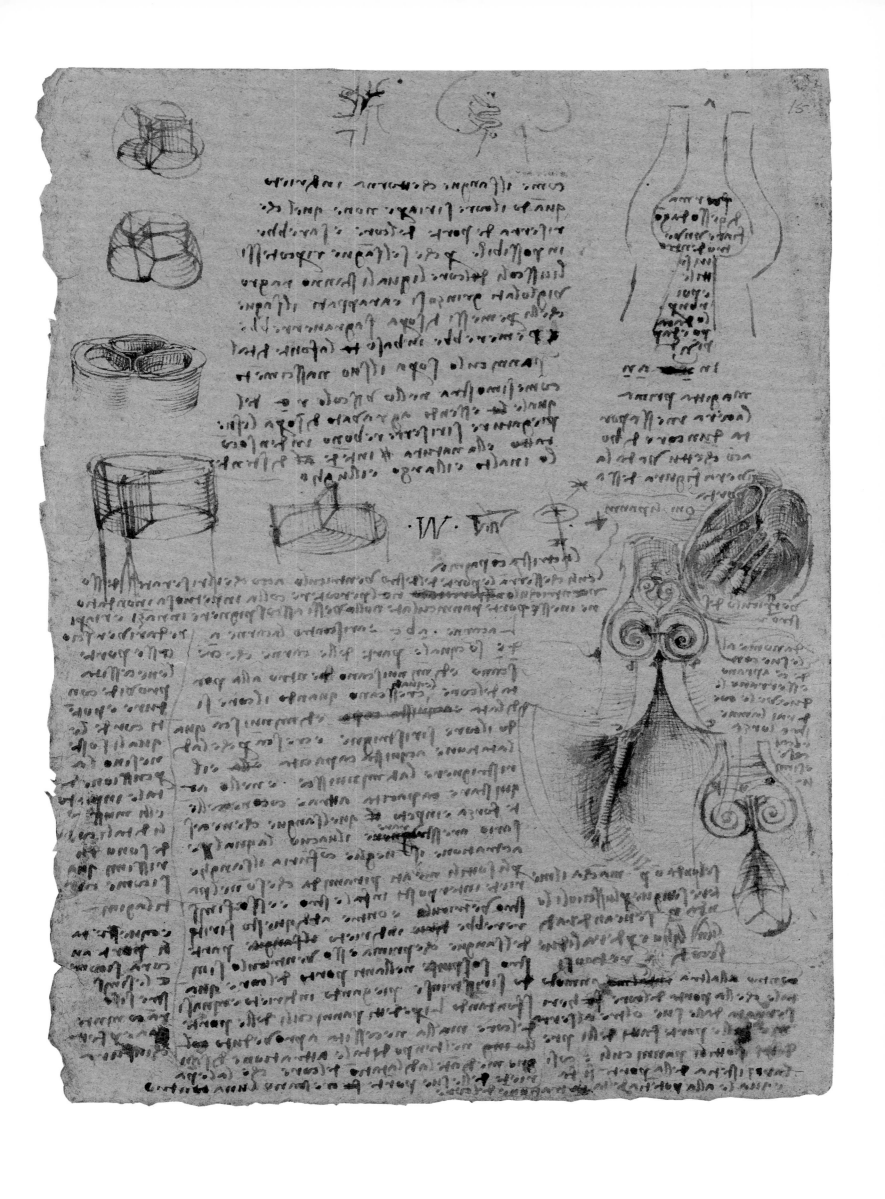

PLATES II.23, II.24
Mory Gharib, **Model of heart valve after Leonardo** (based on Windsor 19082r, no. 2.10), seen from the side (II.23) and from above (II.24)
2002
Perspex, rubber, etc.
Prof. Mory Gharib and Dr Arash Kheradvar, Cardio Vascular Research Laboratory, California Institute of Technology, Pasadena, California

II.25
Flow patterns in the model of Leonardo's heart valve
2002
Mory Gharib

II.23

II.24

II.25

Coincidentally the leading heart surgeon Francis Wells, of Papworth Hospital, was re-examining Leonardo's pages of heart studies with a growing sense of wonder. Many aspects of the drawings – ranging from things that others had recognized, to neglected or overlooked details – testified to the intensity and perspicacity with which Leonardo strove to unravel the working of the heart. Gharib's model approaches Leonardo's heart valve from one direction, Wells's observations from another. They meet satisfyingly in the middle with total agreement on Leonardo's insights. This is not said in the spirit that it is only by proving Leonardo 'right' that we should value what he has left us. Rather, it is to say that the quest he undertook, and the nature of the mental and physical tools he used to further that quest, can speak movingly to anyone who shares Leonardo's deep commitment to discovering how nature works. He is not 'a man ahead of his time', to use that silly cliché, but a man who testifies to the ageless nature of human enquiry undertaken at the most profound level.

Moving Pictures

Thanks to the imaging technologies at Caltech, we can create moving pictures of the flow in Leonardo's valve. He would have loved the moving images we can create today in the various media available to us. We can sense how he strove to imply motion in the flat, static media of his drawings. Giorgio Vasari tells how Donatello, having completed his extraordinarily communicative marble prophet, *Habbakuk*, felt impelled to command it to speak. We can almost feel Leonardo imploring his drawings to move. With computer animation at our command, we can make his unspoken wish come true.

We can use computers to store and present information and images in ways that serve the needs of those interested in Leonardo at many different levels, from basic enquiry to specialist research. The relational databases we can now exploit potentially serve Leonardo well, able as they are to create the kinds of lateral links across fields of enquiry that were so important in driving his thought. This is part of what we are doing with the 'Universal Leonardo' website (www.universalleonardo.org; see p.viii). But there is another, rather different way of using computers to work with Leonardo. This is to exploit the computer's ability to create images that move and morph, according to the programmed rules in such a way that they operate in concert with analogous aspects of Leonardo's thinking and graphics. The idea is to use the architecture of the computer's 'thinking' to collaborate with Leonardo's thought processes.

We first tried this for the 1989 exhibition at the Hayward Gallery, curated by Jane Roberts and myself. The computer graphics were created in the IBM Research Centre at Winchester, with Phillip Steadman (then of the Open University, and now Professor of Urban and Built Form Studies at University College London) providing vital liaison between the IBM researchers and the curators. We tackled what seemed to be five potentially fruitful areas: Leonardo's processes of truncation and stellation in the five regular ('Platonic') solids (see p.109); the invention of almost infinitely varied plans for centralized 'temples' from a few basic elements in the ground plans; the internal

space of the painted room in which he set the *Last Supper*; the impact of light on bodies, casting shadows and passing though apertures; and his branching systems.

The animations worked with varied levels of success. The Platonic solids – spinning in space as their vertices were sliced away, merging when the truncations resulted in the same configuration (11.26 a and b) – fully satisfied Leonardo's ambitions to manipulate the forms as if they possessed sculptural reality. The churches, rising layer by layer from the permutated squares, octagons, crosses and arcs of their ground plans, were comparably effective in working with Leonardo's thought processes, as he drew his many variations on the centralized theme (11.28). The paradoxical space of the perspectival room in the *Last Supper*, apparently so logical, yet so elusive and exploiting a viewpoint high above the head of any spectator, was nicely demonstrated, as was the reason why he did not show the scene from the spectator's viewpoint. From the level of a standing person, the disciples' table, seen from below, would have obscured much of the action and all the symbolic bread and wine (11.27). The re-creation of Leonardo's drawings of the complex play of light and shade not only brought his demonstrations to life, but also stressed the fundamental affinity between the way that computer programs and Leonardo set out to model light and shade on three-dimensional bodies. The computer technique of ray tracing (that is to say, tracking the geometrical path of light rays from their source and recording their impacts and rebounds) is exactly what Leonardo was trying to demonstrate in his drawings. Even a complex form like the human head (11.29) can be treated in this way. Leonardo believed that the intensity of light on a surface was proportional to its angle of impact. Computer ray tracing, used to plot light and shade on shapes generated by computer-aided design, relies upon Lambert's cosine law, formulated by the German scientist in the eighteenth century. Although the mathematics is different – Leonardo's era had no trigonometry – the style of insight is entirely complementary. Only the branching system demonstrations were a disappointment. Time ran out, and the branchings had to be animated rather than programmed according to Leonardo's rules.

II.26a & b

II.26a & b
**Stages in the truncation of
a dodecahedron and icosahedron
into an icosidodecahedron**
1989
IBM Research Centre,
Winchester

II.27

II.27
**Computer reconstruction of the
room of the 'Last Supper' as if
seen from the level of a spectator
standing in the refectory**
1989
IBM Research Centre,
Winchester

II.28
Design for a centralized temple
c.1488
Paris, Institut de France,
BN 2037 5v

in computer graphics. The modelling of light and shade in the computer relies, as does Leonardo, on the exposure of the contours of the form to a defined light source and the calculation of the 'percussion' of light according to its angle of impact. We are not, however, limited to a static rendering, and can plot dynamically what happens when either the target (the human head) or the light source

Again, the intention was not to prove Leonardo 'right' or 'ahead of his time'. What we were seeking to communicate was the nature of his ways of modelling phenomena and creating images through a dialogue with modern techniques that seemed entirely in keeping with his vision.

Our new generation of computer images, devised by Steve Maher in 2005 and 2006, is doing something different yet again. It is picking up on a method we tried when we devised a CD-ROM centred on Bill Gates's Codex Leicester. Many of Leonardo's drawings, even with his supreme graphic inventiveness and skills, make considerable demands on our powers of visualization. He could see what was happening in his brain. We cannot always do so, and the notes do not always help, even when he provided them. But once the drawings move – demonstrating through animation what Leonardo was envisaging – the 'aha' factor kicks in. We suddenly see what is going on. There is also, to be honest, an element of play in this, taking delight in bringing his vibrant studies to life in a way that he would surely have enjoyed. Very remarkably, the 'hammering man' worked perfectly as an animation without additional frames. The cumulative effect of all the animations aims to evoke the onrushing torrents of Leonardo's processes of invention and visualization. The pictures in his mind were clearly anything but static.

Unsurprisingly, Leonardo's 'ray tracing' of light on a human head (II.29) is a prime candidate for realization

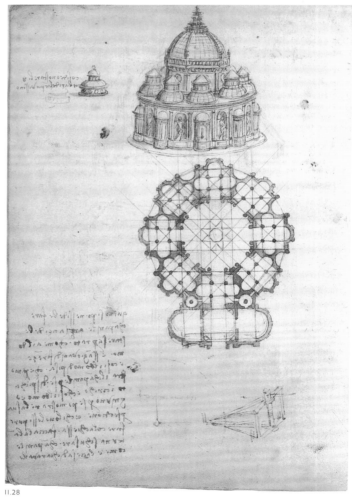

II.28

PLATE II.29
**Head of a man showing how rays
of light fall upon the face from
an adjacent source**
c. 1488
Pen and ink
20.3 × 14.3 cm
Windsor Castle, The Royal
Collection, 12604r

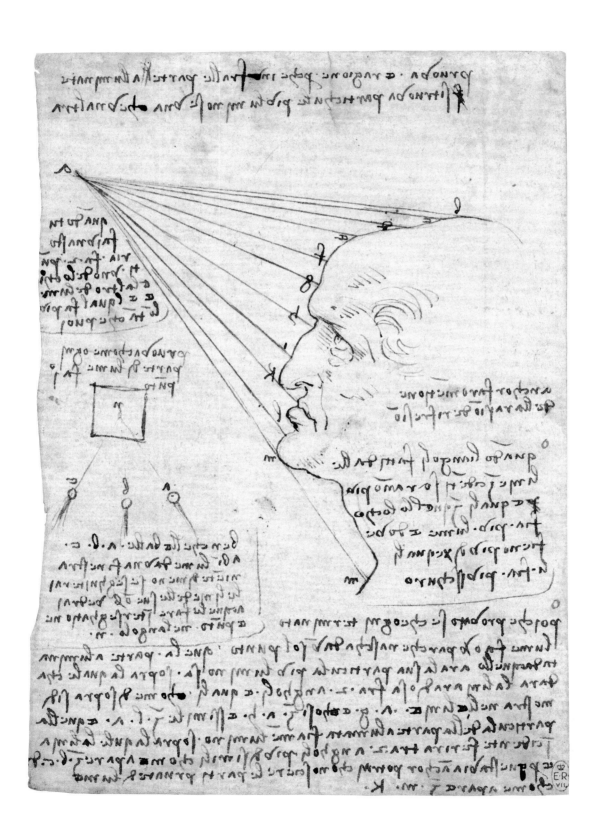

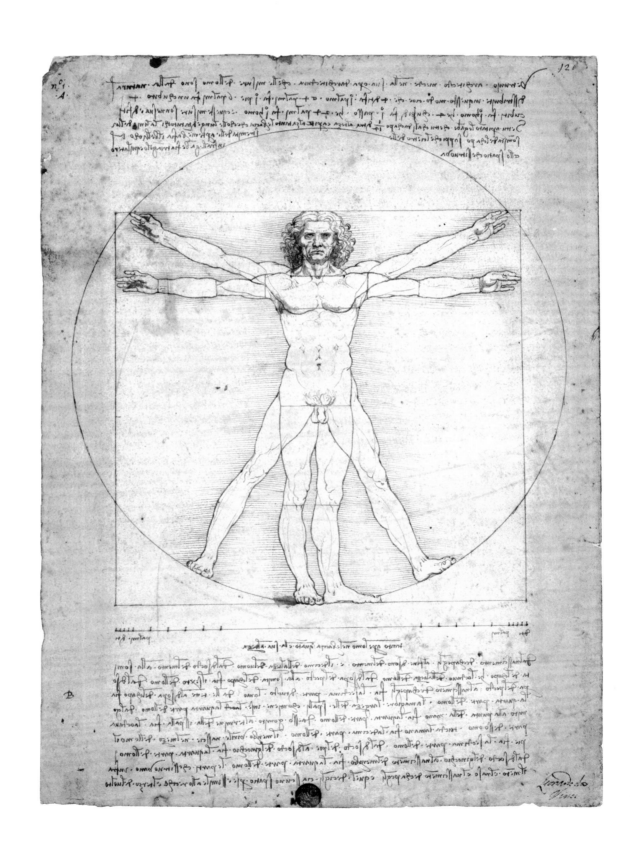

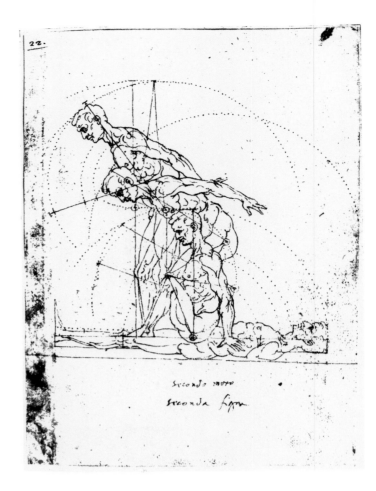

II.31
Carlo Urbino da Crema (?),
**Figure in successive stages
of motion**
Codex Huygens, 22
New York, Pierpont
Morgan Library

(or both) moves within the virtual space of the computer graphics (II.32). The infinitely fluid interaction of light and form across a 'continuous quantity' is precisely what lay behind the vision of *relievo* (relief or plasticity) that Leonardo did his remarkable best to express in pen on paper.

This theme of 'continuous quantity', so close to Leonardo's heart as a student of force and motion, is a thread that runs through all the animations undertaken in 2005–6. The 'cinematic' pen-men positively invite the animator to extend Leonardo's graphic realization of the simple and compound motions of the levels and fulcrums of the body in action. A cast of energetic 'actors' as realized in the computer take their cue from Leonardo's own sequential or near-sequential studies (IV.2, IV.3 and IV.43). Of course, as Leonardo himself demonstrated both in word and drawing, the dynamic actions could themselves be viewed from a series of continuous viewpoints in space. It is a vision that was only to be realized in concrete visual form with the advent of modern cinematography, above all in the hands of a master director like Sergei Eisenstein, who was a devotee of Leonardo. Like Leonardo, Eisenstein's capturing of the motion of bodies in space was not naturalism for naturalism's sake. It served the needs of the rhetorical communication of *il concetto dell'anima* of each of the actors in their cinematographic dramas.

The orbital 'cosmology' of the *Vitruvian Man* (II.30) not least as developed in the Leonardesque Codex Huygens (II.31), merges the 'continuous quantity' of the human body with basic geometry that operates at the grandest of the scales that could be envisaged. He is as much a Ptolemaic man as a Vitruvian one. Leonardo subscribed completely to the Ptolemaic vision of the cosmos. The 'Prime Mover', who stood unmoved in the outermost sphere that lay beyond the physical universe, was the ultimate source of every motion in the world, which would otherwise comprise an inertly stable configuration of the concentric spheres of earth, water, air and fire. The metaphysics of this vision serves to remind us that our modern instrumentalizing of Leonardo's vision of motion is good and appropriate as far as it goes, but that the ultimate goal in Leonardo's mind was to illuminate his unshakeable faith

in the divine harmony of the micro- and macrocosms – a goal that is hardly foremost in the minds of modern computer animators, or even of the historians who provided the ideas and images for the animations.

Perhaps the closest modern animations can come to capturing the 'spirit' of what Leonardo was trying to express is in giving vent to his images of turbulent motion, whether in the raging vortices of water and the deluges (I.22) or in the frantic mêlées of warriors and horses involved in the 'beastly madness' of war. The drawings, even at their most precise and 'scientific', are full of graphic devices that evoke motion, as will be discussed in Chapter IV. They are simultaneously diagrams of forces in violent interaction and charts of a personal engagement that dig deep into the world of instinct and emotion. We can sense this engagement even with the 'cooler' studies of water pouring from culverts (I.20 and I.21), and it is overtly present in the deluges and battle scenes. Again, the animation of the drawings (II.32–7) can achieve something special, complementing both the drawings themselves and the analyses that we make of them. The computer imaging is, in parallel to the text of this book, involved in a mode of analysis and exposition that is, to my mind, a valuable adjunct to our understanding and communication of the wonder of Leonardo's manuscripts and drawings.

II.32

Light

Close scientific analysis of light informed Leonardo's modelling of heads in his paintings. The animations follow his demonstrations of the effect of light falling on a face (see II.29) and why certain areas are more brightly illuminated than others, depending on the angle at which the light hits the surface.

Based on this drawing, and others by Leonardo showing the same figure from different angles, a three-dimensional wire-mesh sculpture of a head was constructed on a computer. The computer model was then lit by a single point of light, generating shadows that could be overlaid onto the drawing in order to move from a two-dimensional image to a fully shaded version that would appear to stand out in relief on the page.

Cosgrove Hall Films Ltd

II.33

Geometric form

Stills from the animation show the truncation and stellation of a polyhedral shape in the style of Leonardo's illustrations for Luca Pacioli's book *De divina proportione* (see III.12).

In order to animate the complex geometry through its various stages from two-dimensional pentagon to stellated and, finally, truncated dodecahedron, a computer modelling package was used. The animation was rendered in outline, and line-shading textures were then mapped onto its surfaces in order to resemble the original woodcut engraving. It is likely that Leonardo constructed three-dimensional models made in wood, on which he based his illustrations.

Cosgrove Hall Films Ltd

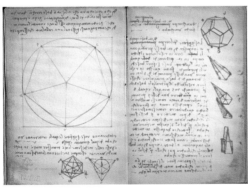

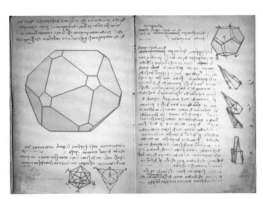

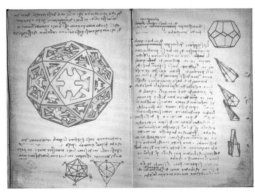

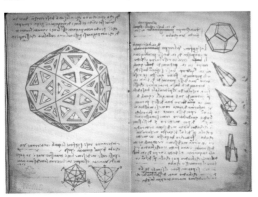

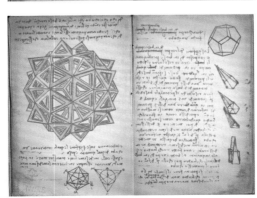

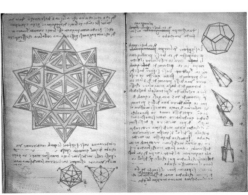

II.34
Motion

Leonardo's notebooks are filled with small
sketches of figures in motion. In some cases
(see III.11, IV.43) these swiftly rendered
sketches capture a rapid burst of activity in
a strip of sequential drawings. This process
also forms the basis of the drawn animations.
The sequence illustrated here expands a few
of Leonardo's three-frame thumbnail movies
to fully animated status.

Cosgrove Hall Films Ltd

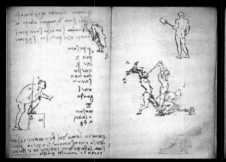
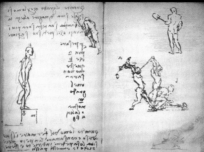
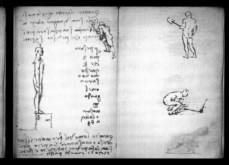
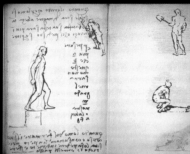
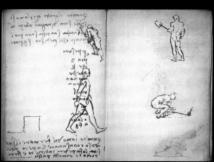
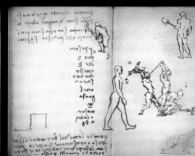

II.35
Flight

These stills illustrate Leonardo's study of
the flight of birds in the Turin Codex (see
IV.6), his comparison of their wing anatomy
with that of the human arm (see IV.9), and
his attempts to use these observations for
the design of a flapping-wing aircraft or
ornithopter (see II.14).

Cosgrove Hall Films Ltd

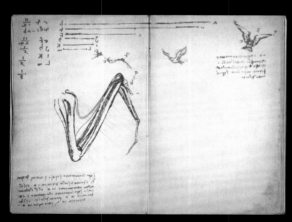
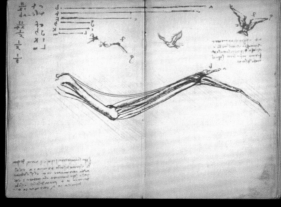
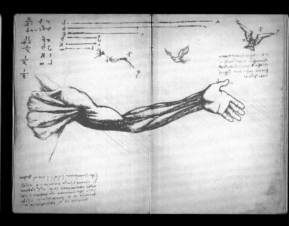

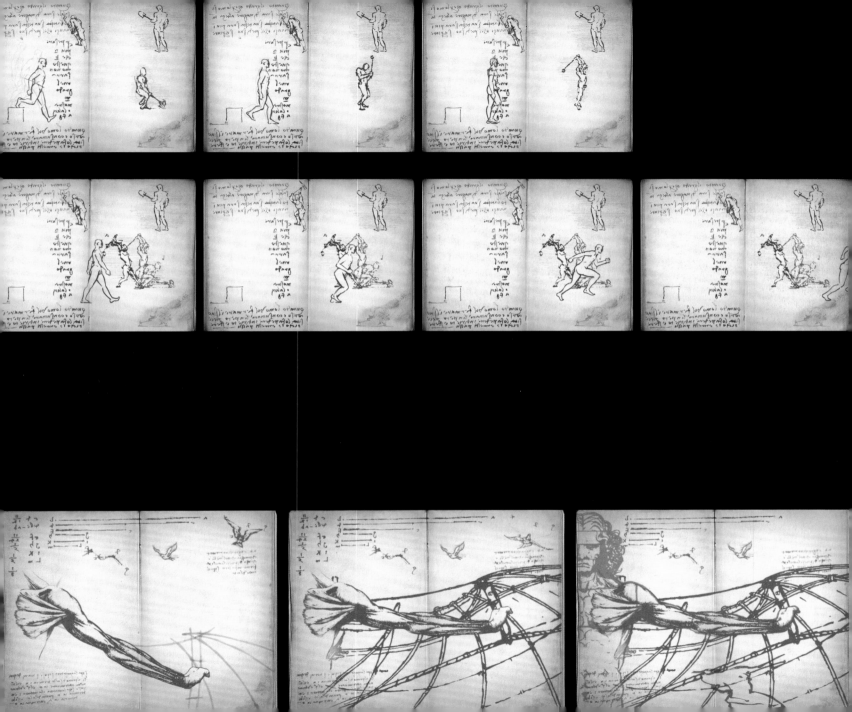

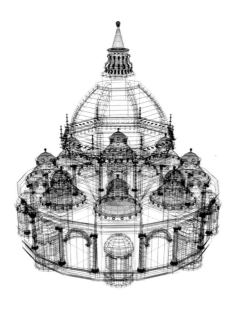

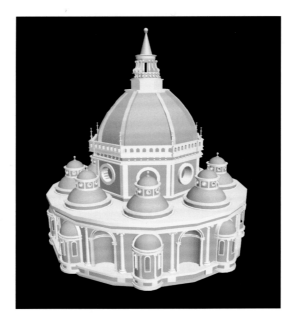

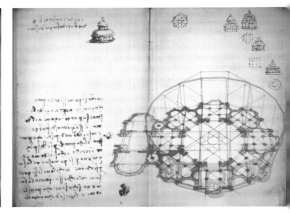

II.36

Centrally planned church

Stills from the animation based on elements from Leonardo's many unrealized designs for a centrally planned church (see II.28), set here at the heart of an ideal city.

The sequence combines traditional techniques of frame-by-frame drawn animation (for the figures and birds) with a computer model of the church. To better resemble the sketchy line quality of the original drawings, the computer model was not lit and its detailed wire-frame geometry was traced and treated so as to appear hand-drawn.

Cosgrove Hall Films Ltd

II.37

Vitruvian man

Panels from a storyboard (that is, a stage-by-stage plan mapping out a proposed animated sequence), bringing together several of Leonardo's drawings that deal with divine proportion within the human body, and its motion. The Vitruvian man (see II.30) is sketched in place, rising from a kneeling position to define first the square and then the circle, before finally reaching his iconic stance. *Cosgrove Hall Films Ltd*

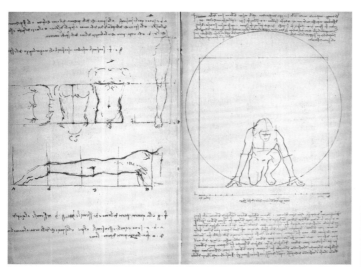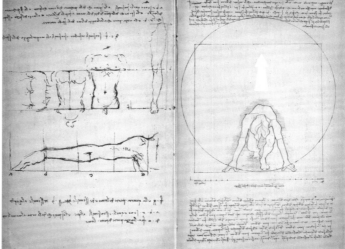

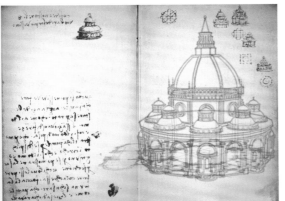

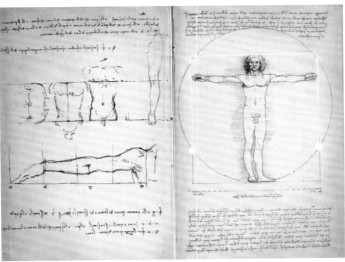
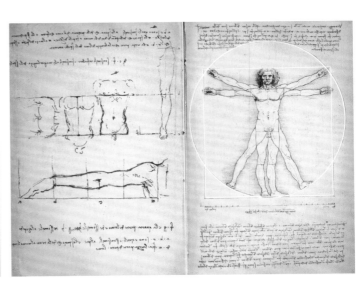

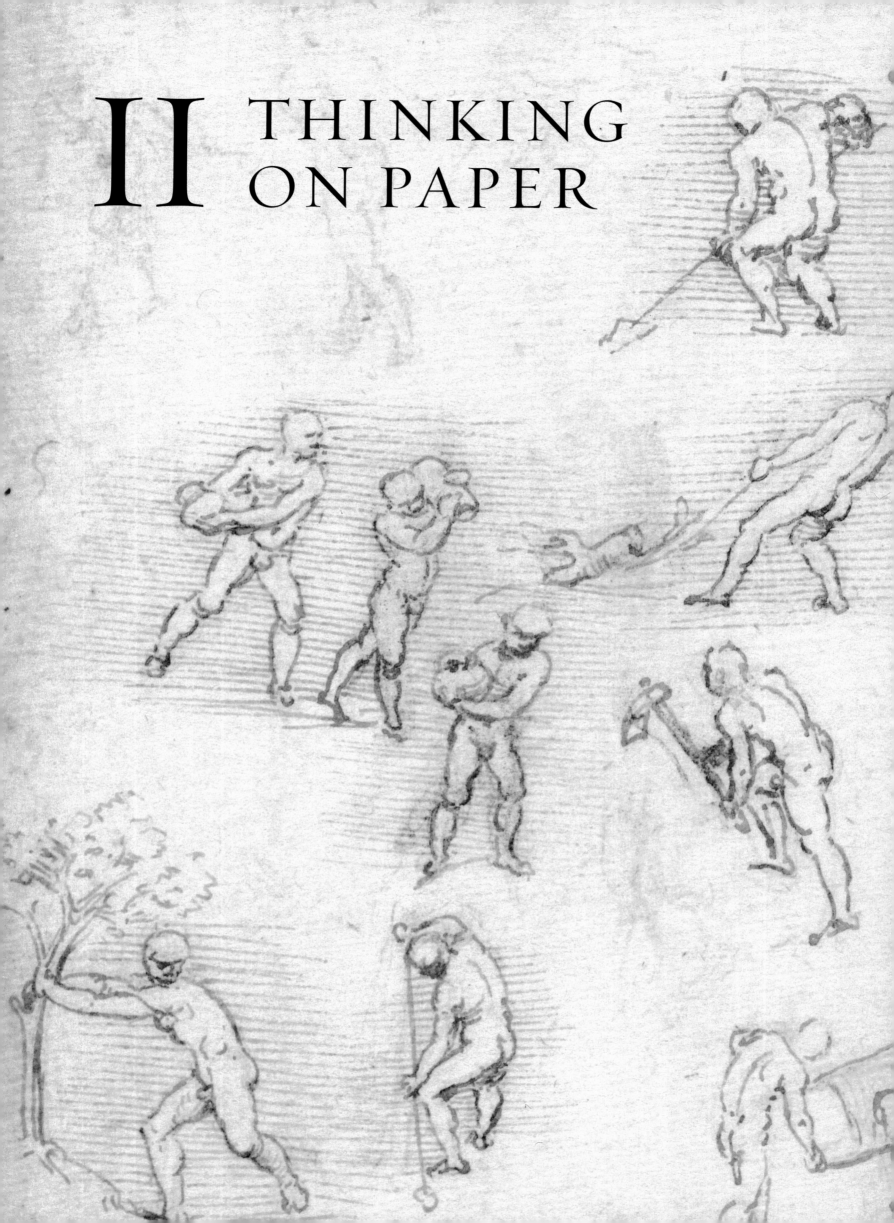

II THINKING ON PAPER

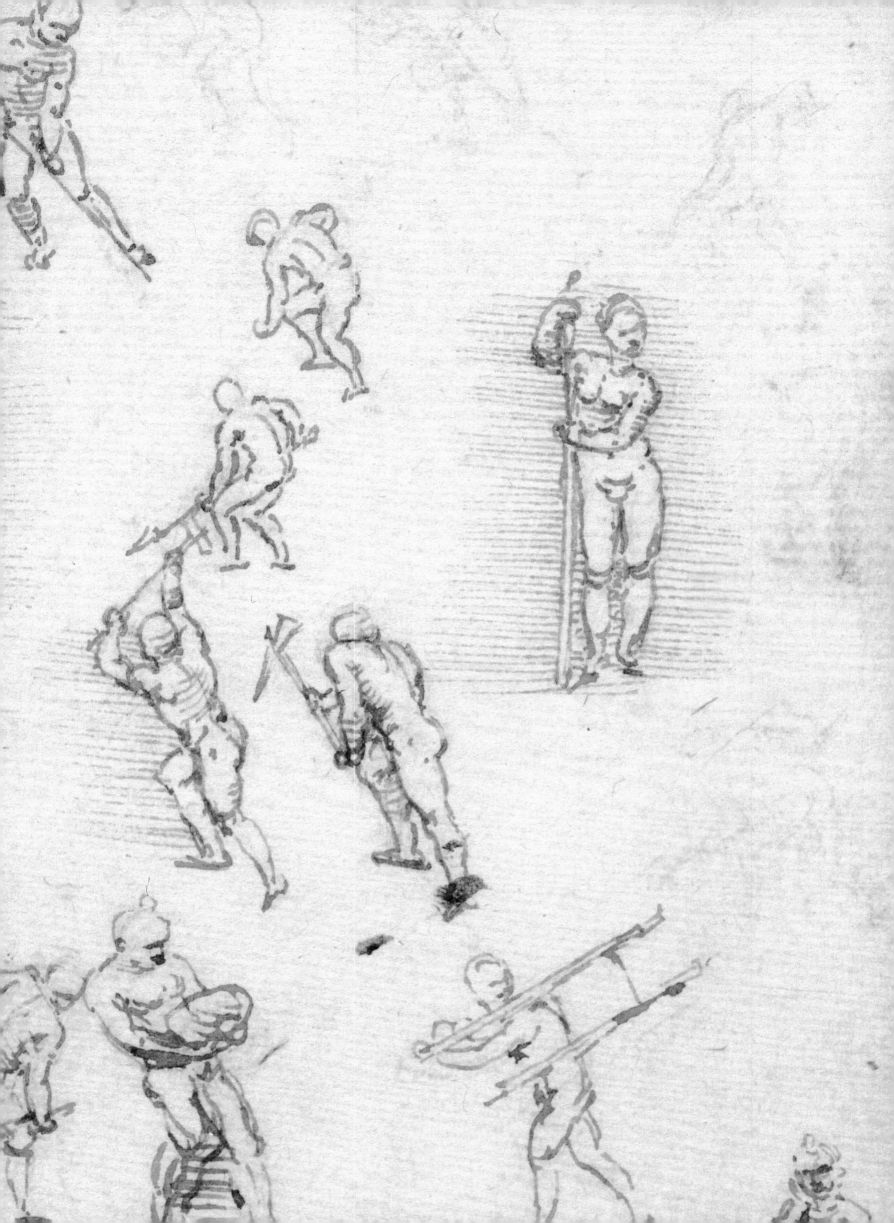

An Excursus on *Disegno*

Leonardo's word for drawing was common to all draughtsmen of the Renaissance. *Disegno* is alternatively translated as 'drawing' or 'design'. In our modern usages, we tend to use 'design' for engineering and the applied arts, while in a fine-art context 'drawing' is likely to be the favoured alternative. Inevitably, in the present context, we speak of Leonardo's 'drawings', although our term 'drawing' is at once too narrow and too imprecise. For Leonardo and his colleagues, *disegno* was the fundamental discipline of draughtsmanship that signalled a mastery of design in its principles and practice. It was based upon the due measure of things according to their form, number, proportion, motion and harmonious composition.

Disegno was the supreme tool that serves the eye, and when Leonardo praised the eye, he was essentially making claims about the ultimate reach of *disegno* as a tool of investigation and exposition:

> Do you not see that the eye embraces the beauty of the world. The eye is the commander of astronomy; it makes cosmography; it guides and rectifies all the human arts; it conducts man to the various regions of the world; it is the prince of mathematics; its sciences are most certain; it has measured the height and the size of the stars; it has disclosed the elements and their distribution; it has made its predictions of future events by means of the course of the stars; it has generated architecture, perspective and divine painting ... And it triumphs over nature, in that the constituent parts of nature are finite, but the works that the eye commands of hands are infinite. [Urb 15v–16r]

In terms of *disegno*, this means: diagrams of the celestial system; the theory and practice of the system of proportions that governs all artistic beauty; the drafting of scaled maps; the visual demonstration of the truths of geometry, both in themselves and as manifested in the sciences of nature; the analysis of dynamics and statics in the behaviour of earth, water, air and fire; the design of buildings using plans, elevations, sections and perspectives; and the 'divine' science of painting with its 'roots in nature'. And he adds, for good measure, that the painter can invent endless compounds from the constituent parts of nature.

His exceptionally expansive vision of the scope of *disegno* should be borne in mind whenever we talk of Leonardo's 'drawings'.

III FORM AND SPACE

EONARDO WAS TRAINED as a sculptor and wished to be considered as such. After detailing the categories of military and civil engineering in which he excelled, in his letter of self-recommendation to Ludovico Sforza, he reminded the Duke that: 'also I can execute sculpture in marble, bronze and clay. Likewise in painting, I can do everything possible as well as any other, whosoever he may be' (CA 1082r). He clearly possessed extraordinary, innate potentials of plastic and spatial visualization, but his apprenticeship in a studio primarily famed for sculpture was highly significant in laying down the tools to realize these potentials. His feeling for the nature of any given three-dimensional form – its solid mass, the manipulations to which it can be subject, the negative shape that surrounds it (its 'mould'), the ways in which it can be sectioned, dismembered and rendered transparent, the manner in which it can be represented from various viewpoints, how it behaves at rest and in motion, and its graphic reduction to plan and elevation – was as strongly developed in him as has ever been the case throughout history. Whenever he drew anything on paper, he was reaching out graphically for its plastic essence.

No one was ever more inventive at devising the graphic means to accomplish visual thinking than Leonardo, and no one was more skilled at inventing presentational methods to let the spectator see what he was thinking. Even the most routine diagram assumes a special kind of life at the touch of his pen. Many of the graphic means that are now taken for granted in science and technology made their first appearance in his manuscripts. And when he adopted a stock technique, it always looked different in his hands. In exploring how he manipulated form and space on paper, I will begin with the most apparently conventional, flat line diagrams and work through to the highly complex systems he devised for the human body.

Mathematics and the Music of Proportion

The drawing of flat diagrams was the stock-in-trade of any geometer. Manuscripts and books of Euclid's *Elements*, the classic point of reference, were illustrated with figures of the kind that still adorn school textbooks. The great Archimedes, according to legend, was butchered by invading Roman soldiers while distractedly drawing diagrams in the sand. The vast majority of geometrical drawings over the ages must have been of this transitory type, drawn and rubbed out or otherwise discarded. Geometers must have undertaken 'experimental' drawings when they were working through a problem or searching for a theorem. Precisely what these drawings looked like, we do not know. Saying confidently that Leonardo's flat geometrical drawings are novel is therefore impossible, but they do have a character that seems highly individual.

The geometry on the 'Theme Sheet' (INTRO.1) is drawn more precisely than the majority of his diagrams, many of which are freehand or combine ruled and compass-drawn elements with freehand improvisations. We do, however, need to take into account that there is 'invisible' geometry on a surprising number of sheets, drawn with a blank stylus that creates incised lines visible only in raking light. Such

PLATE III.2
**Determining the areas of figures
with straight and curved sides**
1509
Pen and ink
29 × 20.9 cm
Windsor Castle, The Royal
Collection, 19145r

III.1

lines are not restricted to pages containing geometrical figures or technical drawings. A number of sheets, as yet unquantified and largely unresearched, contain incised geometrical designs that are unrelated to the ink or chalk drawings added later. Comments on some typical examples are included in the 'note on incised lines' in the final section of the book (see p. 191).

Even on the 'Theme Sheet', the diagrams have an improvised quality, beginning with some formal moves of a standard kind, only to be overtaken by a series of speculative lines that not only express what Leonardo is thinking, but also suggest new conjunctions in their own right. There is a sense of freewheeling search, undertaken with a speed and density that often make it very difficult in retrospect to tease out what he is doing. When something significant seems to be emerging – above all in his search for equivalences of rectilinear and curvilinear areas – he adds some quick hatching lines, so that the designated areas are endowed with an especially emphatic status. Occasionally lines are drawn as a row of dots, when he wants them to play a role in the construction, but wishes to leave them differentiated from the main lines of the figure. He uses letters to denote points, line ends, vertices and areas in a standard way, but very sparingly. It is only when he has reached a point of some resolution that he adds a full suite of letters and an accompanying note, taking us through the sequence of moves in the demonstration or proof. Not infrequently a diagram was lettered, but the interpretative note was never added.

In many of his later pages Leonardo focused heavily on the squaring of a circle or on techniques that might eventually lead towards a solution. The problem was to define a square exactly equal to that of a given circle. It had become a classic problem, in much the same way as Pierre de Fermat's last theorem later continued to bother mathematicians for centuries. Leonardo knew that Archimedes, whom he increasingly came to revere, was deeply involved in this and related questions of areas and volumes. The problem of squaring the circle was to be reshaped in the eighteenth century by Johann Lambert's demonstration of the irrationality of π, which can only be approximated in numbers. Leonardo covered sheets with urgent little diagrams in the quest, or in the subsidiary quest to find rectilinear equivalents to figures that possessed at least one curved side (III.2 and III.3). Various methods were tried, ultimately in vain.

If the circle could be reduced to a polygon, by the subtracting of slices from its circumference (III.1), then the area of the polygon could be calculated without too much difficulty. Leonardo's sketch of what he called the 'Quadrature of Archimedes' is accompanied by a note claiming that 'Archimedes gave the quadrature [squaring] of a straight-sided figure but not of the circle. Hence Archimedes never squared any figure with curved sides; and I have squared the circle minus the smallest portion that the intellect can imagine, that is to say a visible point.'

The basis of Leonardo's claim is unclear. He seems to be referring to something more that the traditional method of 'exhaustion', in which a polygon is drawn with a huge number of sides, so that the curved portions 'sliced' off around the circumference would be of negligible area. This method leads to an infinitely perfectible approximation. It may be that he was referring to his 'mechanical' solution, which involved the 'unrolling' of a segmented circle like an orange folded back on its peel. These rather tangible and plastic procedures appealed greatly to him, but they all involved some measure of mathematical approximation.

It is utterly characteristic that three-dimensional shaping creeps in even when he is ostensibly dealing with flat geometry. The circles all have an inherent tendency to sphericity, and in the lower centre an overt sphere

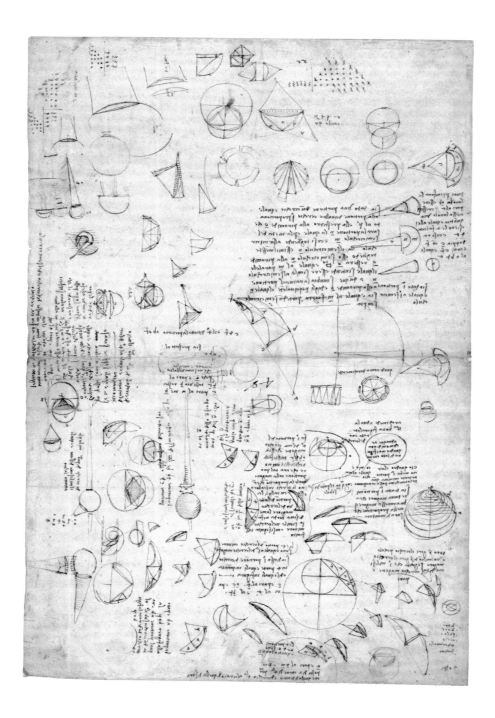

appears, associated with some kind of tapering cylinder. We feel that stereometric problems – that is to say, those concerned with the geometry of volumes and their three-dimensional relationships – are never far away.

Leonardo's approach to the problems of squaring the circle, cubing a sphere and the optics of reflections in curved mirrors involved cognate procedures.

Above the row of geometrical studies, he works a variation on a recurrent refrain. A rhetorical question of great moment appears at regular intervals in his manuscripts. He asks, 'Tell me if anything was ever done?' Often occurring in abbreviated form, this is a recurrent verbal doodle, but it breathes an undeniable air of frustration. Here it reads, 'Tell me if anything similar was ever done?' This variant inverts what seems to be the normal pessimism of the tag,

and suggests that Leonardo hoped he really was breaking new ground with his kind of geometry.

At one juncture he was confident that he had 'completed' the squaring of the circle. In the Codex Madrid I he noted: 'On the night of St Andrew [30 November] I reached the end of squaring the circle; and at the end of the light of the candle, of the night and of the paper on which I was writing, it was completed.' His confidence was misplaced. Or perhaps he just meant that he had gone as far as he could and was calling it a day (or night).

A few years later he announced that he had solved a problem that would potentially release the solution to the squaring of the circle (III.2): 'Having for a long time searched to square the angle of two equal curves ... now in the year 1509 on the eve of the Calends of May [30 April]

III.4
The 'golden section'

III.5
Portrait of a Musician
c.1485
Milan, Biblioteca Ambrosiana

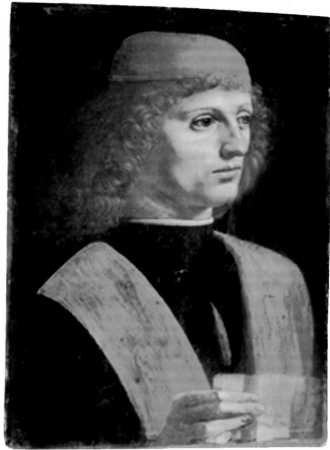

III.5

I have found the solution at the 22nd hour on Sunday.'
The 'solution' is fair enough on its own terms, but does not
help to square the circle. We are presented with the nice
picture of Leonardo working late in the evenings and into
the night by the dim light of a candle, scribbling geometrical
diagrams on sheaves of paper. It is not known whether the
cold light of the next morning immediately doused his
hopes or whether he came to a slower realization that the
squaring of the circle remained elusive. In any event, he
continued to nag at the question in subsequent years.

It is revealing that he wrote down dated records of his
solutions to geometrical problems – something he did on
four occasions – whereas his notebooks contain no dated
references to his paintings or notable successes in other
areas of his activities. Geometry clearly had a special status
for Leonardo, not least in potentially ensuring his place in
posterity alongside Euclid and Archimedes.

The relationship between geometrical areas that triggered
his memoranda belonged to his all-embracing quest to
master the principles of proportion that governed the form
and functioning of all things in the visible and invisible
world. Given his reverence for proportions that could
only be expressed geometrically, such as $\sqrt{2}$ (the diagonal
of a square 1×1) and the 'golden section' – the division
of a line ab at c such that $ab{:}cb = cb{:}ac$ (III.4) – it is perhaps
surprising that he did not corral the squaring of the circle
into the territory of the unquantifiable.

III.4

Leonardo may have been drawn less instinctively to
proportion expressed in numbers, but arithmetical ratios
remained of considerable importance in his theory and
practice. Numerical proportions had been seen as the key to
visual beauty in classical antiquity, as Renaissance theorists
well knew, and the theory of musical harmonics laid down
by Pythagoras continued to provide the bedrock for
musicians, as we have noted (see p.24). Leonardo had great
respect for the *scientia* of music, even if the musician's art
ultimately took second place to painting:

Music is not to be regarded as other than the sister of
painting, in as much as she is dependent on hearing,
second sense behind that of sight. She composes
harmony from the conjunction of her proportional
parts, which make their effect simultaneously, being
constrained to arise and die in one or more harmonic
intervals. These intervals may be said to circumscribe
the proportionality of the component parts of which
such harmony is composed – no differently from the
linear contours of the limbs from which human beauty
is composed. [Urb 16r–v]

His engagement with music and musicians was anything
but casual. He was noted as a performer and a designer
of instruments. As we have seen, he was a colleague of
Franchino Gaffurio, and a collaborator with composers,
instrumentalists and singers on court spectacles. His
Portrait of a Musician in the Biblioteca Ambrosiana in Milan
(III.5) provides an eloquent testimony to this engagement.
There are also fragmentary staves of music in his manuscripts
and, although these have been recorded, they would on
their own do little more than testify that Leonardo knew
musical notation.

His linkage between musical proportion and the visual
arts was not limited to surface proportions. Characteristically
he extended the analogy into visual relations in space:

I shall ... found my rule on a scale of 20 for 20 *braccia*, just as the musician has done for notes. Although the notes are united and attached to each other, he has nonetheless recognized small intervals between note and note, designating them as first, second, fourth and fifth, and in this manner from interval to interval has given names to the varieties of raised and lowered notes. [Urb 17r]

What he means, in a passage that is not one of his clearest, is that the perspectival diminution of objects in front of the eye – even though they 'touch each other as if hand in hand' – can be seen to obey a rule of ratios like that of music; that is to say, the rules of perspective dictate that the apparent size of an object on a picture plane is inversely proportional to its distance from the eye. It seems that in the *Last Supper* (INTRO.4) Leonardo contrived to accord the width of the tapestries, as measured on the plane of the wall, the ratio $1:\frac{1}{2}:\frac{1}{3}:\frac{1}{4}$. In whole numbers the ratio is 12:6:4:3, and we can recognize 3:4 as the musical interval of a fourth, 4:6 as a fifth, and 6:12 as an octave. To achieve this result, the tapestries in 'real life' would have to be of different actual widths.

Some of the puzzling suites of numbers that make apparently random appearances across his pages of drawings and notes do not appear to concern addition, subtraction, multiplication or division (even allowing for his carelessness with arithmetical procedures), but are best recognized as thoughts about harmonic series. Not infrequently they appear on sheets concerned with geometry, indicating a recurrent dialogue between the two kinds of proportional system (e.g. W 12642r).

Testimony to the trouble he took to master the most advanced theories of numerical proportions, well beyond those required by music, is provided by the number square in the Codex Arundel (III.6), which was carefully transcribed from the *Summa de arithmetica, geometria, proportione et proportionalità* published in 1494 by Luca Pacioli, who was his friend and colleague in Milan in the later years of the fifteenth century and seems to have helped Leonardo with lodgings when they settled in Florence after the fall of their patron, Ludovico Sforza. Leonardo notes that he bought

the printed version of his friend's mathematical reference book for 119 *soldi* (CA 104ra; 288r). Having laid out and filled in the table, he begins to note the names assigned to the various multiples – double, triple, quadruple, quintuple – but stops at four of them, presumably because it is too graphically complicated to continue. 'Tell me if ever a thing was done,' he writes under the diagram, again expressing frustration about the perpetual gap between ambition and achievement. On the other side of the sheet he reverts to a more conventional listing of proportions. He also transcribes the square in Codex Madrid II, starting this time to name the proportions down the left-hand side, but again does not succeed in getting beyond number five. Elsewhere in the same codex (78r) he redrew another of Pacioli's illustrations, a schematic tree of 'proportions and proportionality'. Characteristically Leonardo gave his friend's rectilinear layout an organic twist by setting the numbers in round 'fruits' at the junctures of curvaceous branches.

The expression of such proportionality in the visual arts was, as we have seen, implicit in perspective and apparent size, and was also explicit in the proportional systems he sought in the bodies of humans and horses. Verrocchio, his master, had sought to codify horse proportions, presumably during his preparations for the grand bronze monument of Bartolommeo Colleoni (see p.63). Leonardo would also have been aware of attempts to determine the proportional design of the human body, including Alberti's short treatise *De statua*, which expounds an instrument for the taking of the necessary measurements from actual bodies. He keenly followed Verrocchio's lead when he began to tackle the design of a huge equestrian memorial to Francesco Sforza, Ludovico's deceased father. A number of drawings testify to his visits to Milanese stables in order to take precise measurements (III.7). Again, a nice picture emerges of Leonardo in action – this time attempting patiently to get the measure of the thoroughbred horses in the stables of Ludovico, his nobles and his military commanders. The patience of the horses is unlikely to have matched that of their measurer. That Leonardo needed a lot of detail is not in doubt. He breaks down the measurements into *gradi* ($\frac{1}{16}$ of a head), *minuti* ($\frac{1}{16}$ of a *grado*) and *minimi* ($\frac{1}{16}$ of a *minuto*).

PLATE III.6
**Square of multiples and
other studies**
c. 1496
Pen and ink
20.5 × 16 cm
London, British Library,
Codex Arundel, 153r

III.7
**Proportional measurement
of a horse**
c.1490
Windsor Castle, The Royal
Collection, 12319

The search for human proportions occupied him more or less throughout his career. Even his late studies of the heart valves may be seen as feeding his conviction that every aspect of the body was subject to proportional rule. His search embraced the overall geometry of human design, signalled in his reworking of Vitruvius's formula that a man with outstretched arms and legs can be inscribed in a circle and square (II.30). It also dealt arithmetically with the minutiae of the smallest components, such as the toes and fingers. At first sight, the drawing of the Vitruvian man in Venice seems to be concerned with relatively simple proportional relationships between the head, the body and the limbs, but the main vertical axis is pockmarked with compass points, particularly densely in the man's face. It seems that, in order to establish 'the proportionality of the component parts … from which human beauty is composed', Leonardo was dedicated to pushing his measurements down to the smallest practical scale. A set of related drawings at Windsor from around 1490 (III.9 and III.10)

suggests that he was planning a systematic excursus on the subject, either as a free-standing treatise or as part of his planned book 'On the Human Figure'. Other of his proportional studies bear witness to his conviction that the drawings he made around 1490 had far from exhausted the problem, either in detail or in mode of analysis.

The minuteness and intricacy of his efforts to define human proportion may well have drawn inspiration from Vitruvius's systematic account of the proportional rules that govern every component in a classical building. Leonardo followed Vitruvius's account of the proper geometrical and arithmetical relationships in a column base with close attention (III.8). For him, the human face should be treated with no less scrupulous attention than a column base.

No one had previously sought to define the complex and interlocked internal harmonics of the body in such detail. He was striving to show how the dimension of one small part finds continual resonances either separately or in

PLATE III.8
**Names and proportions of
a column base**
C. 1493
Pen and ink
Opening of 2 pages,
each 9.2 × 6.4 cm
London, Victoria and Albert
Museum, Codex Forster III,
44v–45r

PLATE III.9
Proportions of a man's torso and legs
c. 1488
Pen and ink
14.7 × 21.7 cm
Windsor Castle, The Royal
Collection, 19130v

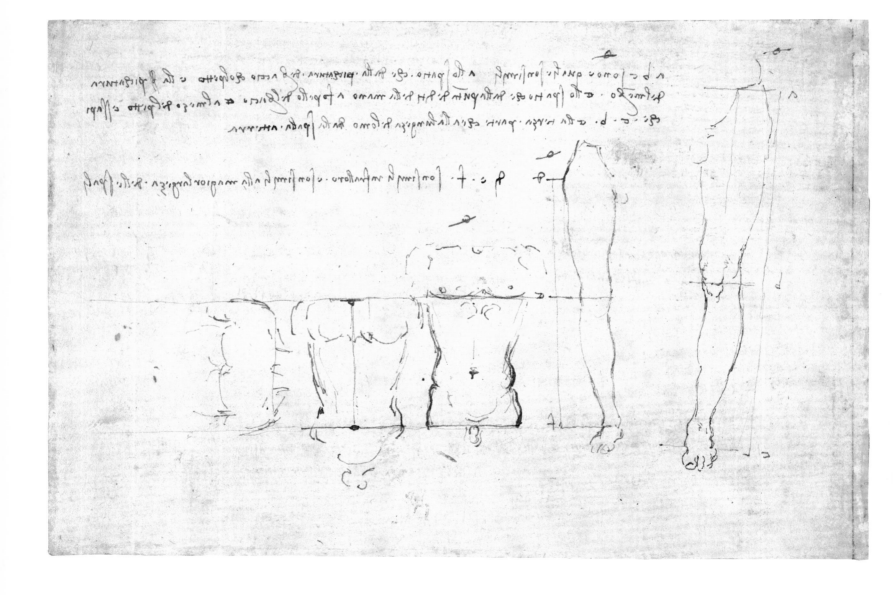

PLATE III.10
Proportions of a man's arm
c. 1488
Pen and ink
12.5 × 20.7 cm
Windsor Castle, The Royal
Collection, 19131r

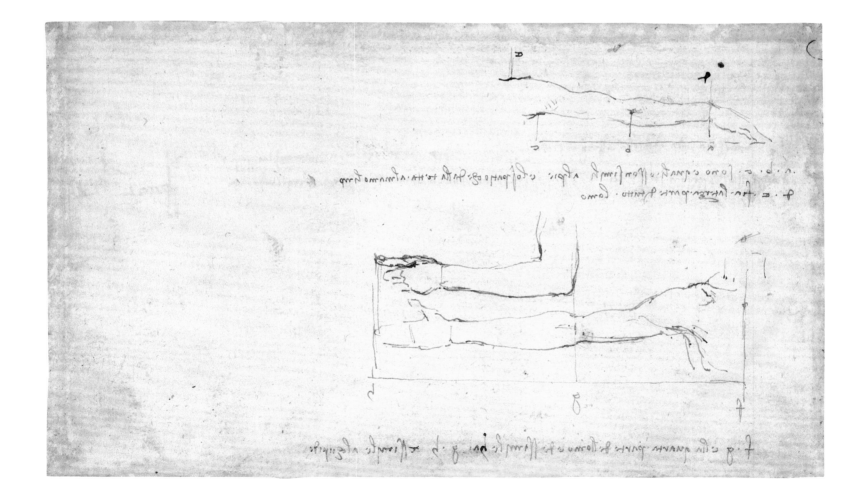

PLATE III.11
**Studies of men climbing stairs
and a running man stopping**
c. 1508
Pen and ink
19 × 13.3 cm
Windsor Castle, The Royal
Collection, 19038v

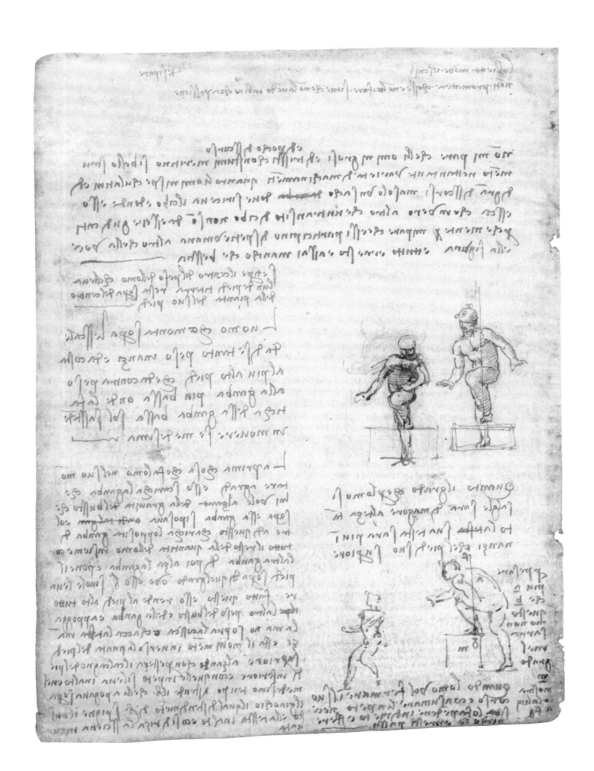

multiples throughout the members of the body – in a kind of intricate visual polyphony in which harmony arises 'from the conjunction of ... proportional parts, which make their effect simultaneously'. His other variation of the tradition of human proportions was not so much an extension of tradition as a departure. Concerned as he was with the body as a mobile, dynamic whole, Leonardo realized that static proportions were not the entire story. What happens when someone sits down, or bends their arm? He could not entertain the idea that proportionality would be lost. Rather, the relationships would change. A number of drawings in the Windsor series tackle exactly this problem, seeking the proportions of the reconfigured body in its whole and in its parts (III.9 and III.10). We can therefore think of watching a body in motion as a kind of musical composition in space and time. The man stepping upwards along the time-line of his axis of gravity can be seen in this light (III.11), as can the hammering man (IV.43), even if in the latter case the music is more Stravinsky than Josquin des Prez.

As in other areas of his activity, there is a complex reciprocation between empirical observation and thinking on paper. Indeed, since no individual can be trusted to provide an ideal exemplar, the quest is ultimately driven by its premises, both in its overall assumptions and in the ratios that are sought and constructed. Often the drawings themselves appear to be investigatory 'experiments', in which new ratios and conjunctions arise during the course of the drafting procedure. I have suggested that detailed measurements were taken *from* the drawing of the *Vitruvian Man* – that is to say, from the paper man, not from nature. The deduced ratios must, in theory at least, always be confirmed in nature by 'experience', but none of his drawings of human proportions (unlike those of his horses) records actual linear measures taken from specific men. There may be lost sheets recording detailed measurements from actual bodies, but their absence in surviving manuscripts seems symptomatic of the main thrust of his research. I suspect that it was predominantly paper-based, with just enough checking to retain its legitimate 'roots in nature'.

From Line to Form

The plastic impulse we have sensed at work in his flat geometry, either in its abstract form or as applied to proportions in nature, was given full rein when Leonardo moved into the realm of solid geometry. His *pièce de résistance* came in the set of drawings he provided for Luca Pacioli's *De divina proportione*, known in two manuscript versions, the better of which is dated 1498, and in the book published with woodcut illustrations in 1509. As such, the woodcuts are the only illustrations by Leonardo published in his own lifetime. Pacioli's treatise, heavily dependent on Piero della Francesca's *De cinque corporibus regularibus*, expounds the basic geometry of the five regular or 'Platonic' solids, and the role of the 'divine proportion' (the 'golden section') in their construction. The five bodies – the tetrahedron (four triangular faces), cube (six squares), octahedron (eight triangles), dodecahedron (12 pentagons) and icosahedron (20 triangles) – are the only solids that are composed of identical faces and wholly symmetrical around their vertices. They had long been regarded as having a special status in revealing the divine perfection underlying the universe. Indeed, as Leonardo and Pacioli knew, Plato had identified four of them with the elements (cube = earth, icosahedron = water, octahedron = air, tetrahedron = fire), with the dodecahedron seen as the quintessence of the universe as a whole. The close collaboration between the two colleagues at Ludovico's court is reflected in the fulsome compliments that the mathematician paid to Leonardo's wide-ranging expertise and 'ineffable left hand'. For his part, Leonardo repeatedly paid direct and indirect homage to the inspiration provided by Pacioli. A nice example is his transcribing of a little verse that Pacioli included in his treatise:

> The sweet fruit, so attractive and refined,
> Has already drawn the philosophers to seek
> Our cause, in order to nourish the mind.
> [M 80v]

Pacioli extended his treatment of the five basic solids into their truncation and stellation. He demonstrated how the symmetrical truncation of the bodies at their vertices (that

Dodecaedron Apotetmimenon Epirmenon Cenon

Dodecaedron Abscisum Eleuatum Vacuum

PLATE III.12
**Truncated and stellated
dodecahedron**
from Luca Pacioli, **De divina
proportione**, Florence, Paganus
Paganius, 1509
(original drawing 1498)
Woodcut
28.7 × 20.4 cm
London, Victoria and Albert
Museum, National Art Library,
87.B.30

III.13
**Lamps with revolving fountains (?)
and geometry**
PLATE IV.24 (detail)

is to say, progressively slicing off their corners) can result in semi-regular or 'Archimedean' solids. The basic and semi-regular forms are then stellated (that is to say, pyramids are erected on their faces). What Leonardo provided for Pacioli were brilliant graphic devices for letting the spectator grasp 'in a single glance' how the forms are constructed. He produced beautiful shaded images of the solids as if they are material bodies suspended in space under directional illumination, and, in a stroke of graphic genius, also displayed them in a skeletal or '*vacuus*' guise (III.12), with each visible face shown as if it is a window frame through which the shape of the whole body could be perceived. Again, Leonardo has found the way to achieve the 'aha' effect, when the spectator is suddenly able to 'see' something that has been difficult to grasp using conventional techniques of representation. All that is missing, to complete the vivid visual demonstration, is the rotation of the solids – something we can now accomplish with computer graphics.

Leonardo, unsurprisingly, did not stop with what Pacioli had achieved, and continued to explore problems of stereometry (the geometry of volumes) in an Archimedean vein. In Codex Forster I (III.14) he considers a series of stereometric problems on irregular and regular bodies. At the top of the right page he draws a transparent and semi-shaded dodecahedron. He wishes to find a cube or rectangular figure equivalent in volume to the dodecahedron. He begins by extracting one pentagonal face with an extended pyramid from the solid. This pentagonal pyramid is then itself sectioned into pyramids with triangular bases, and one of the resulting wedges is transformed into a triangular slice with a rectangular base. Finally this slice is transformed into a rectangular body or cube, the area of which is readily determined.

In the Codex Arundel (III.15) a related set of stereometric problems is tackled with notable plastic fluency. The pyramids, looking uncannily like steeples on towers, are transmuted and turned in space as Leonardo seeks to get the measure of their volumes. What he is attempting to do, here as elsewhere, is to create figures of equivalent volumes, often on the same bases. Once he has projected a cube or box-shaped body equivalent in volume to the original object, the volume of both can readily be calculated.

Once again, geometry becomes a kind of plastic manipulation akin to sculpture.

On another of the Arundel sheets (III.13), he takes the famous formula of Pythagoras – 'the square of the hypotenuse of a right-angled triangle is equal to the sum of the squares of the two opposite sides' – into the third dimension. Rather than squares on the sides of a flat triangle, Leonardo builds cubes on the sides of a triangular box or prism. The ratio of the sides of the triangle is 3:4:5, the cubes of which are 27, 64 and 125. However, the sum of the cubes of the shorter sides is 91, not 125, a difference of 34, as he notes in calculations below the diagram (IV.24). It is unclear how he derived the figure of 100, which he assigns to the largest of the cubes. In any event, he discovered that Pythagoras's theorem could not be automatically extrapolated to the cubes on the sides of a prism. The problem is that the sides will not be squares with side lengths in the ratio 3:4:5, since the length of the sides perpendicular to the triangle sides will be the same.

The rendering of three-dimensional forms on flat surfaces, giving reality to his powers of plastic visualization,

III.13

PLATE III.14
**Determining the volume of
regular and irregular solids**
c. 1505
Pen and ink
Opening of 2 pages,
each 13.8 × 10.4 cm
London, Victoria and Albert
Museum, Codex Forster I, 6v–7r

112

PLATE III.15
**Determining the volume of
pyramidal and rectangular solids**
c. 1505
Pen and ink
21.8 × 14.7 cm
London, British Library,
Codex Arundel, 182v

PLATE III.16
Bust of a warrior in profile
c. 1478
Metalpoint on cream prepared
paper, with some white
heightening, partially oxidized
28.5 × 20.7 cm
London, British Museum,
inv. no. 1895-9-15-474

was an emphatic goal in his techniques of drawing and painting. He continually stressed the need to convey *relievo* (relief or plasticity). In drawing, this meant exploring ever more effective ways to extend the paradoxical ability of line on a flat surface to describe form and space in three dimensions. He knew intellectually that nothing was bounded by actual outlines, but line was the necessary vehicle of drawing and he worked tirelessly to make it plunge into depth and push forward from the surface of the paper. From the first, Leonardo demonstrated an ability to do this even in cursory sketches, setting up a few suggestive clues to denote perspective and foreshortening, and exploiting pen strokes of varied pressure to 'sculpt' the forms. The plastic effect could then be enhanced by hatched shading or, more rarely, with the addition of a translucent wash of ink applied with the brush.

Until the late 1490s his favoured technique of hatching in pen, metalpoint and chalk consisted of parallel strokes running from top left to bottom right (the natural direction for a left-hander), often graded with extraordinary subtlety to convey the passage of light across complex forms. The metalpoint drawing of the *Profile of a Warrior* (III.16) is a virtuoso demonstration of what can be achieved with outlines of curvaceous plasticity and parallel hatching of an almost unbelievable delicacy. It was indeed a demonstration-piece. We know that it was based on a relief sculpture that Verrocchio had provided for the Hungarian king, Matthias Corvinus, and we can sense Leonardo taking on the challenge to create *relievo* in the absence of any actual relief. It is as if he is precociously rehearsing the arguments in his '*Paragone*', the extended comparison of the arts that he was to compose in Milan more than 10 years later:

> The major cause of wonder that arises in painting is something detached from the wall or other flat surface, deceiving subtle judgements with this effect, as it is not separated from the surface of the wall. In this respect the sculptor makes his works so that they appear what they are … [whereas painting involves a] subtle investigation that concerns the true quality and quantity of light and shade, which nature produces by herself in the works of the sculptor.

It is more virtuous to remake the effect through knowledge and technique than simply to take advantage of the fact that it happens.

Parallel hatching served Leonardo well for some 25 years or more. However, in the late 1490s he discovered another method, probably having seen woodcuts by the great German artist, Albrecht Dürer. The first signs of the new hatching – in which the strokes of the pen curve or hook around the shaded parts of the form, as if embracing it – occur in his mechanical drawings from around 1500 (III.17). The technique of short hooked strokes is particularly useful when shading thin forms, such as rods and axles. After 1500 we see curved hatching gradually insinuating itself into other areas of his draughtsmanship. It did not suppress his parallel hatching, which remained especially effective for the shading of backgrounds, but was used more and more frequently when he wanted forms to look truly rounded. The rows of curved lines increasingly encircle the form like a kind of graphic corset, tracking its convexity and tending to trespass even into the lit portions. This hatching acts as a kind of 'descriptive geometry' on the surface of convex features. Particularly potent examples occur in Leonardo's later anatomical studies, such as his powerful drawing of the tongue in isolation (IV.15) and the compelling representations of the heart (I.32). The rotund water vessels in the Codex Leicester are shaded in this way (II.20 and III.23). The curved hatching conveys a strong sense of a united mental, perceptual and physical moulding of form, as it is virtually sculpted on and into the surface of the paper. We can vividly feel the plastic impulse of his visualization transmitting itself into the physical reality of the motion of the pen in his hand.

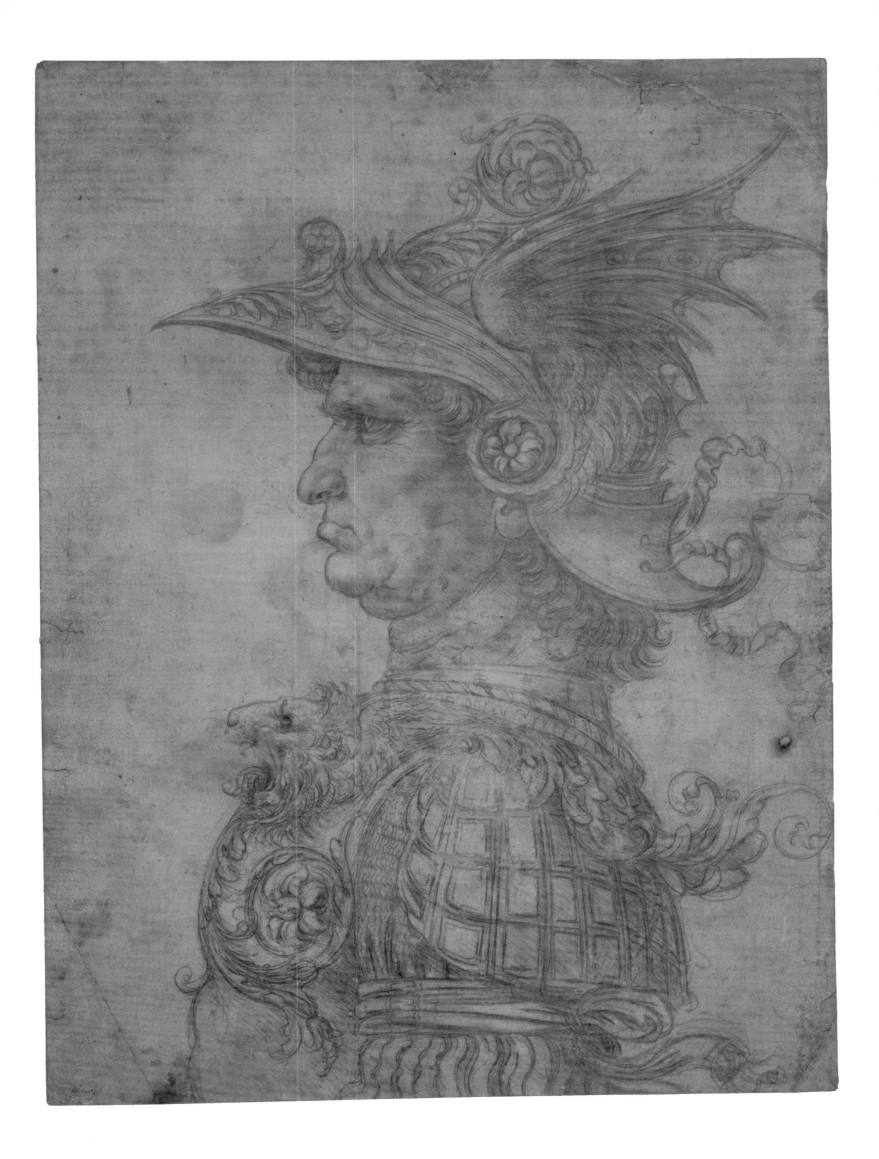

III.17
**Spiral gear attached to
a barrel spring**
c.1499
Madrid, Biblioteca Nacional, I 45r

'Theory Machines'

Leonardo continually emphasized 'experience' as the true source of verifiable knowledge. However, we have already noted that we should not equate 'experience' with the 'experiment' in its modern scientific usage. For Leonardo, 'experience' denoted contact with something real, tangible and visible. Formal experimentation was just one aspect of this. It is clear that his setting down things on paper was not merely a process of representation, but also acted as a form of 'experience', in as much as something could be constructed and subjected to a form of visual testing. The testing of the validity of drawn forms and functions occurred both during the course of the act of drawing and in its subsequent scrutiny. The scrutiny could result in acceptance, modification or outright rejection.

When he drew a highly finished and complex mechanical component, like the beautiful spiral gear in Codex Madrid I (III.17), which must have been preceded by preliminary sketches, the developed demonstration of the device in its whole and in one of its component parts constitutes a kind of 'proof' of how it operates. Leonardo invites us to see, as he clearly could himself, how the conical pinion climbs the track that is configured like a helter-skelter, while its axis slides freely up and down, courtesy of cylindrical sleeves around the two vertical shafts. However, whether our powers of visualization quite match his may be open to doubt!

But, you may be thinking, why is this not a drawing of an actual device rather than a speculative design? The answer is almost certainly that it does not represent an existing gear, since when it was actually constructed a few years ago, quite a number of detailed adjustments were needed for it operate smoothly. The spiral gear, like so many of his inventions, is what might be called a 'theory machine'. It was specifically constructed by reference to a theory of the operation of forces – almost inevitably, the theory of the pyramidal law. The 'tempered spring' that Leonardo labels as being inside the main barrel will lose its power as it winds down, and the progressive loss obeys the pyramidal law. In order to compensate for this diminution, the form of the gear is an expression in reverse of the

diminishing pyramid and is designed to equalize the power delivered by the spring across the whole of its travel.

One of the problems with Leonardo's drawings of machines – like his drawing of dragons – is that he can visualize them so completely and draw them so brilliantly that we cannot readily tell if we are looking at a compelling visualization or an actual object. The neat device used in the Codex Leicester (III.19) to illustrate the progressive increase in water pressure – '*potentia*' – at successive depths in a vessel is a case in point. It shows a rectangular tank, one short side of which consists of a series of horizontal slats held in place by ropes attached to rods at the end of each slat and running over pulleys. The weights at the end

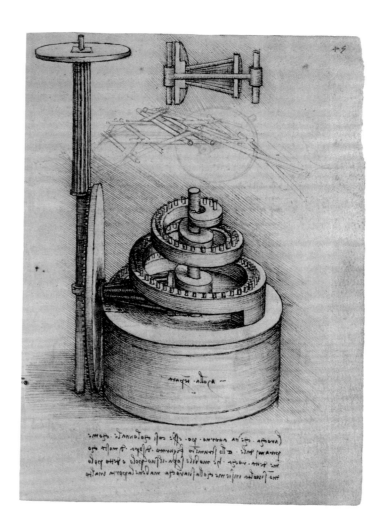

III.18
Studies of water spouts,
based on Codex Leicester 14A (23v)
Technical Art Services

III.19
**Studies of a device to
demonstrate water pressure**
c.1508–9
Seattle, Bill and Melinda
Gates Collection,
Codex Leicester 6A (6r)

III.20
Configurations of ripples
c.1508–9
Seattle, Bill and Melinda
Gates Collection,
Codex Leicester 14B (14v)

III.18

III.19

III.20

of the ropes would need to be increased in the ratio
1:2:3:4:5:6 in order to hold the slats in place against
the increasing weight of the water. The obvious problem
with the demonstration is that the slats are unlikely to be
watertight. Thus, in the drawing below, he shows how he
intends to line the short side of the tank with a bulging
layer of 'sheepskin', against which the slats should push with
sufficient force to keep them in their vertical alignment.
Neat! Whether he actually built this device cannot be
known, but I suspect not. As a 'theory machine' it works
well enough in his compelling drawings.

I think there is no safe generalization to be made here
as to whether the 'theory machines' were virtual or real.
Each instance needs to be examined in its own right.
Some of the drawings of spouts of water from perforated
vessels (III.18) look very schematic and could readily be
categorized as diagrams of theory. Yet the phenomena they
record could hardly be constructed simply by thinking
about them. The ability of one jet of water apparently to
penetrate another with which it intersects is hardly obvious
until we have witnessed that this is what actually happens.
Similarly, the particular pattern of jets emitted from a
series of holes drilled at equal vertical intervals in a tank
surely depends on observation and analysis, and not just
on speculation. Leonardo decides, correctly, that a single

straight line can be drawn diagonally in such a way that
it touches tangentially the curving paths of the successive
jets as they spout more powerfully in proportion to the
increase of depth. The line is effectively a graph of the
pyramidal law that governs the behaviour of the jets at
successive levels. Similarly, the patterns of ripples that he
illustrates in simple line diagrams (III.20) ultimately depend
on observations. It is counter-intuitive to think that
triangular and rectangular objects dropped into water
will generate similar patterns of concentric ripples, and
it is not obvious that two colliding wave systems will cross
without apparently interrupting each other.

In other instances we can observe when the 'theory
machine' did not work, even on paper. In the top right
corner of folio 11A in the Codex Leicester he drew a vessel,
fed by a vertical pipe with a spout that passed above the top
of its neck. 'No,' he thinks, and crosses through the spout.
Below he adjusts the spout, with two right-angled bends,
so that it emerges lower down, to project a jet of water at
a suspended plate. The plate is held in place by a rope that
passes over the pulley, and from which hangs a weight. The
weight needed to hold the plate in position would provide
a measure of the water pressure. In this case, the vertical
feeder pipe is missing, presumably because it is unproblematic
and taken as read. It is highly unlikely that either sketch is

III.21
Veins of water in mountains
c.1508–9
Seattle, Bill and Melinda
Gates Collection,
Codex Leicester 7B (7v)

taken from an actual device. Such crossing out of devices that failed, even on paper, is not infrequent (e.g. III.23).

Another option to crossing out is to provide alternative designs, perhaps with one superseding the other, but also with the preferred design left open for debate. When Leonardo was devising a stove that would generate a supply of hot water, he first sketched two related schemes (III.22). Each has a narrow inlet and outlet so that 'the coal remains alight for long enough … The cover will be of copper and its diameter will be a *braccio* and its height ½, and the remainder will be of terracotta durable in the fire.' In the left design, the water occupies all the dome's space below the burning coals, while on the right he places the coals there, with a cylindrical tank for the water below. The third of the designs passes without comment, but is provided with two horn-like structures on either side, apparently for the admission of air and emission of smoke.

In the note below, he characteristically passes to general issues:

> I will write of the motion of solid bodies, treating of the weight of liquids and air and the motion of fire, and for the motion of this fire I will make comparison with the recoiled motions in air and water, and I will discover the vortex motions of fire will make them more forceful in the uniting of its revolutions, which will be registered in the boiling water.

It may be that the curved horns are intended to work with the shared vortices of water, air and fire. But he does not provide any explicit guidance on the link between the note and the drawing above it. In any event, a fuel-efficient stove generating a good supply of hot water would have served well for the 'Bath of the Duchess' (Isabella of Aragon), on which he was working in the late 1490s.

Leonardo could also, during the course of a dialogue conducted through text and image, illustrate set-ups that he came to realize as unsatisfactory during the dialogue. As part of his debate about the action of the 'veins of water' in mountains, he at one point illustrates 'a vein without movement, which will remain dead' (III.21). At the top of the sheet he noted that 'water rises as much as it descends,

its transit being through a pipe'. Beside the mountain, seen in transparency with its venous network within, he has sketched a kind of standpipe, from which jets of water originate at different levels. His reasoning here remains obscure, with the laconic notes doing little to help. It seems that the dialogue was not leading anywhere fruitful. Below he illustrates the somewhat improbable damming up of a space beside a mountain and envisages the space filled with water to a level as high as the top of the 'vein'. He explains that the flow of water over the dam will not be as strong as it is in the natural set-up, because the lower 'veins' in the mountain contribute to the pressure that exudes the water from the top of the main 'vein'. Again, the diagram and argument do not seem to be going anywhere productive.

On other occasions he deliberately drew a set-up that was unambiguously wrong. He often took trouble to draw erroneous things in such a way that they could clearly be seen to be absurd. The debate about high mountain springs involved various analogies, such as stills, sponges and siphons, and each needed independent investigation as a device in its own right. Thinking about siphons, he inventively considered various alternative forms for the inlets and

PLATE III.22
Stoves for heating water
c. 1498
Pen and ink and black chalk
21 × 14.5 cm
London, British Library,
Codex Arundel, 145v

III.23

outlets – widening and narrowing, single and bifurcated, straight and spiral. At one point he drew two unworkable schemes, each of which he labelled as the 'instrument of the adversary' (III.23). The upper one avails itself of a swelling bowl around the outlet pipe, and looks ingenious enough, but suffers from the fatal flaw that the head of water is still below the bottom of the outlet. The other scheme is manifestly absurd. How anyone could seriously have advocated that a pipe with an outlet high above the surface of the water in the bowl would produce such a prodigious shower is unclear, but it seems that someone had – unless his 'adversary' is make-believe.

Shaping Space

It would perhaps be surprising to consider Leonardo's architectural drawings in this category of 'theory machines' and, in as much as they are not literally 'machines', they clearly do not fit this description. But their mode of operation is essentially similar, and there was a long tradition of architecture and machines that saw them as belonging to the same province of 'design'. Not least, the ancient Roman author on architecture, Vitruvius, included machines in his treatise as integral to his subject. And Leonardo's contemporary, Francesco di Giorgio, produced treatises that treated architecture and machines within the same compass.

III.23
Studies of siphons
c.1508–9
Seattle, Bill and Melinda
Gates Collection,
Codex Leicester 3B (34r)

III.24
**Analysis of the radial
thrusts in an arch,** based on
Codex Madrid I, 124v

Leonardo's architectural designs are literally built from the ground up, in two senses. The first is that the building is extrapolated upwards as a plastic and spatial reality from a plan that depends on the modular combination of a few set geometrical elements. The second involves the accretion of units that are known to obey the basic laws of statics in order to endow the building with structural integrity. To some extent, obedience to the laws is implicit in their geometry, as determined both by intuition and by experience. The circular arch and the hemispherical apse, two of the motifs recurrent in Leonardo's 'temple' designs, exhibit both geometrical probity and structural integrity. On occasions (III.24) he undertakes specific structural analyses of the basic forms, which unsurprisingly respond to his beloved laws of proportion. The proportional design of building involved both visual proportionality and the proportional laws of statics in equal and conjoined measure.

Thus, when he is experimenting on paper with his many variations on the theme of the centralized church or 'temple' (II.28, III.26 and III.27), the geometrical modules – squares, circles, polygons – that are compounded to make the plan are translated into a rising sequence of 'solid' spaces contained within structural shells that are based upon the geometry of the 'Platonic' solids. The octagonal plan seems to have been a particular favourite. In the last of all his architectural endeavours, when he was devising a new chateau at Romorantin, he sketches octagonal ground plans for buildings whose function is unclear (III.25). It may well be, in this case as in others, that he manipulates

III.24

PLATE III.25
**Plan for centralized buildings
and palaces with canals**
c. 1516–17
Pen and ink
21.5 × 14.35 cm
London, British Library,
Codex Arundel, 270v

PLATE III.26
Design for a centralized 'temple' in plan and solid section photographed with ultraviolet light, showing lines not visible in normal light
c. 1488
Pen and ink over silverpoint
on blue paper
19.9 × 28 cm
Windsor Castle, The Royal Collection,
12609v

PLATE III.27
Design for a centralized 'temple' in plan and solid section
c. 1488
Pen and ink over silverpoint
on blue paper
19.9 × 28 cm
Windsor Castle, The Royal Collection,
12609v

III.28
Jointed sections for dam
c.1508–9
Seattle, Bill and Melinda
Gates Collection,
Codex Leicester 15B (22v)

the wholes of buildings. However, Leonardo extended their geometrical building up of form into a fully plastic sculpting of exterior forms and interior spaces – with shaped space intuited as a solid form in its own right. It was a vision that was to affect Donato Bramante deeply when they were working together in Milan, and which was to find its supreme expression in Bramante's definitive design for the new St Peter's in Rome. The form of a projected building was envisaged not only in terms of plan and elevation, but also as a kind of sculptural object, sitting boldly in its surrounding space and moulding the interior space as if it were a malleable substance like wax.

The graphic techniques that Leonardo devised to demonstrate this new vision are as striking as the vision itself, and may themselves have played an active role in shaping what he could visualize. Plans are amplified by solid renditions of the exteriors of buildings as sculptural entities. Interiors are displayed in striking sectional illustrations, in which we can experience the excavated spaces in virtual terms. When he came to demonstrate components of buildings, he was innovatory to a similar degree. A spiral staircase, a '*scala a chiociola*' (literally a 'snail staircase'), which he designed when he was in France (III.30), perhaps for Francis I's projected palace at Romorantin, is drawn with compelling spatial conviction. He explains that it is to fit into a square space. This is the arrangement in a plan at Windsor (II.7), which has been associated with improvements at the Villa Melzi in Lombardy, the family seat of his pupil Francesco. He also shows, in the cross-section of the newel post at the centre, how a handrail is built integrally into the shaft, its grooves designed precisely to accommodate the sliding fingers and thumbs of those traversing up and down – using their left hands on the way up and their right hands on the way down. The balance between complexity and lucidity is miraculously struck in making the drawing perform its descriptive role. We know little about drawings by his immediate architectural predecessors, but it is unlikely that any earlier architects drew their prospective buildings in these compelling sculptural ways.

His most commonly used architectural method of plastic demonstration through solid section also served him well when discussing structural issues. In the Codex

the permutations so that buildings of different scales and functions emerge along the way. We may imagine that the upper octagonal buildings could be large 'temples', while in the case of the two lower plans they could be smallish pavilions.

Where his architectural manipulation of geometrical planes and solids differs from what Pacioli and Leonardo accomplished with the five regular bodies is that the manipulation of the compound forms does not just involve flat planes, but melds spherical and rectilinear components in spatial sculptures that are at once complex in their geometry and lucid to perceive. Cubic elements are spliced with the spherical, and vice versa, in potentially endless variations. Some of the stereometric investigations in the Codex Arundel (III.15) and elsewhere involve curved components as well as rectilinear ones. He seems to be going beyond the squaring of the circle and entering the realm of 'cubing the sphere'.

In his manipulation of form, Leonardo characteristically develops a remarkable sense of 'fittingness' – how one form fits in or interlocks with another, much as a mould fits around a cast. Indeed, his sense of how positive and negative shapes fit together may well have been enhanced by his training in the workshop of a sculptor who specialized in bronze figures. This sense is repeatedly manifested in his engineering, as it is in his architecture (III.28).

His characterization of form and space relies upon a remarkable vision, related to what Brunelleschi and Alberti had accomplished in their use of basic geometrical forms that were consistently expressed in the parts and

PLATE III.29
**Studies of a structural failure
in apses with semi-domes,
and in walls**
c. 1509
Pen and ink
21.5 × 14.5 cm
London, British Library,
Codex Arundel, 141v

PLATE III.30
**Studies of a spiral staircase
and of pumps**
c. 1516–17
Pen and ink
20 × 28.7 cm
London, British Library,
Codex Arundel, 264r–269v

126

III.31
**Staircase designs and paired
'tree-trunk' columns**
PLATE I.31 (detail)

Arundel (III.29), which contains fragments of an intended treatise on 'the generative causes of the breaking of walls … and their remedies' (Arundel 157r), he discusses structural problems in an apse into which a window has been inserted. Two potentially disastrous, curved cracks are developing below the window, to the left and right. He observes that 'the old foundation *b* has already settled, which has not happened with the pilasters *n* and *m*'. He also explains that the cracked portion *d* will collapse outwards, 'not inwards as the adversary claims'.

Then, beside the central diagram, he develops a general analysis of the stability of apsidal structures, typically adducing a telling 'experience' of the kind that we can all recognize:

> When either a whole or half dome is overcome by an overwhelming weight, the vault will burst apart, the crack being small in the upper part and broad below, and narrow on the inner side and wider on the outer, after the manner of the skin of a pomegranate or orange that splits into many parts lengthwise the more it is pressed from the opposite ends.

He concludes: 'the arches of the vaults on any apse should never be loaded more than the arches of the building of which it forms a part'. No part can afford to disobey the rule that governs the whole.

Leonardo's understanding of the kind of cracks that would develop is clearly founded on direct experience (not only of pomegranates, but also of buildings!), while the drawn analyses typically develop in the direction of the general rule, exploiting his instinct for the way that shapes and masses behave, rather than illustrating a particular case. As always, 'experience' and theory are involved in dialogues of such intricacy and simultaneity that we would be unwise to see one as predominating for long over the other.

On occasions the complexity of intersecting forms and spaces solicited a method that he probably first devised for the human body – namely, transparency. On the sheet at Windsor (I.31) in which he sketched out his plan for the 'tree of the vessels', he laid out a scheme for a double staircase. Whether the separate stairs were to serve social imperatives or security (or both) is unclear, since he

considered such arrangements in both his civil and military architecture. Along the left margin of the page he shows plans and elevations, but most of the other drawings aspire to present the set-up in stereometric transparency, with paired doors and diagonally disposed flights of steps. None of the drawings has reached a point of resolution, but they show how Leonardo's graphic means responds to this particular challenge with a new form of spatial representation in architecture. As if to underscore the implicit parallels between natural and architectural bodies, the little sketch of an architectural detail near the lower left corner of the sheet depicts what appears to be the design for a balustrade decorated with a shield, above which rises a pair of coupled columns. The marks on the columns (III.31) clearly denote that they are to take the form of trunks from which branches have been lopped, just as in Bramante's cloister for S. Ambrogio in Milan in around 1498.

Other sheets show that comparable resonances occurred between techniques of anatomical and engineering drawing. A page at Windsor (III.33) contains a rather scrappy series of sketches, including some optical diagrams concerned with reflection from concave mirrors and a costume decorated with ivy, which signifies 'long life'. At the centre are two schematic renderings of an oesophagus and stomach. The other sketches relate to a clepsydra or water clock, including

PLATE III.32
Designs for an underwater breathing device
c. 1507–8
Pen and ink
21 × 14.35 cm
London, British Library,
Codex Arundel, 24v

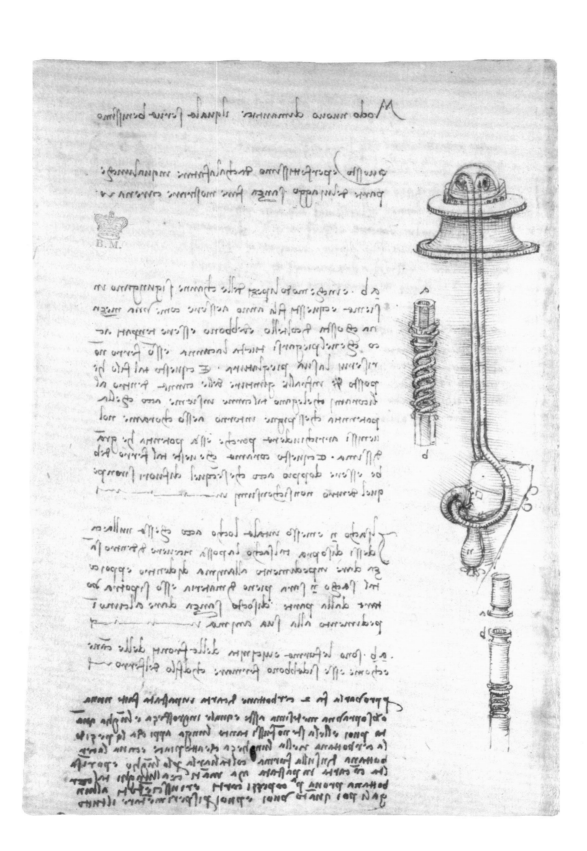

129

PLATE III.33
**Studies for the release
mechanism for a water-clock,
the human oesophagus and
a costume design**
c. 1509
Pen and ink
37.2 × 28.1 cm
Windsor Castle, The Royal
Collection, 12282v

III.34
**The River Adda near
the Villa Melzi**
C.1512
Windsor Castle, The Royal
Collection, 12400

perhaps the hastily drawn water wheel on the right. We know that he was planning water clocks linked to automata for Charles d'Amboise, the French governor of Milan, when he returned to the city in 1508. As the transparent views show, Leonardo was devising a complicated mechanism for a double float for the release mechanism in his water clock and was thinking how to arrange the pipes of a siphon in the neck of the device, either separately or entwined in a spiral. Within the outer cylinder, two inflated rings, shaped like pneumatic tyres, rose progressively through the mechanism, as will be explained later. The moving rings apparently triggered lateral thoughts about how food passes through the oesophagus and into the stomach. In the sketch to the left of the stomachs, he added a man's head to the neck of his water device, which now occupied a familiar territory somewhere between the mechanical and the anatomical. Was this second lateral leap of no consequence, or was he toying with the idea that the release cylinders of his water clock might assume the guise of human automata, perhaps even wearing the costume of ivy? The traditional symbolism of ivy – eternity or long life – would certainly have been fitting for a clock. However, the release cylinders would not have been visible in the design on the Windsor sheet. Either way, we can see how the pipework of the clepsydra and a human body resonated in his thinking, above all when seen plastically in such see-through views.

The same kind of lateral transfers of design from human to machine occurred when Leonardo was extended human powers of breathing through an underwater apparatus (III.32). The apparatus consists of a float designed so that the openings of the inlet and outlet tubes are protected from waves. He explains, using the inset drawings, that canes will be articulated at intervals by coiled tubes, so that the breathing tubes will be flexible enough to avoid fracturing. The sack below the chin of the mask is to collect any waste that might accumulate in the tubes. The whole set-up, though obviously mechanical in nature, is drawn in a manner that gives it the feeling of an organic extension of the human body. He has, in a sense, made a new form of trachea and larynx, comprising flexible tubes and a valve. He considered that such underwater breathing apparatuses

were of such potential in maritime warfare that they should not be made public, because of the 'wickedness of men'. However, he records that underwater breathing apparatus was used for peaceful purposes by divers for pearls in the Indian Ocean (B 18r).

Bodies, Earthly and Human

Leonardo mapped the human body. He charted its skeletal rocks, the course of its 'rivers' and its fleshly soil, both within and without. He dissected the world, teasing out its bony rocks, its earthy flesh and its watery veins, both in its surface topography and deep within its core. The graphic techniques he used in these quests represent one of his greatest achievements. Let us begin with earth, since it is marginally less complex in graphic terms.

Leonardo undertook both geography and chorography as defined by Ptolemy. Geography involves the mapping of a surface area of some extent. Chorography portrays a particular section of the topography (and later became equated with landscape painting). The former, according to a repeated analogy, aspired to show the whole head as a 'portrait', while the latter illustrated just a nose or an ear.

As a chorographer, Leonardo is exceptionally precocious amongst draughtsmen in portraying actual landscapes with such faithfulness that allows them to be matched with the topography today. A number of scenes in Tuscany can be recognized in his drawings, and at one particular site in Lombardy on the River Adda near the Villa Melzi, the family home of his pupil Francesco (III.34), we can still recognize a little arched bridge over a side stream (though the rope ferry has been replaced by an ugly road bridge and the course of the river otherwise tidied up). Always, looking at his drawings of real sites, we can sense his urgent concern with the body of the earth as a functioning system. Even the most straightforward landscape drawing acts as a 'demonstration', rather than serving simply as the pleasing portrayal of an enjoyable or striking view.

The same applies to his geographical maps. They are never just flat records of the relative positions of geographical

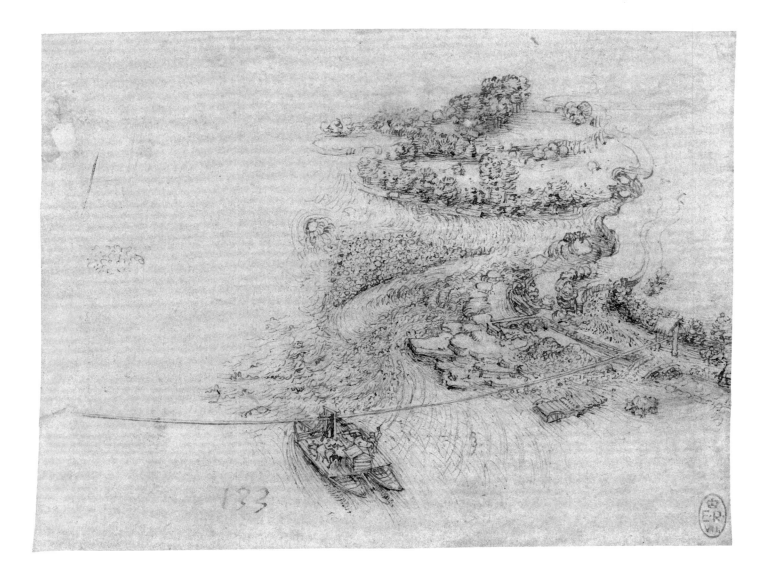

features. Whether they present sweeping bird's-eye views, with features represented in relief, or provide flat maps of the topography, they always convey a vivid sense of the living body of the earth. Perhaps most remarkable in this respect is the series of maps he made while thinking about the great arching canal that was to bypass the unnavigable sections of the Arno (I.11). They are drawn with such vigour and freedom, expressive of the dynamism of the remorseless processes that he saw as continuing the shape of the topography, that it comes as something of a surprise to find that they are provided with precise scales. Even when he focuses in a more obviously measured way on a particular configuration of intersecting steams and rivers (e.g. W 12677), his sense that he is looking at '*vene d'acque*' never leaves him. The effect of the living earth comes not just from the vitality of the configurations that he portrays, but more conspicuously from the graphic vigour of the maps, from the speed and vitality of the way he moves his pen across the paper, often in broken and pulsating strokes.

When Leonardo looks in his mind's eye inside the body of the earth, something that was largely impossible with his actual eye – beyond some caves, tunnels and caverns – comparable vitality is in part retained. The 'veins' in the mountains and the spouts of water are all characterized with typical energy. However, the greater part of the studies of the whole body, in section or transparency, is necessarily tackled in more schematic forms. Sometimes the veins are drawn as irregular channels (I.24 and III.21), but he generally simplifies the forms of the outer crust and inner spaces to demonstrate the principles at work. The collapse of portions of the crust can be shown in terms of geometrical forms (I.26), to make the point about how they affect the centre of gravity of the earth in an exaggeratedly clear manner. As we have seen, the image of the mountainous lands protruding through the sphere of the waters can be reduced to that of a triangle whose vertices emerge across the circumference of a circle (I.25). He also, in a typically tangible image, imagines a cube of lead immersed in, but not covered by, a circular drop of dew (F 62v). The inventiveness with which graphic means spring to mind in the margins of the extensive texts in the Codex Leicester makes the techniques seem effortless. But they are almost all novel.

PLATE III.35
**Analysis of muscles attached
to the spine and ribs**
c. 1509
Pen and ink
28.9 × 20.6 cm
Windsor Castle, The Royal
Collection, 19015v

The same applies to his pictures of the human body. We have lost something of the surprise that these techniques must have caused to those privileged to see them, because so many of his techniques of graphic demonstration were later adopted as standard, whether or not those responsible knew that they were following in Leonardo's wake.

The earliest of his dated sets of anatomical drawings, from 1489, are devoted to the brain and skull (I.27 and I.28). Immediately they announce a remarkable vision of how to convey the three-dimensional form of exterior and interior features, in a way entirely analogous to what Leonardo accomplishes with architecture. Given that some of the key drawings in Manuscript B in the Institut de France and the related Ashburnham manuscript may date from a few years earlier, I suspect that the methods migrate from architecture to anatomy, rather than vice versa. The skull – and it is clearly a real one – has been sectioned in various ways, so that the features that emerge within the bony structure itself (like the triangular frontal sinus), and the topography of the interior of the cranium, can be disclosed as never before. In other drawings in the series, when he attempts to envisage the cerebral structures within the cranium, Leonardo sometimes uses a simple section, sagittal (vertical) or transverse, but he can rarely resist adding some three-dimensional element to convey the sense that we are looking at the 'real thing', even when we can show that we are manifestly not. In the same series he also tests the technique of transparency, to show the ventricles diagonally behind each other within the space of the head (I.29).

In successive anatomical campaigns over the course of almost the next 30 years, Leonardo's fertility in devising graphic means appropriate to the task in hand is astonishing. To the various sectional techniques, he adds a raft of alternative and complementary methods. He displays systems in whole or in part in isolation, either separated from the body or within its transparent outlines. At one stage he even shows the act of copulation in see-through mode (IV.41). He devises schemes for the display of complicated structures from the back, front and sides, and sometimes in sequential views, as if the body is being rotated in front of our eyes. He shows sequential views of the same region in different stages of dissection, with forms lifted away or hinged outwards. He invents the method of 'explosion', in which abutting forms are moved systematically away from each other so that their individual shapes can be seen while their interrelationships remain evident. He contrives a 'cord' technique for the reduction of muscles to cords or wires running along their central axis, so that the total ensemble of a muscular array can be seen as if rendered by open basketwork, in much the same way that the skeletal polyhedra clarify the whole configuration. He moots the possibility that actual models could be made with a skeleton and copper wires.

He produces sequences of drawings in which the structures as seen are successively rendered in increasingly diagrammatic modes to show how they operate. The way that the biceps operates the levers of the arm is demonstrated in a purely mechanical diagram (W 19026v). The array of muscles attached to the ribs and spine (III.35) is progressively abstracted until it assumes the guise of ropes supporting the mast of a ship. He explains that the wider apart the anchor points are, the more effective the pull of the ropes/muscles will be.

As was stressed earlier, Leonardo was not in the business of 'descriptive anatomy' and was not working like a modern medical illustrator or medical photographer serving the needs of a surgeon. Although there are drawings that appear to be sketches made during the course of dissection, these are 'preparatory' in the same sense that he makes preparatory sketches for paintings. He was aware that a literal rendering of a particular dissection would convey little coherent information to the viewer, even with elucidating notes. His final concern was always to create a 'demonstration', forging a synthesis of form and function in an act of remaking. Like his mechanical drawings, the more resolved of his anatomical studies assumed the character of 'theory machines', in which the drawings were simultaneously demonstrations of structures and of their functioning according to natural law.

He also provides a form of anatomical illustration, which is demonstrative not just of function, but also of microcosmic comparison. When dealing with the relationship of the heart to the blood vessels, as we have seen (I.30), Leonardo

PLATE III.36
**Vessels of the arm with comparison
of vessels in the old and the young**
c. 1508
Pen and ink
19 × 13.9 cm
Windsor Castle, The Royal
Collection, 19027r

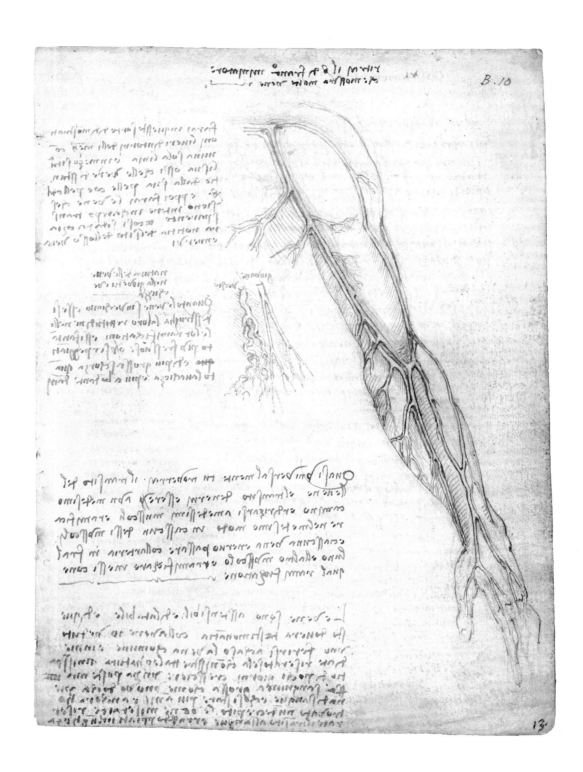

PLATE III.37 (overleaf)
'Irrigation systems' of the female body: respiratory, vascular and urino-genital
c. 1507–8
Pen and ink and wash over black chalk, pricked for transfer
47 × 32.8 cm
Windsor Castle, The Royal Collection, 12281r

sets a sketch of the main structures beside a similarly scaled sketch of a germinating tree. On another occasion he appends a sketch of the straight and coursing vessels of the young beside the tortuous and sluggish vessels of the old (III.36). These are what we might call discursive diagrams, set up to make specific points through graphic demonstration. They both represent and actively certify the idea through the act of drawing. The very cogency of the arguments is positively reinforced as the comparisons emerge on the paper. Both drawings were triggered by the dissection of the 'Centenarian' (see p.50), but are far removed from any concept of dissection drawings.

The culminating synthesis of the major systems in one representation was the great goal towards which he strove in the wake of his autopsy of the 'Centenarian'. The closest he came was in the composite demonstration at Windsor of the respiratory, vascular and urino-genital systems of a woman (III.37). The digestive system, which he did not seem to regard with much favour, was not included, though he did mention digestion in the notes. He has pulled out every graphic stop in playing the great illustrative organ he has assembled over the years. The bronchial tubes and some of the major blood vessels are shown in tree-like guise, with rounded branches. The heart, still apparently two-chambered, is sectioned. The liver is rendered transparent, as are some of the overlying vessels. The left kidney exists in a realm between the plastic and the transparent. The womb, spherical and 'horned' as was traditional, is rendered in an ambiguous compound of plasticity, transparency and section. The techniques of shading, with both hooked and parallel hatching, and the addition of wash, knit the definite and indefinite together in an extraordinary pictorial whole. This is not the end of the matter. The sheet is meticulously pricked, first of all during the transfer of features from the left to the right of the body across the central fold, and then for transfer to another sheet. Leonardo also reminds himself to 'make this demonstration also seen from the side, so that knowledge may be given of how much one part may be visible behind the other, and then make one from behind'. The other notes record his intention to begin the series with 'the formation of the child in the womb', discuss the blood vessels, debate reproduction with Mondino

de' Luzzi, and meditate enigmatically on cycles of death and rebirth, drawing a strange parallel between the role of blood vessels in the digestive processes and burial in tombs.

> How man dies, and is always reborn in part that is by the veins of the mesentery [connective tissue holding the organs in place], which are the roots for vital nourishment. He dies through the arteries that originate together with the mesenteric veins. One takes and one gives. One takes up life and the other gives out death, which is deposited in the mixture of the superfluities from the vessels and intestines. This process is the same as the final internment in the sepulchres.

As a 'portrait' of the remade female body, this extraordinary drawing has much in common with the *Mona Lisa*, both thematically as a microcosmic body and in terms of its elusive suggestiveness. We are not used to thinking of elusive definition as a proper part of anatomical illustration. But if we regard this extraordinary drawing as a magnificently suggestive portrayal of the 'lesser world' – as a form of philosophical anatomy – we can fairly characterize it as the greatest ever attempt to capture on a single sheet of paper the nature of the systems in the human body that grant us the miracle of life.

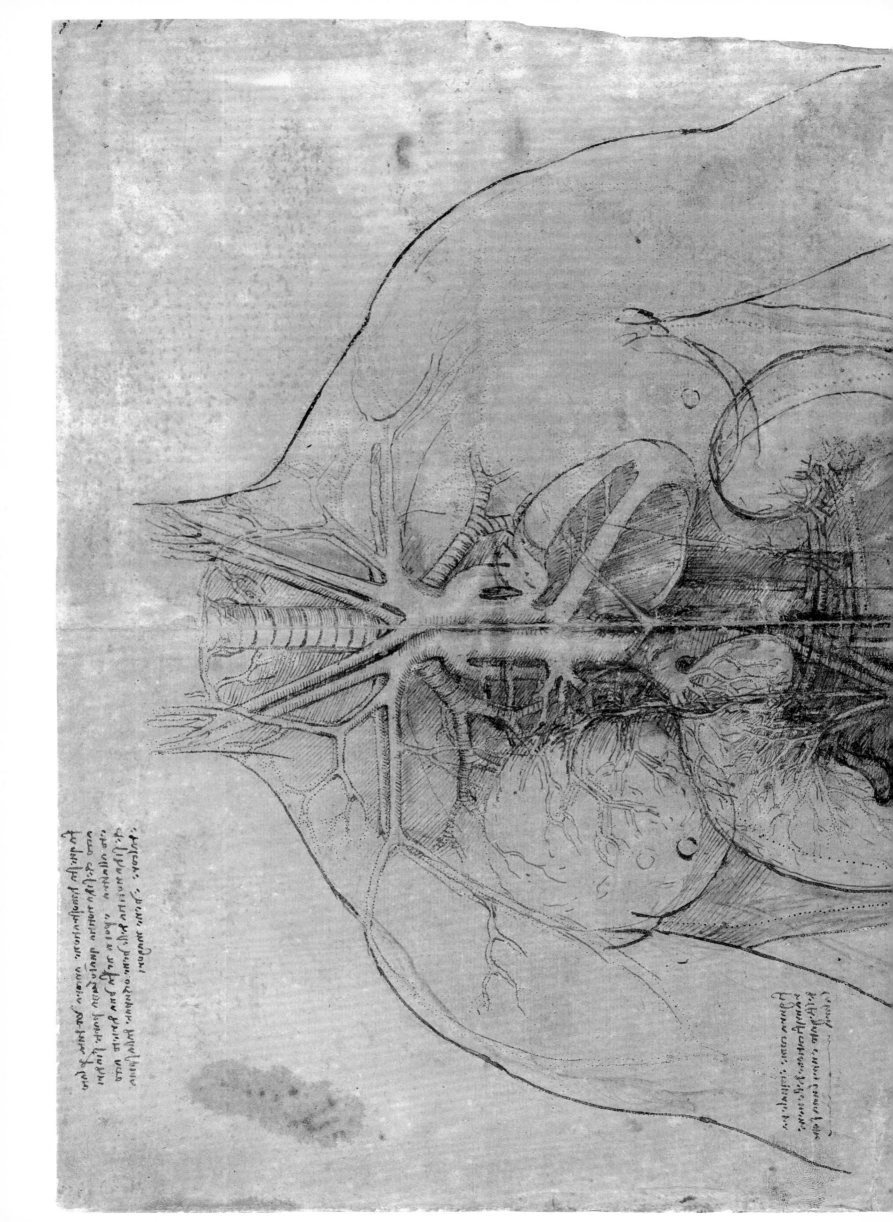

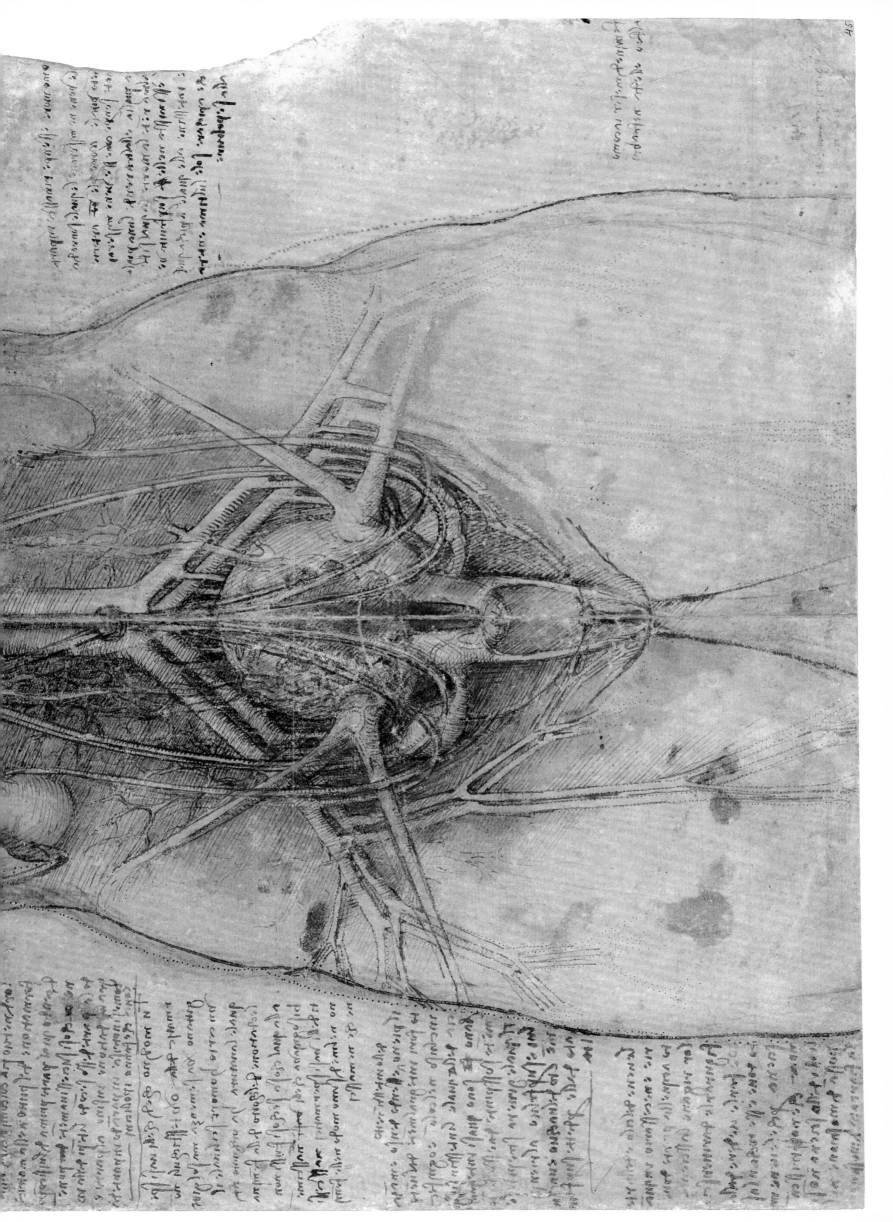

IV FORCE AND MOTION

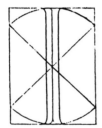 N AS MUCH AS even static forms exude an uncanny sense of life under the touch of Leonardo's pen, chalk or brush, the division between this and the preceding chapter cannot be tidy. Everything drawn by him has an implicit potential for motion. However, the division between forms at rest and those in motion was crucial to his vision of the world. Rest was the natural state. Motion was imparted by force – through 'violence' – by an outside agency, and ultimately by the 'Prime Mover' that endows the cosmos with motion.

We can of course witness bodies in motion, both in the general sense of material bodies and, most importantly for Leonardo as an artist, human bodies. However, many of the most momentous motions were either partly or wholly invisible. We can see when water is turbulent, and yet, as a transparent medium, water does not etch the tracks of its currents indelibly in our eyes. Water in motion is visually elusive and transitory, often too fast and complex for the eye. How can we capture the shape of a splash or falling droplet? Motion in air is even more nebulous, visible only in its secondary effects or 'accidents', as when dust or dry leaves are borne high by its whirling vortices. Sound is even more problematic. It has barely any direct visual effect – at least before the experiments of Christopher Wren, Ernst Chladni and others on patterns of oscillation produced by musical vibrations in water or on plates coated with resin. Leonardo defined time as a 'motion', akin to that of the elements, but how was time to be rendered visible?

Yet he was utterly committed to the sovereignty of *disegno* in bringing every phenomenon before our eyes. How he

performed this task using lines on paper is the story of this chapter. Broadly speaking, we will progress from the most figurative and visible to the most abstract and invisible.

Moving Bodies

Narrative painting stood at the summit of the visual arts for Leonardo, as for all ambitious Renaissance painters. The motions of the body, in its whole and in its minutest parts, were the prime means for telling the story, not just in terms of action, but in terms of conveying the emotions of the participants. Every figure in action should be portrayed in keeping with its inner feelings, its age, status and role in the painted drama. In his anatomies Leonardo expended a huge amount of effort investigating the mechanisms of bone, muscle, tendon, ligament, nerve and brain that drove the body in motion and emotion. He also devoted considerable time to the definition of how the whole ensemble moved and could be shown to be moving.

Little figures in action are scattered widely across his manuscripts, whether specifically to demonstrate some aspect of the motion of the human body for the artist or performing some kind of task, such as firing a giant crossbow (II.4) or striking a bell (IV.50). The summary eloquence with which a few curving strokes of Leonardo's pen convey posture, motion and even character in these homunculi is extraordinary. The number of such figures that have been excised from parent sheets testifies that later collectors fully valued their qualities, although we can hardly approve of such appreciative vandalism (IV.5).

IV.1
**Studies of standing men
on a seesaw**
c.1508–9
Seattle, Bill and Melinda
Gates Collection,
Codex Leicester 8A (8r)

Sometimes, as on folio 8A of the Codex Leicester, the dynamic homunculi perform a demonstration triggered by the discussion of related issues in the text (IV.1). This folio is devoted to a complex discussion of the principles of percussion and impetus in moving bodies and fluids. The two men, poised on a plank centred over a cylinder (perhaps a tree trunk), balance precariously, as on a seesaw. Leonardo explains:

> When two men of equal weight are standing on the opposite ends of a plank set in balance, and one of them wants to jump up, this jump will be made by the man crouching at his end of the plank, and he will never go up, but will remain in place until the man opposite to him causes the plank to be pushed up again with his feet.

What he is explaining through the picturesque example is that motion requires a firm and equal resistance to be realized in full measure.

In a comparable way in Codex Forster II (IV.4) a tiny pen-man climbs a ladder in the service of demonstrating the effect his weight has on the whole set-up. The brief sentence at the top of the sheet reads, 'Pagolo [i.e. St Paul] was raised to heaven.' Such enigmatic fragments are not uncommon in Leonardo's notebooks, and are difficult for us to understand – unless there was some loose association between the ladder and the idea of ascent to heaven! The main note then asks, 'what weight of the man is on these steps at each level of motion?' He tells us 'to observe the perpendicular under the centre of gravity of the man'. This is hardly a profound problem or remarkable solution, but it is utterly typical of his desire to subject every phenomenon of motion to the rule of mechanical law. The undulating

furls of a garment outlined behind the climbing man's shoulders are a typical graphic device to signal the direction of the man's motion and to underscore his presence as a 'real' figure in 'real' air, though he is clearly a product of Leonardo's imagination.

Sometimes gangs of little figures fill sheets with teeming action (IV.2 and IV.3). They stand up, stoop, walk on the flat, uphill and downhill, run, stop, lift, carry, pull, push, dig, chop and hammer, generally alone, but sometimes in pairs. We know that Leonardo carried notebooks with him to note down just such things, probably observed from the workers who were toiling on the new roads and buildings of the Renaissance cities in which he worked. He also jotted down notable faces and made systematic records of noses. The figures scattered across the larger Windsor sheets are probably not first-hand observations, but are drawn from his memory bank, which functioned in such a way that any required posture could be envisaged. Every figure in motion demonstrates some aspect of balance and imbalance. Men lean, bend and thrust out limbs instinctually to sustain a dynamic balance around their centres of gravity. Only if the artist gets all these motions right will the action be convincing. Substantial sections in the 'Treatise', assembled from his notes by Francesco Melzi, deal with such questions. For example:

> We see that someone who takes up weight with one of his arms naturally thrusts the other arm outside himself in an opposite direction, and if this is not sufficient to ensure his equilibrium, he bends so as to impose as much of his weight as suffices to counteract the acquired weight. [Urb 113r–v]

When the whole figure is in motion across the ground, the main weight of the body moves beyond the centre of gravity, with immediately dynamic effect (IV.5):

> Motion is created by disruption of balance, that is to say of equilibrium, in as much as nothing may move of itself which does not depart from its state of balance and it will move more swiftly when it is more remote from a state of balance. That figure will show itself to be progressing fastest that is about to collapse forwards. [Urb 113v and 139v]

PLATE IV.2
**Men at work, digging, carrying,
pulling, etc.**
c. 1509
Black chalk with some pen
20.1 × 13 cm
Windsor Castle, The Royal
Collection, 12644r

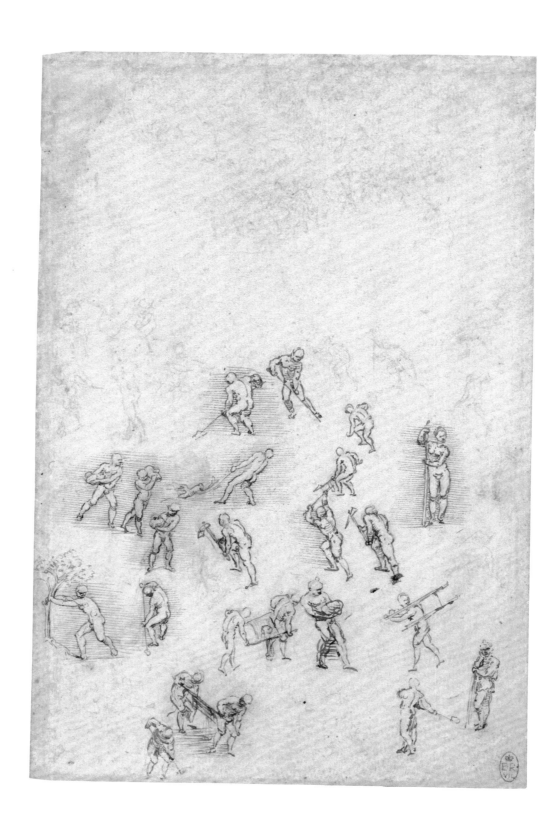

PLATE IV.3
**Men in motion, carrying, digging,
hammering, etc.**
c. 1509
Black chalk with some pen
19 × 12.9 cm
Windsor Castle, The Royal
Collection, 12646r

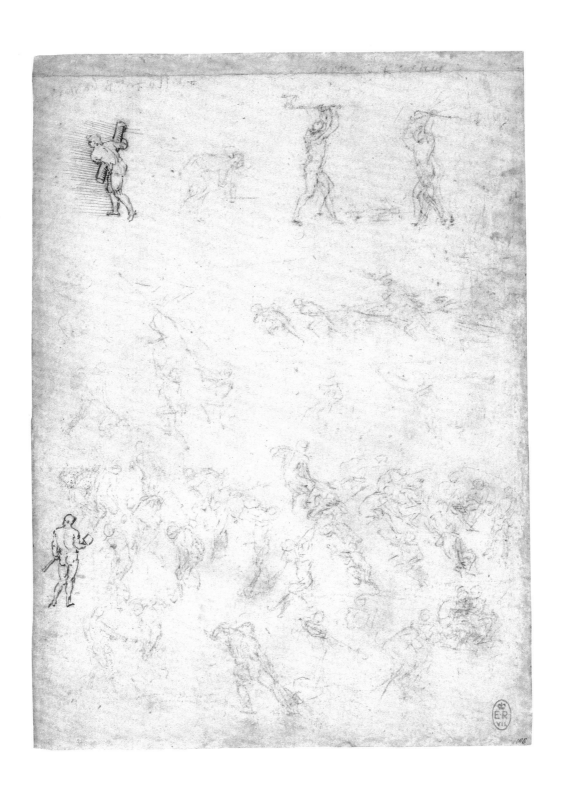

PLATE IV.4
Man climbing a ladder
c. 1494
Red chalk
Opening of 2 pages, each 9.6 × 7 cm
London, Victoria and Albert
Museum, Codex Forster II, 45v–46r

IV.6

All living creatures are characterized by comparable dynamism according to identical principles. Horses rush frantically across the page, fleetingly visible in their impulsive flight. Bearing belligerently energetic warriors, they twist, turn and plunge in foreshortened frenzies of action (IV.8). They bite each other in partisan combat. Not for Leonardo sole reliance on the convention of outstretched and rearing poses, legs locked together in fore and hind pairs. Legs flicker into odd configurations, fracturing the conventional poses. Alternative leg and head positions in the same sketch imply thrashing motions (IV.7). Manes are enflamed with passionate action, nostrils flare and lips are rolled aggressively back to reveal fearsome teeth. There is no essential difference between the ways in which the motion of minds *in extremis* are transmitted into violent facial contortions. Man, horse and lion snarl in a unified expression of unbridled aggression.

This impulse to motion explains why the technically difficult – even impossible – rearing pose recurred in his projects for equestrian sculptures. Although he had settled on a pacing horse for the monument he planned in around 1490 for Ludovico's father, the scheme he developed for Gian Giacomo Trivulzio after his return to Milan in 1508 (INTRO.6) reverts to the dynamic position that he seems instinctively to have favoured. The rearing horse, with its

vigorously gesticulating rider, was to rise triumphantly above captives chained to an elaborate architectural base. As with the earlier monument, political vicissitudes stood in the way of its realization. Only with his equestrian monument to Philip IV in 1643–40 was Pietro Tacca to find the technical solution to the problem that Leonardo posed. He did so by setting a massive counterweight into the base of the statue to balance the asymmetrical and potentially unstable mass above.

In a gentler vein, the balance of a bird on its cushion of air concerns similar issues of centres of gravity. The levers of a bird's wing are correlated with the aerial motions of little pen-birds, the avian equivalents of his drawn homunculi (IV.9). The Turin Codex, which is mainly devoted to bird flight, contains beautifully effective illustrations and texts devoted to the orchestrated actions of wings, tail and body weight (IV.6). Like the little men on the Windsor sheets, these appear to be distillations of many hours of observation, rationalized in terms of the rules of the motion of bodies in air and the positioning of their centres of gravity. Leonardo's aspiration is to understand all the variable phenomena involved in bird flight, so that he can re-create all the elements of flight at will in his explanations of how a bird achieves all it does when it sustains itself in the air.

The advantage for the painter when portraying the human figure or other animals is that we can instinctively sense from the position of their limbs and body whether they are static, performing an action or moving in space.

IV.5

PLATE IV.7
**Horses in action, with studies
of expression in horses, a lion
and a man, and an architectural
ground plan**
c. 1505
Pen and ink
19.6 × 30.8 cm
Windsor Castle, The Royal
Collection, 12326r

PLATE IV.8
**Studies of horses and horsemen
for the *Battle of Anghiari***
c. 1503–4
Pen and ink
8.3 × 12 cm
London, British Museum,
inv. no. 1854-5-13-17

147

PLATE IV.9
Anatomy of a bird's wing, a bird in
flight and studies of proportion
c. 1514
Red chalk and pen
22.5 × 20.5 cm
Windsor Castle, The Royal
Collection, 12656

IV.10
**Study for an emblem of
'obstinate rigour'**
c.1509
Windsor Castle, The Royal
Collection, 12701

These figurative signs can be amplified by supplementary motions. When depicting the human figure, the motion of draperies and hair served as the most effective of these supportive signs. The early *Profile of a Warrior* (III.16) reflects lessons well learned in Verrocchio's studio. Curling ribbons and leaves endow the image with a sense of graphic life beyond the rational, since it is difficult to infer that the stern 'Roman' is actually facing a stiff breeze. The fluttering bands effectively vitalize the image in a way that was not uncommon in Florentine art, and was generically founded on ancient precedents.

Fluttering cloaks, ribbons, skirts and streaming hair are used as a visual shorthand for motion in all the areas of Leonardo's draughtsmanship that involve figures in action. The warriors in his designs for chariots are typically endowed with free-flowing capes (II.1 and IV.34), while the combatants in his drawings for the *Battle of Anghiari* are not only provided with capes, but also brandish fluttering banners, including the large Milanese standard, the capture of which was effectively to mark the end of the battle (IV.16). Needless to say, Leonardo did not neglect to tell aspiring painters about the principles involved:

> The borders of draperies ... move nearer or further from the joints [of the limbs] according to whether the figure is walking or running or jumping, and they may even move without any motion in the figure when the wind strikes against them. And the folds should be accommodated to the nature of the cloths, transparent or opaque. [Urb 168r–v]

The degree of motion that Leonardo could achieve using supplementary devices was incredible. In a relatively early drawing in the British Museum, a combination of rapid pen strokes and surging washes applied with the brush help to conjure up impulsive visions of female figures with draperies streaming both in the wind and in response to the figure's impulsion. The subject of the drawings on the trimmed sheet is conventional enough. The uppermost figure appears to be Fame, while the woman behind her (drawn mainly with a stylus) and the figure below represent Fortune, whose hair characteristically cannot be grasped from behind. The lower figure of Fortune appears to be

using a shield to douse a fire that threatens to consume a pruned trunk (*broncone*), against which is placed a shield bearing a lion (the *marzocco*). The *broncone* was a symbol of the Medici and the *marzocco* of Florence, and the allegory appears to be referring to the dousing of an unspecified threat to the Medicean regime in the city.

Whenever Leonardo designed emblems – normally a conventionalized and largely static art form – they are full of motion of both things and figures. A plough that resolutely excavates a straight furrow is adorned with fluttering ribbons (IV.10). The inscription tells us that the plough signifies 'persistent rigour'. The determined onward motion of the blade of the plough is succinctly signalled by some overturned sods of earth. The leaves of an *Iris florentina* – 'without labour', like the Lily of the Bible – spurt from the ground fountain-like, while ribbons swirl around in elegant spirals (IV.11). 'Falsehood', in the guise of a waxen mask, is melted by the searching light of the sun or consumed by the flames of truth. Leonardo's symbolic forms are never inert, simply standing for what they mean; they always act out the meaning in little dramas, courtesy of Leonardo's graphic dynamism.

It is evident that comparable qualities of dynamism characterized the stage designs he provided for the great courtly *feste* that he played a leading role in orchestrating. He seems to have specialized, as had Brunelleschi before him, in machinery to effect astonishing transformations. His designs for 'Pluto's Paradise' in the Codex Arundel (for an unknown performance, perhaps of Angelo Poliziano's *Orfeo*) rely upon a system of levers and pivots below stage to display the infernal deity and his demonic attendants

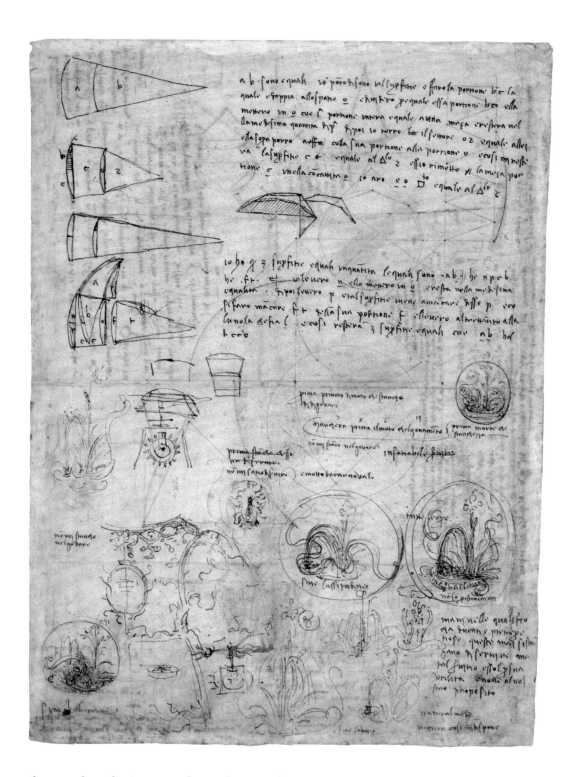

IV.11
Studies of geometry, machinery and emblems
c.1509
Windsor Castle,
The Royal Collection,
12700v

(IV.14 and IV.13). An array of typical Leonardo mountains, apparently solid, was to swing open to disclose Pluto's cavernous lair. His accomplices play on mechanized percussion instruments (IV.12), including *rommelpots*, which, as Leonardo informs us, make an 'infernal noise'. 'Here will be death, the furies, Cerebrus, many cherubs who weep; here fires will be made of various colours.' We gain the impression that any spectacle designed by Leonardo was infused by incessant action and sound.

The motion of the human actors in his paper dramas occurs in space and time through the action of an intricate concert of fulcrums and levers in the human body. Again, a systematic analysis is required:

Motions are of 3 kinds, that is to say motion of place and motion by simple action, and the third is compounded of motion of action and motion of place … Motion of place is when the animal moves from one location to another. Motion by action is the motion that the animal makes in the same place without change of location. [Urb IIIr–v]

Leonardo explains in detail how the joints of the limbs result in a series of orbiting motions. It is a vision that was to be developed by one of his followers, probably Carlo Urbino da Crema, in the so-called Codex Huygens (II.31). Some of the drawings in the codex are direct transcriptions

PLATE IV.12
**Designs for musical instruments
(mainly percussion) and diagram
of the elements with a falling body**
c. 1509
Pen and ink
21.5 × 16.2 cm
London, British Library,
Codex Arundel, 175r

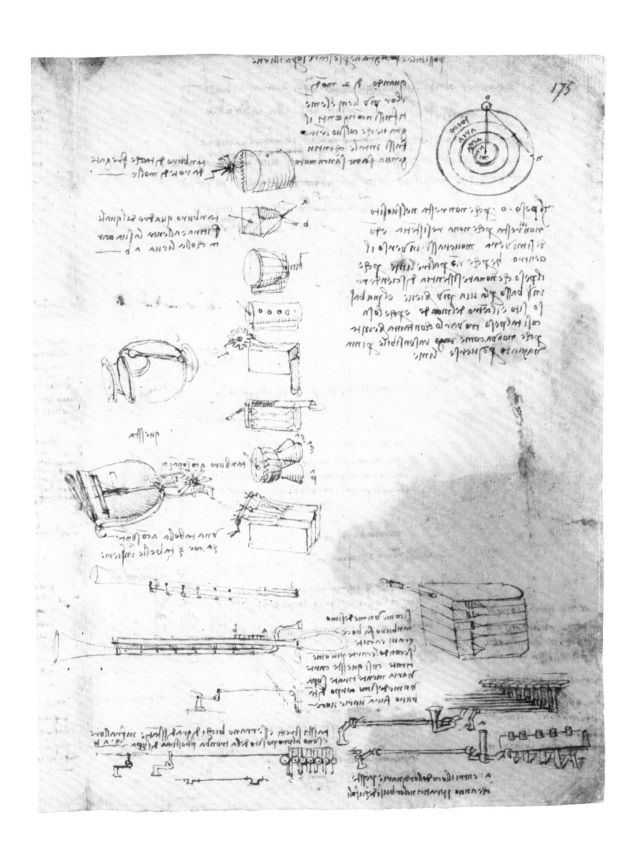

PLATE IV.13
**Stage design for the opening of
mountains** ('Pluto's Paradise')
c. 1509
Pen and ink
22 × 15.5 cm
London, British Library,
Codex Arundel, 231v

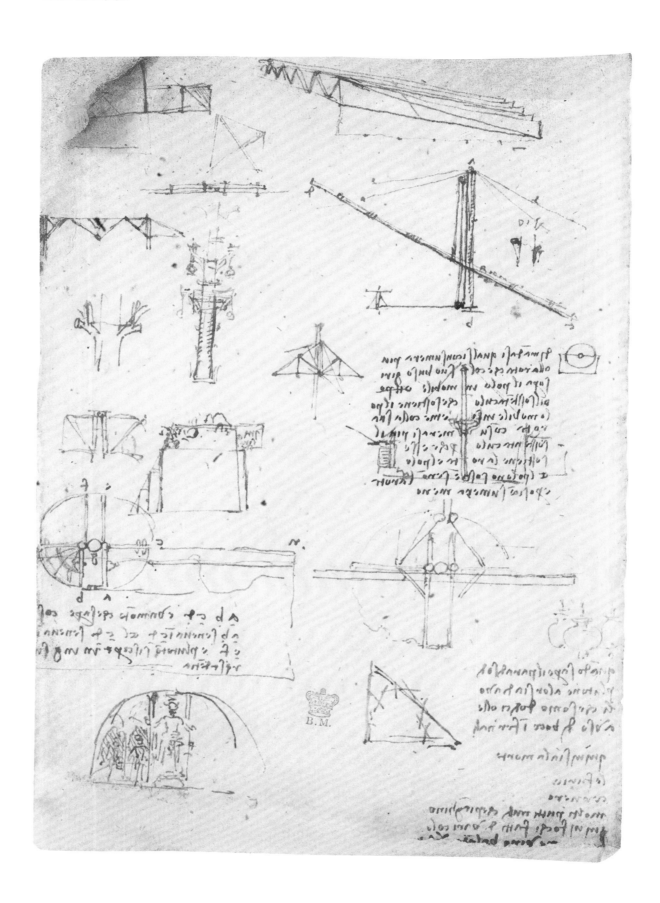

PLATE IV.14
**Stage design for the opening of
mountains** ('Pluto's Paradise')
c. 1509
Pen and ink
21.5 × 16 cm
London, British Library,
Codex Arundel, 224r

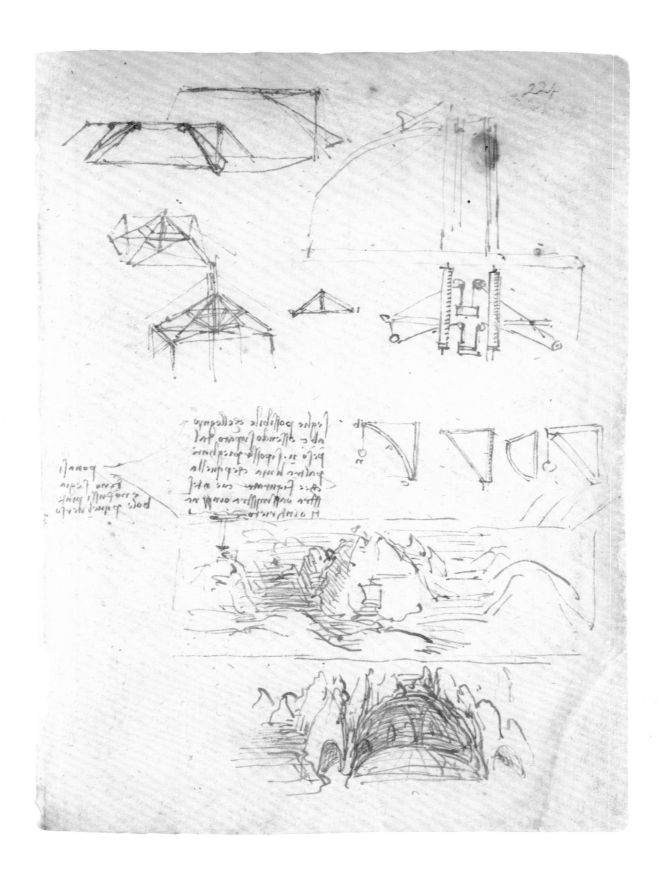

PLATE IV.15
Studies of the tongue and lips
with list of sounds and geometry
C. 1510
Pen and ink and wash on
the drawing of the tongue
31.6 × 21.8 cm
Windsor Castle, The Royal
Collection, 19115r

from Leonardo's manuscripts, most notably studies of the proportions of the human figure and of horses. Others, probably including the 'cinematographic' studies of a man rising from the ground, are variations on Leonardesque themes, while the optical diagrams have a more tangential relationship to Leonardo. In any event, the vision of the cycles and epicycles around the pivoting joints (a Ptolemaic cosmos manifested in the microcosm) is wholly consistent with Leonardo's principles.

He emphasized that every motion, whether of location or action, occurs in a space that 'will be a continuous quantity, and every continuous quantity is infinitely divisible'. Alternately, 'one and the same action will show itself as infinitely varied because it can be seen from an infinite number of viewpoints' (Urb 110v). Leonardo's drawings are full of signs of these double continuities of motion and viewpoint. Sometimes, as in his anatomical illustrations of forms apparently revolving before our eyes, the effect could be attributed either to the motion of the object or the viewpoint. As far as any draughtsman working with lines on paper can overcome the inherent statics of the medium, Leonardo did. His hammering and stepping pen-men (IV.43 and III.11) openly invite us to link the separate drawings of the same action across the continuous qualities of space and time.

An organ that manifests 'continuous quantity' in a particularly wonderful way is the human tongue (IV.15). Seen in splendid isolation, it exudes a sense of independent life as a muscular organism in its own right. Its structure, composed of powerful muscles – Leonardo counts 24 of them – but devoid of a skeleton, endows it with wonderful flexibility and transformational dexterity. Together with the lips, which are also extraordinarily supple, the tongue orchestrates the range of sounds listed in the table at the upper right of the page. It may have been the tongue that elicits the paean of praise for nature that runs down the right margin of the sheet. It begins: 'Though human ingenuity by various inventions and with different instruments yields the same ends, it will never devise an invention more beautiful, ready or shorter than does nature, because in her inventions nothing is lacking and nothing is superfluous.' This in turn triggers thoughts about how the soul arrives in

the body to direct its operations. Leonardo also suggests to himself that he should 'make the movement of the tongue of a woodpecker'. On the verso of the sheet he declares his intention to squeeze the lungs of a dead animal, playing them like a bagpipe, to understand more deeply how the whole instrument of lungs, bronchi, trachea and voicebox produces its wondrous music.

The *Battle of Anghiari* was the painting that should have represented the climactic demonstration of his mastery of bodily motion in men and animals – accompanied by a good deal of shouting. However, it remained unfinished and is probably lost for ever. Commissioned for the large new Council Hall of the Florentine Republic in around 1503, it was to portray a historic battle against the menacing Milanese. It centred on the capture of the Milanese standard, an appropriate subject for a hall dedicated to the Florentine assemblies over which the *Gonfaloniere* (standard-bearer) presided. Michelangelo was commissioned to undertake a companion piece, depicting the *Battle of Cascina* or, rather, the prelude to battle, when naked Florentines scrambled from the river in which they were bathing to take up arms and armour. Faced with competition from the only artist who could rival his command over the structure and motion of the human figure, Leonardo was clearly determined to use the full repertoire of the devices he had to hand to conjure up motion and emotion. To judge from the most effective of the many copies of the central motif (which is all that he painted on the wall), the Italian drawing radically reworked by Rubens (IV.16), the battle was to be a virtuoso demonstration.

The left-hand warrior, in a fantastic *all'antica* cuirass that writhes with organic life, twists with agonized effort as the shaft of the standard bends and perhaps shatters behind his back. The garment at his waist scrolls out like a breaking wave, echoed by the vortices of his horse's tail. The central horseman, roaring with leonine rage, is poised to deliver a slashing blow to his assailants. The impulsive charge of the two warriors from the right is underscored by the flaming mane of the nearest horse and by fluttering draperies, while the horses themselves, their eyeballs glaring with savagery, collide in a tangle of percussion and recoil. If we add – in our imagination, and in keeping with Leonardo's lengthy

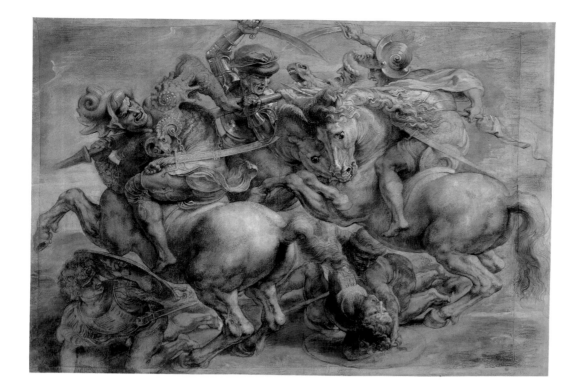

IV.16
Peter Paul Rubens, **Reworking
of a 16th-century copy of
Leonardo's** *Battle of Anghiari*
c.1600–10
Paris, Louvre

description of how to represent a battle – the swirling clouds of smoke and dust, the waters convulsed by those fighting bloodily in the river, the flag of the standard streaming in the wind, and all the subsidiary scenes of fierce slaughter, we might fairly conclude that the visual effects of the violent physical and mental causes would have been irresistible.

On a smaller scale and in a more enigmatic manner, a red chalk drawing at Windsor on red-prepared paper depicts a desperate conflict of frantic figures, horses and gigantic creatures (IV.17). Judging from the 'howdah', the balustraded platform containing soldiers borne on the back of the creature to the centre right of the mêlée, the giants are exceptionally animated elephants, rendered with motions that are more equine than realistic. In any event the fury is evident, conveyed as much by the tangled energy of the chalk lines, elusive on the reddish surface, as by the description of the movements of the protagonists. As always, we can sense Leonardo's instinctive fascination with the unbridled unleashing of force and his rational disgust with primitive violence. He stigmatized war as 'beastly madness' – '*pazzia bestialissima*' in his original Italian, far more expressive than its flatter translation. The tone is that of one of his 'prophecies', one of the succinct literary genres he practised with evident relish:

Animals will be seen on earth who will always fight amongst themselves with great destruction and death on either side. They will have no limit to their malice. By their bold limbs a great proportion of the trees in huge forests will be laid low. And when they are well fed, the nourishment of their desires will be to bring death and grief and labour and fear and flight to every living thing; and from their immeasurable pride they will desire to ascend to heaven, but the overwhelming weight of their limbs will keep them down on earth. Nothing will remain on or under the earth and the waters that will not be persecuted, disturbed and despoiled, and those of one country transported to another. And their bodies will be the sepulchres and passages of all the living bodies they have killed. O earth, how is it you do not open and throw them down into the deep fissures of your great abysses and caverns, and no longer exhibit to heaven so cruel and pitiless a monster. [CA 370 va]

The subject of this coruscating 'prophecy' is man himself.

The Elements in Motion: Impetus and Percussion

Showing men and animals in action and moving in space is one thing. Effectively representing inanimate objects in motion is another. Obviously if something is shown in the air with no visible means of support, we may believe that it is falling, but that is a rather limited case. In any event, any Renaissance painter was likely to have to depict figures or things miraculously floating in the air.

The problem for Leonardo was both pictorial and diagrammatic. He wanted to depict a range of items and

PLATE IV.17
**Battle scene with men
and elephants**
C. 1512
Red and black chalk on
red prepared paper
14.8 × 20.7 cm
Windsor Castle, The Royal
Collection, 12332

elements in motion, and he needed to be able to describe their tracks or paths effectively, whether pictorially or using graphic conventions. As we will see, it is not always clear where the pictorial began and the diagrammatic ended. I intend to look at the way he tackled these problems in terms of the four elements (as he defined them), moving from the most clearly visible – the solid bodies that belong to the element of earth – to the very elusive phenomena of air and fire. I shall finish by looking at the motion of time.

1. Solid Bodies

If an object is shown in the air, how do we know in which direction it is travelling? Has its impetus been expended to such a degree that it is falling to the ground according to the 'desire' of all heavy, earthly bodies to fall to the ground? Or is it still moving with vigour across the skies, or even continuing to rise to its maximum height? What resources can the draughtsman devise to make such motions clear? Are they all conventional or are there any pictorial means available?

There are of course ways of effectively describing how something that cannot move of its own volition is in motion. The fluttering cloaks and streaming manes in Leonardo's *Battle* are examples of this. He also made other observations of the way the appearance of objects changes when subjected to force. He noted that trees, such as olives, showed more of the underside of their leaves when subjected to strong winds, affecting the overall colour of the tree. Additionally, their branches could be seen as bending before the wind, as he showed in his own representations of deluges (IV.18). There were also objects whose shape declared in which direction they were, or should be, moving. A boat with a pointed prow is by implication moving in one primary direction, especially if its sails are billowing, and a missile to be fired from a mortar or cannon leaves us in no doubt – on the basis of our own 'experience' – as to how it is meant to fly through the air (IV.19). Another clue he exploits is to place an object in such a way that we immediately understand that it is ready for action. A hammer poised on or over a release mechanism or part of a device to be struck by a forceful

blow (II.4 and II.5) clearly declares the intended action, though none of the components is in actual movement.

However, for the most part the strictly non-diagrammatic means for showing inanimate objects in motion are very limited. Something moving fast, as is the case with an object thrown into the air, stood outside the range of 'moderateness', as defined in medieval optical science. The Islamic philosopher Ibn al-Haitham (Alhazen), whose work set the tone for medieval and Renaissance optics, explained that vision was designed to operate within a moderate range, and that it could not accommodate extreme effects, such as excessive speed, lightness, darkness, distance or size. However, a fast-moving object might on occasions leave a blurred trace across our line of sight. Leonardo picked up on four kinds of example:

> Certain instruments worked by women, made for the purpose of gathering threads together … by their circular motion are so swift that on account of being perforated do not obstruct to the eye anything behind them. [Forster II 101r]

> That rod of cord that is in rapid vibration appears to be doubled. This happens when a knife is fixed and the top of it is pulled forcibly to one side and released, causing it to shake back and forth many times. The same happens with the cord of a lute when one tests it to see if it is good. [C 15r]

PLATE IV.19
Projectiles and a fortification
c. 1504–5
Pen and ink
21.7 × 15.5 cm
London, British Library,
Codex Arundel, 54r

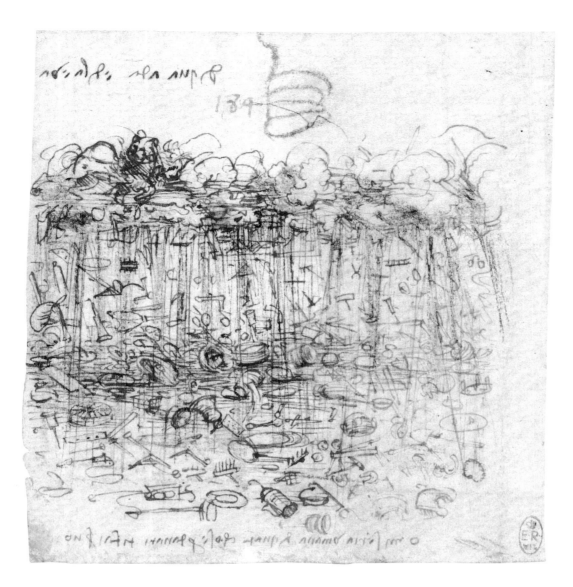

A stone thrown through the air leaves in the eye which sees it an impression of its movement, and drops of water do the same as they descend from the clouds when it rains. [CA 215r]

When lightning moves along the dark clouds, the speed of its sinuous flight makes the whole course appear in the form of a luminous snake. And similarly, if you move a lighted brand with a circular motion it will appear that its whole course is a flaming circle. [A 26v]

These are examples of the phenomenon we now call the 'persistence of vision'. Leonardo attributed it to the way that the *imprensiva* (receptor of impressions) reacted faster than 'judgement'.

The most useful of these pictorially were the 'stair-rods' of rain, and Leonardo did not neglect to take advantage of them when he drew landscapes across which storms were moving (W 12409). When he wishes to show a rain of 'vanities' falling from the sky, the various human implements leave linear tracks behind them on the precipitate descent (IV.20). The 'instrument of the adversary' on the Codex Leicester 3B delivers its chimerical shower in

exactly this way (III.23). However, for the most part these 'immoderate' effects remained outside the scope of the draughtsman and certainly outside the realm of painting. Blur would have ruptured a proper sense of visual decorum – it would have been pictorial bad manners. No angel could be shown with a blur of flapping wings. It was not until Velázquez showed the shiny blur of a spinning wheel in *Las Hilanderas* that such effects entered mainstream painting, and then only rarely. Leonardo explained that these odd effects of vision belonged to the province of the *speculatori* (speculators on natural phenomena) rather than the practitioners of visual representation.

When he depicted a hail of projectiles from a serial array of mortars arching across the wall of a fortification, the linear tracks may be rationalized to some degree as being equivalent to the 'impression' left in the eye by watching a stone flying through the air (IV.21). However, there is no sustained pretence that the graceful arcs with which the mortars deal their deathly blows are fully optical rather than conventional. The balls shot from the mortars have all apparently run their full course, scattered across the assaulted ground like mighty hailstones. Leonardo's

pen is recording the tracks pursued by the projectiles according to a convention that he well knew from traditional diagrams of dynamic phenomena. Yet often, as here, the diagrammatic lines assume a pictorial dynamism, instinctively translated from dry plots of the missiles' paths into suggestive visions of cascading showers, as beautiful as they are potentially destructive.

Sometimes the tracks of a moving body follow its path to an intermediate point in its flight, while at other times they cover the full path of a projectile, telling us where it will go as well as where it has been. The successive positions of the moon and sun in the pages of the Codex Leicester devoted to the transmission of the sun's rays (IV.22) depend

on their implicit orbits. The advantage of such tracking is that the overall geometry becomes wholly explicit.

When Leonardo has to explain the relationship between the path of a ball thrown freely through the air before coming to rest and that of a bouncing ball, different lines do the necessary job, one curving continuously downwards and the other zigzagging from bounce to bounce with decreasing amplitude (IV.23). What these tracks represent in Leonardo's mind are more than simply the plot of the ball's path. They are a visualization of the impetus that is embedded in the object, progressively draining from it, together with the successive percussions that occur when it bounces on a resistant surface. They embody in his

IV.22

**Studies of the transmission
of the sun's light from the moon
to the earth**
*c.*1508–9
Seattle, Bill and Melinda
Gates Collection,
Codex Leicester 2A (2r)

IV.23

**Studies of a ball thrown,
with and without bouncing**
based on MS A, 24r

IV.22

imagination inexorable increments of force and speed that operate in obedience to natural law – that is to say, the 'Necessity' of the projectile's performance. The act of their drawing is itself an experiment, proof and demonstration of the way that impetus works to perform its inexorable destiny in space and time. We feel that Leonardo is always confirming that he can convince himself as well as us.

Sometimes it is not easy to interpret whether lines represent static structures in a schematic manner or plot motion. Drawings in the Codex Arundel (IV.24) of what appears to be a lamp on a pedestal are difficult to read in the absence of explanatory notes. A series of radiating arms bear flames at their tips. The arms are fed by a central reservoir for the oil. In the two more elaborate drawings in the centre, the middle structure is surrounded by a cage of lines. What do these lines represent? They emanate from

the top of the central axis like a fountain and are drawn with the rapid, light, broken touch that Leonardo often used for depicting motion. The best interpretation is that he is combining the arms of the lamp with a fountain of water that cascades just far enough inside the tips of the arms not to extinguish the flames. The base of the pedestal appears to be designed as a basin for the falling water. However, faced with these kinds of sketches, in which he is not intending to communicate to anyone other than himself, any interpretation will be provisional to a greater or lesser degree.

A convention that sometimes accompanies that of the linear tracks is to show the same body more than once at key points in its travel. However, like other conventions, the technique of echoing repetition can approach that of an optical-pictorial method. We have already seen the 'cinematographic' method adopted for the demonstration of the hammering man (IV.43). Inanimate objects can be treated in a related way. Much of the centrifugal surge in what appears to be an exploding mountain (IV.25) comes from a series of echoing forms, involving great slices rent from the stratified rocks and fanning out like the fingers of a suddenly opened fist. They are compounded by parallel streaks of expelled dust that mingle with the air and fire to form dense clusters of scalloped spirals. It is partly because we know that rocks can only adopt such coordinated airborne configurations under the action of the most extreme forces that we feel their motion so keenly. The one *Deluge* drawing that is worked over in ink, on its black chalk base (IV.26), becomes almost a *reductio ad absurdum* of this technique. Spirals of rock, torn in cubic blocks from the mountainside, fall in great arching arrays, like collapsing piles of stacked boxes that have received a hefty push. The desire to be emphatic has led to results that almost become ornamental in their curvaceous formality.

The representations of the maelstroms in his deluges is ultimately dependent on his 'brainstorm' drawing technique, in which each component is potentially seen in more than

IV.23

PLATE IV.24
**Lamps with revolving fountains (?),
geometry, water engineering
and other studies**
c.1508
Pen and ink
22.5 × 14.6 cm
London, British Library,
Codex Arundel, 283v

163

PLATE IV.25
An exploding mountain
C. 1515
Black chalk
17.8 × 27.8 cm
Windsor Castle, The Royal
Collection, 12387

IV.26
Deluge over wooded landscape
c.1516
Windsor Castle, The Royal
Collection, 12380

165

one position in the same sketch. At one level, such drawings are about the study of alternative positions. However, looking at one of Leonardo's compellingly vivacious studies of a cat or horse (IV.7) with alternative leg positions, it is difficult not to see the legs in terms of motion. We know that cats and horses do not have more than four legs, and we instinctively read the alternatives in terms of motion. But is this an anachronistic reading, drawing on our awareness of animation techniques? Did Leonardo see the multiple legs in this way, as a graphic equivalent of blur? I suspect he did, and that it was his awareness of the graphic effect that led to his conscious drawings of sequential postures, such as the hammering man.

Leonardo appears to have been the first to devise organized sequences of pictorial drawings to demonstrate the interrelationships of forms in implied motion, whether the components of the human body or the 'elements of machines'. The most telling application of this technique in his anatomical studies is his demonstration of the three vertebrae of the neck in 'exploded' guise (IV.27). They are set beside the upper section of the vertebral column so that we understand how the vertebrae have been separated. For good measure, he draws lines between their points of mutual articulation to show how they fit together. Not without reason does he boast that such graphic techniques allow him to convey an immediate comprehension of complex forms and their implicit function, 'which is impossible for either ancient or modern writers … without an immense, tedious and confused length of writing and time. But through this very succinct way of drawing them from different aspects, one gives a full and true knowledge of them.'

When he wishes to show the foetus in the womb, Leonardo successively peels back the layered coverings, like a seed revealed by the stripping away of the case that encloses it (IV.28). The interdigitations (interlocking) of the wall of the uterus and the placenta (shown here as multiple pads, as in a cow) are brilliantly elucidated by the peeling away of the layers from each other like strips of Velcro. There is an unerring sense of how to devise just the right graphic mode to achieve his communicative ends in the most eloquent and economical manner.

Sequential studies also demonstrate the same structure in different formal transformations. The three-cusp heart valve is shown in isolation from above and below, open and closed (I.34), which communicates the action of the valve more effectively than an 'immense, tedious and confused length of writing'. In a comparable way, the bladder is shown both full and deflated (W 19100r). The radius and ulna in the arm are shown uncrossed and crossed, effecting the rotation of the wrist, which – as Leonardo shows for the very first time – results from the action of the biceps (IV.29).

We look at such sequential studies without realizing how innovatory they are. They are now so much a part of the paraphernalia of scientific and technical illustration that we take them for granted. But Leonardo needed to invent them, which he did with an apparent facility and undoubted fertility that are disarming. Some of the methods, such as 'explosion' and peeling back, obviously relate closely to the hands-on experience of manipulating mechanical components and active dissection, but previous engineers and anatomists over the centuries had exactly the same 'experiences' without devising the graphic means to convey the formal relationships between things. The explanation – as far as such acts of visual genius can be explained – lies in the capacity for plastic visualization that we have seen driving Leonardo's vision at every stage and in every area of his work.

IV.28
**Studies of the foetus in the womb,
weight and optics**
c.1513
Windsor Castle, The Royal
Collection, 19102r

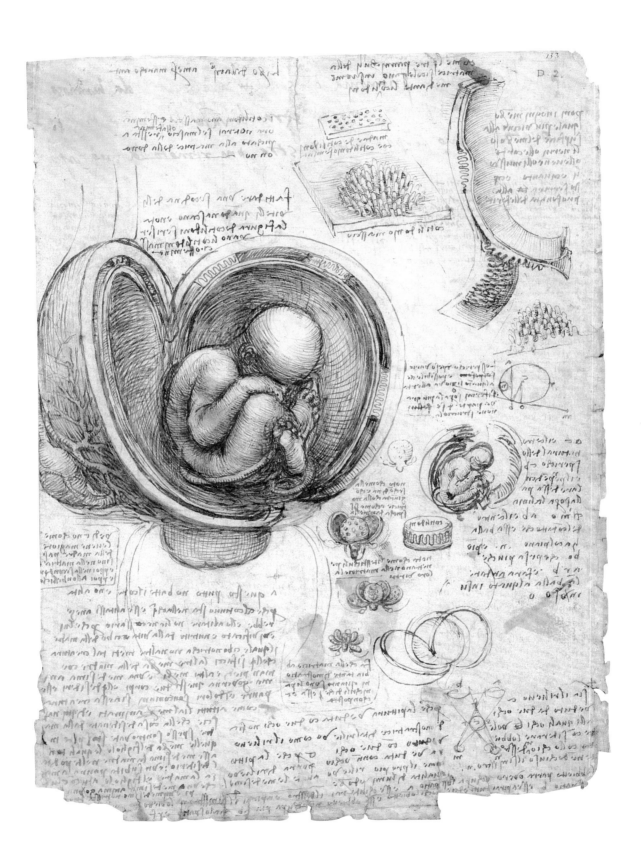

IV.29
**Studies of the bones and
musculature of the arm**
c.1511
Windsor Castle, The Royal
Collection, 19000v

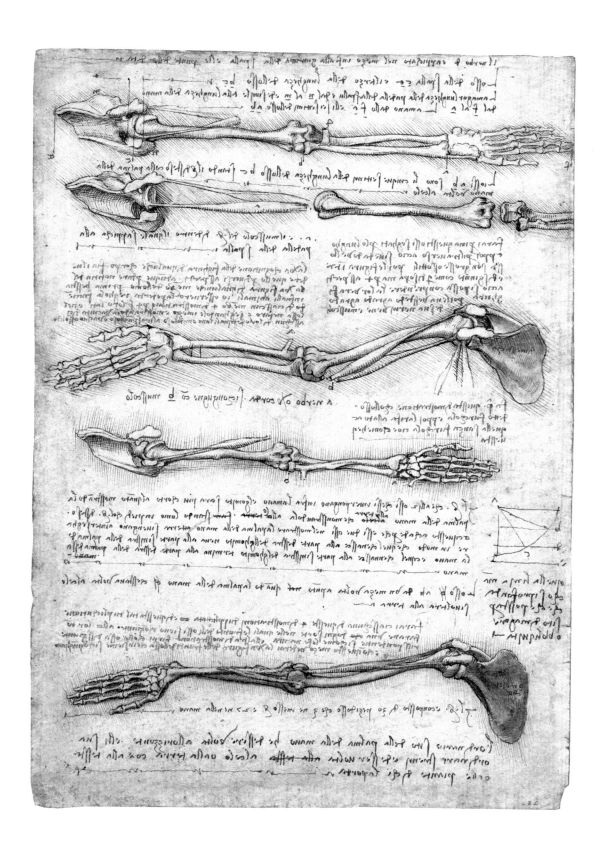

IV.30

Study of successive waves

c.1508–9

Seattle, Bill and Melinda
Gates Collection,
Codex Leicester 4B (4v)

2. Water

If we peer over the stern of a moving boat, or stare at a stream rushing past a pole driven into its bed to support a bridge, we see that the turbulent water currents are sculpted into particular shapes. Yet the shapes are infinitely mutable within certain parameters. We now know, courtesy of chaos theory, that the behaviour of water in such circumstances is unpredictable, relying on probabilities rather than certainties. If we look at any particular circumstance when water is flowing, we can see certain underlying patterns of waves. An irregularity in the bank will result in a pattern of interlaced waves that stay in more or less the same position in relation to the bank. These are known as standing waves. But the longer we look, the less fixed the phenomenon appears. We think we see 'currents' in the water. What we are in fact seeing is the optical effect of convex and concave 'bands' of water as they reflect, refract and absorb the light that impinges on them. The deeper the currents, the less apparent their motions become. It was these elusive optical effects that Leonardo translated into the firm lines that he used to describe the tangled contours of flowing water. At one point, as we noted (see p.80), he suggests adding grains of millet to the flow so that he can track the currents more clearly. But, for the most part, he has to rely on what he believes he can see happening in the transparent medium.

As in other fields in which paths of moving elements are translated into line, his actual drawings typically resist becoming purely diagrammatic. The pen strokes that he uses to describe water in motion vary in definition, continuity, thickness, pressure and density of ink, tending towards pictorial suggestion rather than linear exactness. Suggestive artistry is never far below the surface of his linear diagrams.

Leonardo clearly spent prolonged periods watching water in action, apparently captivated by the hypnotic quality of its order and disorder. The old man holding his head in the drawing at Windsor (I.19) may not originally have been intended to be contemplating the streaming manes of water – the drawing may be a study for a typically bewildered St Joseph in a Nativity or Adoration –

but the unfolded sheet serves as a nice emblem for his contemplative activity. The multitude of notes and little drawings in the Codex Leicester cannot but reflect intimate and prolonged study of the behaviour of water in many different circumstances. Given the nature of the codex, none are likely to be sketches made directly from the phenomenon, but some retain the air of direct observations.

The sketch at the top right of the left-hand page of folio 4B is one of those that looks fresh and uncontained (IV.30). It provides the basis for a typically exhaustive analysis:

> The main break of the succeeding waves always occurs facing the upper part of the preceding wave, which falls over the interval in between, and in the reflex motion made towards the sky it reduces the length of the river, so that the following water hits the base of this wave and pushes it forwards with the rest of the river, and the wave that acquires its motion when it was raised up falls back on the oncoming water.

I confess that I find this difficult to follow, even with the drawing. The letters, *fpg nom*, do not begin to feature until the fifth note, almost halfway down the page:

> … the lunular shape of the interval between the two waves is explained as being created by necessity, for as said in the first of this [the first section of Leonardo's intended book], as the rising waves *nm* consume the time of their motion towards the sky and lose the impetus of their motion towards the end of the river, the waves *fg*, which by rising, are less deep, so that it follows that the time of their motion is directed towards the end of the river, and because of this they are joined together in two lunar cones.

Fg denotes the profile of the rear wave, while *nm* indicates either end of the central line drawn across the trough between the waves. We can reasonably assume that the drawing appeared either as the first or second item on the sheet, and that it was only halfway down that Leonardo returned to label it.

IV.31

Studies of a tree, poles and other obstacles in streams of water
c.1508–9
Seattle, Bill and Melinda
Gates Collection,
Codex Leicester 14A (23v)

IV.32

Studies of shaped obstacles
c.1508–9
Seattle, Bill and Melinda
Gates Collection,
Codex Leicester 15B (15v)

IV.33

Studies of shaped obstacles in a stream of water
c.1508–9
Seattle, Bill and Melinda
Gates Collection,
Codex Leicester 13B (24r)

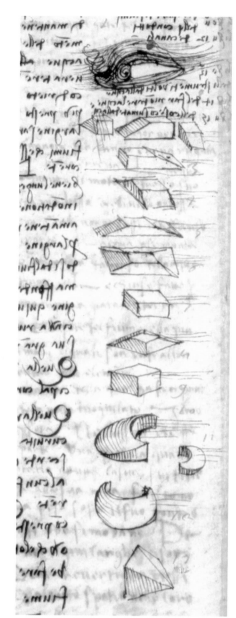

IV.31 IV.32 IV.33

There is something both heroic and dispiriting in his efforts to capture and codify the complexity of such phenomena in word and image. His laboured written vocabulary, some of which he had to invent for the purpose, struggles to formulate the rules behind effects that he could describe so vivaciously in his drawings. Not the least problem is that his drawings can suggest the complex and elusive beauty of the phenomenon, while the words have to operate more ploddingly with precise codification. As he moves from 'case' to 'case' and 'proposition' to 'proposition', there is a certain desperation in the sheer accumulation of effects as he attempts to master the series of causal variables and proliferating effects. The speed of the current, the depth of the channel and the configuration of the bottom and banks all take their effect in what we now know to be unpredictable outcomes.

The left page of folio 14 announces that it treats '15 cases', and the right page contains '26 cases'. The 'cases' continue to accumulate throughout the codex. The upper drawing

(IV.31) shows a relatively naturalistic image of a tree trunk protruding from a swift stream, which is about to merge with another. The note explains:

> When 2 currents meet together, as soon as one of them has percussed the object that protrudes out of the water, then a sudden and great depth will occur, as happens with the current ac, which having percussed f, the protruding object, will excavate at pn where the current bd immediately falls, and finding the bottom deeply hollowed out will augment the given concavity.

This is one of Leonardo's least tortuous descriptions.

The subsequent 'cases' begin to explore variations on the theme of obstacles of varied number, position, orientation and shape. Elsewhere (IV.32), he sketches a series of geometrical obstacles that he intends to place in a stream. On the right page of folio 13B (IV.33) a series of ovoid obstacles – singly, in pairs and in threes – interfere with the flow. The results in these 'cases' are highly formalized

and seem to be synthetic variations rather than relating as directly to specific observations as others in the codex. As is customary, he is aspiring to become so naturalized in the causes and effects of the phenomena that he can construct what will occur in any given circumstance.

We may fairly feel that such studies have passed far beyond immediate utility to the *maestro d'acqua*, and even beyond practicality as pure science. However, as in his prolix variations on balances and pulleys, Leonardo is bewitched by the ornamental and musical variations that he and nature can play on such geometrical themes. They are demonstrations of his having mastered how effects of apparently endless complexity can arise from simple sets of intersecting causes. The seduction of such an achievement, which allows him god-like to act as a 'second nature' in the world, is clear. It becomes more problematic when he expects us to share his persistence in exploring 'case' after 'case', following the necessarily tortuous written analyses that accompany his energetic little sketches. He knows that the text is absolutely necessary, as he recognized elsewhere in his later science, but it nowhere rivals the exhilaration of his drawings.

If the water drawings ultimately seem to be heading in an exhaustively and exhaustingly unproductive direction, his efforts do bear spectacular fruit when he applied what he was learning to the heart. There is, of course, no way that he could observe in detail what was happening with the blood flow in an actual living valve, even with vivisection. The model, with grains of millet added to the flow, would help, but only to a degree. But he was able, as we have seen, to visualize the vortices within the constrained neck of the aorta and the three cusps with notable perspicacity. He accomplished this on the basis of his knowledge of the shapes of the 'containers' and of how fluids behave in such circumstances. Even before he made his confirmatory model (if he did indeed construct it), he had envisaged the flow pattern with astonishing perspicacity. If, to pick up the inadvertent juxtaposition on the Windsor sheet (1.19), the old man's head seems to have been hurting as he contemplated the infinite complexities of nature, he could take comfort that his strivings might bear fruit at any time and in any field of endeavour.

3. Air

When Leonardo had to envisage invisible currents in air, as in his efforts to plot the vortices under the wings of a flying bird, he happily transferred what he had been able to observe and deduce about the motions of water to its sister medium. The graphic conventions that he used to show currents in air and water are identical and, although air is compressible, as he realized, the motions of 'air in air' are characterized as essentially the same as those of 'water in water'. But this is not the same as observation, and Leonardo always desired to 'see' things in order to certify their reality.

The only way in which the behaviour of air in motion can be seen is through secondary effects. The primary way in which air manifests itself visibly is when it moves with sufficient force to affect things in its path. It was this force that he characteristically endeavoured to measure in a systematic way in the Codex Arundel (IV.35), a sheet that announces that it will give the 'rule by which we may learn to gain experience of the motion of air and water'. In the upper diagram, the deflection of the suspended plate along the curved scale will register the force of the wind (and water?). In the first of the diagrams below, he considers the effects of funnels of different apertures and the same length on the collection and amplification of the moving air currents. He seeks to balance the different rotational forces generated on the vanes of a wheel by hanging counterpoised weights of 4 and 20 from the shaft. Below, he thinks about funnels of different lengths but with the same aperture, and even speculates about an improbable funnel curved like a horn. What begins as a practical device to measure the force of air currents develops in a typical way into a set of theoretical experiments, in which the drawings speculatively serve as 'theory machines'. In the final note, he reminds himself to 'test' the set-ups — also with water.

The actual course of the air currents only becomes visible when some light bodies are borne aloft and along in the moving air. Like Dante before him, Leonardo watched the dancing particles of dust in a beam of light passing into a darkened room (Leic 4A (4r) and Dante, *Paradiso* XIV, 112–17). Piero della Francesca had recorded just such

IV.34
**Studies of a scythed chariot
and armoured car**
c.1494
London, British Museum
inv. no. 1860-6-16-99

an effect in the beam of light that streams through the window in his *Senigallia Madonna*. Dust and other particulate matter such as smoke was a godsend for the artist who wished to depict moving air, or objects moving through air.

The famous 'tank' on the British Museum sheet (IV.34) scuttles across the lower part of the page from left to right, throwing up a turbulent wake of dust and smoke, accompanied by shots that pursue visible tracks from the mouths of the guns. This formula became a standby of Leonardo's illustrations of guns firing in his characteristic multiple systems. It is difficult to tell whether the turbulent clouds

are composed of smoke or dust, but the distinction is unimportant since the linear configurations come to serve as an effective and standard way to evoke the physical and emotional fires of battle. His account of 'How to represent a battle' begins by telling us:

> You must first represent the smoke from the artillery, mingled in the air with the dust stirred up by the motion of the horses and the combatants. Realize the mingling effect as follows: dust, being composed of earth, has weight, and although on account of its

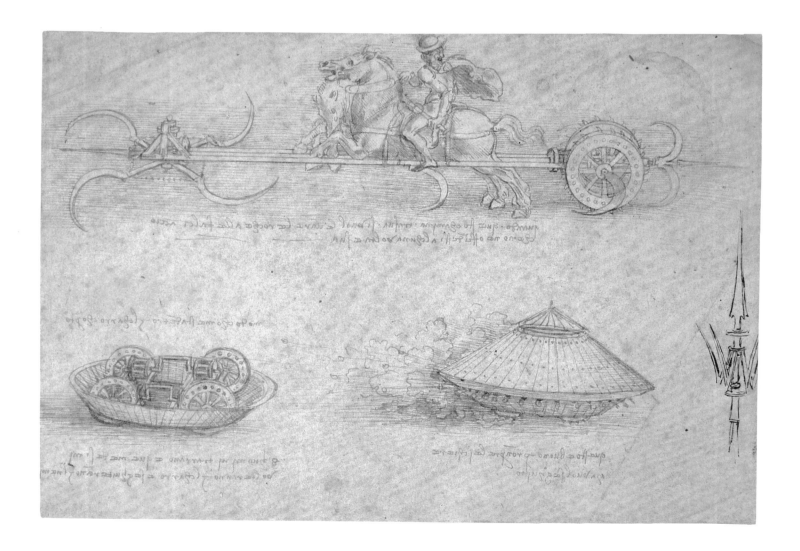

PLATE IV.35
**Devices for the measurement
of the force of wind
and jets of air or water**
c. 1490
Pen and ink
15.1 × 21.2 cm
London, British Library,
Codex Arundel, 241r

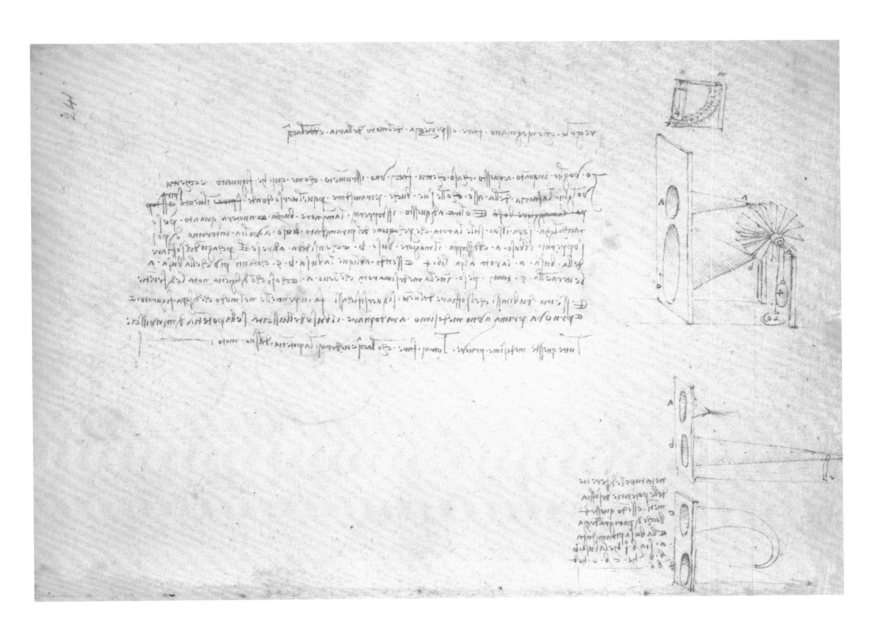

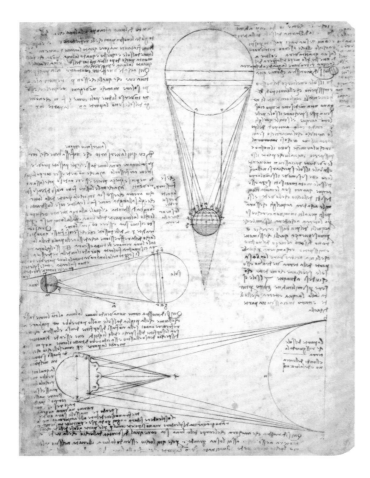

IV.36
**Study of the bright and shaded
portions of the moon in sunlight**
c.1508–9
Seattle, Bill and Melinda
Gates Collection,
Codex Leicester 1A (1r)

fineness it will rise easily to mingle with the air it nonetheless is eager to resettle. The finest particles attain the highest reaches and consequently will be least visible and will seem to have almost the colour of the air. The more the smoke mingling with the dust-impregnated air rises to a certain height, the more it will have the appearance of a dark cloud, and at the summit the smoke will be more distinctly visible than the dust. The smoke will incline to a bluish colour and the dust will tend to its own colour. From the side from which the light comes, this mixture of smoke and dust will seem much more luminous than from the other opposite side. The further amidst this swirling mass just described that the combatants are, the less they will be visible and the less difference there will be in their lights and shadows.

This passage is utterly typical of the demands Leonardo makes on the painter. Even the mixture of smoke and dust obeys rules, both dynamic and optical.

In the *Deluge* drawings (I.22 and IV.26), the raging currents of air are infused with a densely swirling soup of pulverized earth, crashing clouds and waters that are falling from the skies and snatched up from lakes. But he does differentiate between them. The terrestrial waters, even those that are fully airborne, retain the linearity of their impetuous vortices, whereas the particulate matter and droplets rage in spiral clouds with scalloped edges.

Leonardo specifically described how dust 'will rise up like smoke or wreathed clouds through the descending rain' in his account of 'the deluge and its display in painting'. Across the top of the most formal of his deluges, almost obscured by the dark clouds and terrible vortices, he calmly writes: 'Of the rains. Make gradations of rain fall at diverse distances and of varied darkness, and the greater darkness will be closest to the middle of its mass.' As is utterly necessary, the *fantasia* of the artist nourished itself on the *intelletto* of the searcher after truth.

For the most part, phenomena transmitted by or through the air were not visible, unless through proxies mingled in the air or through resistant bodies placed within it. Light only became apparent through its 'percussion', whether on particulate matter in the air or on solid bodies. Sound was not perceptible until it was received in the ear. This did not, of course, stop Leonardo representing how they moved.

Light was conventionally represented as 'rays', characterized in terms of line as straight paths that diverged only when reflected or refracted. Leonardo did not deviate from this practice, which had served optical science well, as the Islamic and medieval investigators endeavoured to plot the effects. Whether he was charting the rebounds of sunlight from the earth (IV.36 and IV.22), the effects of light rebounding from rippling water (IV.37), the mobile sheen of highlights on shiny surfaces or the converging streams of rays reflected from concave mirrors (IV.38 and IV.39), the proof lay in the precise use of ruler and compass. He was much concerned, in his effort to invent ever more effective 'burning mirrors', in emulation of Archimedes, to understand the differences in focus between concave mirrors of different curvatures, in order to produce the right focus that generated the most concentrated heat. If he wished to forecast the performance of a mirror, geometry on paper generally served to provide the answer. However, in the lower drawing on 87r, he shows how he intends to coat a mirror with white paint, which is then scratched off in lines, so that he can see individual rays.

Where he extended the reach of the optical scientists' diagrams was in his plotting of the grades of light and shade on solid bodies and the gradations of cast shadows.

PLATE IV.37
**Water flow and reflections of rays
of light from water, etc.**
c. 1508
Pen and ink
21 × 14.5 cm
London, British Library,
Codex Arundel, 25r

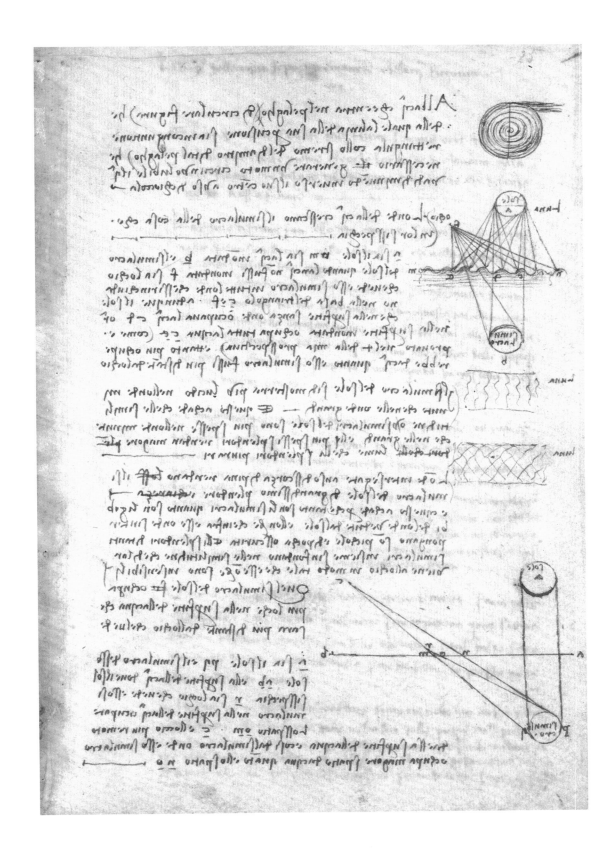

175

PLATE IV.38
Plotting rays of light from concave mirrors, also conic sections and other optical studies
C. 1509
Pen and ink
21.5 × 14.75 cm
London, British Library,
Codex Arundel, 73r

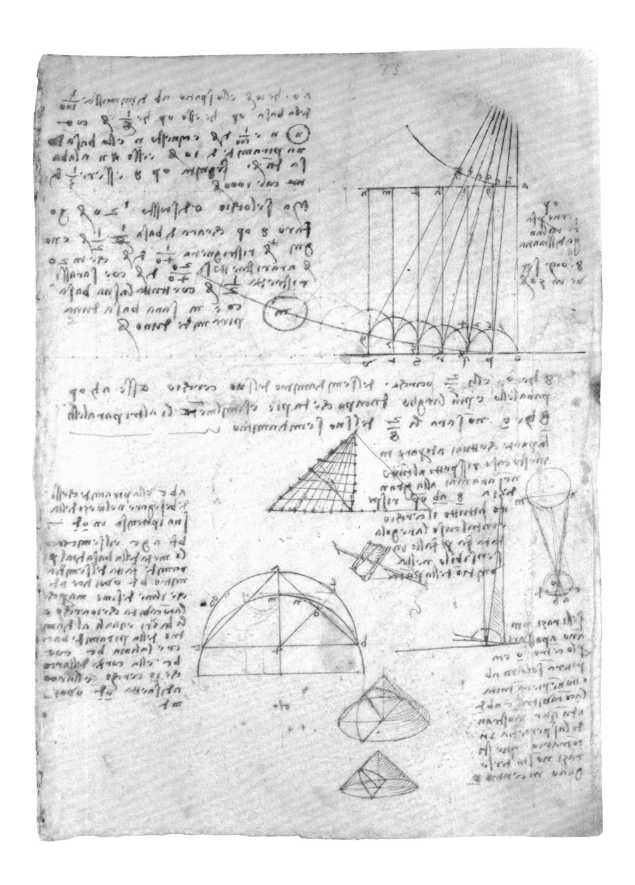

PLATE IV.39
**Plotting rays of light from
concave mirrors**
c. 1509
Pen and ink
21.9 × 14.4 cm
London, British Library,
Codex Arundel, 87v

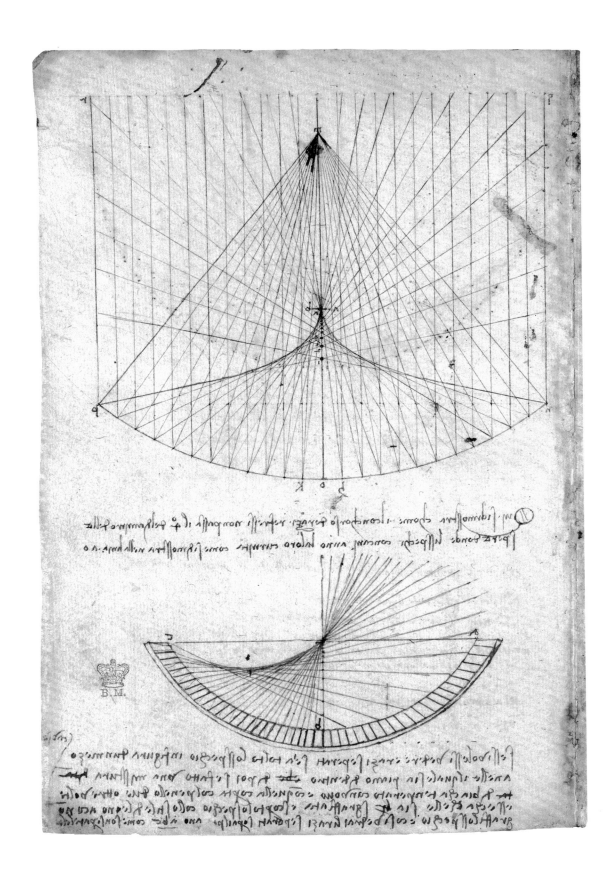

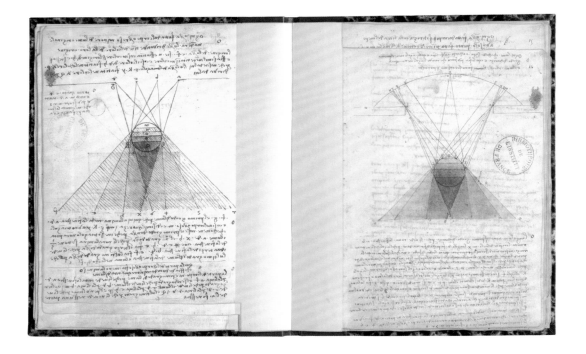

IV.40
**Studies of the illumination
and shadows of a sphere
through a window**
C.1490
Paris, Institut de France,
BN 2038 13v–14r

The systematic definition of light and shade on solid bodies, whether regular or irregular, served the needs of his beloved *relievo*, which was necessary to give the plastic definition of forms on the flat surfaces of his drawings and paintings. The rules were, inevitably, proportional and indeed pyramidal in their operation (IV.40). He knew, of course, that the transitions of light and shade across forms were continuous rather than banded, as were the grades of umbra and penumbra behind the illuminated body. He also knew that we could not see the cast shadow as it passed through the air. But the tracing of discrete rays gave him the opportunity to note how the relative strength of the percussion of the light on an angled surface depended on its angle of impact, as we have seen (II.29). It also allowed him to compute the quality of the 'detached' shadow when it encountered a surface.

He did not limit himself to single light sources or single windows. On the sheet at Windsor containing the hammering man (IV.43), he looks at the patterns of 'detached' shadow that are created by two sources larger than the illuminated body, while on the other half of the folded page he studies a similar phenomenon with coloured sources of light. The red light will cast a blue shadow, since it can 'see' the blue light, while the blue will cast a red shadow. It is a nice effect for an experiment, but certainly not the kind of effect he ever considered for a painting.

The lines in his optical diagrams did other jobs than representing rays. Since the force of the rays diminished according to the pyramidal law, as did relative size, the degree of diminution could be represented by concentric bands or 'ripples', each of which denoted a further grade of diminution at each step away from the source. The effect

was analogous to that of ripples radiating concentrically from a stone dropped into a pool of water, even though there is no evidence that Leonardo considered the transmission of light to occur in waves. The same pattern occurs with sound.

He specifically illustrated the analogies between a sound originating in a rectangular space, and 'pouring out' through an aperture, and wave patterns in water (IV.41). The upper diagram begins with water:

> Go in a boat and make the enclosed space *nmop*, and put inside it two pieces of board *sr* and *tr*, and make a percussion at *a* and see if the interrupted wave passes with its available part as far as *bc*. And that experiment that you make by cutting off the circular wave of water, you will understand to extend to an experiment with that part of the wave of air that passes through a little hole [as when] a human voice enclosed in a box passes through it, as was seen at Campi when a man was shut in a cask with the bung hole open.

The lower diagram specifically shows how the voice *ab* emerges through the aperture *cd*. The sound travels from its source in a tapering pyramid that passes through the hole and expands on the other side, like light passing though the pinhole of a camera obscura (IV.43). As it propagates itself on the other side of the hole, it does so in a new series of concentric ripples, like the water in the upper demonstration. It is characteristic of Leonardo to cite a witnessed 'experience' to tie the abstract analysis to reality.

To judge from his surviving manuscripts, the nature of the propagation of sound occupied relatively little of his attention, at least compared to his sustained explorations of light and water. It was no doubt frustrating that it

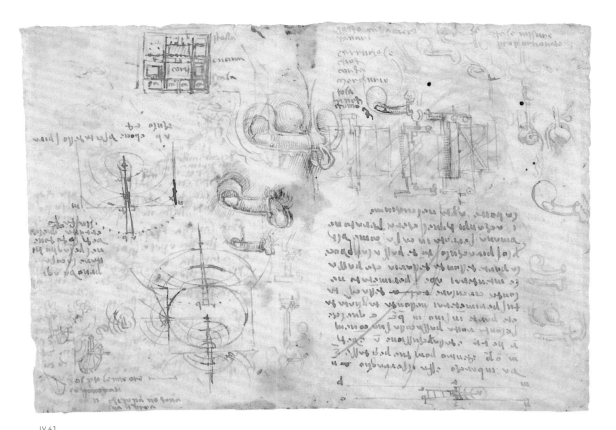

IV.41

IV.41
Studies of the transmission of sound and water, anatomy, sexual intercourse, machinery and architecture
c.1508
Windsor Castle, The Royal Collection, 19106v

IV.42
Studies of light and shadow on the moon
IV.22 (detail)

PLATE IV.43 (overleaf)
Studies of light, the human eye and a hammering man (with pupil's drawing of a crouching man)
c.1508
Pen and ink, red and black chalk
43.7 × 31.4 cm
Windsor Castle, The Royal Collection, 19149v, 19150v, 19152v and 19151v,
(Pedretti 118v)

could not be 'seen', and he assumed that the principles that operated with visible phenomena held good with sound. It would radiate from its source, percuss on objects, rebound and diminish in the way required by 'Necessity', just as in the transmission of light.

Even when drawing linear diagrams of optical effects with geometrical draughting instruments, often laying in the basic geometry with a blank stylus, Leonardo was regularly prepared to let his natural gifts of hand render the beauties of the optical effects in a suggestive manner. The hatched and washed-in shadows are never drily mechanical, and when he comes to describe the 'ashen light' (*lumen cinereum*) that results from sunlight rebounding from the earth to the shaded portion of the moon (IV.42), the effect might even be described as romantic. The lit crescent of the new moon stands out against the incredibly fine, parallel hatching of the background, which serves to denote the darkness of the sky, while the shading of the moon itself lessens almost imperceptibly to convey the subdued glimmer of the light arriving from the earth. Even looked at under magnification – the diameter of the moon is only 2.5 cm/1 inch – the minute delicacy of the shading is remarkable. For such an elusive effect he continued to prefer parallel hatching to the more crudely emphatic hooked shading that he used, for instance, to describe water vessels elsewhere in the same codex (II.20 and III.23).

He came increasingly to realize that optics 'out there' was one thing, and what we actually see is another. In

Manuscript D, which dates from 1507–8, and in other later manuscripts and drawings, he turned his attention to how the eye actually works as a perceptual instrument. He was already worrying about this problem in the 1490s, and on one drawing at Windsor (IV.44) he asks 'whether the rays enter into the eye straight or are bent on entering or not'. The answer to this and related questions about the refraction of the rays in the eye led to his abandoning the idea that it can be understood as a simple instrument for the geometrical reception of the visual pyramid – without any 'bending' of the rays. He increasingly realized that the eye's operation is anything but straightforward. The medieval sources from which he drew so much inspiration, especially the writings of Alhazen, described the eye as a

IV.42

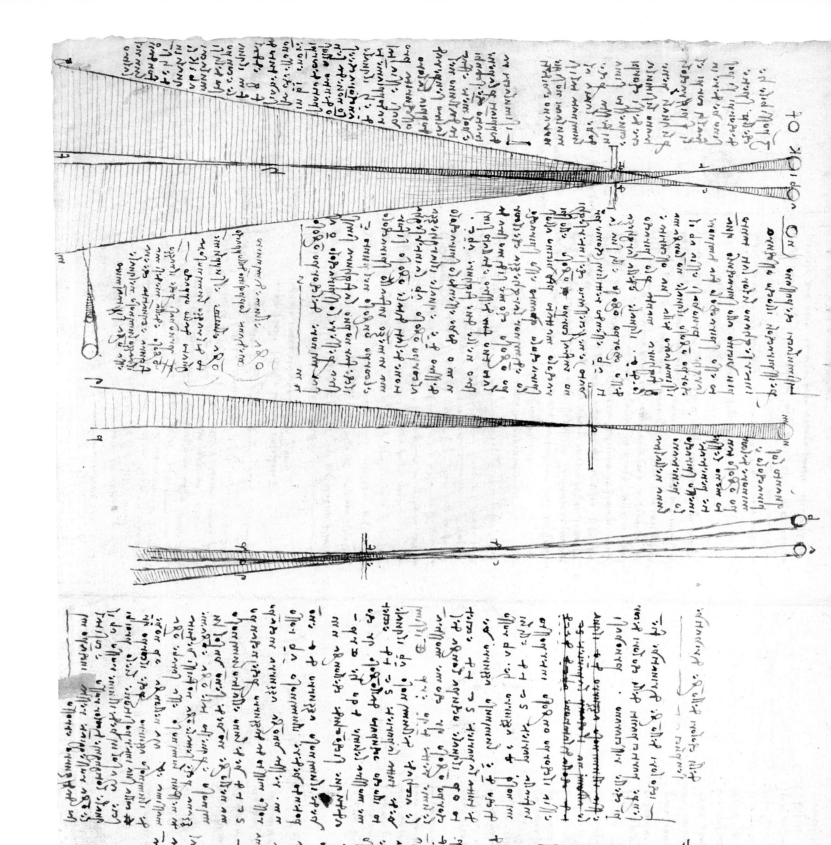

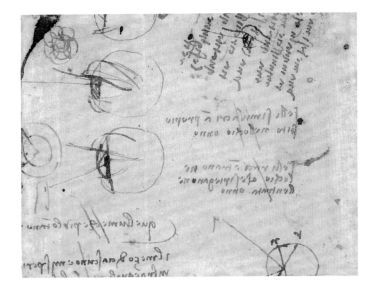

IV.44
**Studies of light rays
entering the eye**
1508
Windsor Castle, The Royal
Collection, 12447v

complex device that refracted the rays to produce an image of finite dimensions.

Accordingly, in Manuscript D Leonardo tried to plot the path of the rays through the translucent humours of the eye, with the 'crystalline sphere' as the main optical component. In a series of drawings (IV.43 and IV.45) he explores various possibilities on the basis of what he knows about the passage of light through apertures and within glass. He is reasoning diagrammatically about what must occur in the eye. At one point he suggests making a model to test his ideas, but for most part he has to rely on speculative plotting of the light rays. He has nothing like the amount of anatomical information that enabled him to resolve the action of the heart valve.

The basic model he adopts is that of what we now call the camera obscura – that is to say, a 'dark chamber' or box with a pinhole aperture through which an image passes from outside to be re-formed inside as an inverted image. The Windsor sheet shows rays from three objects entering two holes in a camera obscura and forming a reversed array of six images inside. The crossing of the rays at a point, and their reconstitution without mingling, was a repeated source of fascination for Leonardo. He considered that the pupil in the eye acts like the aperture of the camera, inverting the image. In the sketches below the camera he experiments with optical arrays that achieve the re-inversion of the image in the eye, since he cannot believe that we see the world upside down.

He concludes that the eye must posses a surface on which an image is received. He is able to adduce various pieces of evidence to support this concept, describing how a very small object close to the eye, or a fine cloth with an open weave, will not occlude what is behind it in a simple way. He argues that the reception of rays across this receptive surface prevents us from ever definitely knowing the precise boundary of any form. The little drawing at the foot of the Windsor sheet (IV.43) shows

schematically how rays from different parts of a surface will pass by the edge of the body *nm* to be received on the receptive surface in the eye. The optical premises around which he is operating remain those of his medieval predecessors, and he is not describing the retina on which a lens focuses an image. However, his willingness to complicate and disrupt a theory that served him well as a painter is an act of considerable intellectual courage.

The medieval sources from which he drew so much inspiration also devoted considerable attention to *deceptiones visus*, optical illusions, or what we call 'subjective effects'. The effects of blur fell into this category. He noted how the narrowing of the pupil in strong light prevents us from seeing clearly through windows into shady interiors, and how when we are indoors the outside light seems glaringly overwhelming. He describes how a very bright light leaves an image in the eye for some time after the light can no longer be seen. He recorded how dark colours are enhanced at their boundaries by juxtaposition with light ones, and vice versa. And he noted the positive effects that some colours, such as red and green, have when placed next to each other.

The 'subjective effects' and optical uncertainties that he defined in his later manuscripts remained largely unpaintable and undrawable. They informed his understanding of how we see, as 'speculators' on natural phenomena, but the painter generally needed to resort to the more concrete optics of laws and effects in the external world to perform his acts of remaking. Leonardo was happy to play with the indefiniteness of edges, but many of the 'optical deceptions' were too disruptive to be admitted to the painter's repertoire.

4. Fire

Fire 'desires' to rise, to an even greater extent than air. Its impulse is vertical, and the patterns it makes in striving to maintain its path in the face of resistant air (including the inevitable vortices) are similar to those of water, and thus to those of air. However, at least flames are a direct and visible manifestation of fire. Flickering tongues of flame, often rapidly and schematically drawn, appear in Leonardo's

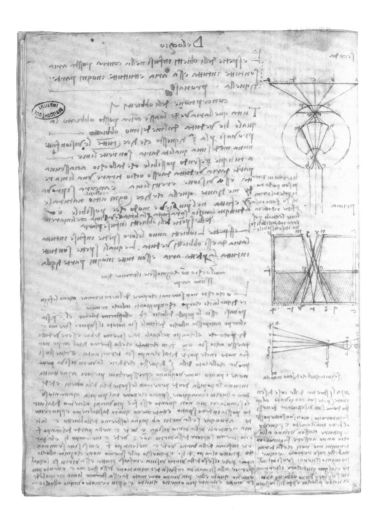

IV.45
Studies of the paths of rays entering the eye and other optical phenomena
1508
Paris, Institut de France, D 10v

emblems and mechanical drawings when he needs to indicate where a fire is placed (IV.11). For once there is nothing particularly innovative about his ways or means.

What Leonardo makes of the conventional ways and means can nonetheless be notable. In the series of apocalyptic drawings related to his late vision of deluges, there is one in particular that relies primarily on fire as a destructive and devouring force. A sheet at Windsor (IV.46) contains a series of explosive sketches, dense with apocalyptic effects and distinctly biblical in feel. The page begins at the top with a sober written account of the effects of lights in clouds. The billowing clouds below the writing serve as illustrations and resemble those much earlier demonstrations in the 'Theme Sheet' (INTRO.1). But these apparently unexceptionable clouds seem to be releasing a shower of menacing curves, more recognizable as tongues of fire than cascades of water. Gathering in density towards the ground, the threatening shower appears to be encroaching on a castle and compound built on rocks. Below to the left, a rain of fire is plunging onto a huddled crowd, at the centre of which is an exceptionally large figure. The crowd is being consumed by flame. Below the castle is an exploding mass of pure energy, expelling flame and smoke from its core and radiating heat in straight beams. The exploding mass hovers above a great cylindrical cavity excavated from a

mountain range. Waters appear to be raging at the base of the cavity. To the left of the explosion is a tangle of little figures, some or all apparently skeletal and on whom more destruction rains from above.

The visionary territory that Leonardo inhabits is clear enough. It takes its cue from the prophets of the Old Testament, who envisaged dreadful torments rained from on high to castigate the sinful citizens of Israel. The skeletons – if such they are – recall the predicted resurrection of the dead at the dreadful Day of Judgement. The vision of the massive 'theatre' in the mountains is reminiscent of Dante's *Inferno*. Leonardo would himself have heard the fiery prophecies of the Dominican monk Girolamo Savonarola, who preached the destruction of degenerate Florence, before its rebirth as a new Jerusalem – to such effect that he catalysed the expulsion of the Medici in 1494. Fires and swords rained down in Savonarola's more violent visions. It seems unlikely that Leonardo's conflagrations were precisely illustrative of a particular text, but arose through a chain of visual associations as he filled the sheet with increasingly terrible thoughts. What began as a meditation on atmospheric effects has transmuted itself into savage visions of the end of human existence.

A Dance to the Music of Time

Leonardo was vividly aware of the inexorable march of time as it eroded the ambitions he had set himself. We have already noted the recurrent refrain 'Tell me if anything were ever done ...' Time was as real and irresistible as it was invisible. As an abstract property, time was essentially different from the other dimensions that governed the physical universe. Although he classified time as a 'motion', it posed representational problems of a different order.

It was of course necessarily present by implication in any of his diagrams in which he traced time-based performance (IV.23). Indeed, a certain measure of continuous time was embedded in all his presentations of time-based phenomena. In fact, none of his images of things in motion

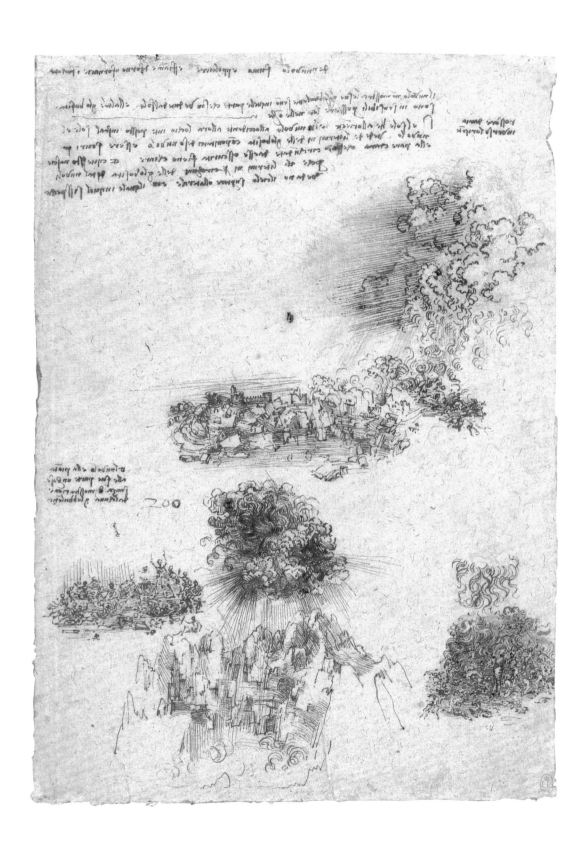

should be seen, anachronistically, as some kind of instantaneous snapshot. Whether he was representing the ravages of a deluge or the reactions of the disciples in the *Last Supper*, he was not portraying a 'moment in time'. Rather he was showing an unfolding phenomenon of a finite and greater or lesser duration, often with rippling references to events that preceded what is happening and that were to follow. Time, like space, was a 'continuous quantity'. Even a figure in action, captured on paper at one point in space and time, was envisaged and was to be seen as part of a continuity, since it would be represented in such a way that we could understand how it has moved to get to that position and where it will shortly be.

The continuity of time was evident, but there were many reasons why it needed to be countable in separable increments. Measuring time was a problem, at least if any degree of precision was required. A sundial performed well enough for hours and larger fractions of hours. Hour glasses and water clocks worked tolerably for fixed intervals of a minute, and even for larger fractions of a minute. But anything approaching a second was very difficult to measure accurately. Although Leonardo was not involved in quantification to the extent that Galileo and his successors were, he did have a desire to measure short units of time when he was studying dynamic systems. Mechanical clocks had achieved a relatively high degree of accuracy, but were far from accomplishing the levels of regularity that became possible with the invention of the pendulum in the seventeenth century.

The problem was not the design of gearing to translate the motion of descending weights or unwinding springs precisely into the turning of the hand or the revolving of the clock face. Rather the difficulty lay in translating the sources of power, none of which were entirely constant, into motions precise enough to count out time in regular increments. Various tick-tock mechanisms had been devised, using escapements attached to horizontally pivoted wheels or arms. Leonardo drew one such escapement mechanism in Codex Madrid I (IV.47), where a wheel with protruding pins successively engages bars or 'pallets' at the top and bottom. The upper and lower pallets will be pushed in opposite directions in a tick-tock motion,

turning the shaft back and forth. Then, two pages later (IV.48), he draws a pendulum mechanism with a 'movement that proceeds and returns like a fan, and if heavy can serve for the escapement [*tempo*] for clocks'. This potentially vital insight was not, seemingly, followed up.

Of the kinds of power available to Leonardo, a barrel spring had obvious advantages of compactness and portability, but its power progressively diminishes as it unwinds. We have already seen one of a number of his attempts to devise a form of gearing that would compensate pyramidally – in reverse – to this diminution (III.17). Brunelleschi, the great architect and inventor, had earlier been involved in the perfecting of the *fusée*, a device to achieve the same result, in which a cord was wound onto a conical, grooved barrel.

At their best, the refined mechanical clocks enabled the minutes and hours to be counted more reliably, and their ticking delivered the kinds of small units that could potentially yield reasonably precise results in the investigation of time-based phenomena of short duration. However, when Leonardo himself talks of measuring small intervals, he reverts to a more traditional method, using what he called 'musical' or 'harmonic' time. Tempo – the term that denotes speed in music – is, after all, the same word in Italian as that for time. The defining of tempo relied on rhythmic beating, and when something approaching a common measure was needed, the beating was most conveniently linked to the heartbeat, or *tactus*, of a resting person. A 60-second pulse rate is in the normal range, but is of course subject to wide variation from one person to another. However, as a relative measure, taking the same person's heartbeat at rest as the reference scale, it is reasonably reliable. This link between music, the physical realities of the human body and the 'motion' of time held an obvious appeal to Leonardo, and transformed time into something that was literally tangible.

The closest he came to a graphic description of the abstract concept of time is when he used either concentric ripple diagrams (III.20) or the pyramid to look at the diffusion and diminution of motion across space. However, the regular steps in the diagrams should be seen as distance rather than time. Indeed, neither he nor his contemporaries

IV.47

Escapement mechanisms

c.1500

Madrid, Biblioteca Nacional, I 7r

IV.48

Pendulum escapement mechanism

c.1500

Madrid, Biblioteca Nacional, I 8r

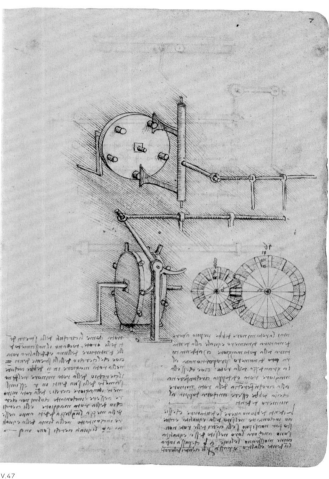

IV.47

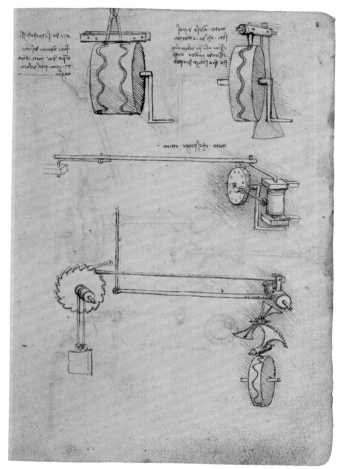

IV.48

had recourse to adequate formulas for the relationships between force, mass, velocity, time and distance. He intuited that there were fixed proportional relationships between the initial impetus embedded in an object and its performance in time and space, and thus its decreasing speed, but the algebraic equations needed to express the relationship between force, mass, velocity, distance and time were not within his, or his contemporaries', scope.

Perhaps the nicest physical realization of time in his manuscripts involves philosophical entertainment rather than precise measurement. He had long been fascinated by water clocks, not least for the way in which the laws that govern the regular flow of water might be used to drive a device for the measurement of time. The peak of his activities

with clepsydras seems to have come in 1508, when he was working on a villa and gardens for Charles d'Amboise in Milan. We have already noted his drawings for a valve and, perhaps, a humanoid automaton (III.33). Two fragmentary drawings at Windsor (IV.49 and IV.50), clearly excised from the same parent sheet, show him experimenting with a series of vessels filled with water and a large bell on a pole. They relate to a series of fragmentary designs in the Codice atlantico and other manuscripts. A series of cylindrical vessels are crammed into cylindrical 'well', surrounded by a small step, on which one of his characteristically animated homunculi stands to strike a powerful blow, or blows, on the centrally mounted bell. The vessels are arranged in a spiral series, in which their diameter increases towards the

PLATES IV.49 AND IV.50
Studies for a water-clock with
automaton bell-ringer
c. 1509
Pen and ink
12 × 12.5 cm (mounted together)
Windsor Castle, The Royal
Collection, 12688 and 12716

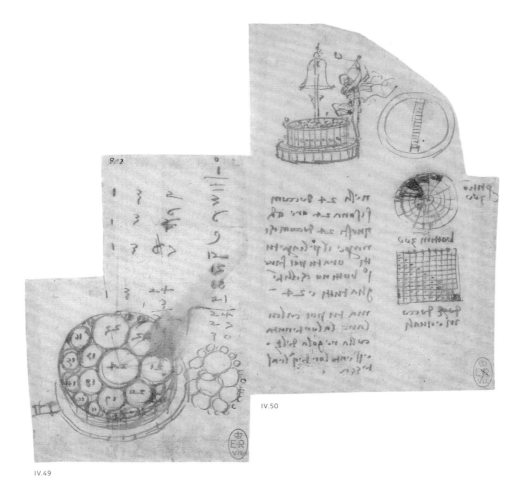

IV.50

IV.49

IV.51
**Studies for the release mechanism
for a water-clock**
PLATE III.33 (detail)

centre. The numbers run from one to 24, corresponding with the hours of the day. Beside the close-up of the tops of the cylinders, in which he has run into difficulty in the placing of the smaller vessels, he makes a rough sketch of the intended spiral. The effect is a kind of reverse phyllotaxis – that is to say, working opposite to the way in which leaves emerge from a germinating shoot.

On the right fragment he draws an alternative arrangement for '300 partitions' in a schematic plan. Above the drawing of the cylinders on the left fragment he begins to work out the amounts of water according 'to the rule of 3'. The modern formula for this rule is $V = \pi r^2 h$, where V = volume, r = radius and h = height. Since, as Leonardo notes, the height of the vessels is the same, the necessary increase in the cross-sectional area of each successive vessel comes from adding one-third to that of the previous vessel, expressible as $A = \frac{1}{3} r^2$, where A = area and taking an approximation of 3 for π (2.9 ...). The vertical sequence of figures above the rough sketch of the vessels begins the process of addition: '3, 6, 6 ...' The square grid on the right fragment does the same job diagrammatically. The first volume comes from adding the 1 and the 2 in the first two columns, while the second comes from adding all three columns together. Thereafter the columns are added in successive sets of three. We may suspect that he liked the diagram better than the columns of figures. In this question of the increase in the cross-sectional areas of cylinders, the problem of squaring the circle lurks not far away.

The general principles of operation are clear enough. The volume of water in each vessel is in proportion to the number of strikes to be delivered by the bell-ringer, who is presumably a mechanized statue. Such a mathematical combination of volume, motion and time was much to Leonardo's liking. The clepsydra was in its own way a 'theory machine'. The specific details of its operation have to be pieced together from an incomplete series of scattered drawings and notes. The filling of each cylindrical vessel was controlled by a regulating cylinder that contained the release mechanism. The upper of the doughnut-shaped floats visible in the Windsor drawings of the regulating cylinder (IV.51) rose steadily as water flowed into it. At the top it triggered (via a tong-like mechanism) the ascent

of the lower float, which rose rapidly. This lower float engaged with a spiral track on the central shaft, twisting it in such a way that a valve opened the main vessel, releasing its water. The released water would have been responsible for driving the bell-ringer, probably via a water wheel of the kind sketched near the suit of ivy on Windsor 12282v. The first vessels would contain only enough water to effect one strike, while the last would have produced all 24.

Although some aspects of the water clock remain conjectural, we see clearly how the 'natural magic' of the clepsydra and the cunning artistry of its contrivance were designed to provide a memorable talking point – even a philosophical talking point – for visitors to Charles's projected new residence, which was designed to establish a new international norm against which all others were to be judged. For Leonardo, the water-driven bell-ringer would have provided a famed achievement to rival those of Heron of Alexandria, the legendary engineer of water automata in antiquity.

There was one other way that time was rendered concrete and visible in images. Every living thing (including 'the body of the earth') was subject to highly visible signs of ageing. Leonardo's anatomy of the 'Centenarian', as we have seen (p.50), centred on the processes of ageing and decay that found their analogies in the earth as whole. At one point he draws an effective and moving analogy with the ageing of a fruit removed from the nourishing sap of its tree:

> The old dread the cold more than the young, and those who are very old have skin the colour of wood or dried chestnut, because the skin is almost completely deprived of sustenance. And the network of vessels behaves in man as in oranges, in which the peel becomes tougher and the pulp diminishes the older they become. [W 19027v]

In the same note he also observes that:

> The liver loses the humour of the blood ... and becomes like desiccated bran in both colour and substance, so that when it is subjected to even the slightest friction its substance falls away in tiny flakes like sawdust and leaves behind the veins and arteries.

His manuscripts contain not a few meditations on the corrosive effects of time. Beside an early drawing for a relatively simple water clock, he wrote:

> We do not lack ways nor devices for the dividing and measuring of these miserable days of ours, wherein it should be our pleasure that they be not frittered away or passed over in vain, without leaving behind any memory of ourselves in the mind of men. [CA 878v]

The idea that fame that would endure and, to some degree, transcend time was a thoroughly Renaissance perception. How Leonardo would have relished his extraordinary prominence in 2006, even if he would not have recognized himself in some of his contemporary manifestations.

Coming from someone in his late twenties, his implicit declaration that he intended to strive for famous achievements demonstrates a high degree of self-consciousness, while his evident concern that he might 'fritter' away his days suggests an early strain of anxiety and even pessimism. At about the same time he wrote, paraphrasing Ovid:

> O timer, devourer of all things, and O envious age, you destroy all things and devour all things with the hard teeth of old age, little by little with lingering death. Helen [of Troy] looking in a mirror, seeing the shrivelled wrinkles of her face made by old age, wept and contemplated bitterly that she had been twice ravished. [CA 195r]

Throughout his career, Leonardo drew the weathered and collapsed faces of aged men with evident fascination and apparent sympathy. The most moving of all comes from late in his life, and shows a very elderly man, with sunken eye, hooked nose, gasping mouth and deeply flowing beard (IV.52). Drawn in black chalk with what Kenneth Clark aptly described as a 'broken crumbling touch' on coarse paper, it is the human and humane equivalent of the deluge drawings. It stands alongside the late portraits by Titian and Rembrandt as a profound visual meditation on old age.

Towards the end of his life in France, signs of Leonardo's own mortality began to bear in sharply. From the report of Antonio de Beatis, who had been in the visiting entourage

of the Cardinal of Aragon in October 1517, we can deduce that he had suffered a stroke that affected the right side of his body. Later drawings testify that he recovered well enough to draw with his previous facility and precision. But his making of a will in April 1519 signalled that he was aware of his impending death, which came no more than two weeks later. Our final assignation with time, as Leonardo well knew from the traditional imagery, was a dance of death.

THE EXHIBITION

Every drawing in the exhibition has been discussed and illustrated in the preceding text, which thus serves as a kind of 'narrative catalogue'. The details of each drawing in the following list include references to the relevant plates in this book.

At a late stage in the lead-up to the exhibition, the specific conditions set for the display of the Codex Leicester proved inoperable for the show as a whole and excessively expensive to implement. It has been decided that quite extensive discussions of material from the codex should remain in the book, since the Leicester material is integral to its themes.

A note on codices, pocket books and sheets

As illustrated in modern publications (other than in hugely expensive facsimiles), Leonardo's drawings and manuscripts generally assume a misleading appearance. Reproductions tend to falsify the scale of the sheets and often give no clue as to whether they are separate pages or part of a bound manuscript.

His surviving works on paper are of six types: separate sheets, especially drawings for works of art, that have never been part of a bound volume; separate sheets that have later been inserted in bound volumes and either left in the volumes or removed and mounted separately (such as the Windsor drawings); notebooks or volumes bound by Leonardo that have survived more or less in

original form; notebooks or volumes bound by Leonardo that have been rebound collectively, either in his lifetime or subsequently (such as the Forster Codices); pages from notebooks or volumes bound by Leonardo that have since been dismembered and mounted separately (such as the Leicester Codex); pages from notebooks or volumes bound by Leonardo that have subsequently been rebound in collections of miscellaneous sheets (such as the Codice atlantico and the Arundel Codex).

The bound volumes in Leonardo's workshop ranged in type from assemblages of large sheets, which were often folded and used before binding, to very compact 'pocket books', fat with pages, which he took with him to record observations and thoughts 'on the road'. What regularly surprises first-time viewers of his manuscripts is the tiny scale of much of his writing and drawing, particularly in the pocket books, which breathe an extraordinary air of intensity.

Obviously the miscellaneous assemblages of sheets are likely to contain material from different dates, but this is also true of the notebooks that have survived in their original form. A single pocket book might be set on one side and taken up again later, maybe beginning at the 'back'. Even a single page may contain material from different dates. Leonardo acknowledged on one of the Arundel sheets that:

This will be a collection without order drawn from many pages that I have copied here, hoping to put them in order in their places, according to the subjects with which they will deal, and I believe that before I am at the end of this I will have to repeat myself many times. [Arundel 1r]

In what has come down to us, the repetitions are more apparent than any immediately obvious order. The underlying order is that of his lateral thinking rather than that of standard classifications.

The Codex Arundel has presented particular challenges in the present context. When the sheets of which it is composed were removed from their binding, it was found that they were of four types. Some were single pages, while others were double sheets laid on top of each other before stitching. Among the double sheets, some of the pages contained related material and were filled with notes and drawings during the same phase of work. These are shown here as double pages. In other cases, the 'second' page in the double spread contained unrelated material or was blank. In such instances, the 'second' page has not been shown.

A note on incised lines

There are many incised lines on Leonardo's drawings, the great majority of which have not been recorded or researched. They are

drawn with a blank stylus, generally with a sharp point. Such 'invisible drawings', apparent only in strong raking light, served various purposes. In compositional studies for works of art, they served as a way of laying down initial thoughts, without remaining apparent in the final drawing. For drawings requiring precision, such as studies of machinery, they laid down a precise armature for the designs. Unsurprisingly, they were used extensively in the preparatory stages of his geometrical drawings. More unexpectedly, blank geometrical designs, often of some elaboration, appear not uncommonly on sheets on which the later ink or chalk drawings are wholly unrelated.

Of the illustrated sheets from Windsor, ten have been observed to have incised underdrawings either on their rectos or versos (III.9, II.29, I.31, III.26 and III.27, IV.9, II.1, IV.7, INTRO.1, III.33). The 'Theme Sheet' (INTRO. 1) is richly covered in blank geometrical diagrams, preceding those that are visible. The technical and architectural drawings show incised constructional lines, as might be expected. The sheets of the human/animal heads (IV.7) and of the valve for the water-clock (III.33) provide instances of incised designs of some elaboration that are apparently unrelated to the subjects drawn in visible media.

The proportional lines at the top of the sheet with the bird's wing are pockmarked with numerous compass points, some closely clustered, that suggest Leonardo was working out proportional intervals on a trial-and-error basis. The sheet containing the study for the 'tree of vessels' (I.31), is the most surprising of all. On both the recto and verso of the sheet, two incised, parallel, vertical lines have been drawn. A series of divergent lines curve from the top of one of the parallels. Each is pockmarked by fusillades of compass points, some of which are closely paired on either side of

one of the lines. Again he seems to be experimenting in a trial-and-error manner with varied compasses openings – but to what end? The only suggestion I can make at present is that he is considering ways to construct the profiles of columns with an entasis (the variable, shallow curves favoured in classical architecture). However, the uncertainty serves to underline that such blank designs are virtually unstudied.

The widespread presence of elaborate sets of incised lines underlying Leonardo's drawings and notes is confirmed by pages from the Codex Arundel. As might be expected, those diagrams that involve very precise drafting with straightedge and compasses are constructed over armatures of incised designs, some lines of which are inked in, while the majority remain more or less invisible, having served their function as preparatory manoeuvres. The complex calculation of the tracks of rays from concave mirrors (25r and 73r) unsurprisingly involves detailed constructional procedures with a blank stylus. Similarly, the analytical diagram of the perpetual-motion wheel (44v) reveals a good deal of preparatory thinking with incisions before the final diagram is inked in. More surprisingly, the sheet with the Pythagorean number square (153r) contains a large geometrical diagram (including a large circle) unrelated to the visible diagram and drawings. Given that the number square is taken from the mathematical encyclopaedia by Luca Pacioli, it may be that the geometry was inspired by the same source, but did not proceed to the point at which Leonardo wanted to ink it in. Again, there is a series of unrecorded drawings that await full transcription and adequate research.

Exhibition themes

The exhibition is about how Leonardo thought on paper. It contains some of his

most complex and challenging designs. Although many other artists, inventors and scientists have brainstormed on paper, none of his predecessors, contemporaries or successors used paper quite as he did. The intensity, variety and unpredictability of what happens on a single sheet are unparalleled.

However, behind the apparently erratic diversity are a series of unifying themes in his vision of how the world works. The dominant theme is the mathematical operation of all the powers of nature. The manner of operation is proportional – that is to say, all static structures and dynamic phenomena manifest simple ratios in their form and motion. These ratios comprise the 'music' of natural design. The beauty of the human body, the action of levers, the motion of a thrown ball and the flow of water all obey proportional laws.

Every small part of nature mirrors the action of the whole, and the human body is specifically a 'lesser world' – lesser in terms of scale, but not in terms of wonder and complexity. In short, everything is related to everything else. Leonardo saw connections where we see only differences.

Drawing served as the primary tool of analysis and as the most potent way to demonstrate the essential unity of all things designed by nature. The human designer, whether working as painter, sculptor, architect or engineer, acts as a 'second nature' in the world, creating inventions in harmony with natural law.

Yet for all the intellectual analysis and measured description, the drawings retain an extraordinary communicative potency, able to engage us in the living nature of the world, in human motion and emotion, in the violence of battle and in the elemental force of cosmic powers.

INTRODUCTION:
A SPEAKING LIKENESS

We think we know what Leonardo looked like. The famous drawing in Turin of a beetle-browed man with gruff mouth and flowing beard is taken as a self-portrait. But it is not. The only reliable contemporary likeness is the profile drawing at Windsor, probably by his faithful companion Francesco Melzi.

Leonardo cultivated a gracious appearance, as a gentleman rather than an artisan. Although guarded in his personal feelings, he appears to have been an eager conversationalist, enquiring of knowledge and ready to express his views. In the courts where he served, he became valued as an impresario of all visual things, from weaponry to stage design. By the end of his life he was cherished as someone who possessed an unrivalled range of knowledge.

The portrait is here paired with the magnificent drawing of a warrior from the British Museum. It testifies to Leonardo's artistic origins – it is based on bronze reliefs of Alexander and Darius made by his master, Andrea del Verrocchio. It also immediately signals the special vitality with which he endows his drawings. This uncanny vitality endows his renderings of each varied subject with the qualities of 'a speaking likeness'.

No.1
Francesco Melzi (?), *Portrait of Leonardo da Vinci*
*c.*1508
Red chalk
27.5 × 19 cm
Windsor Castle, The Royal Collection,
12726
Frontispiece

No.2
Bust of a warrior in profile
*c.*1478
Metalpoint on cream prepared paper, with some white heightening, partially oxidized
28.5 × 20.7 cm
London, British Museum,
inv. no. 1895-9-15-474
Plate III.16

1. THE MIND'S EYE

Leonardo believed that any knowledge that could not be certified by the eye was in vain. Sight was the noblest and most certain sense, providing access to 'experience' of the way nature works and allowing us to work out the mathematical properties of nature's operations.

He investigated the relationship of the eye to the brain, devising a system through which visual stimuli could be transmitted to the intellect via the *imprensiva* (receptor of impressions) and the *sensus communis* (the 'common sense'), where all sensory inputs are coordinated).

The human body, as God's most perfect design, yielded a complex set of proportions. Not only could a man with outstretched arms and open legs be inscribed within a circle and a square (as the ancient Roman architect Vitruvius had claimed), but it was also possible to find detailed proportional relationships between all the various parts of the face, torso and limbs.

The building blocks of basic geometry underlay the beauty of natural form. Leonardo provided ingenious illustrations for the treatise that his mathematician friend, Luca Pacioli, wrote on the five regular or 'Platonic' solids and their variants. He also strove on his own behalf to solve a series of classic problems in flat and three-dimensional geometry.

Divine geometry in nature was most apparent in the action of light, which propagated itself in straight lines. All the powers of nature acted mathematically and obeyed the rules of proportion. Proportion was also expressed in number, most notably in the harmonies of music. Proportional formulas allowed Leonardo to work out complex variations on weights suspended from balances and to undertake destructive analyses of the quest for a perpetual-motion machine.

No.3
Profile of a man, plants, geometrical figures, machinery, etc. (also known as the 'Theme Sheet')
*c.*1488
Pen and ink
32 × 44.6 cm
Windsor Castle, The Royal Collection,
12283r
Plate INTRO.1

No.4
Studies of light, the human eye and a hammering man (with pupil's drawing of a crouching man)
*c.*1508
Pen and ink, red and black chalk
43.7 × 31.4 cm
Windsor Castle, The Royal Collection,
19149v, 19150v, 19152v and 19151v,
(Pedretti 118v)
Plate IV.43

No.5
Vertical and horizontal sections of the human head and eye
*c.*1489
Pen and ink and red chalk
20.2 × 14.8 cm
Windsor Castle, The Royal Collection,
12603r
Plate I.28

No.6
The human brain, cerebral nerves and eyes
*c.*1508
Pen and ink
28.7 × 21.1 cm
Windsor Castle, The Royal Collection,
12602r
Plate I.29

No.7
Proportions of a man's torso and legs
*c.*1488
Pen and ink
14.7 × 21.7 cm
Windsor Castle, The Royal Collection,
19130v
Plate III.9

No.8
Proportions of a man's arm
*c.*1488
Pen and ink
12.5 × 20.7 cm
Windsor Castle, The Royal Collection,
19131r
Plate III.10

No.9
Truncated and stellated dodecahedron
from Luca Pacioli, *De divina proportione*,
Florence, Paganus Paganius, 1509
(original drawing 1498)
Woodcut
28.7 × 20.4 cm
London, Victoria and Albert Museum,
87.B.30
Plate III.12

No.10
Determining the volume of regular and
irregular solids
*c.*1505
Pen and ink
Opening of 2 pages, each 13.8 × 10.4 cm
London, Victoria and Albert Museum,
Codex Forster I, 6v–7r
Plate III.14

No.11
Determining the volume of pyramidal and
rectangular solids
*c.*1505
Pen and ink
21.8 × 29.4 cm
London, British Library,
Codex Arundel, 182v–183r
Plate III.15

No.12
Determining the areas of figures with straight
and curved sides
1509
Pen and ink
29 × 20.9 cm
Windsor Castle, The Royal Collection,
19145r
Plate III.2

No.13
Head of a man showing how rays of light fall upon
the face from an adjacent source
*c.*1488
Pen and ink
20.3 × 14.3 cm
Windsor Castle, The Royal Collection,
12604r
Plate II.29

No.14
Plotting rays of light from concave mirrors
*c.*1509
Pen and ink
21.9 × 28.8 cm
London, British Library,
Codex Arundel, 86r–87v
Plate IV.39

No.15
Plotting rays of light from concave mirrors,
also conic sections and other optical studies
*c.*1509
Pen and ink
21.5 × 29.5 cm
London, British Library,
Codex Arundel, 73r–78v
Plate IV.38

No.16
Water flow and reflections of rays of light
from water, etc.
*c.*1508
Pen and ink
21 × 14.5 cm
London, British Library,
Codex Arundel, 25r
Plate IV.37

No.17
Square of multiples and other studies
*c.*1496
Pen and ink
20.5 × 16 cm
London, British Library,
Codex Arundel, 153r
Plate III.6

No.18
Studies of centres of gravity and
compound balances
*c.*1508
Pen and ink
21 × 14.75 cm
London, British Library,
Codex Arundel, 3r
Plate I.2

No.19
Analysis of a perpetual-motion machine, the
pyramidal rule for weights on balances, a joint
and optical study
*c.*1500
Pen and ink
21.5 × 15.75 cm
London, British Library,
Codex Arundel, 44v
Plate I.7

2. THE LESSER AND GREATER WORLDS

The theory of the microcosm and macrocosm was an ancient one. It stated that the human body contained within itself, in miniature, all the operations of the world and universe as a whole. Leonardo wrote of analogies between the rocks and bones, the soil and flesh, and the rivers and blood vessels. He spoke of the 'body of the earth' with its 'veins of water', and of the 'tree of the vessels' in the human body.

He gave the old analogy fresh cogency through his brilliant graphic realization of the analogy. He also used the analogy as a potent tool of explanation. After performing an autopsy on a very old man, he explained that the old are enfeebled because of the tortuous and silted-up nature of their blood vessels.

Leonardo was one of the 'masters of water' consulted by the Florentine authorities at the time of the war to recapture Pisa; he also devised a canal to bypass the unnavigable stretches of the River Arno. His interest in hydraulic engineering extended far beyond the making of devices or schemes for irrigation. He investigated the nature of water in motion and its behaviour in the 'body of the earth'.

In the last major phase of his anatomical researches he focused on the design of the heart, and most notably on the operation of its valves. His detailed studies of the structure and vortex motion of the blood in the tricuspid valve (formed from three geometrical cusps) have been confirmed by modern science.

Above all he was fascinated by the action of vortices, which were unique in that they speeded up rather than slowed down, like most things set in motion (other than falling bodies). Using meticulous observation and intricate theoretical constructions, he created compelling images of water in complex motion – which reminded him, typically, of the curling of hair.

No.20
The 'tree of vessels', staircase designs and paired 'tree-trunk' columns
*c.*1508
Pen and ink, sepia wash and red chalk
29.2 × 19.7 cm
Windsor Castle, The Royal Collection, 12592r
Plate I.31

No.21
'Irrigation systems' of the female body: respiratory, vascular and urino-genital
*c.*1507–8
Pen and ink and wash over black chalk, pricked for transfer
47 × 32.8 cm
Windsor Castle, The Royal Collection, 12281r
Plate III.37

No.22
Vessels of the thorax with comparison of the heart and a germinating seed
*c.*1508
Pen and brown ink (two shades) over traces of black chalk
19 × 13.3 cm
Windsor Castle, The Royal Collection, 19028r
Plate I.30

No.23
Vessels of the arm with comparison of vessels in the old and the young
*c.*1508
Pen and ink
19 × 13.9 cm
Windsor Castle, The Royal Collection, 19027r
Plate III.36

No.24
Plan for an Arno canal
*c.*1504
Black chalk, pen and ink, wash, with signs of pouncing
24 × 36.7 cm
Windsor Castle, The Royal Collection, 12685r
Plate I.11

No.25
The River Arno immediately west of Florence
1505
Red chalk
21.5 × 14.5 cm
London, British Library, Codex Arundel, 149r
Plate I.8

No.26
Schematic plan of Florence with the Arno
*c.*1515
Pen and ink over black chalk
29.8 × 19.9 cm
Windsor Castle, The Royal Collection, 12681
Plate I.12

No.27
Diagram of the atria and ventricles of the heart
*c.*1513
Pen and ink
29.1 × 21.5 cm
Windsor Castle, The Royal Collection, 19062r
Plate I.33

No.28
Studies of the heart of an ox (?)
*c.*1515–16
Pen and ink on blue paper
28 × 41 cm
Windsor Castle, The Royal Collection, 19073–4v
Plate I.32

No.29
Studies of a three-cusp valve and scheme for
a model of the neck of the aorta
c.1516
Pen and ink on blue paper
28.3 × 20.7 cm
Windsor Castle, The Royal Collection,
19082r
Plate II.22

No.30
An old man seated in a landscape and
studies of water flowing past an obstacle
c.1513
Pen and ink
15.2 × 21.3 cm
Windsor Castle, The Royal Collection,
12579r
Plate I.19

No.31
Water pouring from a culvert
c.1510
Pen and ink
8.4 × 19.3 cm
Windsor Castle, The Royal Collection,
12659r
Plate I.16

No.32
Studies of water swirling away from
a concave surface
c.1508
Pen and ink
8.8 × 10.1 cm
Windsor Castle, The Royal Collection,
12666r
Plate I.17

3. FORCE

Leonardo's vision of the natural world was extraordinarily dynamic. Force was the key to the vision, and the application of force was necessary for anything to move. Motion gave life to all things, but also exercised huge destructive potential.

At the centre of this vision was the motion of the human body. Bodily movements expressed the 'motions of the mind' and were essential in the telling of a pictorial story. Leonardo's 'cinematographic' images of little figures in action manifest a continuity of motion in space in a way that no one had previously captured.

As an engineer, his supreme ambition was to amplify human motion so that man-powered flight might become possible. The key, as always, lay in nature – above all in the study of flying creatures and their anatomy.

Leonardo described war as 'beastly madness' and wrote 'prophecies' and 'fables' about the horrors of its weaponry and destruction. Yet he was fascinated by military engineering and the harnessing of power on huge scales. He worked as a military engineer for the rulers of Milan, Cesare Borgia and the French king. He devised chariots in the ancient manner, weapons systems and projectiles, and devices for operating underwater.

His representations of battles, especially his drawings for the *Battle of Anghiari* in the Council Hall in Florence (unfinished and now lost), depict the savagery of conflict as never before, with humans and animals acting in violent concert. One small drawing depicts an extraordinary vision of 'beastly madness' so intensely tangled that we can hardly discern one combatant – animal or human – from another.

The ultimate expression of force in the natural world is witnessed in dreadful storms during which wind, rain, waters, trees, soil and rocks are wrenched up in a whirling cataclysm. Whole mountainsides are torn apart and explode with elemental fury. Beside such forces, human power remains puny.

No.33
Men at work, digging, carrying, pulling, etc.
c.1509
Black chalk with some pen
20.1 × 13 cm
Windsor Castle, The Royal Collection,
12644r
Plate IV.2

No.34
Men in motion, carrying, digging, hammering, etc.
c.1509
Black chalk with some pen
19 × 12.9 cm
Windsor Castle, The Royal Collection,
12646r
Plate IV.3

No.35
Studies of men climbing stairs and
a running man stopping
c.1508
Pen and ink
19 × 13.3 cm
Windsor Castle, The Royal Collection,
19038v
Plate III.11

No.36
Man climbing a ladder
c.1494
Red chalk
Opening of 2 pages, each 9.6 × 7 cm
London, Victoria and Albert Museum,
Codex Forster II, 45v–46r
Plate IV.4

No.37
Analysis of muscles attached to the spine and ribs
*c.*1509
Pen and ink
28.9 × 20.6 cm
Windsor Castle, The Royal Collection,
19015v
Plate III.35

No.38
Bird's wing, architectural sketches, pulleys,
ground plans for courtyards
*c.*1512
Red chalk, gone over with pen
27.5 × 20.1 cm
Windsor Castle, The Royal Collection,
19107v
Plate II.7

No.39
Anatomy of a bird's wing, a bird in flight and
studies of proportion
*c.*1514
Red chalk and pen
22.5 × 20.5 cm
Windsor Castle, The Royal Collection,
12656
Plate IV.9

No.40
Chariots armed with flails, an archer firing an arrow
through a shield, and a horseman with three lances
*c.*1483–4
Pen and ink wash
20 × 27.8 cm
Windsor Castle, The Royal Collection,
12653
Plate II.1

No.41
Projectiles and a fortification
*c.*1504–5
Pen and ink
21.7 × 15.5 cm
London, British Library,
Codex Arundel, 54r
Plate IV.19

No.42
Studies of horses and horsemen for
the Battle of Anghiari
*c.*1503–4
Pen and ink
8.3 × 12 cm
London, British Museum,
inv. no. 1854-5-13-17
Plate IV.8

No.43
Horses in action, with studies of expression in horses,
a lion and a man, and an architectural ground plan
*c.*1505
Pen and ink
19.6 × 30.8 cm
Windsor Castle, The Royal Collection,
12326r
Plate IV.7

No.44
Battle scene with men and elephants
*c.*1512
Red and black chalk on red prepared paper
14.8 × 20.7 cm
Windsor Castle, The Royal Collection,
12332
Plate IV.17

No.45
An exploding mountain
*c.*1515
Black chalk
17.8 × 27.8 cm
Windsor Castle, The Royal Collection,
12387
Plate IV.25

No.46
Deluge with rocks, floods and a tree
*c.*1516
Black chalk
15.8 × 20.3 cm
Windsor Castle, The Royal Collection,
12377
Plate I.22

4. MAKING THINGS

Leonardo performed many roles and
undertook numerous tasks for his court
patrons. He performed many of his diverse
duties with enthusiasm, but they did take
him away from the making of paintings and
sculpture, upon which he pinned most of
his hopes for fame.

Architecture was the most prestigious
of these activities. He developed a highly
innovatory vision of architecture as a plastic
way of shaping space. He depicted buildings
both as sculpted forms and as solid sections.
He was particularly concerned with
centralized buildings. He was able to
represent with extraordinary plastic clarity
the structure of a spiral staircase.

Leonardo was renowned as a maestro of
devices and visual effects at the court and
in noble houses, particularly those involving
water. He invented entertaining water
clocks and fountains. His planned water
clock for the French governor of Milan was
elaborately automated, with a mechanical
man as a bell-ringer. He also contrived
underwater breathing devices for use in
times of peace and war.

In addition he was the author of
spectacular theatrical designs, including one
for an opening mountain, which discloses
Pluto and his infernal companions making
cacophonous noises on specially designed
instruments. He was closely involved with
instrumental and vocal music for the court
and studied the way the tongue and lips
shape the sound of the voice.

No.47
Design for a centralized 'temple' in plan
and solid section
*c.*1488
Pen and ink over silverpoint on blue paper
19.9 × 28 cm
Windsor Castle, The Royal Collection,
12609v
Plate III.26, III.27

No.48
Names and proportions of a column base
c.1493
Pen and ink
Opening of 2 pages, each 9.2 × 6.4 cm
London, Victoria and Albert Museum,
Codex Forster III, 44v–45r
Plate III.8

No.49
Studies of a structural failure in apses
with semi-domes, and in walls
c.1509
Pen and ink
21.5 × 29 cm
London, British Library,
Codex Arundel, 138r–141v
Plate III.29

No.50
Studies of a spiral staircase and of pumps
c.1516–17
Pen and ink
20 × 28.7 cm
London, British Library,
Codex Arundel, 264r–269v
Plate III.30

No.51
Plan for centralized buildings and
palaces with canals
c.1516–17
Pen and ink
21.5 × 14.35 cm
London, British Library,
Codex Arundel, 270v
Plate III.25

No.52
Scheme for a rubble-filled dam and
mechanical studies
c.1503–4
Pen and ink
22.1 × 14.5 cm
London, British Library,
Codex Arundel, 81r
Plate II.5

No.53
Lamps with revolving fountains (?), geometry,
water engineering and other studies
c.1508
Pen and ink
22.5 × 28.3 cm
London, British Library,
Codex Arundel, 282r–283v
Plate IV.24

No.54
Stoves for heating water
c.1498
Pen and ink and black chalk
21 × 14.5 cm
London, British Library,
Codex Arundel, 145v
Plate III.22

No.55
Studies for a water-clock with
automaton bell-ringer
c.1509
Pen and ink
12 × 12.5 cm (mounted together)
Windsor Castle, The Royal Collection,
12688 and 12716
Plates IV.49 and IV.50

No.56
Studies for the release mechanism for
a water-clock, the human oesophagus and
a costume design
c.1509
Pen and ink
37.2 × 28.1 cm
Windsor Castle, The Royal Collection,
12282v
Plate III.33

No.57
Designs for an underwater breathing device
c.1507–8
Pen and ink
21 × 14.35 cm
London, British Library,
Codex Arundel, 24v
Plate III.32

No.58
Devices for the measurement of the force of wind
and jets of air or water
c.1490
Pen and ink
15.1 × 21.2 cm
London, British Library,
Codex Arundel, 241r
Plate IV.35

No.59
Stage design for the opening of mountains
('Pluto's Paradise'); c.1509
Pen and ink
21.5 × 16 cm
London, British Library,
Codex Arundel, 224r
Plate IV.14

No.60
Stage design for the opening of mountains
('Pluto's Paradise'); c.1509
Pen and ink
22 × 15.5 cm
London, British Library,
Codex Arundel, 231v
Plate IV.13

No.61
Designs for musical instruments (mainly percussion)
and diagram of the elements with a falling body
c.1509
Pen and ink
21.5 × 16.2 cm
London, British Library,
Codex Arundel, 175r
Plate IV.12

No.62
Studies of the tongue and lips with list of sounds
and geometry
c.1510
Pen and ink and wash on the drawing
of the tongue
31.6 × 21.8 cm
Windsor Castle, The Royal Collection,
19115r
Plate IV.15

LEONARDO'S WAY THROUGH LIFE

This digest of securely dated events in Leonardo's life is edited from my *Leonardo* (Oxford University Press, 2004), which was in turn abridged and edited from *Leonardo da Vinci: Master Draftsman* (New York, The Metropolitan Museum of Art, 2003) by permission of The Metropolitan Museum of Art, copyright © 2003, and with warm thanks to Carmen Bambach.

1452
15 April — On Saturday, around 10.30 p.m. ('at three o'clock in the night' in Renaissance time), Leonardo is born out of wedlock, as recorded by the artist's paternal grandfather, Antonio di Ser Piero da Vinci. Leonardo's father is the notary Ser Piero di Antonio da Vinci (1427–1504), and his mother is a young farmer's daughter, Caterina, who in 1453 married Accattabriga di Piero del Vacca.

1457
28 February — The five-year-old Leonardo is listed as a dependent *bocca* ('mouth') in the tax-assessment declaration of his grandfather, Antonio.

1462 — Leonardo's father is employed in Florence as a notary by Cosimo de' Medici, 'Il Vecchio'.

First Florentine Period (*c*.1464/9–1481/3)

1469 — The tax declaration of Leonardo's father, Ser Piero, and of his uncle Francesco suggests that Ser Piero is already working as a notary at the *palagio del podestà* (seat of the chief law officer, today the Palazzo del Bargello) in Florence.

1472 — Leonardo appears in the account book of the painter's confraternity, the *Compagnia di San Luca*, in Florence.

1473
5 August — Leonardo inscribes a landscape drawing: 'day of St Mary of the Snows/ day *of 5 August 1473*' (Uffizi, Florence).

1476
9 April and
7 June — By now in Andrea del Verrocchio's employ, Leonardo is among those charged with sodomy with Jacopo Saltarelli, a 17-year-old apprentice in a goldsmith's workshop. The charge is not followed up.

1478
10 January — The commission for an altarpiece in the Chapel of S. Bernardo in the Palazzo della Signoria of Florence.

16 March — A payment of 25 florins for the S. Bernardo altarpiece.

28 December (or in the few days that follow) — Leonardo draws an eye-witness sketch of the hanged corpse of Bernardo di Bandino Baroncelli (Musée Bonnat, Bayonne). A drawing in the Uffizi is inscribed, ' ——ber 1478, I began the two Virgin Marys'.

1481 — Leonardo undertakes the *Adoration of the Magi* altarpiece.

July — The contractual memorandum for the *Adoration of the Magi*, in which the monks record the commission for the main altar of their convent church of S. Donato a Scopeto.

June–September — Payments in money and commodities for work at S. Donato.

28 September — Payment in wine for work at S. Donato.

First Milanese Period (1481–1499)

1481–3
September
1481–April 1483

Leonardo leaves Florence for Milan.

1483
25 April

Leonardo, with the brothers Evangelista and Giovan Ambrogio da [de'] Predis, signs the contract to decorate the altarpiece for the Confraternity of the Immaculate Conception in its chapel in the church of S. Francesco Il Grande in Milan.

1485
16 March

Leonardo observes a total eclipse of the sun.

23 April

Ludovico Sforza sends a letter to Maffeo da Treviglio, ambassador to the court of Matthias Corvinus, King of Hungary, in which he states that he has commissioned a Madonna from Leonardo on the King's behalf: 'a figure of Our Lady as beautiful, as superb, and as devout as he knows how to make without sparing any effort'.

1487

Leonardo prepares designs for the domed crossing tower (*tiburio*) of Milan Cathedral, and hires the carpenter's assistant Bernardino de' Madis to build a wooden model based on his drawings. Payments for the model are recorded on 30 July, 8 August, 18 August, 27 August, 28 September and 30 September.

1488
January

Leonardo collects additional payment for the project of the *tiburio* of Milan Cathedral.

1489
2 April

Leonardo inscribes one of his skull studies, '*a dj 2 daprile 1489* … book entitled "On the Human Figure"' (Windsor 19059).

22 July

Piero Alamanni, the Florentine ambassador to the Sforza court in Milan, writes to Lorenzo de' Medici, 'Il Magnifico', in Florence stating that 'Il Moro' has entrusted the model of the 'Sforza horse' to Leonardo, but that he still needs 'a master or two capable of doing such work'.

1490
13 January

Leonardo produces the stage set for Bernardo Bellincioni's *Feast of Paradise* (*La Festa del Paradiso*), performed in the Castello Sforzesco, Milan, to celebrate the wedding of Gian Galeazzo Sforza and Isabella d'Aragona.

23 April

He notes that he has resumed work on the Sforza horse.

10 and 17 May

Payments for the model of the *tiburio* of Milan Cathedral.

21 June

Leonardo accompanies Francesco di Giorgio to Pavia in connection with the project to rebuild the cathedral; they are both paid for their expertise.

27 June

Leonardo loses the design competition for the *tiburio*, which is awarded to Giovanni Antonio Amadeo and Giovanni Giacomo Dolcebuono.

22 July

Salaì (Gian Giacomo Caprotti di Oreno), who is ten years old, arrives in Leonardo's workshop as a rascally trainee.

7 September

Salaì steals a silverpoint from one of Leonardo's assistants called Marco (d'Oggiono?).

1491
26 January

Leonardo is 'in the house of Galeazzo da Sanseverino' to prepare a festival and tournament honouring the wedding of Ludovico Sforza and Beatrice d'Este.

2 April

Salaì steals the silverpoint of another of Leonardo's workshop assistants called Giovan Antonio (Boltraffio?).

1491–5

In an undated letter, Leonardo and Giovan Ambrogio da Predis complain to Ludovico Sforza about the Confraternity of the Immaculate Conception's poor payment for the *Virgin of the Rocks* and the two flanking paintings of angels.

1492

Leonardo travels to the Lake Como region in Lombardy, visiting Valtellina, Valsassina, Bellagio and Ivrea.

1493
November

An equestrian effigy of Francesco Sforza (Leonardo's actual model of the Sforza horse or an image based on his design) is displayed under a triumphal arch inside Milan Cathedral during the festivities for the marriage of Ludovico's niece, Bianca Maria Sforza, to the Emperor Maximilian I of Hapsburg.

20 December

Leonardo decides to cast the Sforza horse on its side and without the tail. Bernardo Bellincioni's *Rime...*, published in this year, praises Leonardo's *Portrait of Cecilia Gallerani*.

1494
January

In Vigevano.

17 November

Ludovico Sforza, 'Il Moro', sends the bronze for the Sforza horse to his father-in-law, Ercole d'Este, Duke of Ferrara, to make a cannon.

1495

Leonardo goes to Florence, where he acts as a consultant in the building of the *Sala del Gran Consiglio*.
Giovanni da Montorfano signs and dates the *Crucifixion* fresco on the south wall (opposite Leonardo's *Last Supper*). The much-damaged portraits of Ludovico Sforza and Beatrice d'Este with their two small sons – painted in oils rather than in *buon fresco* – are inserted in the foreground, and have sometimes been attributed to Leonardo.

14 November

A record suggests that Leonardo may be at work on the decoration of rooms in the Castello Sforzesco in Milan.

1496

Leonardo drafts a detailed petition about the making of bronze doors to the administrators of Piacenza Cathedral.

8 and 14 June

Letters note that the painter decorating rooms in the Castello Sforzesco (Leonardo?) has abandoned the project, and it is suggested that Perugino might be approached.

1497
27 June

Ludovico Sforza sends a memorandum to his secretary, Marchesino Stanga [Stange], expressing his hope that Leonardo will soon finish the *Last Supper* so that he can commence work on another wall in the refectory.
Leonardo designs the suburban villa of Mariolo de' Guiscardi, near the Porta Vercellina in Milan.

1498
8 February

Fra Luca Pacioli dedicates his *De Divina Proportione* to Ludovico. He praises Leonardo, indicating that the Sforza horse measures 12 *braccia* ('the said height from the nape [of the neck] to the flat ground', i.e. over 7 m/23 ft) and would have a bronze mass of 200,000 *libbre* (i.e. 67,800 kg /147,400 lb).

17 March

Leonardo travels to Genoa harbour and makes notes on the ruined quay.

22 March

A letter addressed to Ludovico states that the work in the refectory of Sta Maria delle Grazie is to progress expeditiously.

20, 21 and 23 April

Leonardo is recorded at work on the murals in the *Saletta Negra* (little back room) and the *Sala delle Asse* (room of the boards) in the north-west tower of the Castello Sforzesco of Milan.

26 and 29 April

Isabella d'Este, Marchioness of Mantua, asks Cecilia Gallerani to send Leonardo's portrait so that she might compare it with Bellini's portraits.

1499
26 April

Ludovico Sforza has given Leonardo a vineyard near Porta Vercellina, between the monasteries of S. Vittore and Sta Maria delle Grazie in Milan.

9–10 September

The French troops of King Louis XII storm the city, led by the mercenary general Gian Giacomo Trivulzio, for whom Leonardo was later to plan an equestrian monument.

October

King Louis XII enters Milan.

14 December

Milan falls decisively to the French. Leonardo sends money to his account at the Hospital of Sta Maria Nuova in Florence, in anticipation of his return to the city in company with Luca Pacioli.

Second Florentine Period (1500–1506/7)

1500 Leonardo may have accompanied Count Louis of Ligny (courtier of Charles VIII, and later of Louis XII) on a mysterious trip to Rome, and possibly Naples.

Leonardo is working for the Venetian Republic on a proposal for a defence system against the threat of a Turkish invasion in the Friuli region.

With Boltraffio, Leonardo is possibly the guest of Casio in Bologna.

February Leonardo stays in Mantua as the guest of the Gonzaga.

13 March The lute player Lorenzo Gusnasco da Pavia sends a letter to Isabella d'Este from Venice stating that Leonardo had showed him a portrait of her.

24 April Leonardo arrives in Florence and probably resides in the church complex of Santissima Annunziata (hosted by the Servite brothers), where he draws a cartoon of the *Virgin and Child with St Anne*.

He offers advice on the damage to the foundation of the church of S. Salvatore dell'Osservanza (San Francesco al Monte) above Florence, and on the construction of a campanile for the church of S. Miniato.

11 August Leonardo sends Francesco Gonzaga a drawing of the villa of Angelo del Tovaglia near Florence.

1501 From Mantua, Isabella d'Este asks Fra Pietro da
28 March Novellara (head of the Carmelites in Florence) to obtain information about Leonardo's activities.

3 April Fra Pietro replies that Leonardo is at work on a cartoon for a *Virgin and Child with St Anne and a Lamb*.

14 April Fra Pietro sends another letter to Isabella, noting that Leonardo is working on the *Madonna with the Yarnwinder* for Florimond Robertet, secretary of King Louis XII.

19 and 24 September Letters by Giovanni Valla, ambassador to Ercole I d'Este, enquire of the French authorities in Milan whether the Duke may use the moulds of the Sforza horse, which were 'exposed to daily decay as the result of neglect', to cast his own equestrian monument in Ferrara.

1502 Leonardo evaluates drawings of antique vases
12 May from Lorenzo de' Medici's collection that are being offered to Isabella d'Este.

May–18 August Cesare Borgia, 'Il Valentino', Captain General of the Papal Armies, names Leonardo 'familiar architect and general engineer' in the Marche and Romagna.

July–September Leonardo travels to Urbino, Cesena, Porto Cesenatico, Pesaro and Rimini in Cesare's service.

1503 Leonardo returns to Florence. He writes to Sultan
February Baiazeth in connection with a project for a bridge on the Bosporus.

9 March, 23 June The notary for the disgruntled Confraternity of the Immaculate Conception makes a summary of events regarding the *Virgin of the Rocks*.

June–July During the siege of the city of Pisa, Leonardo stays in the Camposanto and makes topographical sketches, designs for military machines and fortifications for the *Signoria* of Florence.

24 July A letter by Francesco Guiducci states that Leonardo and others have come to show schemes for the diversion and canalization of the Arno River.

July Leonardo is paid by the *Signoria* of Florence in connection with the scheme to level the Arno at Pisa.

He is reinscribed in the account book of the painters' confraternity.

24 October Leonardo receives keys to the *Sala del Papa* and other adjacent rooms in the great cloister of Sta Maria Novella, Florence, which will serve as

his workshop and living quarters while preparing his cartoon for the *Battle of Anghiari*.

1504

25 January

With 29 others, Leonardo participates in a meeting on the final placement of Michelangelo's giant marble *David*.

February– October

Leonardo is paid a steady salary for work on the *Battle of Anghiari* cartoon.

28 February

Payments for the ingenious movable scaffolding that Leonardo invents to draw the *Anghiari* cartoon, and for a very large quantity of paper.

4 May

The *Signori* of the Florentine republic, led by the chancellor, Niccolò Machiavelli, sign a contractual document that summarizes the state of Leonardo's work on the *Battle of Anghiari* and confirms his monthly salary of 15 *fiorini*.

14 and 27 May, 31 October

Letters record Isabella d'Este's intention to commission from Leonardo a devotional painting of 'a youthful Christ of about twelve years old'.

30 June

Further payments to various artisans are recorded for Leonardo's work on the *Battle of Anghiari* cartoon.

Leonardo goes to Piombino to work on military engineering projects at the request of Jacopo IV Appiani, lord of Piombino and an ally of Florence during the Pisan war.

9 July

In the evening Leonardo's father, Ser Piero di Antonio da Vinci, dies in Florence. The settling of his estate causes acrimonious disputes for almost six years between Leonardo and his seven living, legitimate half-brothers.

August

Leonardo's uncle, Francesco, bequeaths him property.

30 August

Payment for the iron wheels and parts to be used for Leonardo's scaffolding.

30 November

Leonardo records that he believes he has solved the problem of squaring the circle.

30 December

Payments suggest that Leonardo incurs further expenses for supplies.

1505

28 February, 14 March

The expenses for Leonardo's scaffolding are reimbursed.

30 April

Additional expenses for the *Anghiari* are recorded. The painting assistants are Raffaello d'Antonio di Biagio, Ferrando Spagnolo and Tomaso di Giovanni, who 'grinds colours' for Ferrando.

6 June

Leonardo writes: 'On the 6th day of June, 1505, Friday, at the stroke of the 13th hour I began to paint in the palace. At that moment when [I] applied the brush the weather became bad, and the bell tolled calling the men to assemble. The cartoon ripped. The water spilled and the vessel containing it broke. And suddenly the weather became bad, and it rained so much that the waters were great. And the weather was dark as night.'

31 August

Further payments to Leonardo's assistant, Ferrando Spagnolo, and the 'colour grinder' Tomaso di Giovanni.

31 August, 31 October

Painting supplies for the *Anghiari* mural and the cloth covers for the scaffolding are reimbursed.

Second Milanese Period (1506–1513)

1506

13 February

Leonardo and the heir of Evangelista de' Predis (who died in 1491) designate Giovan Ambrogio de' Predis to represent them in the dispute with the Confraternity of the Immaculate Conception.

4 April

Arbitrators are appointed regarding the dispute over the price of the *Virgin of the Rocks*.

27 April

Giovan Ambrogio de' Predis, on behalf of Leonardo who is in Florence, comes to an agreement with the Confraternity regarding the *Virgin of the Rocks*, which still seems to be unfinished.

3 and 12 May

Letters between Isabella d'Este and Alessandro Amadori (brother of the first wife of Ser Piero da

Vinci) mention 'those figures, which we have beseeched from Leonardo'.

30 May — A contract between Leonardo and the *Signoria* of Florence requires that, before Leonardo can depart for Milan, he is to return to Florence within three months to finish the *Battle of Anghiari*.

18 August — Charles II d'Amboise, governor of Milan, who had become Marshal of France in 1504, writes to the *Signoria* in Florence requesting Leonardo's services in Milan.

19 and 28 August — Letters between the French court in Milan and the *Signoria* of Florence record negotiations concerning Leonardo going to Milan without penalty.

Early September — He sets out for Milan with Salaì, Lorenzo and 'Il Fanfoia'. Their host is Charles d'Amboise, who commissions Leonardo to design a suburban villa and garden.

9 October — The frustrated *Gonfaloniere* of the Florentine republic, Piero Soderini, accuses Leonardo of impropriety.

16 December — In a letter to the *Signoria* of Florence, Charles d'Amboise expresses his satisfaction with Leonardo's work.

1507
12, 14 and 22 January — In an exchange of letters between the Florentine ambassador Francesco Pandolfini, the *Signoria* of Florence and the royal court at Blois, it is agreed that Leonardo should stay in Milan to serve the French.

March — Leonardo returns with Salaì to Florence.

27 April — A decree restores to Leonardo his vineyard at S. Vittore near the Porta Vercellina, which had been expropriated during the fall of Milan in December 1499.

23 July — Leonardo designates representatives in an unnamed legal case and seems to be living within the parish of S. Babila in Milan.

26 July — Florimond Robertet intervenes in Leonardo's dispute with the *Signoria* of Florence over the unfinished *Battle of Anghiari* project, and requests on behalf of the King the presence in Milan of 'our dear and well-loved Leonardo da Vinci painter and engineer of our trust'.

3 August — A member of the Dominican order is appointed as arbitrator in a dispute between Leonardo and Giovan Ambrogio de' Predis.
Leonardo produces stage designs for *Orfeo*, the play by Angelo Poliziano, with a set for a 'mountain which opens'.

15 August — Charles d'Amboise demands that the *Signoria* of Florence ensure that Leonardo can return to Milan again, 'because he is obliged to make a [painted] panel' for King Louis.

20 August — Leonardo finds someone to represent him legally in Milan.

26 August — The arbitration decisions regarding the *Virgin of the Rocks* commission are summarized.

18 September — Leonardo writes a letter from Florence to Cardinal Ippolito d'Este in Ferrara, soliciting support in his legal dispute with his brothers.
He meets the young nobleman Francesco Melzi (1491/3–*c*.1570) from Vaprio d'Adda who is to be his devoted pupil, companion and major heir.
Leonardo's uncle, Francesco, dies, leaving Leonardo as his sole heir.

In the winter — Leonardo returns to Florence at some point during the winter of 1507–8. He also dissects an old man, supposedly 100 years old (the 'Centenarian'), at the Hospital of Sta Maria Nuova in Florence.

1508
22 March — Leonardo is staying at the house of Piero di Baccio Martelli.

23 April — By this date Leonardo has returned to Milan to serve Louis XII.

22 July	From now until April 1509 Leonardo records the salaries that he is being paid by the French king.
18 August	Giovan Ambrogio de' Predis and Leonardo receive permission to remove the *Virgin of the Rocks*, newly installed in S. Francesco Il Grande in Milan, so that Giovan Ambrogio can copy it, under Leonardo's supervision.
12 October	Leonardo authorizes a release of a quittance regarding the *Virgin of the Rocks*.
23 October	Giovan Ambrogio de' Predis receives a final payment of 100 *lire imperiali* regarding the copy of the *Virgin of the Rocks*, and Leonardo confirms the settlement of the confraternity's debt.
1509 28 April	Leonardo notes that he has solved a problem concerning the geometry of curved and rectilinear areas.
1510	He is paid a salary of 104 *livres* for the year by the French state, under Louis XII.
21 October	Leonardo is asked to advise on the design of the choir stalls of Milan Cathedral.
1511 2 January	Leonardo writes that a quarry 'above Saluzzo' has marble of the hardness of porphyry, 'if not greater', and that his friend the *maestro* Benedetto has promised to give him a piece to use as a painter's palette for mixing colours.
10 and 18 December	He records that the invading Swiss soldiers have set fires in the city of Milan, marking the end of the French domination of Milan. Leonardo and his household abandon the city, settling for some time at the Melzi family villa in Vaprio d'Adda.
1513 25 March	Leonardo may have returned to Milan, when he appears in one of the register books of the Milan Cathedral masons' works.

Roman Period (1513–1516)

1513 24 September	Leonardo writes, 'I departed from Milan to go to Rome on September 24 with Giovan Francesco [Melzi], Salaì, Lorenzo and "Il Fanfoia".'
October	He and his four companions probably pass through Florence.
1 December	Leonardo is in Rome as part of the household of Giuliano de' Medici (brother of Pope Leo X), who sets the artist up in a workshop in the Belvedere wing of the Vatican Palace.
1514 7 July	Leonardo writes that a geometrical problem was 'finished on July 7 at the 23rd hour at the Belvedere, in the studio made for me by Il Magnifico [Giuliano de' Medici]'.
25–7 September	He writes that he is in Parma and 'on the banks of the Po'. He visits Civitavecchia to undertake studies of the harbour and archaeological ruins.
8 October	Leonardo is inscribed in the confraternity of S. Giovanni dei Fiorentini in Rome.
1514–15	Leonardo writes drafts of letters to Giuliano de' Medici, which mostly concern his disputes with Giovanni degli Specchi, a German mirror-maker.
1515 9 January	Leonardo notes that his master, Giuliano de' Medici, departed at dawn from Rome in order to marry in Savoy.
12 July	At a banquet honouring the entry of King Francis I into Lyons on his return from Italy, a mechanical lion invented by Leonardo is presented as a gift from Lorenzo di Piero de' Medici, Duke of Urbino.
30 November	Pope Leo X makes his triumphal entry into Florence, and Leonardo and his employer Giuliano de' Medici travel as part of the papal entourage. Leonardo plans a new palace for Lorenzo di Piero de' Medici, opposite Michelozzo's Palazzo Medici.

7–17 December	He leaves Florence, passing through Firenzuola, on his way to Bologna, where the Pope is to meet the French king. For his trip Leonardo receives 40 *ducati* from Giuliano de' Medici.
1516 13 March	Leonardo records the solution to a mathematical problem.
17 March	Giuliano de' Medici dies and Leonardo writes: 'The Medici made me, and destroyed me.'
August	He takes measurements of the large early Christian basilica of S. Paolo fuori le Mura in Rome.

French Period (1516–1519)

1516	Leonardo goes to France as *paintre du Roy* for King Francis I. He is accompanied by Melzi and Salaì.
1517 May	On Ascension Day the artist writes that he is in Amboise and Cloux.
1 October	A letter from Rinaldo Ariosto to Federico Gonzaga in Mantua describes a celebration for King Francis I in Argentan, mentioning Leonardo's mechanical 'lion which opened, and in the inside it was all blue, which signified love according to the customs here'.
10 October	Leonardo receives a visit from Cardinal Luigi d'Aragona and his secretary Antonio de Beatis, who records the event in his diary. De Beatis saw three paintings: a portrait of 'a certain Florentine woman done from life at the request of the said magnificent Giuliano de' Medici', a young St John the Baptist, and a Virgin, Child and St Anne. Because Leonardo had suffered paralysis of his right side, possibly caused by a stroke, 'he can no longer paint with the sweetness of style that he used to have, and he can only make drawings and teach others'.
11 October	De Beatis's diary amends his record of the previous day: 'there was also a picture in which a certain lady from Lombardy is painted in oil, from

	life, quite beautiful, but in my opinion not as much as the lady Gualanda, the lady Isabella Gualanda'.
29 December	De Beatis's diary records his visit to see Leonardo's *Last Supper* at the refectory of Sta Maria delle Grazie in Milan: 'although most excellent, it is beginning to deteriorate'.
End of the year	Leonardo is recorded at work in Romorantin in connection with a project to build a palace for King Francis I.
1517–18	The very substantial stipend from the King for the 'master Leonardo da Vinci, Italian painter' amounts to 2,000 *écus soleil* for two years. 'Francesco Melzi, Italian nobleman', receives 800 *écus* for two years, and 'Salaì, servant of master Leonardo da Vinci', 100 *écus*.
1518 Until 16 January	Leonardo remains in Romorantin, working on the plans for the palace and related canals.
19 June	In celebration of the wedding of Lorenzo de' Medici and Maddalena de la Tour d'Auvergne, niece of King Francis I, *The Feast of Paradise*, originally staged by Leonardo in 1490, is performed in Cloux with mechanical scenery.
24 June	Leonardo writes that he has left Romorantin to go to the castle of Cloux at Amboise.
1519 23 April	Leonardo, 67 years old and ailing, goes before the royal court at Amboise to acknowledge his will.
2 May	Leonardo dies in the castle of Cloux (Clos Lucé). Following his wishes, he is buried in the cloister of the church of Saint-Florentin at Amboise (later destroyed).
1 June	His beloved companion and artistic heir, Francesco Melzi, writes movingly to Leonardo's half-brother Ser Giuliano da Vinci to notify the family of Leonardo's death.

FURTHER READING

This is an edited version of the annotated list that appeared in my *Leonardo* in 2004. This selection from the vast literature on Leonardo is designed to guide the reader towards some of the more accessible, recent and authoritative sources, and to open a door into the primary sources and documentation for Leonardo's works and life.

1. GENERAL MONOGRAPHS, ETC.

K. Clark, *Leonardo da Vinci*, ed. M. Kemp, London, 1993 (and Folio Society 2005), remains the most eloquent introduction to Leonardo as an artist.

M. Kemp, *Leonardo da Vinci. The Marvellous Works of Nature and Man*, rev. edn Oxford, 2006, covers the full range of Leonardo's work and thought chronologically, while *Leonardo*, Oxford, 2004, treats his ideas thematically in a more compact form.

P. Marani has published a series of valuable monographs and catalogues of Leonardo and his followers, most recently *Leonardo da Vinci*, New York, 2003, including a useful appendix of documents by E. Villata.

The most comprehensive and fully illustrated recent catalogue is by F. Zöllner, with J. Nathan, *Leonardo da Vinci*, Cologne, 2003.

A penetrating account of Leonardo's artistic origins is given by D.A. Brown, *Leonardo Da Vinci: Origins of a Genius*, New Haven, 1998.

A valuable collection of writings on Leonardo, from early accounts to modern scholarship, has been edited by C. Farrago, *Leonardo's Writings and Theory of Art*, 5 vols, London, 1999.

The regular journal, the *Raccolta Vinciana*, ed. P. Marani in Milan, publishes bibliographical updates, as did *Achademia Lionardi Vinci*, ed. C. Pedretti.

Leonardo's posthumous reputation is discussed by A.R. Turner, *Inventing Leonardo*, New York, 1993.

The afterlife of the *Mona Lisa* is discussed in A. Chastel, *L'illustre incomprise – Mona Lisa*, Paris, 1988.

2. SOURCES, FACSIMILES, ETC.

The documentation of Leonardo's life is edited by E. Villata, *I Documenti e le testimonianze contemporanee*, Ente Raccolta Vinciana, Milan, 1999.

Facsimiles of Leonardo's Manuscripts were earlier published under the auspices of the Reale Commissione Vinciana, and new facsimiles are being published by Giunti as the Edizione Nazionale dei Manoscritti e dei Disegni di Leonardo da Vinci from 1964 onwards.

A compact, three-volume version of the huge *Codice atlantico* in the Biblioteca Ambrosiana, Milan, was published by Giunti in 2000, ed. C. Pedretti, with transcriptions by A. Marinoni.

Recent Italian transcriptions, generally accompanying the facsimiles, are by the major scholars of Leonardo's manuscript legacy, C. Pedretti and A. Marinoni.

A series of translations by J. Venerella of the Manuscripts held by the Institut de France are being published by the Raccolta Vinciana in Milan, from 1999 onwards.

The standard anthologies of excerpts from the manuscripts in translation are J.P. Richter, *The Literary Works of Leonardo da Vinci*, 2 vols, Oxford, 1970, with *Commentary* by C. Pedretti, 2 vols, Oxford, 1977; and J. McCurdy, *The Notebooks of Leonardo da Vinci*, 2 vols, London, 1938.

The standard edition of the *Treatise on Painting* is by C. Pedretti, Berkeley, 1964, and London, 1965.

For the *Paragone* (comparison of the arts), which opens the Vatican manuscript of the *Treatise*, see C. Farago, *Leonardo da Vinci's Paragone: A critical interpretation*, New York, 1991.

An anthology of Leonardo's writings on art is provided by *Leonardo on Painting*, ed. M. Kemp, trs. M. Kemp and M. Walker, New Haven and London, 1989.

3. DRAWINGS

The best compact general collection remains A.E. Popham, *The Drawings of Leonardo*, London, 1947 and 1994 (with intro. by M. Kemp).

The important collection of drawings at Windsor is catalogued by K. Clark and C. Pedretti, *The Drawings of Leonardo da Vinci in the Collection of Her Majesty the Queen at Windsor Castle*, 3 vols, London, 1968; and more recently in the series of facsimiles by Giunti, and the Johnson Reprint Corporation, mainly edited by C. Pedretti.

A series of exhibitions of the Windsor drawings at the Queen's Gallery have been accompanied by catalogues by Lady J. Roberts and M. Clayton.

C. Bambach's catalogue of the exhibition, *Leonardo da Vinci Master Draftsman*, New York, Metropolitan Museum, 2003, contains important scholarship by Bambach herself and essays by various authors, as does F. Viatte, *Leonard de Vinci Dessins et Manuscrits*, Paris, Louvre, 2003.

4. ARCHITECTURE AND ENGINEERING

The most complete review of Leonardo as an architect is C. Pedretti, *Leonardo Architect*, London, 1986.

P. Galluzzi, *The Renaissance Engineers*, Florence, 1996, sets Leonardo's engineering in context.

Useful material and essays are gathered in *Leonardo. Engineer and Architect*, ed. P. Galluzzi, Montreal, 1987.

For military architecture, see P. Marani, *L'Architettura fortificata negli studi di Leonardo da Vinci*, Florence, 1984.

For the water clock, see Mark Rosheim, *Leonardo's Lost Robots*, Berlin, Heidelberg, New York, 2006.

5. ASPECTS OF SCIENCE, ETC.

K. Keele, *Leonardo da Vinci. Elements of the Science of Man*, London, 1983, sets Leonardo's anatomical researches into the context of his thought.

A comprehensive treatment of Leonardo's optics is provided by K. Veltman, *Linear Perspective and the Visual Dimensions of Science and Art*, Munich, 1986.

The best treatment of Leonardo's mathematics is A. Marinoni, *La Matemica di Leonardo da Vinci*, Milan, 1982.

Comprehensive analysis of the water drawings and notes is provided in a series of volumes by E. Macagno, *Leonardian Fluid Mechanics*, Iowa, 1986 onwards.

C. Starnazzi, *Leonardo Cartografo*, Florence, 2003, has explored Leonardo's geological interests.

A good introduction to Leonardo's thought is provided by R. Zwijnenberg, *The Writings and Drawings of Leonardo da Vinci: Order and Chaos in Early Modern Thought*, New York, 1999.

For the physiognomics, see M. Kwakkelstein, *Leonardo as a Physiognomist*, Leiden, 1994.

INDEX